THE SAINTS OF MODERN ART

CHARLES A. RILEY II

'THE SAINTS OF MODERN ART

The Ascetic Ideal in Contemporary Painting,

Sculpture, Architecture, Music, Dance,

Literature, and Philosophy

University Press of New England

Hanover and London

University Press of New England, Hanover, NH 03755

© 1998 by University Press of New England

All rights reserved

Printed in the United States of America

5 4 3 2 1

CIP data appear at the end of the book

For my mother,

ISABEL COOPER RILEY,

who taught me the pleasure of the arts

and the discipline required to deeply enjoy them

and who has supported my work

from the very beginning—

with heartfelt gratitude.

◐

Contents

III. Asceticism and Architecture / 164

IV. Asceticism in Music and the Dance / 182

V. Asceticism in Literature and Philosophy / 254

Contents

Illustrations

Preface

Despite the austere sound of *asceticism* as the premise for a study of contemporary art and thought, this is a book that is meant to bring the kind of intense pleasure to readers that it brought to me as I wrote it. These essays are offered to be enjoyed, not as a monolithic attempt to account for the evolution of Modernist aesthetics through the rubric of self-denial nor as a definition of one ascetic ideal after which all great Modern art is in some way fashioned. This is a series of interconnected essays, each as short and as jargon-free as possible, on a very wide spectrum of artists and thinkers who fostered an asceticism that is so individualized as to defy generalization. The pleasure of considering this diverse group of thinkers and artists will, I hope, arise from the realization that asceticism can be so varied and, in that way, so alive at a time when its religious foundations have all but crumbled.

With that in mind, I hope that my readers will not feel compelled to proceed straight through the entire study, page after page, in pursuit of some grand conclusion regarding asceticism and art. With so many essays to choose from, the reader is invited to enjoy hopping from discipline to discipline, tracing some of the connections that I have made and drawing others for herself or himself. The delight of putting these figures together was derived, in part, from finding the ties that already existed— the way, for example, that Thomas Bernhard used Glenn Gould as a character in one of his novels, and then Walter Abish composed a seminal essay on Bernhard in turn, so that the three can be strung like beads on a thread. In the same way, John Cage becomes ubiquitous, appearing in conjunction with Jasper Johns, Merce Cunningham, Simone Weil, and a number of other figures.

As a nexus for a variety of vital issues in art and philosophy, asceticism proved to be an astonishingly fertile topic. It gave me the chance to explore the relationship between the life of the artist and the work in a certain context (not all of these artists are saints, and many of the biggest rascals produce the most ascetic art), as well as a lens through which I could reconsider the issues of Classicism in contemporary art, the interaction of

the Western and Asian traditions, the dynamic relationship between abstraction and the art of the body, and the endlessly engaging question of the continuing role of spirituality in art and philosophy. I hope that readers will find similar points of contact between their own strongest interests in aesthetics and the theme of asceticism. I also hope that readers will use this as a pretext for a reconsideration of the art and thought many of the figures that I might have considered in these pages but elected to leave out, such as Franz Kafka, Andy Warhol, Maurice Blanchot, Roland Barthes, T. W. Adorno, Jacques Derrida, Marguerite Yourcenar, Yukio Mishima, Hart Crane, Tennessee Williams, Antonin Artaud, J. K. Huysmans, William Carlos Williams, Geoffrey Hill, Constantin Brancusi, Richard Serra, Sol LeWitt, Carl Andre, Dan Flavin, Leoš Janáček, Richard Rorty, Henry James, and many others. Readers will have their own list of additions, I am sure.

The choice of artists and philosophers was completely personal and depended in part on the accessibility of the figures themselves, as I have based much of the book on interviews with them as well as on their writings. My aim is to allow the painters, sculptors, architects, composers, poets, novelists, and philosophers of our time to articulate what asceticism means to them in their own words. I was very fortunate indeed to have the cooperation of so many of them and would like to extend my thanks in particular to Brice Marden, Mark di Suvero, Peter Halley, Lawrence Carroll, Mark Innerst, Mark Milloff, Nancy Haynes, Theresa Chong, Yu Yu Yang, Walter Abish, Philip Glass, Tan Dun, and Robert Wilson for the patience with which they endured my questions and read my text. Asceticism is a curious state of mind. It attracts not only artists and philosophers but particular types of art collectors, dealers, and audiences as well; and I have been fortunate enough to have had access to many of the private collections that are particularly ascetic in their taste, such as those of Agnes Gund, Asher B. Edelman, Joel and Sherrie Mallin, and Warner H. Kramarsky, all of whom I thank for their generous help.

At the University Press of New England I was blessed with a wonderful editor, Phyllis Deutsch, and with the guidance of editorial director Philip Pochoda. I must once again thank Thomas L. McFarland, former director of UPNE, for his perfect understanding of the way in which I work and his complete support of this project from the beginning.

Like many of the artists and scholars of the liberal arts who will, I suspect, be reading this book, I work alone. There are no research assistants or secretaries to systematically thank here, but there are friends, colleagues, and family without whom a book like this is not possible. Among them in particular I am grateful to David Collens, Lisa Hahn, Jennifer Vorbach, Richard Milazzo, Carol Green, Tricia Collins, Christopher

Burge and Michael Findlay of Christie's, Susan Dunne, Professor Robert Pincus-Witten, Professor Patrick Cullen, Charles Clough, Steve Mumford, Michele Basora, Kara Somerville, Kate Finneran, Devon Dikeou, Lawrence Carroll, Byor K. Kim, Professor Arthur Danto, Kazuhito Yoshii, Lucas Reiner, Robert Burke, Seward and Joyce Johnson, Debbie and Bill Richards of the Art Alliance of Pasadena, Thomas and Maxine Hunter of the Friends of the Art Institute of Chicago, the Friends of the Los Angeles County Museum, Roland Hasler of Swissair, Peter Peck of Xerox, Mrs. Elizabeth Sanders of the Speed Museum, Mr. and Mrs. Lawrence Kyte of the Cincinnati Museum, Virginia Lemoyne and Juliet Waite of ArtFocus/Au Point, the Friends of the Orlando Museum, Barb and Jerry Schauffler of the Oakland Museum, Milo Beach of the Freer Gallery, and many of the other distinguished museum and arts organizations with whom I have enjoyed great experiences under the auspices of Art Horizons International. Laurentian University gave me the one and only opportunity to present these ideas within an academic setting, and I am particularly indebted to Bruce Krajewski of the English Department for that opportunity and for an unforgettable one-on-one session with Peter Simpson of the Philosophy Department that reshaped this book significantly.

Most important, my mother, to whom this book is dedicated, offered the sort of encouragement and interest that could sustain a writer through a project as ambitious as this. My sisters Diane and Robin kept a wonderful stream of ideas and enthusiasm coming my way, and my extraordinary wife, Ke Ming Liu, fought those battles with me that, alas, in this day and age we are forced to wage, wherever in the world we are, if we are going to attempt to accomplish anything genuinely and passionately intellectual. Let this book be the sign of one small victory in that regard.

C. A. R.

Cutchogue, New York
January 1988

THE SAINTS OF MODERN ART

Introduction: From Gravity to Grace

W hen Hildegard von Bingen suddenly appeared next to the hooded monks of Saint Silo among the best-sellers in the window displays of music stores—a medieval prioress and a bunch of chanting Benedictine brothers packaged by major labels to calm the angst-ridden 1990s—it was a sign. Other harbingers were converging from various quarters at the same moment. For the austere new Calvin Klein flagship store on Madison Avenue, architect John Pawson copied the cold stone configuration of a Cornish monastery. A nun called Sister Wendy, tittering on television in front of Renaissance nudes, became England's most popular art critic since John Ruskin. On a more serious plane, a series of short films elevated the reclusive Glenn Gould's cult status to new levels. Seamus Heaney won the Nobel Prize in part for a lyric sequence based on a pilgrimage to a bleak island in the north of Ireland.

Within two cultural seasons we had a combination of musical, dance, and other artistic events that also fit the pattern. The Metropolitan Opera added Philip Glass's *The Voyage* to its repertory, across the plaza at Lincoln Center the City Opera presented an opera by Paul Hindemith based on Mathias Grunewald's Isenheim altarpiece and another based on Yukio Mishima's *The Golden Temple*, and a summer festival featured Virgil Thomson's *Four Saints in Three Acts*. Dance audiences not only maintained their allegiance to the lean and mean legacy of George Balanchine (grumbling only when they felt his company did not maintain his rigid standards of speed and perfection) but were treated to a revival of interest in the Shaker-inspired dances of Doris Humphrey and tough new work by Pina Bausch, as well as computer-based abstractions from Merce Cunningham. The most notable art exhibitions of the same period were retrospectives of Joan Miró, Cy Twombly, Robert Ryman, Piet Mondrian, Jasper Johns, and Bruce Nauman, closely followed by the crisp perfection of Vermeer. In fiction and philosophy, the hard-edged austerity of Robert Musil (in a new English translation) and Walter Abish complemented a surge in interest in the work of Simone Weil and the media's discovery of the laughing pragmatist Richard Rorty.

What did these events have in common? They are just a few current indications that a broad-based asceticism is a powerful factor in the intellectual life of our time, wielding an uncanny and anachronistic power over taste in music, dance, literature, architecture, and art. Add the broader constituencies that are influenced by the ascetic element in design, popular music (including New Age and rap), cyberspace and video games, even aerobics and the culture of the body, and the trend takes on the scale that might entice a journalist to coin a slogan like "the new asceticism" or "neoascetic"—if only asceticism were not new and had not always been a part of aesthetics and culture. Modernism in particular has always depended on asceticism as a foundation for its various types of formalism and Classicism. For many established and emerging artists, composers, choreographers, architects, writers, and philosophers, the lure of the ascetic ideal turns out to be one of the most vital (and misunderstood) creative forces in contemporary art.

Still Life and Studio Life

The psychology of the studio is almost by necessity ascetic. The studio is the working space, the laboratory, the gathering place for the tools and ideas, a solitary arena of accident as well as progress toward perfection. It would be naive not to acknowledge that an essential gesture on the part of almost any writer or artist (even those who have assistants) is retreat—the battle for time off from the demands of others and from all the distractions of today's generally unsympathetic, antiartistic climate. On a deep level, all intellectuals in some way are ascetics in that they actively impose some distance between themselves and a world that cannot at every stage help them with their work and very often seems to conspire against it. These essays pick out a diverse group of ascetic figures who bring that tendency into their work in some thematic, conceptual, or technical manner.

The crossover from the ascetic isolation of the artist in the studio to the work that can be called ascetic is partly effected by the way studio practice so often finds its reflection in the content of the art. Perhaps no genre of painting is so studio-oriented and primarily ascetic as the still life (even better, *nature morte*); and as we move from the rather traditional examples of still life by Joan Miró or Giorgio Morandi to later and more diverse (especially in terms of media) examples by David Smith, Cy Twombly, Eva Hesse, Joseph Cornell, and Bruce Nauman, we become more aware of the emotional resonance of what in previous centuries might have been an objective or just plain academic exercise in perception and technique. Think also of the "studio" paintings of Georges

Braque and Jasper Johns, the ballet stagings of George Balanchine and Jerome Robbins (particularly his *Afternoon of a Faun*) that use the practice room, or the revolutionary perception of the recording studio that is a major part of the legacy of Glenn Gould. They build the studio environment into the art so that the often romantic behind-the-scenes drama of making becomes the story of the piece. Then there is the elevation of the studio itself to a kind of artwork as cloistral retreat, as exemplified in the cork-lined room of Marcel Proust, Martin Heidegger's alpine cabin, the anechoic sensory deprivation tank where John Cage experimented with silence, the extraordinary desert compounds of Frank Lloyd Wright, Donald Judd, Agnes Martin, and Bruce Nauman, the remote island stronghold where Isamu Noguchi lived samurai-style in Japan, and the stone castle in Bolsena where Cy Twombly lived.

Once in the studio, it is assumed (especially following the Minimalist lead) that the isolated ascetic will pursue the utopian path of pure perfection through discipline and the habits of a strict working regimen. This is the way of Judd, early Robert Mangold, Philip Glass, George Balanchine, Glenn Gould, Robert Mapplethorpe, Mies van der Rohe, Stéphane Mallarmé, and others considered in this study. Asceticism for them is a fundamental component of the ethical dimensions of their artistic lives (often in complete contrast to their personal lives, a topic we will return to in a moment). The pursuit of perfection is more than technical—it is a mission. Driving themselves and their work to reach a pure ideal, characterized by a pride in clarity and structure, they embrace the crystalline ascetic model, with and without the vestiges of its religious origins.

That is the easy account of the artist as ascetic. Yet there are variations on the theme. A nearby path, which looks parallel but is actually slightly askew, is exemplified by those for whom perfection is slightly suspect because it seems inhuman, unartistic, perhaps impossible except as a useful point of reference. Among those who took this route are Claude Debussy, Mondrian, Agnes Martin, Hart Crane, Frank Lloyd Wright, Steve Reich, Mangold in his more recent work, Peter Halley, and many of those near-Minimalists who feel the tug of purism and discipline but want freedom as well.

Then there are those who take the freedom and ostensibly rebuke the discipline of form, although the pressing recollection of the formal haunts them like a passion. Theirs are the various arts of destruction so familiarly known in accounts of Modernism and Postmodernism: antiart, antiaesthetic, antiformalist. From Gerard Manley Hopkins and Samuel Beckett to Elliott Carter and John Cage, Alberto Giacometti, Mark Tobey, Cy Twombly, and Mark Milloff, Michel Foucault and Richard Rorty, they attack the rectilinear or figural structures of perfection with gestures that

overwhelm, interrupt, contradict, parody, efface, blur, remove, empty out, dissolve, disfigure, dismember, and cut. Through it all, the ascetic ideal holds on, a ghostly icon that can still be traced above or behind the work because the artist still believes in what he or she is trying to destroy.

The Body Ascetic

Somewhere between Mondrian and Minimalism, asceticism gained a permanent association with geometry, but it involves the art of the body, too. The attenuated standing figures of late Giacometti, the body casts of Bruce Nauman or the strange gray-eyed, waxen black nude Lilith of Kiki Smith, the starkly classical black-and-white nudes of Robert Mapplethorpe or the disturbing color photographs of Cindy Sherman are just the most obvious reflections of asceticism in the art of the body. More abstractly, the "skin style" in sculpture exemplified by Eva Hesse, Carol Hepper, Byron Kim, and Glenn Ligon takes asceticism in one direction while the abstract torsos of Isamu Noguchi and the open, dancing figures of David Smith, Mark di Suvero, and Joel Shapiro pursue another. When Jasper Johns, Cy Twombly, and Louise Bourgeois incorporate bodily forms in their work, they maintain an ascetic distance and control over the desires that could be provoked. At a recent exhibition devoted to the "Post-human" at the FAE Musée d'Art Contemporain in Lausanne, Switzerland, the artists explored the distortions and various perfections of the body through computer graphics, plastic surgery, and other ways of "improvement" (or destruction), mannerist metamorphoses that aimed at gaining a distance from the body as it is in order to have a glimpse at how it might be.

The body is always the starting point in dance, but some choreographers take an ascetic approach to achieve gravity-defying, pure effects that the normal body cannot attain. Balanchine, after the publication of his ex-dancers' memoirs, is the bête noire for the speed, elongation, thinness, and stamina that he "sadistically" demanded of his dancers, some of whom turned to drugs, plastic surgery, anorexia, and other extreme measures to give him that perfection. Merce Cunningham has turned to computers for imagery that can do what ordinary dancers cannot—and then he choreographs from the schemata for his company. In music, the distortion or purification of the voice, put through faster and faster solfège or minced and mixed in electronic collage, is the best analogue for what Balanchine—or Cunningham in another way—did to their dancers. For example, one of Steve Reich's most recent pieces for voice and instruments, "Proverb," uses a line from Ludwig Wittgenstein's notebooks— "How small a thought it takes to fill a whole life!"—repeated and broken

up and then sung with harmony in the manner of the twelfth-century chants of Magnus Perotinus.

This bridge to medieval or ancient Asian monastic life is more than a convenient technical tool for Reich and other recent composers and artists. It symbolizes the powerful connection between contemporary art and traditional spirituality that asceticism maintains. For some Modern masters, such as Samuel Beckett, Robert Musil, Jean Genet, Eva Hesse, Robert Mapplethorpe, and others considered in this study, the religious undertones of the ascetic ideal offered ironic possibilities, through parody or other forms of rebellion. In the Postmodern era the formal religious content is more thoroughly hollowed out, yet it remains a key psychological and even ethical principle at the core of so much that is thought and created in our time. For still others, devout Buddhists as well as those worshipping in the Western tradition, the spirituality is no less fundamental. They keep the door open to an innate spirituality that many in the art world are reluctant to completely exclude from their lives, despite the cynicism that surrounds metaphysics in Postmodern circles. That is why a powerful religious sense pervades the work of the composers Olivier Messiaen, Arvo Part, Henryk Gorecki, and Philip Glass, as well as the art of Mondrian, Mark Tobey, Barnett Newman, Twombly, Martin, and many more recent artists. The religious devotion of Gerard Manley Hopkins, T. S. Eliot, William James, and Simone Weil will come as no great revelation to students of literature and philosophy, but it remains an underestimated force in the development of Isamu Noguchi, W. B. Yeats, Jack Kerouac, George Balanchine, Seamus Heaney, and others.

The question of spirituality raises biographical issues that can very rapidly complicate the picture. Does ascetic art necessarily stem from belief? Does it even have to arise from an ascetic life? If Jean Genet, Robert Mapplethorpe, Michel Foucault, and Martin Heidegger are "saints"— following the ironic thinking of Roland Barthes who viewed the Marquis de Sade as the paragon of asceticism—then the vexing question is obviously the relationship between the life and the work. One of the forgotten novels of Modernism is George Santayana's *The Last Puritan*, written by the philosopher whose last days, spent in a monastery in Rome, were captured by a great Wallace Stevens poem and a fascinating essay by Edmund Wilson. Glenn Gould used to call himself, only partly in jest, "the last puritan," while others in this study, particularly Agnes Martin and Simone Weil, could make even stronger claims regarding the ascetic conduct of their lives. Yet for most of the artists and writers under consideration here, there is a division that must be acknowledged. Just as I was finishing this book, I received a phone call late one Friday afternoon from Brice Marden, arguably one of the most formidable of contemporary

ascetic artists, who was worried about this very question. "I hope you're not casting me as some kind of genuine ascetic—I lead a pretty luxurious life, you know, and there's not a lot of denial involved," Marden cautioned me, his bags probably packed for the annual trip to his villa in Greece. Marden continued, speaking for most contemporary artists I know: "I think that when you are actually doing the work, and in the contemplation of the work, asceticism provides the severe but necessary discipline and you are always trying to come back up to that severity and not wander from the path. Asceticism is not just my way of accomplishing this—every artist does this."[1] When Marden's ravishingly beautiful exhibition combining paintings and Chinese tombstones opened in New York's Chelsea in May 1997, the word among admittedly envious artists was that the immensely successful Marden had bought the whole sacred mountain of Han Shan from which the stones were brought.

Even more difficult than the apparent contradiction between the saintly aspect of the work and the hedonism of the life is a deeper dilemma that threatens the whole premise of a book on asceticism and the arts. The very words *ascetic* and *aesthetic* have a troubled relationship. Beyond the mix-ups created by the similarity in sound ("You're writing about the aesthetic ideal?") there is an underlying conflict between them. The traditional definition of asceticism is the denial of the senses. Unfortunately, the very root (etymologically as well as logically) of the aesthetic must be the senses, by which it is first grasped, enjoyed, and understood. Whatever art does conceptually or thematically, it still appeals to the senses and can be viewed, particularly in an era that pays so much attention to the monetary value of art, as a luxury or indulgence. Art that attacks the senses or this luxury status (occasionally construed as the view of art as a commodity or luxury item) argues from a precarious position, as art is not technically a necessity. In a genuinely ascetic world, perhaps it would have no place. The pilgrim's begging bowl and staff are not sculpture, the robe is not a costume, the chant is prayer, not a performance. When Van Gogh and Heidegger use the image of peasant shoes, the transformation into metaphor brings sensory pleasure that the strict ascetic would not indulge; even John Cage had to admit that there was a difference between his "artistic silence" and the "real" kind. We've traversed the spectrum, from a position where all artists are by definition ascetics to the point where no artist can be a true ascetic.

If life is carved out of fact and art from inspiration, it is understandable that life and art can be at odds. This conflict is also the primary problem of asceticism. As a retreat from life or as a violence against life, asceticism follows a parallel course to a certain type of art. It calls pleasure into question and elevates complexity or difficulty to a higher level

(as George Steiner has shown in his masterful book *On Difficulty*). The simplest view of this would be the opposition of abstraction to the forms, such as the human body, that we associate with ordinary life. Visitors to the recent Mondrian retrospective might not have noticed, but the first and last trace of a human figure encountered was a drawing in the first room of the show—a riveting self-portrait in charcoal that just depicted his eyes. The uncompromising architecture of Mies van der Rohe, the bitter misanthropy of Robert Musil or Thomas Bernhard, the hard edge of Philip Glass's music, and the severity of Balanchine all testify to the attitude many artists take toward pleasure, yet undeniably their work brings pleasure.

The most engaging recent consideration of this tough question is Wendy Steiner's *The Scandal of Pleasure: Art in an Age of Fundamentalism*. In her view, art steers its precarious course between the dual puritanisms of the political left and right, both of which project value into form. She uses case studies of Mapplethorpe, Heidegger, Salman Rushdie, and other "bad boys" of scandal to dramatize the way in which misreadings or overreaction can confuse art and life. With all the rubbish that has appeared in the media on this topic, here is the most sensible sentence on pleasure and principles that has yet been written: "What art *can* do, and do very well, is show us the relation between what we respond to and what we are, between our pleasure and our principles. As a result, it inevitably relates us to other people whose pleasures and principles either do or do not coincide with our own. Comparing one's pleasure with others' makes one compare analogies."[2]

The Ascetic Tradition in Modernism

As one vestige of the sacred in a profane era, the ascetic ideal has attracted its own canon of Modernists. Beyond Nietzsche's considerable writings on the topic—his Zarathustra is an ascetic—Schopenhauer's frequent allusions to Indian philosophy and the "path of coals" in his *World as Will and Representation* stands as one possible source of the themes of silence, *ascesis*, and disembodied ecstasy that unites Modernists as apparently disparate as Yeats, Gustave Flaubert, and Mallarmé, as well as many others considered in this study. The symbolic connection between Schopenhauer's circular path and Seamus Heaney's extraordinary lyric sequence "Station Island," which traces the thousand-year-old pilgrim's path around a series of little gravel circles on an Irish island about which Yeats also wrote poetry, attests to the contemporaneity of the image as well as the idea. Compare it also with the evocations of pilgrimage in the circular paths made by the "earth artists" Robert Smithson, Andy

Goldsworthy, and Richard Long, who use remote wilderness locations, such as Iceland or Alaska, or create meditative arrangements of stones inside galleries and museums.

Many of the formative literary and artistic critical judgments that shaped Modernism were offered by individuals who were personally and intellectually as ascetic as Marcel Proust, Walter Pater, and John Ruskin (who, perhaps it is unfair to point out, fled from the bedroom on his wedding night at the sight of his wife in the nude). Pater dramatized the dialectic of *ascesis* and sensual ecstasy in his "spiritual romance," *Marius the Epicurean*, as well as in his introduction to *The Renaissance*, where he praises "the charm of *ascesis*, of the austere and serious girding of the loins in youth."[3] In the essay "Style," Pater offered a similar exhortation: "Self-restraint, a skillful economy of means, *ascesis*, that too has a beauty of its own; and for the reader supposed there will be an aesthetic satisfaction in that frugal closeness of style which makes the most of a word, in the exaction from every sentence of a precise relief, in the just spacing of word to thought, in the logically filled space connected always with the delightful sense of difficulty overcome."[4] The exemplar of this style and of *ascesis* was for Pater, as for Barthes, Flaubert, who compared himself to an ascetic in a letter to Louise Colet in 1852: "I am leading a stern existence, stripped of all external pleasure, and am sustained only by a kind of permanent rage, which sometimes makes me weep tears of impotence but which never abates. I love my work with a love that is frenzied and perverted, as an ascetic loves the hair shirt that scratches his belly."[5]

Among their contemporaries, Cézanne was another hero of asceticism. Rilke, celebrating the "martyrdom" of Cézanne, called him, "This dear zealot, in whom something of the spirit of Saint Francis was coming back to life . . . in his paintings (the *arbre fleuri*) poverty has already become rich: a great splendor from within. And that's how he sees everything: as a poor man."[6] This Flaubertian "martyrdom" to style is echoed in the work of Charles Baudelaire's self-destructive night thoughts, as in these lines from "The Abyss": "Pascal's abyss went with him at his sides. . . . Above, below me, only depths and shoal, / the silence!"[7] Van Gogh's years in the Dutch countryside, spent in abject poverty, were similarly ascetic, giving him the subject matter for works such as *The Potato-Eaters* and *Peasant Shoes* and setting up the later self-portraits as a monk with shaved head. Heidegger's remarkable commentary on the peasant shoes functions as an introduction to his theory of the "clearing" in which the work of art stands, a milestone in the "negative" aesthetic of Modernism. More explicit references to sainthood are part of the legacy of Modernism. Paul Claudel, writing to André Gide at Christmas in 1905,

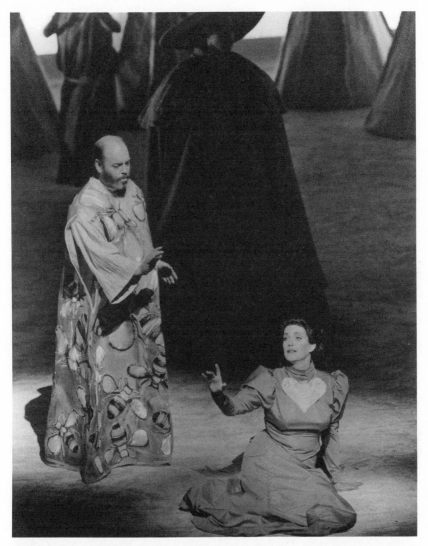

Modern hagiography: Virgil Thomson and Gertrude Stein delved the parallel between the lives of sixteenth-century Spanish monks and contemporaries such as James Joyce in their opera *Four Saints in Three Acts* (staged here by Robert Wilson). Photo: © 1997 Ken Howard. Courtesy of Lincoln Center for the Performing Arts.

compares great art to Saint Francis's "Canticle of the Sun," deplores the iniquity of recent French literature, and urges Gide, in a burst of piety, to examine his conscience: "We cannot all become Saints, but it is our duty to do what we can, in all honesty, every moment of our lives; and, to speak the truth, it is in this alone that sanctity consists—in a filial submission of our will to the Will of our heavenly father."[8]

Virgil Thomson's *Four Saints in Three Acts*, with a libretto by Gertrude Stein, is a landmark in the Modernist treatment of the ascetic ideal. In 1986, Thomson revealed that the sixteenth-century Spanish monastic life on which the opera was based concealed references to Stein (Saint Teresa) as well as James Joyce (Saint Ignatius). As the composer commented, "We didn't imagine ourselves to be virtuous saints, but still our lives were devoted to a disinterested and worthy endeavor. Our lives were exactly like those of Saint Teresa and Saint Ignatius and of the like-minded young people surrounding them."[9] For Wallace Stevens and William Carlos Williams, sainthood and the ascetic ideal were important elements in their view of Modernism, as exemplified in Stevens's "Snow Man," the flagellants in "The High-Toned Old Christian Woman," or the "Man on the Dump." This ideal is succinctly articulated in the line from "Credences of Summer": "Exile desire for what is not."[10] Williams, whose "Desert Music" inspired an important musical work by Steve Reich, used Saint Francis in "The Mental Hospital Garden" and "St. Francis Einstein of the Daffodils" and proposed that Francis be the official patron saint of the United States.

Postmodern proponents of "negative thought," particularly in France, have taken up the theme of asceticism from the writings of Mallarmé, Sartre, and Beckett. In Continental philosophy and criticism, asceticism is linked to the theory of the "emptiness" of the sign. From Sartre's *Saint Genet* the ascetic strain passes through the silence-invoking theoretical effusions of Jean Baudrillard, Maurice Blanchot, Jacques Derrida, Emmanuel Levinas, George Bataille, and Jacques Lacan, to arrive at *Saint Foucault*, the latest hagiography (by an American, David M. Halperin). Derrida and Blanchot push the question into the province of language. In a slim book on style, Derrida cites a passage from Nietzsche on the "impossible ascetics" to introduce his own connection between stylistic impotence and asceticism: "One should survey the whole history of the priests and philosophers, including the artists: the most poisonous things against the senses have been said not by the impotent, nor by the ascetics, but by the impossible ascetics, by those who really were in dire need of being ascetics."[11] The poet and art critic Yves Bonnefoy extols the "simplicity of utter solitude, the sort of quietness that accompanies the most radical negations" in Giorgio Morandi's still life paintings.[12] For Bonnefoy, the

silence of the paintings opens another dimension of meaning: "These tensions of bare color, in their threatening intensity, this smoothness of tone, so constant but suspended in pure carbon dioxide; this is the *further side of meaning*, the revelation of a new and irreparable silence."[13]

As this wave hit American shores, with its powerful and already well documented impact on literary criticism, its ascetic undertow maintained its strength. The central role of *askesis* as the third of six tropes or "revisionary ratios" in Harold Bloom's theory of the "anxiety of influence" allows for a chain to be made pulling together Socrates, Schopenhauer, Nietzsche, and Freud as theorists of negative sublimation, "a way of purgation intending a state of solitude as its proximate goal," and as its ultimate goal, hoping to induce the "ecstasy of priority, of self-begetting, of an assured autonomy."[14] Bloom uses this solitude to distinguish the members of an Orphic canon of British and American poets that runs through Milton, Wordsworth, Shelley, Keats, Browning, Yeats, Whitman, Emerson, Stevens, Dickinson, Frost, and Crane. In the case of each, *askesis* led to a necessary but limiting solipsism that prompts Bloom to associate asceticism and narcissism. This "negative sublime" is also involved in his view of the relationship between Modernism and Romanticism. Bloom connects *askesis* with what he calls "fear of godhead," or the uneasy relation between the mortal Modern and the "immortal" reputation of the precursor: "All poetic ecstasy, all sense that the poet steps out from man into god, reduces to this sour myth, as does all poetic asceticism, which begins as the dark doctrine of metempsychosis and its attendant fears of devouring a former version of the self."[15]

The most recent critical literature on asceticism has viewed in a broader way its link to power and its role in the visual arts. In Geoffrey Galt Harpham's *The Ascetic Imperative*, asceticism is central to culture: "Where there is culture there is asceticism; cultures structure asceticism, each in its own way, but do not impose it."[16] His study of the aesthetics of self-denial, which takes as its keynote a sensitive analysis of the Isenheim altarpiece by Mathias Grunewald supplemented by wide-ranging references to related paintings by Schongauer, Teniers, Cranach, Bosch, and Brueghel, through Cézanne and Dali, shows how asceticism can be a "strategy of empowerment or gratification" by resisting other powers as well as an artistic strategy or "form-producing agent."

Harpham's connection of discipline and asceticism holds for contemporary artists as well as medieval saints: "Ascetic discipline is a bodily act that points beyond itself, expressing an intention that forms, and yet transcends and negates, the body; discipline makes the body intelligible by indicating the presence of a principle of stability and immobility with the constantly changing physical being" (p. xx). Instead of limiting asceti-

cism's role to the historical context of the early Renaissance, Harpham admirably brings it into the twentieth century. He relates the ascetic imperative to the perpetual yearning for perfection, for innocence and objectification, bringing in Freud's *Beyond the Pleasure Principle* and the "untiring impulse towards further perfection" (p. 42). Using the examples of Nietzsche and Foucault, Harpham places asceticism in the middle of the struggle of power and pleasure in art in terms of the task of managing desire, a means of defining one's thinking or self by refusal. Harpham connects asceticism and Modernism—not just abstraction—in a continually present way: "Rather than insisting as some have that Modernism is a uniquely ascetical art, we should say that asceticism constitutes the perennial modernism of art" (p. 140).

Other recent studies in the visual arts have secured a particular place for the influence of the ascetic ideal on the development of Modernism. Among the most important critical works are Mark Cheetham's *The Rhetoric of Purity*, with its particularly solid chapter on the role of Neo-Platonism in the development of Mondrian's art, and *Painting as Model* by Yve-Alain Bois, which also focuses on Mondrian as well as Barnett Newman. As Cheetham's title suggests, he is particularly attuned to the language of the early abstract painters and their use of "purity" as a fairly seductive password for the "essentialist" philosophy they espoused. From a feminist angle, Robin May Schott's *Cognition and Eros* examines the link between asceticism and misogyny since Plato (through Augustine, Aquinas, and Kant's "disdain for touch," as well as Oscar Wilde's "desensualization of sensibility"). In her view, "objecticity" comes from the ascetic exclusion of eros from cognition, even though (especially after Susan Sontag) it is clear that the total displacement of eros from knowledge is an impossibility. The tension created by this attempted suppression drives the ascetic ideal from religion to modern philosophy, which becomes the new "purveyor of religious notions of purification." As Schott observes, "Men's willful control of their bodily passions is necessary for spiritual purity, and the exercise of their authority over women is requisite for such self-control. This commitment to the values of purity and control ultimately becomes transferred in the modern period from the religious to the philosophical domain."[17]

For the Romanian philosopher E. M. Cioran, asceticism and the "voluptuousness of suffering" was a source of fascination at a crucial and, from our point of view, perfectly apt moment in his life. When he was on the verge of being declared a "nonperson" in Romania, just before his permanent move to Paris in 1937, he wrote a passionate volume of short meditations recently published in English as *Tears and Saints*. Cioran confesses that he had an odd youthful appetite for hagiographies,

written by what he calls "historians of god's insomniacs," with which he escaped his dreary life in his home town of Sibiu. In a poignant sentence that sets the tone for much of this study he wrote, "I imagine man's isolation thus: a wintry landscape in which the snow is like materialized ingenuity; a light mist blurring the contours of the land; white silence, and in it, Man, ghost-like, an exile among the snow flakes."[18] In a style that is reminiscent of his beloved Nietzsche, as well as Kierkegaard, Cioran marvels at the "passionate naivete" of medieval saints, and like William James he trains a Modernist eye on the connections between illness (especially madness) and mysticism, ecstasy and boredom, space and silence, and most important, music and asceticism. The brooding atmosphere sets up a Modern equivalent of the medieval "aridity of consciousness":

> Whenever I think of austere solitude, I see gray shadows cast in deserts by monasteries, and I try to understand those sad intervals of piety, their mournful boredom. The passion for solitude, which engenders "the monastic absolute"—that all-consuming longing to bury oneself in God—grows in direct proportion to the desolation of the landscape. I see glances broken by walls, untempted hearts, sadness devoid of music. Despair born out of implacable deserts and skies has led to an aggravation of saintliness. The "aridity of consciousness" about which the saints complain, is the psychic equivalent of external desert. The initial revelation of any monastery: everything is nothing. Thus begin all mysticisms. It is less than one step from nothing to God, for God is the positive expression of nothingness. (pp. 60–61)

For this twentieth-century Romanian, sainthood was not a remote historical oddity but a living force that helps shape our view of modern literature, music, art, and thought. Many of Cioran's critical perceptions go right to the heart of asceticism in Modern literature, music, and painting. For example, he writes, "Baudelaire rivals St. John of the Cross. Rilke was a burgeoning saint. Poetic genius and saintliness share a secret penchant for self-destruction" (p. 71). His comments on the ascetic origins of geometry offer a similar insight into the architecture and painting of our time:

> Disjunction from life develops a taste for geometry. We begin to see the world in fixed forms, frozen lines, rigid contours. Once the joy of Becoming is gone, everything perishes through too much symmetry. What is known as the "geometrism" of so many kinds of madness may very well be an exacerbation of the disposition towards immobility characteristic of depressions. Love of forms betrays a partiality for death. The sadder we are, the more things stand still, until everything is frozen stiff. (p. 100)

The Ascetic Trace

The telltale themes that often reveal the ascetic undercurrent in Modern art make up a divergent and sometimes even contradictory group. Following the medieval tradition, the experience of pain, poverty, and privation usually signal ascetic violence against the body. In the work of Samuel Beckett the suffering is so constant as to have a numbing effect, while in the novels of Thomas Bernhard and Jean Genet or the poetry of W. B. Yeats and Hart Crane there is a sharpness to it that makes the senses all the more acute. Although the experience of dissonance is not, in the Wittgensteinian sense, a real source of pain, the discomfort produced by a blaring Bruce Nauman video of a clown screaming or by a relentless Philip Glass opera caught at full volume from orchestra-level seats, where one is accustomed to drifting away on gossamer pianissimo string passages of Wagner, becomes part of the sensory experience of art, just as the pressure on the eyes of looking hard at a Day-Glo painting by Peter Halley or a Dan Flavin neon piece can be painful.

The sadomasochism of Mapplethorpe and Genet is self-explanatory, but the agony of Giacometti's "rape" works or even the too-often-related tale of the two-ton Richard Serra steel sculpture that crushed an art handler also lie tangent to our sense of pain in art. The whole of Weil's philosophy is imbued with the necessary pressure of physical pain, while the nausea of Sartre and the physical weakness of Heaney at the end of his Station Island pilgrimage are more than metaphorical. Pain is a fact of life for dancers—who must learn to hide it—but the excessive demands that Balanchine's ballerinas recount in their memoirs or the brutal arthritis that made it almost painful to watch Cunningham limp up a few steps to the stage (only to seem to free himself from constriction once in the spotlight) take on dramatic resonance in the eyes of a knowledgeable audience.

Among the symbols of pain that weave their way through this study, the most persistent is a strangely recurring chair image—so often a dilapidated plain, straight-backed wooden chair—that pulls together connotations of torture, stillness, the throne of a ruler and the solitude of a loner, the immobility of the contemplative and the restraint of a prisoner under arrest. The most memorable of these chairs is the low, folding contraption that Glenn Gould hauled around on tour for so many years that in the film, where it plays a role as important as any character, it looks like a lopsided piece of junk. It is echoed in the wooden chair that Jasper Johns attached to one painting and later painted into many of his great gray works; the almost identical wooden chair that Johns's friend Merce

Cunningham would dance with, sometimes strapped to his waist; the massive wooden chair of Beckett's *Endgame*; the thronelike chair of the chess game scene in Eliot's *Waste Land*; or even the uncomfortable "Second Empire" furniture of Sartre's *Huis Clos*. It turns into the chair suspended upside down in a gallery by Bruce Nauman to symbolize victims of torture, the electric chair that is the pope's throne in Francis Bacon's horrifying portraits, the hanging chair in Robert Wilson's *The Life and Times of Sigmund Freud* (as well as the multiplicity of chairs in his other works), or the wheelchair of the Stephen Hawking–style character in Philip Glass's *The Voyage*. It becomes an emblem of the era's embrace of discomfort and austerity in Witold Rybczynski's rather amusing account, in the "Austerity" chapter of his book *Home*, of the competition among Marcel Breuer, Mies van der Rohe, and Frank Lloyd Wright to devise the best-looking, most uncomfortable piece of furniture.[19]

With pain comes the imagery of the wound, a staple of Modernism from Wagner's *Parsifal* through Edmund Wilson's great essay on "The Wound of Philoctetes" and beyond. From Kierkegaard's strangely psychosomatic spinal disorder through the raw violence of Francis Bacon's paintings and the woundlike metaphors of Eva Hesse and Joseph Beuys to the bright red and blue "guts" that are opened up when Mark Milloff slices through the gray or white exteriors of his paintings to delve the soft paint inside, suggestions of wounds abound in the art of asceticism. Another important ascetic symbol is the desert or mountaintop, landscapes of barrenness and sterility that echo the early Christian asceticism of "the Desert Fathers" in works as diverse as T. S. Eliot's *Waste Land* and Reich's "Desert Music" or in the desert compounds of Donald Judd, Frank Lloyd Wright, Isamu Noguchi, Marguerite Yourcenar, Paul Bowles, and Bruce Nauman. The psychological dimension of these barren places extends beyond the need for solitude to the complex awareness of impotence that beset many of the artists themselves as well as the characters they create. In the letters of Hopkins and Eliot, the writings of Weil, Beckett, Gould, Foucault, Kierkegaard, Pater, and Crane, and the dance of Balanchine and Cunningham—all of them childless—the typically ascetic battle against desire is compounded by a sense of impotence (Blanchot calls it the "neuter") that is tied as well to the aesthetic of purity—Mallarmé's virgin whiteness of the page or Cage's silence.

Both lightness and heaviness play their role in asceticism. The bronze mass of Mies's Seagram building on Park Avenue, the threatening steel of Serra, and the immobile concrete of Donald Judd's half-mile-long train of huge boxes in the West Texas desert all invoke an almost oppressive sense of heaviness. Pina Bausch's frightening cinder-block wall that comes crashing down toward the audience at the beginning of *Palermo*,

Palermo is a reminder that the dance, while more often associated with the weightlessness of Balanchine's sylphs, wages a constant battle against gravity. In art, the heavy impasto of Mark Milloff (whose larger oil-on-canvas paintings weigh hundreds of pounds) and the leaden grays of Johns and early Brice Marden are directly countered by the lightness of the "white writing" of Mark Tobey, the chalky, evanescent lines of Twombly, and the peculiar inner brightness of Giacometti's paintings or Mark Innerst's small, gemlike paintings built of white highlights under colored glazes. Weil's *Gravity and Grace* plays both sides of this dichotomy, as does the pianissimo of Debussy's Mélisande against the darkness of his Golaud. Although one knows that Mark di Suvero's steel I-beams weigh a ton, the open forms they create are as light as the wind-catching nets of Judy Pfaff or the fragile, suspended cords of Hesse.

The restraint, purity, and attention to geometry that we associate with Western Classicism are all aesthetic criteria that go hand in hand with *askesis*. From Elliott Carter and George Balanchine through the "Greek and Roman" paintings of Twombly and into the Greek-centered thought of Martin Heidegger and Simone Weil, the ever-problematic role of Classicism (troublesome because it can seem so anachronistic against the leveling forces of Postmodernism) draws on asceticism to maintain its grip on a certain faction in contemporary aesthetics. The "restraint" that is one of the characteristics of Classicism in any medium is analogous to the principle of denial and control that is at the psychological heart of the ascetic regimen. Certain aesthetic qualities, moreover, are shared by the two, including a tendency to steer clear of varied and bright color, a dependence on regular geometries, and an intensity and concentration of formal vocabulary on a streamlined shape and a particular economy of gesture and effect. Within the parameters of a larger project (such as Miró's Constellations series, Newman's *Stations of the Cross*, Gould's Bach projects, Eliot's *Four Quartets*, and Walter Abish's closely interconnected novels and stories), the details are worked out according to predetermined limits. Like the ticking of the metronome, the insistent voice of the rule exerts its pressure on the compositional process.

What is even more interesting, because it appears to reach a deeper and more universal level, is the crossing between asceticism and Classicism's Eastern spur, particularly as seen in the work of Wright and Marden (both of whom combine Greek and Chinese or Japanese Classical traditions), Cage (for his use of Zen and Schoenberg), and Reich and Glass for their own appropriations of Eastern instrumental and compositional traditions, as well as in the role of Eastern thought in the asceticism of Schopenhauer, Sartre, and Foucault. The perduring influence of Hindu and Buddhist thought on composers like Cage and Glass, painters like

Tobey, Johns, Agnes Martin, Sam Francis, Marden, and Nancy Haynes, and writers like Eliot (who specifically links the two asceticisms in a footnote to *The Waste Land*), Jack Kerouac, Genet, and Mallarmé is a crucial issue in more than just its ritualistic or exotic context. That traditional attraction to order, serenity, and control that lies at the center of Classicism in its Eastern and Western incarnations comes together in asceticism. Looking at its influence on a handful of artists whose background is Eastern but whose training is Western (e.g., I. M. Pei, Toru Takemitsu, Tan Dun, Isamu Noguchi, Yu Yu Yang, and Theresa Chong) isolates and perhaps makes clearer the intersection of Eastern and Western Classicism in asceticism.

Classical discipline places a premium on the process of correction as well as on measure. This is a guiding principle for the composers, like Carter and Glass, who worked with Nadia Boulanger, as well as for Hopkins's assiduous musings on prosody or Doris Humphrey's studies of rhythm. For painters like Miró, Mondrian, Richard Diebenkorn, Johns, Marden, and a generation of later artists, the process of correction finds its way into the final work in the form of traces, pentimenti, and other textural signs of the previous layers of paint. Although some of the most geometric painting under consideration in this study is made by artists who adamantly refuse to measure their canvases, the notion of measure is fundamental to the sculpture of Serra, Judd, and Carl Andre and to the geometric pictures of Frank Stella and Agnes Martin. All the terms of aesthetic approval involving measure, particularly within the Classical tradition, emphasize a static kind of perfection: correct, *juste*, proportionate, balanced, even, or in tempo.

One of the links among many of the artists in this study is the prevalence of a regimen in their working lives that often translates into a strong rhythmic element in their art. Some of the famous work routines of artists can be more clearly understood in terms of the ascetic tradition. For Weil and Heaney, as for many other artists who create "labor-intensive" art, the rhythms of work bring sanctification. From Proust huddled in his cork-lined chamber and Cage floating in the absolute silence of his sensory deprivation tank to Robert Mangold tracing ellipses in the white cube of light inserted in an old barn surrounded by farmland or Twombly dripping white paint from his canvas on the old stones of a medieval villa in Italy, the monkish tendencies of many artists are often quite pronounced. As Beckett emphasizes in a study of Proust, habit is a powerful force in aesthetic life; and by exploring the habitual in the lives of the figures under consideration, it may be possible to become attuned to the inner laws of development through which great and often baffling works evolve.

The direct line between the habits of Modern artists and the function of a regimen in the conventional ascetic tradition, going back to its religious origins, is easily drawn. In the case of Hopkins as well as, to a less convincing degree, a number of the artists who during the 1960s and 1970s became involved in the meditative practices of Zen, the rhythms of religious life are experienced literally through prayer, chant, and meditation and perhaps more important, through the physical aspects of ascetic practice: the steps of a pilgrimage, the fingering of beads, the ritual bowing and kneeling, or more dramatically, flagellation. These literal repetitions filter into the work in patter—the pronounced rhythmic figures, the compulsively multiplied back-and-forth action of a paintbrush or pencil on paper, the arrangement of extended serial sculpture, the echoing words or phrases in texts—works, in other words, that depend to a great degree on overtly repetitive gestures.

Rhythm and repetition are vital elements for all types of art, but there is a special relationship that seems to exist between asceticism and rhythm. Even among the great range of rhythmic innovations of twentieth-century music, it plays a unique role in the pulsing compositions of Glass and Reich and in a perhaps less conspicuous way in the Asian-inspired rhythms of Olivier Messiaen. No twentieth-century painter is more closely identified with rhythm than Mondrian (in literature, Hopkins occupies something of the same place), but the clear geometries of Miró, the cross-hatch patterns of Johns, the long box-reliefs of Hesse, and the big looping strokes of Twombly's blackboard paintings are all examples of a powerful rhythmic force in composition. In addition, the rhythm of ritual is a part of the way that Miró, for example, used the studio ritual of cleaning brushes on paper to turn out virtually one painting each day during his flight from the Nazis, producing one of the great serial works of the century: his Constellations. Like a Book of Hours, this type of "clockwork" production is a means of attaining a higher spiritual plateau, sometimes speeded up to an ecstatic allegro, sometimes slowed to a more contemplative lento.

One crisp October day while I was supposed to be hammering out this book, I was up the Hudson at Buckhorn, the estate of Joel Mallin, a lawyer whose sculpture collection includes important pieces by Serra, Mimmo Paladino, René Magritte, Antoine Bourdelle, Kiki Smith, and many other artists. Strolling around the manicured lawns of this trophy collection, smugly thinking of the gardens described in Yeats's "Ancestral Houses," my thoughts and steps were arrested by the *sound* of a work of art in progress. The Scottish sculptor Andy Goldsworthy was creating a new site-specific work. I could barely see Goldsworthy on the top of a hill overlooking the path into the woods, yet I received an extraordinary

lesson in the meaning of rhythm and labor in the practice of contemporary art. Echoing down through the woods came a resonant, five-beat tapping sound made by hammering the old slates that had been taken down from the vast roof of the main house into a conical structure that resembled a rock cairn. Within a week the piece was in place, and its silhouette through the bare trees offered a dark, tomblike image of solitude that was deeply disturbing. Yet there had been something cheerfully musical about the constant rhythm that suggested the purity of labor. Next, Goldsworthy was off to Alaska to arrange hundreds of icicles in the winter landscape, which sounds as ascetic as any earthwork one could imagine.

Among sculptors, of course, this physical rhythm is not uncommon. The steady, quasi-mechanical repetition of the ceramist's wheel, the stonecutter's chisel, the metalworker's hammer, even the piece-by-piece addition (or in the case of Giacometti, subtraction) of clay are all examples of the way in which the hand follows a pattern that, at certain moments, even the assiduous will admit can become almost automatic. Athletes and dancers are the epitome of how this principle is used to prepare for performance. The difficult sequence in dance, the complicated breakout play in hockey or basketball, which must be executed at such a speed that reflexes more than thinking are in control, is repeated often enough to become "second nature." The same holds true in music for the preparation of a blindingly fast allegro passage, the speed of which makes reading it and turning the pages on time a near impossibility. At these moments, the intellectual and physical dimensions of art-making are united, and the cement that keeps them together generally is rhythm.

The Art of Impersonality

In a consideration of the ascetic strain in the contemporary arts, the incongruous ethical problem of anonymity arises. The arts are not the kind of occupation that generally attracts the self-effacing type; even where "self-expression" is remote from the stylistic program, there is an implicit desire for recognition when one shows, performs, or even simply frames or records one's work. The saintly heroes of this particular strain of Modernism and Postmodernism compose a special canon. Rather than Pablo Picasso or Vincent van Gogh, the Modernist parade of ascetic heroes begins with Joan Miró and Piet Mondrian. In place of Jackson Pollock with his vast, signed canvases, we have Tobey working on small sheets of paper in gouache (and no signature in sight) and Newman's *Stations of the Cross*. Later, Twombly and Marden become the crucial figures, where the usual focus is on Willem de Kooning and Robert Rauschenberg. Then the Minimalists like Judd, Mangold, Andre, Flavin,

and LeWitt hold sway. The same reconfiguration can be made in music, literature, and philosophy. The epic grandeur of Richard Wagner gives way to the whispered mysteries of Debussy and miniatures of Webern; and in an era of flamboyantly publicity-hungry, image-conscious stars like Herbert von Karajan, Nadia Solerno-Sonnenberg, and Ivo Pogore-lich, two of the most influential figures were recluses: Nadia Boulanger and Glenn Gould. The strongest voice to be raised in poetics regarding impersonality was that of T. S. Eliot, and it is no wonder that Eliot offered a preface to the *Pensées* of Pascal as well as an introduction to a volume by Weil. At the core of Weil's thinking on art and writing is a theory of impersonality that is in perfect harmony with Eliot's own "impersonal theory of poetry." As Weil wrote in "Beyond Personalism," a posthumously published essay:

> Gregorian chant, Romanesque architecture, the *Iliad*, the invention of geometry were not, for the people through whom they were brought into being and made available to us, occasions for the manifestation of personality. . . . Truth and beauty dwell on this level of the impersonal and the anonymous. This is the realm of the sacred; on the other level nothing is sacred, except in the sense that we might say this of a touch of color in a picture if it represented the Eucharist. What is sacred in science is truth; what is sacred in art is beauty. Truth and beauty are impersonal. All this is too obvious.[20]

Wherever the sacred is invoked, the art of light prevails. From the Lucite rods of Frank Lloyd Wright's interiors to the glass pyramid that I. M. Pei designed for the Louvre, or from the invocations of light in the choral works of Olivier Messiaen to the golden light of the Byzantine paintings described in Yeats's later poetry, many of the masterpieces under consideration here are virtuoso examples of light in art. That is particularly true of the paintings of Tobey, Martin, Twombly, Ross Bleckner, Nancy Haynes, and Giacometti. But shadow plays its role as well in the story of asceticism, as the work of Johns, Robert Mapplethorpe, Peter Halley, Debussy, and others will show. The dim recesses and darker psychology of ascetic solitude are not always light-filled. Wright's cold buildings, Reich's *Cave*, and Mallarmé's ice in which a swan becomes trapped are just a few of the chilly venues that are associated with asceticism.

If there is one particular material or medium that can be associated with contemporary asceticism, it would have to be glass. As a cold, hard barrier separating the ascetic from the world, it is the most prevalent membrane in novels by, for example, Musil or Proust, in which the most sympathetic character always seems to be looking out on the world through a window; and one of the clearest autobiographical images we

have of Gould comes from a moment when he is comfortable behind the glass partition of the recording booth during a Karajan concert. The philosopher Richard Rorty starts his most important book, *Philosophy and the Mirror of Nature*, with the "glassy essence" of thought, and this theme is reflected in the proliferation of glass images and works, as well as in the use of its close ally wax or encaustic, in this study. The great glass *Bride Stripped Bare of Her Bachelors, Even* of Marcel Duchamp, the foggy translucent sculpture of Christopher Wilmarth, the strange use of glass in front of Francis Bacon's paintings or Joseph Cornell's boxes, the shards and fragments of glass in the work of Kiki Smith, and the infamous glass tanks of Damien Hirst and Jeff Koons are all examples of how it works in contemporary art. Koons suspended basketballs in aquariums and called them "equilibrium" sculptures, and the thirty-one-year-old "bad boy" Hirst is probably most famous for *The Physical Impossibility of Death in the Mind of Someone Living*, a piece he made for advertising executive Charles Saatchi, which features a fourteen-foot-long tiger shark suspended in an aquarium full of formaldehyde. Although its status as great art may be questionable, its ascetic resonance is not—death-centered, emphasizing separation from the world, it isolates and reveals. In the architecture of Wright, Mies, Pei, and many recent architects, glass was the "miracle" medium. The same feeling is captured by Cioran, invoking another great ascetic image: the prison. He writes, "As you roam through the streets of a town, the world seems to be still in its place. But look out the window and all will vanish. How can a mere piece of transparent glass separate us from life to such an extent? In fact windows bar us from the world more than prison walls. By looking at life one begins to forget it."[21]

The glass of the computer screen is another example of this separation and isolation. It is a medium that has captured the habits of a generation for whom the Internet and World Wide Web have become a hot growth area for types of art, such as Tod Machover's *Brain Opera*, that are, by comparison with traditional opera or paintings, rather impoverished in quality. They are closer to video art in that they often involve animation, sound bites, three-dimensional effects, and other virtual displays of graphic virtuosity that are coming from an ever expanding bag of tricks as designers dump more gadgetry on the Net. The strange virtue of virtual reality is this isolation, for hours on end, of cloistered individuals whose contact is through glass screens.

While these essays are mainly concerned with the rarefied area of the fine arts, literature, and philosophy, the "crossover" phenomenon of asceticism as a force in popular culture provides a more general context. Consider the tremendous popularity and commercial success of New Age and rap music that is based on Gregorian and other chants. After the

huge success Angel Records had with *Chant*, closely followed by *Chant II*, which also "went platinum" (not quite outselling Madonna, but coming close), labels like Harmonia Mundi and a slew of even cheaper Eastern European outfits rushed to market with their own albums of Gregorian, Tibetan, Celtic, Sufi, Sephardic, and other exotic modes of chanting. All share the hypnotic, calming effects—an hour of droning harmony so repetitious that it could be cut like fabric or wallpaper by the yard—that endear them to a "stressed-out" audience. With titles like *Heavenly Peace*, *Quietude*, and *Vision*, all are directly religious in content as well as atmosphere. With the end of the millennium approaching, critics say that the appetite for this type of music has been awakened in part by its mysterious strangeness but also by its spiritual origins. As Katherine Bergeron, a music professor at the University of California at Berkeley, commented in the *New Republic*, the "romantic draw" of *Chant* and its ilk is the restorative sense of time suspended that it offers:

> The substantial literature that has surrounded this record in the press returns again and again to an aspect of the recording that conveys, I think, an important sense of this music's "otherness" on the pop music market. That aspect is what might be called its poverty. This poverty is as much a musical trait as an economic one. We are reminded again and again of chant's drastically limited means of expression. . . . It is thus a queer space of suspended faith that *Chant* inhabits, an oddly comforting interval in which, neither believing nor disbelieving, we recognize the very experience we never expected to find as something already potentially lost.[22]

Gregorian chant is used as an anaesthetic by some; others go for deprivation and pain, such as the self-punishment of extreme aerobics, a strange echo of the discipline of dancers. The sports press has a field day with football stars like wide receiver Jerry Rice, who obsessively hones his body down to an ideal playing weight and then insists on an immaculate uniform, or with tennis star Pete Sampras, who will not allow his girlfriend to touch him for a number of days before a tournament. The lean and clean, if uncomfortable, look of commercial design and architecture stems directly from the ascetic ideals of Mondrian and De Stijl, and software designers import ascetic elements from literature, music, art, and theater design into the games they create. As Cioran and so many of the early Modernist figures under consideration here were beginning to sense decades ago, the isolation of contemporary existence enforces asceticism even on those who want to break through that glass. It is against this broader background that we look at some of the saintly avatars of the eternal ascetic impulse.

The Ascetic Ideal in Contemporary Painting

It is unlikely that asceticism will ever just go away as a significant factor in the evolution of art, but of all the moments in recent history when one might choose to stop and consider it as an isolated phenomenon, this seems the most appropriate. The reasons are more circumstantial—specifically, economic—than intellectual, but they filter back into the work in subtle ways. During the 1980s many more artists were making a killing in the market than are even able to make a living today. In addition to stipends from the galleries of several thousand dollars a month, they were enjoying the benefits of six-figure prices for paintings, huge studios with assistants, the best materials, and the sort of social status—thanks to the rich collectors and flush dealers who courted them—that would make the notion of the artist as hermit appear ludicrous. Artists were celebrities who cultivated their images more carefully than they attended to the priming of their canvases. In the village of the "art world," everybody knew when Julian or Jeff or Ross or David or Jean-Michel had an opening, and these stars played to the spotlight in what now seems a clownish and cynical fashion.

Eventually, the pack turned on Julian Schnabel, Jeff Koons, Ross Bleckner, David Salle, Jean-Michel Basquiat, and their kind but not before a great deal of damage to the credibility of all contemporary artists had been inflicted. These heavily hyped stars, with their advanced degrees in ego and public relations from the school of Andy Warhol, entered the broader public arena through film (Schnabel, Cindy Sherman, and Robert Longo tried directing) and mass media (especially in the case of Koons, who used his marriage to a former porn star and Italian politician for all the publicity he could muster). At the same time, the rising prices that made the contemporary art scene attractive to socialites, business figures, and celebrities suddenly dried up. For young artists the closing of hundreds of galleries, the downscaling of corporate and private collecting, and cuts in government grants were signs that choosing to pursue a career in art meant, once again, taking a vow of poverty. Ironically, during the 1960s through the mid-1970s there was a movement in

Italy, exemplified by the work of Mario Merz, Giulio Paolini, Michelangelo Pisteletto, and others, known as Arte Povera, named for the poverty of its materials, such as cast-off bricks and rags and newspapers. The commercial success of these artists in the galleries, however, makes the *povera* label seem largely rhetorical by comparison with the real hardship faced by many talented artists today.

One winter afternoon in the studio of a painter named Robert Burke, looking at the new paintings he was lining up for a Soho exhibition, I diverted the conversation from the Whitney Biennial to the topic of asceticism, only to have him declare, "Asceticism is a dead issue today, because those Baroque personalities like Koons and Schnabel were so far out there, so much a part of the world, that artists can no longer be viewed as the detached and pure figures we once were." Ironically, that afternoon, across town in Soho, a new Schnabel exhibition with an ostensibly "ascetic" theme—"The Conversion of Paolo Malfi"—was about to open. In a dozen huge canvases (one of them ten feet long), Schnabel mourned the death of his friend Paolo Malfi, an "idiot savant" (to borrow Schnabel's phrase) who was one of Schnabel's studio assistants and had worked for Francesco Clemente and Sandro Chia before he was run over and killed by a speeding Alfa Romeo in Rome in the summer of 1995. Schnabel repeats "Saint Paolo" over and over, in an allusion to the conversion of Saint Paul on the road to Damascus, scrawled into what he calls the "puritanical and raw" surface of the expressionistic works.

In a brief statement on the paintings and Malfi in an issue of the magazine *Grand Street* devoted to the topic of egos, the painter Francesco Clemente wrote, "Free from responsibility, unable to acknowledge one another, living icons of impotence and fragmentation, in our comfort, we lack nothing and share nothing, except the solitude of the dead, and, above all, their silence."[1] Between Schnabel's dramatic gestures toward sainthood, martyrdom, death, and poverty in the paintings and the choral flourish added by Clemente, this should be fertile ground for any study of ascetic tendencies in contemporary art; but putting aside the obvious allusions, it is precisely the opposite of true asceticism. The stumbling block is, as Clemente picked up, the role of ego—a word that follows as naturally in a sentence about Schnabel as "pure" follows Mondrian. It is not just a matter of personality. The presentation of the paintings and their Wagnerian dynamics and scale are all about the kind of projection that goes in entirely the opposite direction from asceticism.

The art scene abounds in contradictions of this kind. Warhol was, of course, the epitome of the self-appointed saint (the thrust of a famous Robert Mapplethorpe portrait of him surrounded by a halo of white light). In person he was vacant and detached, a pointedly indifferent

observer who did not even put up the appearance of being attentive. Warhol could be ascetically identified with a major body of work that stressed repetition, maintained an oddly distant perspective on desire that hollowed it to a skeletal core, and explored pain and death—he even looked dead as he wandered New York. Yet his orientation was, as with his protégés Schnabel and Basquiat, toward rather than away from the publicity he craved.

In a similar, although far less offensive and dangerous vein, one of the great "acts" of today's art world is the husband and wife team of Christo and Jeanne-Claude, whose wrapping of the Pont Neuf in Paris (1985) and the Reichstag in Berlin (1995) in miles of specially designed fabric, echoing the Classical use of drapery in art, became global media events. The "headquarters" for their extraordinary operation is a run-down nineteenth-century commercial building on the fringe of New York's Chinatown. Small groups of art collectors and fans are ushered to a nearly bare second-floor room, where they sit on little folding chairs or on the floor and listen to Jeanne-Claude, Christo's wife and the business mind of the team, briefly explain the Reichstag effort (a twenty-four-year legal and political battle) as well as their upcoming projects. Quantity is a big part of the pitch. Jeanne-Claude rattles off the figures, including the 51,181 feet of blue nylon rope used to secure the million-plus square feet of aluminum-coated polypropylene fabric that a team of 90 professional climbers and 120 other installation workers used to cover the Reichstag. Of course, the key figure is the cost: over $20 million for the project, none of it paid for by corporations or governments, all of it provided by the sale of Christo's art (mostly pastels that he turns out nonstop from seven in the morning until midnight in the bleak fifth-floor studio, reeking of pastel dust and fixative). With polished humor, Jeanne-Claude delivers the story to the awe-struck admirers. Then it is time for Christo to appear. She reaches for a walkie-talkie to summon him: "Cheri, il faut que tu descend maintenant."

A moment later, Christo's steps can be heard on the stairs. The saint appears sheepishly at the open door behind her. His hands are thrust deep into the pockets of a pair of tattered blue jeans, ripped to reveal two bony white knees. His longish, graying hair is unkempt in the manner of Woody Allen, his black-rimmed glasses make his eyes seem sunken and distant, his tattersal shirt is rumpled, and he is almost painfully thin. Apologizing repeatedly for his accent (he was born Christo Javacheff in Bulgaria in 1935 and studied and lived in Vienna and Paris before establishing his home in New York in 1964), he mumbles through a few comments on dealing with bureaucrats and answers the inevitable questions regarding the mysteries of their financing. The pastel-coated hands almost

never come out of the pockets as he watches his feet shuffle back and forth like an uncomfortable schoolboy in front of the audience; then it is time for him to ascend the creaking steps again and resume his infinite renderings of the Reichstag and other projects in skillful, delicately colored pastels reminiscent of the drawings of Claes Oldenburg.

Why isn't Christo's art "worthy" of being called ascetic? He covers buildings in a skin or shroud; his regimen is, if he really does raise all that money with pastels, phenomenally abstemious as well as mechanically productive; and it is hard to imagine anyone more remote from the glitzy scene of Schnabel than this scruffy mendicant. Yet the history of Christo's vast projects, especially the well-documented run-ins with federal and state governments from Japan to California, is that of a public figure engaged in massive, media-savvy public art that reaches out to, rather than pushes away, the "real" world. The contradictions between concealing and revealing, advancing and retreating, pose interesting questions; but as this group of essays on a diverse group of figures—beginning with Mondrian and ending with a few young artists who are not yet well known—hopes to make clear, art that is genuinely ascetic has a very different orientation. Most of the artists under consideration here define their lives by retreat rather than attack, and it is no coincidence that many of them abandoned the hothouse of New York's "art scene" for more remote studio locations (Bruce Nauman, Susan Rothenberg, and Agnes Martin in New Mexico; Donald Judd in Texas; Cy Twombly in Italy; David Smith in Bolton Landing, and so forth). Even among those who remain in New York, the ability to shut themselves off in their own worlds—like Jasper Johns in his comfortable Connecticut mansion—is the defining biographical characteristic. The art, more importantly, is ascetic, a reaction against the self-indulgence of the 1980s through this motion of retreat and self-effacement.

The Habit of Perfection: Piet Mondrian

If it were not for the recent retrospective of his work, Piet Mondrian might still be thought of more in terms of the rigid legacy he left to design than for his fluid gifts as a painter. By bringing the full range of his development together in one stage-by-stage survey, the retrospective (which was seen in the United States at the National Gallery in Washington and at the Museum of Modern Art in New York) reminded viewers that he was a painter of great passion. This is nearly impossible to grasp if Mondrian is known only from the reproduction of his "grids" (black lines on seemingly monotonal white planes with strategically deployed rectangles

of red, blue, and yellow) in bookplates, postcards, and slides or lifted by fashion and graphic designers for their own purposes. Flattened and evened out in tone, they are reduced to mere icons—they become illustrations, not paintings. They are rendered as static and uniform, too close to the quiet of Minimalism and arguably too pure. In a typical textbook survey of Mondrian and his importance to the development of abstraction, the contemplative nature of his work is stressed:

> He was that rarity, a great religious mind, a secular saint inspired by an unflinching faith that if he could heal the breach even at a single point, the whole world would be redeemed. Thus his paintings, composed of a few colored squares, are not merely the artistic exercises of an eccentric and highly dogmatic Puritan—they are exercises in the spiritual, almost ecclesiastical sense, products of a mind contemplating and reflecting on the cosmic order, objects of meditation, which make us aware of the existence of a universal harmony. It is this faith that impelled Mondrian to work on his canvases until they became icons of an elementary truth.[2]

The renowned perfectionism provides one smooth avenue, of course, to depicting Mondrian as Modern art's original ascetic. His pioneering role in the development of abstraction helps, particularly to the extent that abstraction can be regarded as inherently ascetic for denying the figure and forms of the outside world. This version of the story stresses the *reduction* of the palette to the primaries and a similar compositional retreat to the secure geometry of verticals and horizontals pursued obsessively in serial fashion under laboratory-like studio conditions. In John Russell's solid account of the rise of abstraction, Mondrian faithfully reflects the puritanical order of Dutch life: "Straight line and right angle are the basis, in Holland, of an agriculture which would otherwise soon be under water. They also stand for that element of unyielding puritanism which is basic to the Dutch character; geometry was the basis after all of the ethical system which was erected in the 17th century by the Dutch philosopher Spinoza."[3] For Mark Cheetham, the "rhetoric of purity" invoked by Mondrian is attributable to Neo-Platonism. In his precise and valuable analysis of Mondrian's writing on Neoplasticism, Cheetham draws a parallel between Mondrian's view of the historical situation of Neoplasticism and the idealism of Hegel: "Mondrian is here very close to the Hegelian *Aufhebung*, that dialectical process of abrogation in which the negation or cancellation of an element within the dialectic is at the same time a preservation of that element within a higher unity."[4]

In the writings on Mondrian of Yve-Alain Bois, who curated the recent retrospective along with Angelica Rudenstine, there is a wonderful

sensitivity to the struggles Mondrian faced from moment to moment in his career. Not only did Mondrian have to contend with the Cubist legacy, but he also had to deal with the urges to systematize and draw and the need to dismantle traditional compositional hierarchies, the desire for an ideal flatness (Bois points out what a difference the evenness of electric lighting in his New York studio made after the flickering gaslight of Paris), and frustration with the limitations of painting as compared with sculpture, as well as with elemental problems like color and gravity. The powerfully argued essays that Bois collected under the title *Painting as Model* make Mondrian the hero of a battle fought in the studio to redefine painting after Cubism.[5]

Following the lead of Bois, we can appreciate the passion of the painting within those grids as well as his progress toward abstraction. Mondrian's paintings are anything but static, reductive, confident, placid, and flat. They are alive with motion, mingled colors, gestural surprises, and most important, the signs of struggle. Too many visitors to the New York version of the retrospective walked right past the re-creation of Mondrian's studio, with its lattice window casting a gridded shadow at angles on the white walls, on which, at a level beginning below the knees to above the head, cardboards of (importantly) six different tones of red, seven different whites, and two blues were pinned but could be moved. In a corner, opposite the little Victrola playing the boogie-woogie recordings, was a case with two palettes and a row of fifty brushes in it, and those brushes told a story. Far from the perfectly cropped, impeccably clean surgical instruments that one might expect of Mondrian (who after all painted in a jacket and tie in a pure room of white), these were beaten-up old brushes with gaps and tangled bristles.

Retain that image for a moment as you look at the paintings with their textured brushstrokes and the ridges and ripples of paint that come off an uneven tip, and the false impression of an even weight and perfected surface is broken up. In a splendidly lyrical essay on Mondrian, the poet Yves Bonnefoy describes the action of that determined, "violent brush."[6] To thoroughly appreciate how much lay behind the Classical "calm" of Mondrian, whom friends compared to Poussin, it helps to have seen the battlefields of unfinished works that the retrospective so thankfully included. Like the scarred and anguished collages of Richard Diebenkorn or the paintings of Brice Marden, these unfinished compositions tell a far different tale from the familiar Mondrian saga. A study from 1938 has ragged bits of blue, yellow, and red papers hesitantly applied to a paper scored and scored again, its proportions changed a dozen times and even added to, as Degas used to add strips of paper to the edge of his pastels. An unfinished composition of about the same

time is almost *entirely* covered in a fine layer of charcoal because it has so many lines interwoven across it that, once the painting had begun, would have been erased. The mobile colored tapes that Mondrian used to set up his New York paintings allow us to see how the superimposition of line on line really does trap an intermediate space within paintings that are not as flat as have been assumed.

That is not to say that there was not something genuinely saintly about Mondrian. His disciplined retreat from the impurities of the outside world to an ideal sphere of control and discipline, through two world wars and in the middle of Paris, London and New York, is similar to what Miró accomplished with his Constellations series. The bare-bones sketch of his undramatic life points to an ascetic existence that funnels all its passion into the work itself, as well as into a group of essays that Mondrian left in which his deeply spiritual, rigorous thinking is revealed. Born in 1872 in the small town of Amersfoort in Holland, Mondrian was the son of a strict Calvinist school principal who supported his son's interest in art from the age of fourteen (collaborating with him in childhood on a series of prints and even giving him a job in his school teaching studio classes after he was licensed to teach secondary school drawing in 1889). Mondrian's Uncle Frits was an artist who would take Piet along on painting trips. The Corot-like, silvery tones of the early landscapes are distinctly similar to those of his uncle and the Hague school landscapes. This restricted palette, in which a firm, Degas-like green is the most vibrant element, was an ascetic characteristic of Mondrian's work long before he adhered to the gray and brown of Cubism or his famous "reduction" to primaries. The composition of these enchanting landscapes, particularly the view of the farmhouse and its reflection across the Gein River outside Amsterdam, initiates the flat oval shape that would become very important to the partly abstract pier and ocean paintings of 1919.

At the age of twenty, Mondrian went to Amsterdam to study for four years at the Rijksacademie. He was captivated by exhibitions of Van Gogh (particularly an influential major show at the Stedelijk Museum in 1905) and Munch and copied works by Hals and Steen. His relatively meager life-drawing skills twice cost him a chance to win the Prix de Rome. From a psychological as well as an intellectual perspective, one of the significant developments in this first stage of his career was the day late in 1909 when he decided to purge his studio of all the nineteenth-century bric-a-brac, throw rugs, figurines, and other trappings and whitewash the walls and furniture of the entire room to create as pure and bright a workspace as possible. A concomitant turning point in his stylistic development came in October 1911 after he had visited Paris for

ten days in June and come home to Amsterdam to help organize the first major Modernism show at the Stedelijk Museum. The exhibition included twenty-eight paintings by Cézanne from the Hoogendijk collection, other works by André Derain and Raoul Dufy, and the first examples of Cubism—works by Picasso and Braque—to be seen in Holland.

The impact on Mondrian's work was immediate. It appears in his new approach to a subject he had used often before—the bare branches of a twisting, curving tree. In *The Gray Tree* (1911), Mondrian cuts loose from the delicate, calligraphic tracery of the branchwork that he had used in his paintings of the farmhouse on the river and the blue and red trees of 1908. The finer details are dissolved in a rhythmic and atmospheric Cubism that is already partly abstract. He swings brief arcs in black, interlacing them toward the edges of the canvas and knotting them at its center, where the column of the trunk curves over to the viewer's left. But that is not what is most fascinating—and ultimately ascetic—about this work. The heaviest of the painting and the most fastidious and rhythmic of the brushwork is not to be found in the black lines that depict the solid tree. The trilling gray and white and blue and the thickest application of mingled gray and black and white, with touches of green or blue in a loaded brushstroke, all are given to the *empty* spaces between the branches, the interstices of the composition, promoting those "background" or void moments to a higher level in the hierarchy of the composition. It is an attention to what is framed between solids, specifically to sky, that we will see again in our consideration of the sculpture of David Smith and Mark di Suvero.

During 1911, Mondrian began two still-life paintings showing the influence of Cézanne. Their central figure, a ginger pot echoing Cézanne's own use of the ginger pot, dramatically shows the transition to Cubism. The first, dated 1911, uses a firm array of glasses, books, knife, and table in front of a silvery bright window. In the second, which is based on what seems to be the identical arrangement of objects, the faceted geometry of Cubism has taken over. The almost rectangular white gleam of light near a central seam on the shoulder of the pot is still there, but Mondrian has moved in on the objects and created an irregular oval inside the large canvas (36 by 47¼ inches), allowing the black lines in which he has traced his angled forms to fade into the corners. This evanescent, highly sophisticated painting, completed when Mondrian was forty, is the bridge to a new style. He literally took it to Paris from Amsterdam in May 1912 (as Miró would move *The Farm* in 1922) to take on the leading artists of the day, including Picasso and Braque.

In Montparnasse, where he had his studio, he found the perfect subject for semiabstract painting in the distressed, silvered facades of the

buildings in his neighborhood. In a haze of blue, gray, gold, and sometimes pink—dissolving all form in the corners as in the Cézanne-style still life—Mondrian used maplike straight lines, often in black, with an occasional curve to render the facades. Within these "windows" a world of color is disclosed, as in *Composition Number IV* (1914) in which swirling, rounded masses of pink or gold and blue and grays are mingled inside the cloisonné patterns, like miniature Rothko paintings that occasionally spill over the black lines. Heavily textured (remember those uneven brushes), vigorously reworked, these early forays into the vocabulary of the famous grids are so painterly and even romantic as to dispel that chilly image of Mondrian the adherent of geometry. Even in the later Neoplastic paintings, one of the most exciting revelations of close examination is the retreat from the bounding lines, where the white, blue, red, or yellow strokes pull back from contact with the black, leaving two edges at the intersection.They also bring us to an important technical and conceptual detail. The counterpoint of curved and straight lines, which is at least as important as the dialectic of vertical and horizontal, is a dynamic factor because the horizontals in particular can be viewed as curves under tension, bent down or up to straightness from the arches that one still sees in the early abstractions. This is clear as we move to the pier and ocean series, where curved lines linger in a vocabulary that becomes straighter and straighter with each work.

Founding Another Order

As many art historical accounts have noted, Mondrian's metaphysical orientation, toward theosophy as well as Christianity, is important to an understanding of the highly idealistic aspect of Neoplasticism, and its constant emphasis on the pure and the utopian is certainly a significant aspect of Mondrian's asceticism. After that heady dose of Cubism, Mondrian's own complete breakthrough to pure abstraction, in the piece now known as *Composition with Color Planes*, came in 1917. It coincided with a fruitful period of writing, including his first essay on Neoplasticism, one of the most annoying instances of catachresis in Modern art history, it can be a stumbling block to understanding Mondrian. *Plastic* usually means the art of molding sculpture from malleable materials such as clay and wax, but Mondrian meant something entirely different. In a "trialogue" written in Paris he virtually recapitulates his entire career through the use of three characters who watch the landscape disappear at twilight and then describe the creation of a white studio, like a monk's cell, in which the "pure" plastic can be explored. As Mondrian writes, "Let the artists concentrate exclusively on equilibrated relationships of

form and color, and their work will never be poor, although its character will vary with the materials. But for all this to be widely realized, social life, too, will have to be purified. From this purer life a new beauty will spontaneously arise. . . . The new is plastic expression of purely equilibrated relationship through spiritual consciousness."[7]

What makes the theory as well as the practice of Neoplasticism ascetic is its inward-directed hermeticism. Mondrian, most art historians agree, was aiming at a picture language that operates on its own, a closed system (although its descriptive background is never completely eradicated). Volume and recession are exiled, and the shape of the picture (generally square in the later work, occasionally turned forty-five degrees to become a diamond) is a prime factor in setting the inner language in motion. The progress toward abstraction was an attempt to remove the world as it is from the picture, even if we still see trees, ocean waves, building facades, or church decorations when we look at a roomful of Mondrians. As Meyer Schapiro explains, Mondrian's paintings create a whole that remains introspective and detached: "The precise grid of black lines in a painting by Mondrian, so firmly ordered, is an open and unpredictable whole without symmetry or commensurable parts. The example of his austere art has educated a younger generation in the force and niceties of variation with a minimum of elements."[8]

Before the reputation of Mondrian soars off over the treetops like a helium balloon with Neoplatonism printed on it, another dimension of his seeing and thinking ought to be examined. Like the passionate brushwork that is often hidden by a distant view of the paintings, there is a side of Mondrian that is very tightly attuned to the real world. There are so many typically precise, closely argued articulations of the Neoplastic aesthetic that it seems odd to turn to a more casual yet vivid document— an attempt to make a literary equivalent of Neoplasticism that Mondrian wrote in a Parisian cafe—for a glimpse into the way in which he moved through the visual translation of the world. For example, note the shift from the bright orange to white on white in this sequence: "Orange on the white plate on the white napkin. Purity through one color and purity through fullness of colors. Purity by reflection and purity by absorption. Who absorbs *purely* and reflects *purely*? The orange is a feast in the sun. Yet sometimes one is afraid of pure color. White envelope on white napkin."[9]

Mondrian would have liked to sit in Parisian cafés doing verbal still lifes all through the decade, but World War I broke out as he was visiting Holland in the summer of 1914, and he was forced to stay away from Paris until 1919. He began a series of "plus-minus" works in gray, black, and white using motifs observed in Domburg: the facade of the church

tower, the sea and horizon, and the sea and pier beneath a starry sky. The ascetic qualities of these works are manifold, beginning with that aerial view, as from a seagull or from heaven itself, of the pier and the waves surrounding it and including the pure white across which the linear elements, one or two curved in most of the studies, dance in an oval. Schapiro brilliantly compares the rhythm of these figures with the "fine flicker" of Seurat, and the overhead viewpoint with the views of Parisian streets and squares by Pissarro.[10] For an uncanny later echo of the rhythmic and thematic elements of Mondrian's pier and ocean series, have a look at a helicopter shot in a documentary about Robert Smithson that shows him standing at the tip of his *Spiral Jetty*, with the sun glancing in rhythmic patterns off wavelets churned up by the chopper all around him.

The first of the true Neoplastic paintings is called *Composition A* (1920); it was begun in Holland and completed after Mondrian moved back to Paris in November 1919, taking a studio on the rue de Coulmiers. The nonhierarchical deployment of red, blue, and yellow against not only white and black but a range of grays announced the vocabulary of his painting for the next forty years. Few reproductions do this work or any of the Neoplastic paintings real justice, because they fail to convey the amount of overpainting (in this case, a yellow rectangle is covered in white, and the configuration of gray, black, and white panels is changed around) or the way in which Mondrian differentiated among the tones of the rectangles by painting with vertical or horizontal strokes, adding a subtle textural variety that can be appreciated only from very close to the surface. There is an assumption, too, that the red, yellow, and blue of the Neoplastic works are identical, flat tones, whereas the deep blue and the vibrant red of this painting are very different from the cooler or more yellow tones of the subsequent work. Mondrian built up his areas of color, much as composers like Philip Glass and Steve Reich build up their rhythms—additively (this is even the expression John Cage used to discuss how he created his famous 4' 33" of silence). Within the paintings the subtle adjustment of the panels takes such a painterly touch that the conception of them as even is misleading. In dim light, as Mondrian found when he was finishing the work, the red of the thickest rectangle, near the bottom left corner, is too intense for the tones near it but in bright light "is so beautifully dissolved" that the delicate equilibrium is restored.[11] As Fernand Léger realized, according to Bois, the triad of primaries represented a rehabilitation of the principle of color constancy (against the fleeting colors of Impressionism), but the tempering of the tones within paintings made the ideal of "nonrelational" color an impossibility.[12]

The most ascetic of the Neoplastic works are dominated by white and involve the greatest simplification of composition, such as the elegant

Schilderij Number 1 (1926), a lozenge that has one powerful vertical on its left side, intersected by a low horizontal and accented by a tiny triangle of blue at its very edge; the other primaries can somehow, inferentially, be felt, and the degree of restraint is profound. Similarly, those compositions of 1928 that use, within an approximate three-foot-by-three-foot square, a dominant white cell around which rectangles of red, blue, yellow, and black travel in a pulsing rhythm can convey a sense of emptiness if they are read in a certain (rather Asian) way as negative space. Yet Mondrian was building these pictures outward at the viewer (they are on "platforms" of white wood, projecting the plane forward), and that reversal of the usual three-dimensional pictorial space—a concave bubble, to use Frank Stella's analogy—results in a movement *toward* the viewer.

A Motion of Denial

Where the ascetic work of art is generally praised for its calm—the stillness of the vase in Eliot, the suspended monotone of Debussy, the arabesque of Balanchine—there is a rhythmic velocity in the art of Mondrian that runs counter to this presumption. A fascinating anecdote tells how Alexander Calder, visiting Mondrian's studio, wondered aloud what it would be like if the colored rectangles of the paintings were set in motion (an obvious anticipation of his own mobiles). Mondrian, aghast, replied, "My paintings are already very fast."[13] The effect of the late New York works in particular is one of a musical accelerando; not only are there more elements and more color that interact in a "faster" weave, but the facture contributes to the speeding up of the effect. Lines are doubled, and Mondrian introduces a "plurality of straight lines in rectangular opposition" (to use his words) that end up "leaving the planes as 'nothing.'"[14] Like a car driven over its own speed limitations, the system starts to rattle and break up under the strain of the added complexity. The viewer's eye begins to react in odd ways, too. For example, at the intersection of the black lines of the more complex paintings, gray "stars" (Mondrian's term for the phenomenon) begin to pulse, appearing and disappearing and adding a supernatural sense of motion that Mondrian himself likened to his beloved constellations, such as those that appear in his ocean series. In the case of *Composition Number 12* (1937–42), a wild allegro of multiple black lines with one fairly pale blue square near the bottom right corner, Mondrian used a striated brush stroke to overpaint the white interstices, adding to the kinetic effects. A small pencil sketch that might have been a study for *Broadway Boogie Woogie* shows what might have been a plan for the flickering optical effect using little *x* marks.

The fear of Nazism drove Mondrian first to England in 1938 and eventually to New York, where he had a number of admirers in the art world (including a group of painters, like Ilya Bolotowsky, Burgoyne Diller, Fritz Glarner, Harry Holtzman, and Charmion von Wiegand, who followed closely in his footsteps), a solid dealer in Sidney Janis, and a chance to plug into the kind of urban energy and verve that would eventually incite the huge, vibrant *Broadway Boogie Woogie* (1942–43) and the even larger, more complex, and more colorful *Victory Boogie Woogie*, which was on his easel when he died on the first of February 1944. Until two weeks before his death, Mondrian worked relentlessly on *Victory Boogie Woogie* until four in the morning, and he had it to the point where it was taped and ready for painting. Although its multiplicity and complexity of color may seem Baroque by comparison with the "empty" feeling of the paintings of the late 1920s, there is an added ascetic quality to *Victory Boogie Woogie* in the way that the lines, not just the planes, are "interrupted" by new colors from left to right, creating a staccato effect that disrupts the flow of the horizontal. If the vertical lines of the earlier paintings could be interpreted as interruptions of pure planes of color, then this added intervention pushes interruption to a new level (anticipating, in a different mode, the use of interrupting color fields in Roy Lichtenstein's *Reflections* series of the 1980s and 1990s). In his catalog essay for the retrospective, the curator Bois offers a superb reading of the painting:

> In *Victory Boogie Woogie*, we no longer confront a surface geometrically defined as a continuous plane—and it is thus impossible for us to perceive any optical negation (one cannot negate something that does not exist, visually or otherwise). It is a collage of elements woven in thickness, in a shallow cut of actual (not illusionary) space. The relative position of those elements, each with regard to the other, is in a perpetual state of shift. Nothing that we could master. What we behold is a ghost, the ghost of a ground whose only possible existence, a fleeting one, is that of appearing above the figure.[15]

In the eyes of Yves Bonnefoy, the transcendent dimension of Mondrian's yearning for purity set up an all-important tension between the real and the ideal, which ascetically requires a sacrifice on the part of the viewer as well. In a moving essay on Mondrian's *Red Cloud* (1908), Bonnefoy writes, "Forgetting that a painting is not our life, we tell ourselves that it is here that we must linger, here in this phosphorescence that we must light a fire, here that we must lead the fettered animal to its sacrifice."[16] The visual equivalent of the music of Pythagoras, which Bonnefoy

relates to the compositions of Webern, is the aim of the grid, described in the most ascetic of terms: "Hairshirts and the chastisements of a monk given to a single unremitting temptation come to mind, as well as the anguished realization that there, at the deepest levels of essentiality—where the objectivity of harmonic laws should have asserted itself before the artist's eyes—the arbitrary merely forms again."[17] This recurrence of the arbitrary against the constant attempt to control spells the ultimate downfall of pure laws. Asceticism and its rules take Mondrian only so far into the realm of spirit—as they had Hopkins, who struggled so against the constraints he imposed on himself—and then something has to give.

In the end, as the great *Victory Boogie Woogie* remained in the state of fluttering tabs of paper and tape with dashes of paint pointing the way to a more finished state, the return to reality is a matter of acceptance and resignation. As Bonnefoy explains, "Mondrian did not reach the realm of pure spirit; for years he strove only to believe that nothing on earth was of any value, that for us only nothingness remains. Yet he knew even then, even before his beautiful New York paintings, how never to lose sight of enigma."[18]

The Floating World: Joan Miró

Throughout the letters and writings of Joan Miró there are so many direct references to ascetic habits of mind and work that it is difficult to choose just a few particularly abstemious examples. Whether he was in Paris or in the little Catalan hill town of Montroig where he retreated from the world periodically, Miró, in many ways like Mondrian, maintained a clockwork consistency in his habits. "May our brush keep time with our vibrations" was his invocation, and Miró's brush had the inviolate to and fro of a metronome to the end of his life.[19] If the studio environment maintained by an artist is any indication, then Miró must surely be one of the most monkish of the artists considered in this study. Even when he was desperately poor, Miró kept his Paris studio on the rue Blomet so immaculate, even waxing the floors, that he drove his Surrealist neighbors crazy; like André Masson, whose studio across the hall Miró called "a pigsty." In his "Memories of the Rue Blomet," where Miró spent the crucial period of 1921 through 1927, Miró recalled, "I liked to leave my monk's cell and go to the studio next door, with its unbelievable clutter of papers, bottles, canvases, books and househould objects. . . . I could only work alone and in silence, with ascetic discipline" (pp. 101–103). This was enforced by dire poverty, which in turn had a

direct impact on his paintings. The squiggly, biomorphic forms that float through important works like *Harlequin's Carnival* (1924–25) are renderings of the visions Miró would have when he was fainting from hunger: "I ate little and badly. I have already said that during this period hunger gave me hallucination, and the hallucinations gave me ideas for paintings" (p. 103). Visitors from his home in Catalonia would bring him country sausages and vegetables, and at other times he fasted, ate lunch once a week, chewed gum and dried figs, and drank a river of strong coffee. It's no wonder he kept blacking out. When he had the strength to roam in Paris, Miró spent his time looking at the art of Rodin as well as that of Matisse, Marquet, De Chirico, Rousseau, and Klee, all of whom he admired "when they are pure and immaculate."

Miró was born in Barcelona, the son of a watchmaker, appropriately enough; but he is more closely associated with Montroig, where he painted his most famous landscapes and where he sought refuge frequently on the family farm as well as in the nearby village of Siurana. As he wrote to his friend and Barcelona studio-mate, the painter Enric C. Ricart, in the summer of 1917, the ascetic quality of the pastoral life was fundamental to his working habits: "The solitary life at Siurana, the primitivism of these admirable people, my intensive work, and especially, my spiritual retreat and the chance to live in a world created by my spirit and my soul, removed, like Dante, from all reality (do you understand all this?) I have withdrawn inside myself, and the more skeptical I have become about the things around me the closer I have become to God, the trees, the mountains and to Friendship" (p. 50). In July 1922 he wrote to his friend Roland Tual from Montroig, "I see no one here, and my chastity is absolute" (p. 79). He took pride in being rooted in country life and in the simplicity of ordinary objects, like the little wooden spoon that he used to fish olives from a jar.

Although often Miró would play the professional Catalan, he was no hick, as shown by his art historical range, wide reading in contemporary and classical literature (particularly the "eloquence of silence" in the poetry of Saint John of the Cross, the "purity" of William Blake, and the "clairvoyance" of Tristan Tzara, whose work he eventually illustrated, as well as that of Arthur Rimbaud and Alfred Jarry), and the way he thought of Haydn's *Seasons* when in the countryside or expressed his love of Bach, Mozart, Bartok and Schoenberg (he told a friend that if he ever choreographed a ballet, he would want the music to be composed by either of the latter). Miró shuttled back and forth between Montroig and Paris for most of his adult life after 1920. The letters to Ricart and others persistently show how he submitted himself to a tremendously demanding regimen—rising before dawn, painting seven hours a day,

swimming and jumping rope, and doing calisthenics (often in the nude). Throughout his life he would keep in taut physical shape, the physical equivalent of the "mental tension" he espoused in the studio. He had a fondness for tough sports, in Paris he boxed (with Ernest Hemingway among others), and later, when he spent nine months in New York in 1947, he loved to go to pro hockey games.

The only way to describe Miró's studio practice is with reference to the work ethic and to strict, mechanical routines of military life. On the door of his studio in the Cité des Fusains in Montmartre he posted a small sign: "Train Passant Sans Arret." He drove himself daily to the point of exhaustion. "I continue working with the same intensity and the same humility as a worker who works all day long to support his family," he wrote to J. F. Rafols from Montroig in October 1921, emphasizing not only the humility but the discipline he valued (p. 76). It was a trait he picked up during the three months of military service he turned in every year from 1915 through 1917. When Ricart painted his portrait in the studio they shared in Barcelona, Miró is shown wearing the trousers of his military uniform as he paints, their stripe clearly visible, and in Paris he answered a Surrealist questionnaire by pointedly alerting them to the "militarylike discipline" that true artists need (and they lacked).

Leaf by Leaf

The masterpiece of Miró's earliest period and in many respects the best guide to the vocabulary of much of the later work is *The Farm*, which he started in 1921 in Montroig and took to Paris in 1922 (along with a piece of turf from Montroig to keep in front of him the precise blades of grass he was painting) for a continual process of reworking—of *correction*, really, in layers of chalk that can still be seen, particularly around the powerful vertical of the eucalyptus tree at its dead center—much as Mondrian had taken his *Still Life with Ginger Pot* from Amsterdam to Paris just ten years earlier. Following on the heels of a number of geometrically precise, rhythmically pronounced landscapes that emphasized the straight rows of the tilled fields and the sharp peaks of the hills near Montroig, Miró's ambitious rendering of every detail of the family's farmyard under the perfectly even, relentless summer sun is a virtuoso example of painterly precision. In 1918 he had explained the stylistic principle that guided his hand in *The Farm* to his friend Ricart: "No simplifications or abstractions, my friend. Right now what interests me most is the calligraphy of a tree or a rooftop, leaf by leaf, twig by twig, blade of grass by blade of grass, tile by tile" (p. 54). The particularly long time it took to perfect this canvas was equated in Miró's mind with what was

needed to arrive at Classicism through "calligraphy," his metaphor for exquisite execution. "I feel the need for great discipline more every day—the only way to arrive at classicism—(that is what we should strive for—classicism in everything)" (p. 57).

The geometry of *The Farm* is the wellspring of its strength. During the nearly two years it took Miró to paint it he never overpainted the linear structure but brought it out more and more in the skeletal branchwork of the tree and the open beams of the outbuilding on the right side. The most revealing structural feature is a geometric network of red lines that traces the box of the architecture and lays out, like a diagram, the logic of the whole canvas. As a guide those red lines are a student's delight, like the table of correspondences that James Joyce provided for baffled readers of his *Ulysses* or the footnotes that T. S. Eliot provided for *The Waste Land*—maps for thinking and interpretation. Faced with a chronic lack of money, Miró was tempted to cut *The Farm* into four parts to make it easier to sell. Hemingway stepped in and saved the day by buying it, and it ended up in the collection of Mary Hemingway.

The stillness of *The Farm* is palpable. All movement, even the trembling of the tiny leaves lovingly delineated on the ends of the tree branches, has been arrested under the heat of the sun. The bird perched on top of the ladder inside the shed is frozen in profile; the pump handle of the well is at rest. Miró was fascinated by immobility and once wrote:

> Immobility strikes me . . . Immobility makes me think of vast spaces that contain movements that do not stop, movements that have no end. As Kant said, it is a sudden irruption of the infinite into the finite. A pebble, which is a finite and immobile object, suggests not only movement to me but movement that has no end. In my paintings, this translates into the sparklike forms that leap out of the frame, as though from a volcano. . . . What I am looking for, in fact, is an immobile movement, something that would be the equivalent of what we call the eloquence of silence—or what Saint John of the Cross, I believe, called soundless music. (p. 248)

Not all of Miró's paintings share this breathless, static quality. Among the early Paris canvases, *Harlequin* (1924–25) is as active as it is full, with its dancing white hand at the end of a pulsating long, black, snakelike arm; its cat and dog toying with string; and a ballet of indescribable, fantastic thingamies that float around the Paris studio while the Eiffel Tower, in a stylized conical form, looks on from outside the window. Miró, ever the loner, kept the Surrealists at arm's length, but anyone studying this picture would understand why they claimed him for their own. The distance along the road to abstraction from the referentiality

of *The Farm* is considerable, but the clean, "Classical" geometry of the later work's verticals and diagonals is every bit as firm—Miró threads his curves in and among them. It is interesting that he remarked on the fact that he himself did not paint in the same way when he was in the city as he did in the country, and he mocked the kind of indifference to location that allowed an artist to do so: "Everything moves him equally, he speaks in the same way, he is the same, and he paints the same; with the same feeling that he would paint Majorca, for example, he paints Toledo, changing only the 'photographic' or realistic details" (p. 51). The details of *Harlequin's Carnival* came to Miró in one of the hunger-induced ascetic spells he recalled later in life, when he wrote a breathless sentence to accompany it:

> The ball of yarn unraveled by cats dressed up as smoky harlequins twisting around inside me and stabbing my gut during the period of my great hunger that gave birth to the hallucinations recorded in this painting beautiful bloomings of fish in a poppy field marked down on the snow-white page shuddering like a bird's throat against the sex of a woman in the form of a spider with aluminum legs coming back in the evening to my place at 45 rue Blomet a number that to my knowledge has nothing to do with 13 which has always exerted a tremendous influence over my life by the light of an oil lamp the beautiful haunches of a woman between the wick of the bowels and the stem of a flame that threw new images on the whitewashed wall during this period I had pulled out a nail from the pedestrian crossing and put it in my eye like a monocle a gentleman whose fasting ears are fascinated by the grace of a flight of butterflies musical rainbow eyes falling like a rain of lyres a ladder to escape the disgust of life a ball thumping against the floor the revolting drama of reality guitar music shooting stars crossing blue space to pin themselves on the body of my fog that goes around in a luminous circle before diving into the phosphorescent Ocean. (p. 164)

Embedded in the passage is a quick reference to "a ladder to escape the disgust of life," drawing our attention to a central motif in all of Miró's work. The chiaroscuro of pain and pleasure, comedy and tragedy, are all wrapped up in this very ascetic "revolting drama of reality."

His escapes to Montroig or Barcelona were deliberate attempts to air himself out after too much continuous time in the stuffy art world of Paris. It is important to register the shifts from fullness to emptiness in his compositions. Some assume that the great wall-size blue or red fields of color painted at the end of his life were the culmination of a lifelong process of gradual emptying out, but in fact the emptying and refilling with complexity played off one another more as a dialectic in parallel

with his escapes from the city. One of the great examples of Miró's ability to "empty out" a canvas and to simplify, its composition almost to the point of Minimalism, is a work known as *The Bullfighter* (1927). In the most elementary terms it is a brown ground covered in the center and upper-left corner by a large white form interrupted by a rectangular, heavy panel of black—the bullfighter's cape. Across the white background is a very thin, black, cruciform line drawing of the bullfighter in black, surmounted by a floating red sphere nearly tangent to the upper border of the canvas. Like a Giacometti standing figure, the wavering black vertical, which drifts from the center to the viewer's left, connotes fragility and the winnowing of the figure to its abstract essence. The thinner and thicker wavering black horizontal thread of the arms is nearly effaced in the white ground and disappears into the massive black form of the "cape." That heavier, more secure surface, suspended in the upper-right corner of the composition, across the arm of the bullfighter, is a dark window that hangs in profound contrast to the other elements in the composition—the stick figure, the larger white form of the background, and the similarly floating red globe of the head, which seems scarcely visible.

The white form behind the bullfighter, another ghostly touch, billows downward like a cloud from the upper-left corner. Spatters of white in the lower-right corner emphasize the loose strokes with which its ragged contours were created, and within its borders the thinness of the wash is accentuated by large areas of the underlying brown, trace elements of a sky blue peeking through, and crests of white, as in a Robert Ryman canvas. The brown and white washes are very thin, enhancing the palimpsest effect and bringing out the woven grid of the canvas itself. The figure is delineated in black on white—austere enough—and the almost ironic touch of red reminds us of Miró the colorist; while brown almost functions as a noncolor, like the sandy floor of the bullring against which the action transpires.

The Great Escape

The Constellations series of gouache-and-ink paintings (according to the terminology of the artist) is regarded by many critics as a miracle. It brings together so many of the qualities that characterize asceticism and so many of the traits that set Miró apart as an artist from his contemporaries (particularly Picasso) that it must be considered in some depth. Among these the dimension of rhythm is arguably foremost, and in this regard it is important to distinguish between the rhythmic innovations of Mondrian and those of Miró. It is never as easy to grasp the nature of

rhythm in the visual arts as it is, obviously, in music and dance, where tempo and pulse are measurable by the metronome and the elemental aural unit of the work—the tone—is created by a vibration that in itself bears a rhythm. Rhythm, like structure, is the product of repetition. The ornaments and structure of architecture, like the entablatures that Roy Lichtenstein so forcibly captures in long, horizontal shadow paintings, are probably the most easily identifiable embodiments of rhythm in the visual arts. The strongest twentieth-century statement on rhythm in painting was made by Mondrian, whose interaction with Miró was brief but intriguing. In Miró's eyes, Mondrian was straight out of the Dutch tradition of Vermeer and the atmosphere of Holland, where Miró spent a significant period in his development in 1929, a time when he worked on paintings of interiors rather than the semiabstract landscapes for which he is still best known. At about that time, Mondrian invited Miró to exhibit with his Abstraction Creation group, and Miró declined to be included in their "deserted house," clinging to the idea that his paintings were neither surreal nor abstract.

For Mondrian, rhythm was a force pushing painting in the direction of abstraction. He wrote, in one of his most important essays, "Rhythm becomes determinate: naturalistic rhythm is abolished. Rhythm interiorized (through continuous abolition by oppositions of position and size) has nothing of the repetition that characterizes the particular; it is no longer a sequence but is plastic unity. Thus it renders more strongly the cosmic rhythm that flows through all things."[20] The pulsing of brief gold bars (many like to think of them as yellow cabs) in *Broadway Boogie Woogie* represents rhythm in repetition, but not all rhythm in painting is based on strictly repeated, quantitatively identical units. Jackson Pollock's *Autumn Rhythm* in its loopy, seemingly spontaneous skeins of paint, represents another approach to this problem, followed by the recent paintings of Brice Marden, who has been insightfully called the "slow Pollock" by *New York Times* critic Roberta Smith.

Rhythm is the key to understanding Miró in a number of ways. His geometric period—particularly major works like *The Farm* and the still lifes—offers a fine demonstration of the use of repetition to establish firm linear patterns in composition, whereas the pulsing black lines and quasimusical notation of the Constellations offer a more fanciful take on the notion of rhythm. The latter was closer to the work of Pollock, who saw the Constellation series at the Pierre Matisse gallery in January and February of 1945—the first artistic message, according to André Breton, from war-torn Europe. Certainly Pollock's "all over" style of composition was indebted to Miró.

The rhythmic quality of the works reflects Miró's attempts to create

order in his own life. The technical origin of the Constellations series is cozily related to a ritual of studio practice: the cleaning of brushes, which Miró wiped on a pad of paper bought in Paris. He liked the effect of the thinned paint on paper so much that he began working on top of it in black ink, and this commonplace aspect of studio life was melded to the ritual of the sketchbook. Like many artists, Miró used his sketchbooks as diaries, and the whole Constellations series, among the greatest works he ever did, became a type of journal, or daily prayer, that he used to impose his own diurnal order on a period of tremendous fear and uncertainty when Miró and his family were forced to flee from the Nazis. The sketchbooks are directly related not only to Miró's view of painting as calligraphy but to the use of writing in Miró's "poem paintings," where, in a manner that anticipates René Magritte and Cy Twombly, he inserted his own poetic phrases, such as "sourire de ma blonde" and "hirondelle d'amour."

The Constellations were made in secret—"furtive" was the word Miró used—out of fear that the Nazis would take away his brushes as they had Emil Nolde's and that he would end up drawing in the sand or with the smoke from his cigarette. The pocket account of how he created the suite is a compelling anecdote about the flight of Miró and his family before the Nazis in 1940, ending with the artist staring day after day at the reflection in a pool of water of the stained-glass windows of the cathedral of Palma on Mallorca, then returning home to work in silence on these exquisite gouache compositions. As a tale of withdrawal—to use Miró's term, evasion—from a world convulsed by war and a life surrounded by the chaos of refugee existence, it is a moving story. In Miró's own version, the Constellations gained complexity with every day:

> They were based on reflections in water. Not naturalistically—or objectively—to be sure. But forms suggested by such reflections. In them my main aim was to achieve a compositional balance. It was a very long and extremely arduous work. I would set out with no preconceived idea. A few forms suggested here would call for other forms elsewhere to balance them. These in turn demanded others. It seemed interminable. I took a month at least to produce each watercolor, as I would take it up day after day to paint in other tiny spots, stars, washes, infinitesimal dots of color in order finally to achieve a full and complex equilibrium.[21]

As Miró sat alone in the empty cathedral, he listened to the organist practicing. His wife took care of the children and saw to it that the family remained safe while Miró drifted off in his own world, reading the poetry of Mallarmé, Rimbaud, Saint John of the Cross, and Saint Teresa.

As he later recalled, "I saw practically no one all those months. But I was enormously enriched during this period of solitude. . . . It was an ascetic existence: only work" (p. 210). The actual history of the compositions is, of course, much more complicated. Because the works are dated on the verso to the day when they were made, the pinpoint account of their creation is possible. The first ten are dated January 1940, which means that Miró was working on them in Normandy in the town of Varengeville, where his family had sought refuge. In a nearby cottage, Braque was also living in fear, and the dialogue between the two was part of a daily routine. When the Nazis hit Flanders, the Miró family decided that they should return to Spain (an alternative destination was the United States). As they moved through France and crossed the Spanish border, Miró was at work on the Constellations daily. They reached Spain by mid-June and pushed on to Palma, where his in-laws lived, and there he did spend hours in the cathedral contemplating the light of the stained glass, turning it into his most intimate, restrained in scale and medium, paintings.

The stained-glass effect is almost phosphorescent in some of the Constellations, night pieces that echo the fascination with constellations of both Mallarmé and Mondrian. They are full of movement, a swirl of forms that echoes the birds and planets of Olivier Messiaen, linked by a dancing line in black that swings back and forth across the paper and makes diagonals and then loops in a suggestion of movement that is every bit as direct as Paul Klee's little arrows. Although Miró called them paintings, they bear a strong relation to drawing and calligraphy, as well as what we call doodling, anticipating the importance of drawing to contemporary painting in the work of Pollock, Twombly, Marden, and so many others.

The key image in the Constellations is that ascending or receding ladder, often angled into the sky, its feet spreading into the earth or into the silhouette of a figure. A time-honored symbol of the religious ascetic's stepwise ascent to ecstasy and heaven, it had been a hallmark of Miró's work since his early career. The most pronounced use of the ladder in the early paintings is in the funny, famous *Dog Barking at the Moon* (1926), in which a remarkably solid ladder is composed of a jutting yellow beam disappearing into the black night sky and a converging white beam with rungs of glowing red. It falls just short of the top of the canvas, with the moon well out of reach to the right. A more delicate, centered ladder appears in *Landscape with Rooster*, which Miró painted back in Montroig in 1927, in which the wavering black lines of the ladder, interrupted by a passage of yellow, give the instrument a kind of fragility that is all the more touching. Miró explained the image in an interview: "In my first

years it was a plastic form frequently appearing because it was so close to me—a familiar shape in *The Farm*. In later years, particularly during the war, while I was on Majorca, it came to symbolize 'escape': an essentially plastic form at first—it became poetic later. Or plastic, first; then nostalgic at the time of painting *The Farm*; finally, symbolic" (p. 208).

One of the Constellations, titled *The Escape Ladder* and painted in Normandy on the last day of January 1940, solidifies the ladder with a checkerboard pattern in black and red steps, contrapuntally set against each other in the figure of a ladder that converges dramatically under a crescent moon, similarly striped black and red with a bright blue tip. The first two rungs of the ladder are hairlines in black, and a blue bar is the last step to the moon. Behind the ladder is a wonderful haze of gray, gold, and black. With Miró on the verge of his flight across Europe, the autobiographical significance of the piece is obvious. Nine months later in Majorca, Miró, who had hidden the vertical element of the ladders in a number of the intervening Constellations, returned to the motif with *On the 13th the Ladder Brushed the Firmament*. One of the most chromatically complex works in the series, with its array of gold, blue, red, and an intermingling of rose and blue as well as an olive green in the background washes and with accents in white as well as large modules of black, its jewel-like quality reminds us of the wonderful lines from the fifth act of Shakespeare's *Merchant of Venice*: "Look how the floor of heaven is thick inlaid with patines of bright gold." The ladder is most prominent in the lower-right part of the picture, arising from the bottom of the paper and leaning to the left, toward the stars, which almost immediately begin to surround it, sweeping it up into the firmament where the planets dance through their tracks. Miró creates a star from four swift lines converging in an asterisk, so lightly delineated they float between the traces of the planets in their motions. More subtly, there are fragments of the ladder that have seemingly broken free and begun to rise upward in and among the planets, the last of them nearly at the top, and then one, interrupted, drifting across the upper border of the left corner as though it will never stop floating upward.

The later work of Miró is full of ascetic moments, in both sculpture and painting, that suggest many of the other artists considered in this study. As John Cage created works on paper using fire and smoke, Miró burned the canvases of a group of paintings in 1973, pouring gas on them and lighting it or using a blowtorch and controlling the progress of the fire. In one sculpture, called *The Fork* (1963), the ascetic ideal is captured in a tall, tapered column, akin to the ladder, that traces a triangular form inside which Miró punches an oval, like those of a Georgia O'Keeffe pelvis painting, open to the sky. The thin, fingerlike fork soars into space

from a pedestal on a hilltop, with pine trees to either side, at Saint-Paul de Vence, where the famous chapel of Matisse is located.

In a marvelous anticipation of Barnett Newman's *Stations of the Cross*, Miró created a series of three large black-and-white panels collectively called *Mural Painting for the Cell of a Solitary Man*, which went on view the day the Spanish government garroted a Catalan nationalist "boy" named Salvador Puig Antich in 1974. They were actually begun in 1968, when Miró was seventy-five, using many of the techniques Miró admired in Japanese calligraphy. It was a period of anguish and silence, of torment beneath an outer calm that Miró described as almost trance-like. "For me, these three paintings are decorations for the solitary life. They could be hanging in the cell of a man condemned to death," he commented (p. 275). The huge, nearly monochromatic abstractions that Miró painted in his later years were closely related to the mural tradition, particularly those in blue. He found it nearly exhausting to perfect the background blue of these big paintings, trying to make them "emptier and emptier" to invoke "the void," on top of which he used a filament of black to trace his "dream progression." In the huge abstractions, with what a critic calls their "limitless blue mist," he dissolved the multiplicity of forms that had filled his teeming canvases. "This need to destroy my own signs corresponds to my old desire to 'break the guitar' of Cubism. Afterwards, however, I applied this asceticism to myself," he noted (p. 271). There are videotapes that preserve Miró shuffling about the studio and chatting in his charming, accented French. Delightful anecdotes about him will survive, as well, such as the story about Miró dancing a tango with a woman at least a foot taller than he was—slowly, carefully, as though repeating the steps from a textbook.

Yet one of the most insightful portraits of his "lightness" is a self-portrait in pencil, crayon, and oil on canvas begun in 1937, completed in 1938, and now in the collection of the Museum of Modern Art in New York. It is a study in transparency: the figures of the Constellations and earlier paintings are dancing in his forehead and cheeks, running through his hair and the fabric of his jacket and tie. The eyes are burning with a sunlike radiance, and the oddly folded palimpsest of colors and forms reveals a "transparent man" through whose skin and bone the thoughts can be seen. Miró emerges from the whorls and web of his own forms, more a ghost than a man, transformed into one of the odd personages in which he took such delight. The picture has a strange history. In 1960, when Miró moved into a huge new studio in Majorca, he returned to the image, beginning with a black-and-white copy of it and then starting off with the intention of reworking it with the precision of Mantegna; but he instead used a very heavy, thick black line to outline

the head, and the eyes and to make a body. The image is tilted to the right, and another layer is added to the palimpsest, crushing the delicate lines under the heavy black one, more like a graffiti commentary that locks him into a black-lined prison. It invokes one of his most directly confessional statements:

> Anonymity allows me to renounce myself, but in renouncing myself I come to affirm myself even more. In the same way, silence is a denial of noise— but the smallest noise in the midst of silence becomes enormous. The same process makes me look for the noise hidden in silence, the movement in immobility, life in inanimate things, the infinite in the finite, forms in a void, and myself in anonymity. This is the negation of the negation that Marx spoke of. In negating the negation, we affirm. In the same way, my painting can be considered humorous and even lighthearted, even though I am tragic. (p. 253)

Written in White: Mark Tobey

There is a photograph taken in 1931 by Edward Weston that shows Mark Tobey's head and shoulders. In a white crew-neck shirt against a gray sky, the artist is holding a burned-downed cigarette, vertically up-ward, with the thumb, index, and middle fingers of his left hand. His eyes are narrowed, and his brow is furrowed as though he were concentrating very hard on the tiny column of ash, a delicate black structure with a swirl of light gray through it, that tops the white base of the butt. In a moment, you would think, he is going to draw with it. With the lightness of ash, as though they might be scattered upward and off the paper with the slightest puff of your breath, Tobey's gouaches of the 1940s through 1960 redefined, for a small group of connoisseurs and fellow painters, the prevailing notion of Expressionism. Small-scale, lyrical, luminous, and delicate, Tobey's "white writing" may be viewed as the ascetic alternative to the massive black, operatic style of Jackson Pollock, Willem de Kooning, Franz Kline and Clyfford Still. As highly regarded as Tobey is among artists, his name is scarcely known to the broader public. There was not one important solo exhibition of his work in New York between 1962, when a retrospective at the Museum of Modern Art seemed to confirm his "arrival," to 1995, when the Yoshii Gallery brought together a distinguished but small retrospective. Doubtless, the neglect, one of those oddities of canon formation that take decades to remedy, is attributable to the subtlety with which Tobey's work speaks. More than in the case of Mondrian or Kandinsky and their theosophy,

Mark Tobey's "white writing" drew on the Japanese calligraphic tradition as well as his deep belief in the spiritual principles of Zen and the Baha'i faith.

Photo: Edward Weston. Courtesy of Yoshii Gallery, New York.

Tobey's asceticism is grounded in a strong spiritual foundation. He was an ardent student of Zen and a devotee of the Baha'i sect, making his first pilgrimage in 1926, when he was thirty-six, to Haifa, Sinai, and Mount Carmel, as well as to the tombs of Baha'u'lla in Akka and Abdul-Baha. The luminous quality of his work is a direct correlative of the religious light of the scriptures he studied after being introduced to Baha'i by Juliet Thompson, a portrait painter, in 1918. Tobey was born in Centerville, Wisconsin, in 1890 and grew up in small towns in Wisconsin and Indiana until his family moved to Chicago, where he took classes at the Art Institute. After his father's early death, he left school at the age of seventeen to take a job drawing (mainly faces), in a fashion studio. His career in the arts began as a teacher at the Cornish School in Seattle, where Merce Cunningham and John Cage also taught and where he earned eighty cents on every two dollars of tuition coming in from his four students. One of the earliest formal influences on Tobey's development came from Asian calligraphic traditions. In Seattle he met a Chinese student named Teng Kuei, who introduced him to Chinese calligraphy and painting styles; and during a trip to Barcelona, Greece, Constantinople, and Beirut he developed an interest in Islamic calligraphy.

He was invited to Devon, England, in 1930 to teach at Dartington Hall (an innovative school founded by Leonard and Dorothy Elmhirst that was similar to the Free and Creative Art School that Tobey had founded in Seattle three years earlier), and he spent most of the 1930s there in the company of Pearl Buck, Arthur Waley, Aldous Huxley, Rabindranath Tagore, and Kurt Jooss. During a leave in 1934 he traveled to Hong Kong and Shanghai, where he renewed his acquaintance with Teng. More important, he went on to spend a month at a Zen monastery outside Kyoto, where he studied in much greater depth the correlated techniques of calligraphy, painting, meditation, and poetry. Tobey's considerable gifts as a lyric poet complement the literary associations of his "white writing." In "Portrait" he echoes the Japanese tradition in a manner reminiscent of Ezra Pound:

> You are as a dead thing living . . .
> One from the mountains, walking in the valleys,
> And your face has the sadness of pale, imprisoned moons.
> You are like a white lotus, floating upon an opal sea,
> Men dream of you, but do not find you,
> Your path lies alone, strewn with stars.
> Your eyes have the knowledge of dead and distant worlds,
> Your hands are pale and lifeless, like the tiny white
> flowers in a child's dream:

The movement of your body is like the breathing of
 reflection in an unknown lake,
And upon your hair, no shadows fall.
O! remain not by the fountain of Human Sorrow;
The joys others seek, are not for you.
Return! Return! unto the worlds from whence you came![22]

Tobey returned to the United States in 1938 to live in Seattle as a WPA
artist; there he studied with the Zen master Takizaka as well as with
Japanese artists like Paul Horiuchi and George Tsutakawa, who helped
him learn *sumi* flung-ink painting. Works such as *Composition Number
One* (1957) are clearly indebted to his advanced work in *sumi*. The first
of the "white writing" pieces were shown at the Willard Gallery in New
York in 1944, the same year that Tobey began his long friendship with
Lionel Feininger, whose crystalline style is important to keep in mind.
Tobey spent time in New York in 1954, living on Irving Place and work-
ing on the important Lights and Meditative series. The following year he
traveled to England and Switzerland, including Basel, where he would
settle in 1960 until his death at age eighty-five.

The Bearable Lightness of Being

Those are the bare particulars of a life, somewhat like John Cage's, spent
trying to avoid the distractions and conflicts of family life and the more
public art careers that were blossoming at the same time. Tobey pre-
ferred drinking a *citron presse* in a Paris café to Johnnie Walker Red at
the Cedar Tavern in New York. The work steered its own course. A pre-
cise and fluid draftsman, Tobey produced early paintings that have the
precisionist look of Charles Sheeler and Marsden Hartley, whom he met,
along with Martha Graham, during a trip to Mexico in 1931. With a few
small tempera-on-board paintings of 1935, however, he crossed over to a
webby, dancing white line on a colored ground, which would lead even-
tually to the great "white writing" style for which he is best known. In
Broadway Norm and *Broadway*, both done at Dartington Hall in 1935,
the white is interlaced with green, red, and a pair of blue figures. *Broad-
way* retains its referential link to the converging streets and buildings of
New York, but *Broadway Norm* is a torsolike shape, rounded at its cor-
ners; that is, like the Rothko paintings that were basically the only con-
temporary abstract art that Tobey genuinely admired, a floating cloud of
white on a brown ground. The line becomes chalky, and then, under a
pressure you can feel, it is more solid. At the very moment that Mon-
drian was working on *Broadway Boogie Woogie*, Tobey was doing his

The dancing white flecks of
Mark Tobey's *Legend* (1943)
are reminiscent of the
fluttering effect of the plaster
studies by Alberto Giacometti
or the rhythms of Joan Miró's
Constellations. Photo: Tomo
Sukezane. Courtesy of Yoshii Gallery,
New York.

own *Broadway Boogie* (1942), a ghostly city in the center of which a tiny dancing figure is seen. Tobey did not become irreversibly abstract at this stage, as *Modern Saint* (1943) shows: a standing male figure wrapped tightly, like a mummy, in shimmering white gauze streaked with red and blue, his hands helplessly outspread by his thighs while around his head (eyes closed and mouth muzzled by the gauze) dance numbers and letters in a kind of halo. Its style is reminiscent of the shelter drawings of Henry Moore as well as the paintings of Alberto Giacometti.

The figure plays a subtle, romantic role in *Legend* (1943), which could easily serve as the visual counterpart to Hart Crane's great poem of that title. The tiny figure stands at the bottom of a narrow blizzard, his back to us and his right side partially dissolved in the atmosphere of dancing white marks into which he seems ready to disappear. In quick, arching strokes that suddenly accumulate in a kind of luminescent network, giving the impression that they are descending, Tobey lets loose an inner light that is remarkable. The same uncanny effect is seen in the entirely abstract gouache on paper, *Crystallization* (1944) which, as its title connotes, has all the fragility of ice forming. The white strokes on a brown ground, with a swirl of gold at their center, also resemble scars, particularly as they are longer and straighter than the strokes in *Legend*. While the rectangular form of the paper is echoed in the composition, Tobey gives up the upper left-hand corner especially, in a much less dense passage, a compositional element that is also important to *Edge of August* (1953) and the Meditative series of 1954. In these works, Tobey relies less on white than on deep reds and blues, across which he scatters the white strokes like a Miró constellation (an effect that is particularly striking in the eighth piece, which uses white flecks through which the pale colors read dimly). The ninth of the Meditative pictures is a breathtaking shower of light over a gold ground that descends and folds itself in veils of pure white.

One of the coldest and most modestly ascetic paintings is a small horizontal panel called *New York Winter* (1954). Like a detail from one of the bottom panels of a Rothko, it floats a cloud of white and blue on a gold ground. The white rectangle is a denser field of white strokes, as though *Crystallization* had advanced to a later stage of concentration. Tobey pulls back the lower-right hand corner to reveal the blue and gold beneath, near his (uncharacteristically enough) signature in red. The point of view of the spare, disconcerting Above the Earth series of 1956, using gouache on paper, is somewhat reminiscent of the ascetic distance Mondrian achieved with his overhead view of the pier and ocean series. Tobey seems to have joined the stars in order to gaze down on earth and planets from above.

In his later work, Tobey introduced a dark border to frame the squiggling linear forms within, as in *Ritual Fire* (1960) and the strong blue ground of *Homage to Rameau* (1960) bordered in black and using a looser, more calligraphic stroke to intermingle long, looping lines of white across a black ground, which in turn is swallowed up in a rectangle of opaque blue. Although it suggests the work of Paul Klee, who used the same colors to paint a portrait of Casals playing the cello, the atmospherics of Tobey are different from the more diagrammatic work of Klee. Tobey's painting is a delightful translation of the Classical lightness of Rameau's harpsichord music (Tobey was a keyboard player and even did a bit of composing, including the sound track for a documentary about his art). Like David Smith, Tobey is an example of the great tradition of lightness in ascetic art, as well as the invocation of light itself.

Appropriately enough, some of Tobey's last works included a series he called Void. As with Rothko's late maroon and black canvases, the Void pictures have a density and chromatic degree of saturation that is unusual for Tobey. They seem even more distant but not heavier, as he manages to create that cloudlike effect of color floating on top of color. The second of the Void pictures uses a deep plumb rectangular form, lightened at two points to suggest a torso and pulled back as usual from the corners and edges to reveal the gold and orange below. The backlighting of that gold penetrates the cloud of darker tone in a granular fashion, subtly invoking that inner light that Tobey has passed on to a few sympathetic painters in our own time.

Pilgrimage to the Sublime: Barnett Newman

The conscience of the National Gallery of Art's twentieth-century collection is cloistered in a small room on the lower story of the East Wing that attracts few visitors, One or two each day will linger on the bench at the center of the nearly circular room, swept away by the emotional power of Barnett Newman's *Station of the Cross*, a group of fourteen black-and-white paintings in identical format, joined by a fifteenth piece, an afterthought that adds a bright orange tone to the austere vocabulary of the others. Despite its obvious religious overtones the series was not commissioned by any church or patron and not even conceived as narrative. Although the death of his brother in 1961, midway through this work, was one event in Newman's life that added tragic significance to the overall impact of the series, the works are not an elegy either.

Because the room is nearly always empty, the enjoyment of *Stations of the Cross* remains one of those rare museum experiences of genuine

peace and contemplation. The understated palette of the circle of paintings, the charcoal carpet and shin-high white stanchions and rope to protect the fragile surfaces, even the ticking of the little white humidity monitor, enhance the hushed, spiritual effect. As with the Rothko and Twombly "chapels" in Houston, built by the de Menil family (those Medicis of our time) or the Chapel of the Good Shepherd that Lousie Nevelson created for the Citicorp building in Manhattan, the scale and tranquility combine in a religious way, complementing the theological tenor of the title of Newman's work.

The quick take on this absorbing and difficult series would suggest that it is a set of variations on a theme. A second look seems to indicate that the variations are paired in a series of binary oppositions that lead from beginning to an end, Newman specifically disavowed the theme-and-variation relationship and continually stressed the individual identity of each painting. In a statement that he wrote for an exhibition of the *Stations* at the Guggenheim Museum in the spring of 1966, Newman offered the Aramaic subtitle for the series *Lema Sabachthani* ("My God, why have you forsaken me?") as a philosophical point of departure for its complex iconography, His goal was not to tell the story of Christ carrying the cross but to compose a cry and pose a question:

> This is the Passion. This outcry of Jesus. Not the terrible walk up the Via Dolorosa, but the question that has no answer. This overwhelming question that does not complain, makes today's talk of alienation, as if alienation were a modern invention, an embarrassment. This question that has no answer has been with us so long—since Jesus—since Abraham—since Adam—the original question *Lema*? To what purpose—is the unanswerable question of human suffering. Can the passion be expressed by a series of anecdotes, by fourteen sentimental illustrations? Do not the Stations tell of one event? The first pilgrims walked the Via Dolorosa to identify themselves with the original moment, not to reduce it to a pious legend; nor even to worship the story of one man and his agony, but to stand witness to the story of each man's agony; the agony that is single, constant, unrelenting, willed—world without end. No one gets anybody's permission to be born. No one asks to live. Who can say he has *more* permission than any body else?[23]

During the Guggenheim exhibition, Newman and the critic and curator Thomas Hess, then an editor of *Artnews* magazine, held a public dialogue in which Newman tried to impress on the audience the point that the most difficult thing about painting is sitting in the studio by oneself ("You are there all alone with that empty space"). by emphasizing the

solitude of the artist in the midst of a void—the unique space of his greatest works—he connects the ascetic experience of the artist in the studio with that of the viewer in the gallery. For an article in conjunction with the same exhibition he told a *Newsweek* reporter, "In my work, each station was a meaningful stage in my own—the artist's—life. It is an expression of how I worked, I was a pilgrim as I painted."[24]

The circular arrangement of the *Stations* creates a cycle that puts pressure on the side-by-side juxtaposition of the paintings, taking away the definite sense of an end and beginning. Like theological categories, these individual canvases emphasize the breaks or divisions among them, relying on the white walls behind (in the eyes of some curators the paintings are hung much too closely) to provide the sensation of spacing, or what Jacques Derrida has called *espacement*. Like a literary caesura or a musical coda, both of which follow formal indications of an imminent ending that can be picked up well in advance of the real ending, the many gestures of closure in Newman's *Stations* include the inner edges of individual paintings as well as their outer edges. This draws attention to the rhythmic—but not regular—division of horizontal space in the paintings, how each begins and ends many times before its edges are reached.

The secure black border with which the series begins, the left-hand margins of the first painting, is flatter and tighter than the black "zips" (as Newman called them) that float out into the subsequent compositions. Most of the first painting is open canvas, brushed actively with a colorless plastic glue, according to Newman, that barely shows up in reproduction but produces the sensation of a yellow tinge in real life. Because Clyfford Still achieved a similar effect with a rabbit glue or sizing on raw canvas, many have assumed that Newman used the same materials. The canvas Newman used has a lot of color in it, and the glue he used on it brings this out. To the viewer's right in the first painting is a zip created by a channel of raw canvas (in which the glue is occasionally seen) carved through a very actively brushed cloud of thicker, shinier black that licks up and down (mainly down, the prevalent direction of the strokes) its edges like flame. It is the tension between the active brush and the hard edge that makes these paintings come alive. The straight edges are held securely against all this activity, even as the black flares to the left or billows out to the right in a lighter cloud, and droplets of black spatter away into the corner. The ascetic emptiness of the zip is accentuated by the crispness of this edge in comparison to all the gestural activity around it.

In the second painting, the compostion is nearly repeated, but a range of grays, held in place by lines in darker gray outside the zip, adds to the impression of activity. Within the black of many of the next few stations

there are streaks of white as well as pulsations of the stroke, where the paint grows momentarily lighter or heavier (somewhat like the pulses in the stroke of an Agnes Martin or Robert Ryman painting). Not all of the paintings use this downward stroke exclusively; in the fifth painting, Newman pulls the black from a heavy left border over to the right, over-runnning the edge and progressing across the piece, which has an inter-vening field of raw canvas and then a very sharp, thin line that cuts like a knife edge down through the right side. In the sixth painting this sharp edge is broadened by a Morris Louis–like staining effect that softens the edge. In the seventh painting the heavy border shifts to the right side, the thin line moves over to the left, and the staining effect moves within the heavier band but stops short at the straight edge of the heavy right-hand border. The two black lines more directly echo each other in this panel, where they are more balanced in thickness and weight.

The most dramatic shift occurs between the eighth and ninth pieces, where white takes the place of black as the "painterly" tone. The channel or zip of raw canvas is now defined between two white borders, and the reversal is like the negative of a photograph, although the composition does not correspond in every detail to any of the previous paintings. A range of grays enters the series at this stage. In the twelfth painting a very blue slate gray, particularly "colorful" by comparsion with the black, oc-cupies the central space, flanked by white zips that have the unevenness of Cy Twombly's white. The black returns in the thirteenth station, which uses a white left-hand border, like a musical inversion of the ear-lier pieces, The proportions of the zips are now altered, magnified to turn around the division of the vertical space and call into question which part is the zip and which is the "field"—another way that Newman finds to break down the hierarchy of conventional figure and ground. The ele-gance of the fourteenth and final station, which Newman completed in 1966, is conjured by a veil of white over which a scar of white, just a pencil point in thickness, floats to the right of a gray border. The close values and delicate brushwork bring the series to a quiet close. The fif-teenth work, which brings in an orange that has connotations of blood and flame, uses a far thicker surface because the orange is painted over white on the left border, to the point of impasto, making it all the more different from the others. While the painting, begun in 1961 and com-pleted in 1964, uses the same compositional vocabulary as the other sta-tions, the series really stops at the fourteenth.

The more time you spend in the room, the more movement among the panels seems to take over. In an almost diagrammatic way, relationships across the room begin to form as one piece comments on another, an echo that is not created just by the inversion of black and white but by

the narrowing and broadening of the zips, the enlarging of borders, and the emptying of the central space. These "diagonal" moments of resonance create pairings that are different from the side-by-side ones, affirming Newman's proscription against reading them straight through as the familiar Via Dolorosa progression.

Newman's *Stations* anticipate so much in later painting, particularly vis-à-vis the ascetic artists to be considered in this study, that it is difficult to limit the list of associations. After the painterly blacks of Ad Reinhardt and Franz Kline, Newman's work, along with the historically important black paintings of Frank Stella, offers a more introspective use of black, closer to what an artist does when he is drawing, setting up an immediate comparison with the paintings of Robert Ryman, Cy Twombly, and Jasper Johns (whose use of gray can also be compared to the grays in the *Stations* and who conveys solitude in a different but equally powerful way). Newman's atmospheric effects tap the same sources of the sublime and serial sensibility of Rothko, his onetime rival, and Clyfford Still. The linear vocabulary and use of a regular format invoke Agnes Martin and even, in the use of repetition, the serial sensibility of two very, very different artists: Andy Warhol and Roy Lichtenstein (who also used magna to get his white). In terms of the compositional vocabulary of geometry and edge work, the paintings of Peter Halley and Sean Sculley both look back to the example of Newman, while his black-and-white vocabulary has its closest analogue in this study in the work of Theresa Chong, who has studied the *Stations* carefully.

The work is no less resonant when it comes to other fields. The "grammatical" pacing reminds me of the structural virtuosity of Walter Abish's fiction, while the range of emotions is closer to T. S. Eliot's *Four Quartets*, with a side glance at the pain of Samuel Beckett's novels. A similar split between structure and feeling could be made in describing the philosophical analogies suggested by Newman's *Stations* which are reminiscent of the "paths" of Ludwig Wittgenstein's circling lines of questioning but are emotionally far closer to the suffering of Simone Weil. Among the other art forms, however, it is music that seems closest to the overall power of the *Stations*. The perfect concert in the room would be a solo cello recital devoted to unaccompanied suites by Bach and Britten. Newman builds an illusion of space that is just as vast and disorienting as the illusion of time induced by the compositions of Philip Glass and Steve Reich; the mastery of intervals provides an interesting visual correspondence for the intervallic procedures of Anton von Webern or Elliott Carter (whose loaded rests are as dense as the white zips of the *Stations*), and the spirituality of the work is close to the great religious pieces of Oliver Messiaen.

Finally, Newman's *Stations* capture a particular kind of silence that a performing musician can appreciate. In a master class at the Aspen Music Festival in 1994, I watched as Emmanuel Ax counseled a Julliard piano student to "find the still point" in any piece—they were working on a Mozart sonata at the time—and work from there. Like most conservatory-trained soloists in our time, the young woman was skittish as a thoroughbred, ready to barrel through the piece as fast and as dramatically as possible, and Ax was trying to provoke her to think structurally by setting up her dramatic climaxes from an identified moment of quiet. More than just a performer's little trick, the ability to zone in on an inner silence is absolutely fundamental to grasping the *Stations*. Newman was able to locate a still point not once but many times, and the result is one of the great ascetic experiences—touching on many of the elements we have isolated, including rhythm, solitude, anachronism, austerity, and pain—in contemporary painting.

The Purest Space

Writing about the *Stations of the Cross* or any of Newman's later painting, one wants to invoke Mondrian; but for all their genuine similarities, it is important to remember that Newman was adamantly opposed to Mondrian in an overstated way that resembles the sort of gallerygoer who turns on his heels the moment he steps across the threshold and does not care for what he sees. The most public of his anti-Mondrian gestures was the large painting *Who's Afraid of Red, Yellow, Blue I*, in which Newman turned loose the primaries in a brusque gesture of defiance. In his writings he was equally impolite, using Mondrian as a counterexample to the "true" sublime that he was pursuing and taking a tough stance on the link to overt beauty that European painters had to maintain. As long ago as 1948, in an essay titled "The Sublime Is Now," Newman was articulating as "anti-aesthetic" as well as antirhetorical stance that seems very close to the ascetic concerns of today's artists:

> So strong is the grip of the *rhetoric* of exaltation as an attitude in the large context of the European culture pattern that the elements of sublimity in the revolution we know as modern art, exist in its effort and energy to escape the pattern rather than the realization of a new experience. . . . Even Mondrian, in his attempt to destroy the Renaissance picture by his insistence on pure subject matter, succeeded only in raising the white plane and the right angle into a realm of sublimity, where the sublime paradoxically becomes an absolute of perfect sensations. The geometry (perfection) swallows up the metaphysics (exaltation). The failure of European art to achieve the

sublime is due to this blind desire to exist inside the reality of sensation (the objective world, whether distorted or pure) and to build an art within a framework of pure plasticity (the Greek ideal of beauty, whether that plasticity be a romantic active surface, or a classic stable one).[25]

This could be construed as setting impossibly high standards for one's own painting. Newman goes after regular geometry in works such as *Euclidean Abyss* (1946–47), a rather small and historically very important oil and gouache on canvas that uses a wavering yellow zip and a reversed L-shape in yellow on the right border as the uncertain Euclidean elements around or in a vast gulf of black, painted in a highly suggestive grainy texture that opens to a strange inner light at the top. The limitless extension of even a small work like this can be contrasted with the tight control of Mondrian. As he commented, "There is a difference between a purist art and art form used purely."[26] The most important area in which the difference comes into play is the treatment of space. In addition to rebelling against Mondrian and most architecture with which he was familiar, Newman adopted his spatial ideas from contact with Native American burial grounds in Ohio and what he still called "primitive" art, as well as from his meditations on the universe or cosmos and the origins of planetary creation, as reflected in so many of the titles that play off that theme (such as *Origin, Onement,* and *Genetic Moment*). As he rather immodestly asserted,

> I don't manipulate or play with space. I declare it. It is by my declaration that my paintings become full. All of my paintings have a top and a bottom. They are never divided; nor are they confined or constricted; nor do they jump out of their size. Since childhood I have always been aware of space as a space-dome. . . . Is space where the orifices are in the faces of people talking to each other or is it not between the glance of their eyes as they respond to each other? Anyone standing in front of my paintings must feel the vertical domelike vaults encompass him to awaken an awareness of his being alive in the sensation of complete space.[27]

Perhaps the most personal, and ascetic, thought in this passage is Newman's momentary focus on the spaces that separate people—"between the glance of their eyes"—in which that isolation that is so much a part of the *Stations* is felt by the viewer who is dwarfed by the illusion of vast space in front of a major Newman painting. It is the kind of artistic effect that reduces most writers to babble. Among the many critics who have tried to capture the spatial effects of Newman's paintings, the most successful (pace the fans of Harold Rosenberg and Thomas Hess, who

knew the painter well) has been Yve-Alain Bois, whose approach to Newman emphasizes the primary conditions of visual perception. As Bois points out,

> We cannot both fix the zip and look at the painting at the same time, and it is precisely upon this impossibilty that Newman based the dazzling effect of his canvases. In this way, he paradoxically laid bare one of the most traditional conventions of painting, a convention that lies at the base of the narrative tradition of this art, namely, the dissociation between the perceptual field (which is radically transformed when we pay attention to and try to fix one of its elements) and the pictorial field (whose elements solicit our attention). It is as if Newman succeeded in isolating this condition, as one isolates a chemical element, in stripping it from the narrative, so to speak, and in making it one of the most significant means of his art (his statement that his "paintings are neither concerned with the manipulation of space nor with the image, but with the sensation of time" points to this among other things).[28]

Aside from standing in front of a huge Newman painting in a quiet gallery, one of the most effective ways to appreciate the elusive spatial ideas of Newman is to study one of the artist's few sculptures, the *Broken Obelisk* (1963–67). Although there are three versions of the twenty-six-foot-high, Cor-ten steel work, the most beautifully sited one is poised on its pyrimidal base in a pool of water in front of the Rothko Chapel in Houston. The obelisk is dramatically flipped on its point, which meets the point of the pyramid and gives the whole work a precarious tottering look, and its shaft is snapped roughly in half, leaving a choppy, unfinished edge facing the sky. While the sharp edges and smooth surfaces of the pyramid and obelisk are severe enough to connote asceticism on their own, it is this breaking off in midflight, like the disappearance of the zip at the edge of the canvas, that carries the ascetic dimension of interruption and fragmentation that much further. Between the empty spaces of the *Stations of the Cross* and the emptiness defined by the space around the *Broken Obelisk*, Newman has managed to master a vast, emotionally loaded territory that later generations, including the Minimalists as well as Pop and Neo-Geo artists, would carve up for themselves. Without really obliterating the ascetic legacy of Mondrian, Newman fearlessly turns both painting and sculpture in a different direction. This new orientation alllows for heartfelt metaphysics and conscientious formalism, despite his strict views on the rhetoric of the past. For artists after Newman, asceticism is propelled forward by his no-nonsense critical pressure and his almost unapproachable achievement in paint.

A Mind of Winter: Jasper Johns

Who would be a better guide to the ascetic side of Jasper Johns than his old friend of fifty years, John Cage? In an idiosyncratic, wonderful catalog essay for the Jasper Johns retrospective at the Jewish Museum in 1964, Cage blended loving anecdotes with some of John's most forceful, difficult perceptions. Many of the analytic pointers are worth savoring, as when Cage relates the linear format of a Johns flag to the lines of a Shakespearean sonnet, as well the view of him as an artist whose production is endless and "natural" even if it is both abstract and to a certain degree destructive. As Cage observes, this leads to the anonymity that, even under the "difficult" circumstances created by his fame, Johns still ascetically endeavors to maintain:

> He is engaged with the endlessly changing ancient task: the imitation of nature in her manner of operation. The structures he uses give the dates and places (some less confined historically and geographically than others). They are the signature of anonymity. When dealing with operative nature he does so without structure, he sometimes introduces signs of humanity to intimate that we, not birds for instance, are part of the dialogue. Someone, that is, must have said Yes (No), but since we are not informed we answer the painting affirmatively. Finally, with nothing in it to grasp, the work is weather, an atmosphere that is heavy rather than light (something he knows and regrets); in oscillation with it we tend toward our ultimate place; zero, gray disinterest.[29]

Little has changed except the repertoire of styles and images since Cage wrote this piece. Johns is still engaged in mimesis, as in the deliberate use of trompe l'oeil in the most recent works, an anachronism even in the eyes of the artist. The beauty of Cage's observation lies in the way it puts its finger directly on the distance Johns maintains from the materials of his art and on "anonymity." As in the works of Cage himself and even those of Merce Cunningham, despite the inevitable problem of the star and the individual body in dance, the ability to render the materials of art anonymously, turning them into lead as in Johns's gray, is the secret to the ascetic quality of that work. Although Johns frequently incorporated his name, notably in stencil form, in some of his works and later signed paintings and drawings, the anonymous flags and masks that he built into the top of some of the target paintings, with the eyes cut off and the mouths sealed shut (as the eyes and mouths in a Mapplethorpe portrait are tightly closed) are among the most charged elements in the

works. In the drawings related to the work, he simply writes "faces" in white chalk where the reliefs are placed.

Cage considers the negative and positive of the everlasting Yes or No of literature, specifically in Joyce, Musil, Carlysle, and others, and places Johns firmly in the "no" camp, despite the ironic way he builds little flip-flop moments (the easiest to pinpoint is the "duck-rabbit" perception test in which a figure is seen by some people as a duck and by others as a rabbit until someone points out the duality; it was an emblem of the critic E. H. Gombrich, who used it to explore pictorial illusion). Johns's paintings are compared to the weather, shuttling between yes and no, heaviness and lightness. But Cage has a firm sense of where it is heading, its target, which is the "zero, gray disinterest." This flip-flop comes from Johns himself, who wrote, "Sometimes I see it and then paint it. Other times I paint it and then see it. Both are impure situations, and I prefer neither."[30]

In the published interviews that have accompained his infrequent exhibitions through the past decade, Johns is cagey and noncommittal. He has the reputation of being a recluse, and precious few paintings are squeezed out of the studio on the island of St. Martin in the Caribbean or the country house in Connecticut where he spends most of the year. When his drawings were on view at the National Gallery in Washington, Johns agreed to an interview that was verbose by his standards. Ducking and weaving, he left the exasperated interviewer swinging at air on even the most basic questions. Pressed to explain why he preferred tracing and reusing images to "imagining" new ones, he explained that the range of images with which he feels comfortable is distinctly limited: "They are not chosen from a more extensive repertoire. And perhaps I'm more confident working with images of a schematic nature or images that lend themselves to schematization than with things that have to be established imaginatively. At any rate, I seem to be attracted to such things and frequently work with them. Images that can be measured, traced, copied, etc. appeal to me, and I often enjoy that my finished work should contain the suggestion that I have used such procedures."[31]

The answer captures a quintessential Johns moment—guarded, ambiguous enough to avoid being pinned down to a position, and yet clear from sentence to sentence, attentive to the boundaries he has set. While the ascetic aspect of Johns's art is privileged in this study—his tendency toward "schematization" and his limitation of imagery to a fixed repertoire as well as his limitation of colors to Mondrianesque primaries and gray—the rule of pleasure is clearly one of his guidelines. It would be naive to claim that someone who spends half the year on St. Martin and who paints with such lush brushwork is entirely an ascetic. Yet that distancing

gesture, the insistence on clarity and the evasion of the more personal ideas or revelations is a dominant strain in his conversation.

Almost the only time that Johns offered a guide to reading one of his allegorical canvases, the *Watchman* of 1964, the text he produced was as allegorical and shadowy as the painting. The key word Johns uses to describe the erotic and adversarial, obviously ambiguous relationship is "continuity." The role of the viewer as the final participant in a painting is built into this text as the spy, recalling a comment Johns once made about the active response of viewers to drawings rather than paintings. ("Don't you think it has to do with the scale of the gestures that made the drawing and the scale of the gestures that the viewer makes to examine the drawing?"). One of the curious and ascetic aspects of this passage is the subtle nod it gives toward pain, through the word "irritation":

> The watchman falls "into" the trap of looking. The "spy" is a different person. "Looking" is and is not "eating" and "being eaten." (Cézanne?— each object reflecting the other.) That is there is a continuity of some sort among the watchman, the space, the objects. The spy must be ready to "move," must be aware of his entrances and exits. The watchman leaves his job and takes away no information. The spy must remember and must remember himself and his remembering. The spy designs himself to be overlooked. The watchman "serves" as a warning. Will the spy and the watchman ever meet? In a painting named *Spy*, will he be present? The spy stations himself to observe the watchman. If the spy is a foreign object, why is the eye not irritated? Is he invisible? When the spy irritated we try to remove him. "Not spying, just looking"—Watchman.[32]

The humor of the last part, echoing the noncommittal phrase ("just looking") that is the despair of shopowners everywhere, underscores the disengagement that Cage admired. Two ascetic factors slip through the net of Johns's litttle narrative. The invisibility of the watchman and the spy point to the kind of transparency that is important not only to Johns's techinque (specifically, his unparalleled use of a wax medium called encaustic that permits color and form to be read through it, although in a Giancometti-style softened blur) but also to the way he makes forms hover between solids and transparent outlines in his more complex paintings—particularly in The Seasons, a series he painted in 1985–86, which will be considered in greater depth in a moment. The other point is Johns's view of the spy as a "foreign object," a depersonalization that psycologically permits Johns to turn paintings of human figures into still lifes.

While Johns may be best known for the simplicity of his imagery—the flags and targets are inevitably invoked—the trajectory of his career has

brought him to a multiplicity of images and rhythmic patterns that are partly responsible for the ascetic quality of his work in that it pushes the reader to a fabric of allusions. Like many of the ascetic artists considered here, Johns is a master of complex rhythms, such as the interlocking crosshatch passages that allude to tantric imagery in *Dancers on a Plane*, which is dominated by the famous Johns grays, and *Cicada* (1919), which moves from primary colors for the inner passages to secondaries at the perimeter where the cicada is supposedly shedding its shell.

Another ascetic element in Johns involves his use of poetry, particulary the work of Hart Crane and Wallace Stevens. The large paintings that have been associated with the poetry of Crane, for example, *Diver* (1962) and *Periscope (Hart Crane)* (1963), use the silhouetted figures of outstretched arms. In the case of *Diver*, the gesture is that of a swan dive, recalling for many the way Crane committed suicide by diving off the stern of a cruise ship on the way back to New York from Mexico. Johns adds imprints of his own hands and feet in the painting. More important, the use of straight edges to make the arms diagrammatically stiff and geometric suggest the use of geometry in Leonardo's canonic "Vitruvian Man" image (a tendency that also looks ahead to the work of Mapplethorpe); the outstretched palms of a "stigmata" scene are also involved.

Along these lines, one of the most important sources for Johns's imagery is that paragon of asceticism, Matthias Grunewald's *Isenheim Altarpiece* (the centerpiece of Geoffrey Galt Harpham's important critical study, *The Asectic Imperative*). In 1980, Wolfgang Wittrock, a dealer in Dusseldorf, gave Johns a portfolio of prints using details of the *Isenheim Altarpiece*, which Johns had visited in 1976 and 1979, and Johns traced the images for individual drawings to serve as components of his major works. He uses the outlines of arms, reduced to flat patterns, particularly from the Saint Anthony panel of the altarpiece, in *Perilous Night* (1982) as well as in *The Seasons*—references to the *Isenheim Altarpiece* appear in more than seventy of Johns's paintings, drawings, and prints between 1981 and 1989. The steady stream of allusions to this icon of asceticism creates a constant if oblique presence of ideas of denial and resistance to temptation in Johns's work that seems all the more ascetic because he uses the body parts (like skulls and genitalia) severed from the whole.

Toward Transparency

Among the later paintings, the series that Johns devoted to the classical theme of the four seasons includes one of the most ascetic paintings of his career, *Winter* (1986). The movement and active eye of the viewer,

who must work to read, is compulsory for an appreciation of a work so heavy with text. A visual point of entry with Johns, as with Newman, is the edge or seam with which he often splits a painting. To experience the torque and force of an earlier painting like *Gray Painting with Ball* (1958), for example, the viewer has to insert himself imaginatively between the gray plates of steel that are just held apart by the small gray ball. The way in is shown, but it looks perilous. There is a central seam in *Winter*, too, accented partly in red; and in contact with its edge the human figure, which is the immediate peg of sympathy, begins to slip behind the surface into some other world. The silhouette looks and is autobiographical—the idea for the Four Seasons began in St. Martin when Johns asked the young English painter Julian Lethbridge to trace his shadow under the strong sun, and the tilt of the silhouette comes from a realistic depiction of the way it would fall across the ground. As Roberta Bernstein points out in her catalog essay for the recent retrospective at MOMA, one of the sources for the work is the black silhouette of the artist in the studio in Picasso's *The Shadow* (1953).[33]

Johns does two things to this silhouette to depersonalize it: he straightens the curves of the arms and shoulders and even the head in his dark outline, much as he had straightened out the arms of *Diver*, and he makes the figure transparent, almost to the point of vanishing in the lower part of the painting. You can see right through to the brick pattern behind, a grid that comes from the stonework at Johns's townhouse in Manhattan. On the other side of the central seam is a seeming jumble of objects and allusions, particularly a group of references to art history. From Picasso's painting *The Minotaur Moving His House* (1936), Johns has borrowed the image of a ladder, a rope, and a wooden frame that suggests the cart in which the Minotaur's belongings are gathered together (the silhouette suggests another Picasso painting, *The Shadow* [1953]). The ladder, which juts upward into a blue and gray sky full of stars, is reminiscent of Miró in many ways, whereas in others—because Johns carefully paints the jagged edges of its broken sides where it has been snapped off at the top—it is similar to the broken column of Newman's obelisk. The meticulous rope that swings around the rung of the ladder and zigzags its way through the left-hand part of the picture, until it is pulled taut in a strong line very close to coinciding with the central seam, is a great textural and illusionistic detail in the work.

I was lucky enough to live in the same house as this painting for a month one summer, and one of the great pleasures of studying it was to run my finger along the braided, rhythmic pulse of the rope, so meticulously painted—just one of many complex textural devices in the work. Among the others is a vigorous crosshatch pattern within the wooden

frame, reminiscent of *Cicada* and *Dancers on a Plane*, as well as the faux-wood grain in the geometric figures that run across the bottom of the canvas (a triangle, two circles, another triangle, and a square). Tumbling down over the center of the picture are three upside-down pots by George Ohr (in the previous works in the series they appear right side up) and an angled childlike drawing of a snowman, using for one of its arms the branch that appeared in *Fall*, another element in the trompe l'oeil collage. A tight iron wire runs from the left edge to the seam, twisted together at its center and subtly introducing a physical tension that is like the tightened-down curves of a Mondrian.

The bottom-left corner is dominated by a large gray sphere with an arrow swinging down its edge and a hand half cut off by the left edge of the canvas, pointing to six o'clock. In the previous paintings the hand has swung counterclockwise from twelve for *Spring*, nine for *Summer*, and seven for *Fall*; Johns seems to be reversing its direction with *Winter*. For the final textural and spatial effect, Johns has increased the depth of the painting by dotting its surface with prominent snowflakes that float over all the other collagelike elements, seeming to push them back into the picture plane. He has used references to snow before and even did a series of paintings called *Usuyuki*, which is Japanese for "light snow" as well as a reference to a famous Kabuki play with a particularly complex plot that complements the intricate rhythms Johns uses. The allegorical meanings that can be read into the cycle and into *Winter* in particular, are legion. Johns began working on them with *Summer* in the summer of 1985, having just moved to St. Martin, so the Picasso references to a house on the move are autobiographical in their simplest interpretation, while the deeper connotations of the movement of the hand through the circle, and the ghostly fading of the silhouette are more philosophical.

Of the four paintings in the series, *Winter* is the pinnacle from a technical as well as philosophical standpoint. Even if Johns started the series as a celebration of summer in his new home in St. Martin, he is more at home with gray and winter. Johns is said to have taken his literary inspiration for the painting from Wallace Stevens's short lyric "The Snow Man," a reflection on what John Ruskin called "the pathetic fallacy." At the time the artist was working on the Four Seasons, he had been asked by United Limited Artists Editions to prepare a portfolio of prints for an edition of Steven's poetry. A staple of the anthologies and surveys of Modern literature, "The Snow Man" is a meditation on sensory perception, the emotional response to nature and the idea of death. It is also a marvelous example of asceticism in literature, with its chilly mise en scene and its depersonalizing injunction "not to think of any misery in the sound of the wind." It begins with the connection between mind and

senses: "One must have a mind of winter / To regard the frost and the boughs / Of the pine-trees crusted with snow."[34] Painting and poem are more than just illustration or caption in this case, since so many of the central thoughts of the poem are captured in Johns's work.

As John Cage pointed out in his essay on Johns, "the work is weather," which can be translated as a comment on the idea that the necessary receptivity of the lyric "I" to the surroundings depends on a kind of self-effacement, so beautifully caught by the near-transparency of the fading silhouette. The intricate textures of the painting pick up on the "rough" spruces and "junipers shagged with ice" in the Stevens poem, which uses the middle stanzas and the ending to drive home the core point that the mind must resist identifying the moan of the wind blowing through the last leaves of a "bare place" with a human cry. In the last lines, Stevens synesthetically manages to annihilate both the inner and outer realms of the duality he has set up: "For the listener, who listens in the snow, / And nothing himself, beholds / Nothing that is not there and the nothing that is."[35] This is one of the most difficult moments in twentieth-century American literature. Poems and paintings do not have to equate, of course, and Stevens wrote his poem three decades before Johns took it up again; but if you were teaching Stevens and you wanted to schematically suggest what sublimation in the Stevensian sense might be, the Johns painting would come in handy. In *Winter*, Johns crossed a boundary. When all of nature, including the figure of the artist himself, becomes *nature morte*, grayed and straightened in one big still life, then an ascetic point has been reached that is at least as severe and self-effacing as any other moment in the history of abstraction.

Instant Apotheosis: Robert Mapplethorpe

Diogenes, the first Cynic, roamed ancient Athens with a lamp searching for the face of the one just man who could become his model. Robert Mapplethorpe wielded his light in much the same way, wandering through the long, dark, decadent night of New York in the 1970s and 1980s in quest of perfect form. Neither could be called innocents, and yet neither would have kept at it if he did not have an underlying faith in some state of grace—if not religious, then aesthetic—conceived and held tightly in the mind. Grasping this idealism is essential to understanding what endures in Mapplethorpe's work. Sensing the tightness of the hold it had upon him—reflected in the almost rigid kind of control he exercised in his work—one can perceive the ascetic nature of Mapplethorpe's work, even as his life was a veritable orgy. His flowers adorn a strange,

airless Eden, and his nudes and portraits create a pantheon of unknown gods on their pedestals, lifted from underworld to divinity by a single, blindingly fast flash of transcendence. Mapplethorpe's sense of the beautiful, his sole criterion of fidelity, led them across the boundaries between mortal and immortal, real and ideal.

Time was of the essence for Mapplethorpe, who died of AIDS at forty-three in March 1989, becoming one of the contemporary art scene's most visible martyrs. The speed with which he developed—his style was established with his earliest Polaroids—and worked was his answer to the accelerated pace of the art world and life in New York in the 1970s and 1980s. Even his choice of medium was based on its speed. He shifted from sculpture to photography because it did not take too long to achieve an effect. "I realized that all kinds of things can be done within the context of photography, and it was also the perfect medium, or so it seemed, for the seventies and eighties, when everything was so fast."[36]

Mapplethorpe grew up in Floral Park, Queens, in a thoroughly Catholic, middle-class environment that is reflected in his use of the crucifix and altar forms. Mapplethorpe himself used the word *iconic* to describe, and limit, the impact of Christianity on his work. "When I work, and in my art, I hold hands with God," Mapplethorpe wrote in an early notebook.[37] He left home in his late teens and entered Pratt Institute, from which he graduated in 1970 with a bachelor of fine arts degree. Mistaken for a Dionysian, Mapplethorpe was really an Apollonian of the first degree, a priest of the Classical ideas of balance, serenity, and most important, perfection. "My work is about order—I'm a perfectionist," he insisted.[38] For the Apollonians of his time, trained in the ascetic language of Minimalism, the flower images pose particular problems, but these are the most radical works of his courageous career. To dedicate oneself to beauty in the extreme is as audacious a strategy as any in contemporary art. Mapplethorpe was a contrarian even in his schooldays, when color field and pop ruled the studios. When he was a student at Pratt, he rejected the fashion of painting big, colorful geometric canvases to do life drawing and sculpture in studios that had been all but deserted by his contemporaries.

There is a link between the idiom of Ad Reinhardt and Brice Marden and the way that Mapplethorpe bound his flower images with panels of subtly modulated color. For example, *Tulips* (1987), with its use of lavender and green panels, is related to the surface and proportions of the Postminimalist era, but in the strictly black-and-white, stand-alone images of *Orchid* (1987) and *Roses* (1987) the handle that those color panels afford is lost. These images demand the suspension of all aesthetics but that of the Platonic ideal of floral form, forcing the viewer to a

unique level of aestheticism that is as unforgiving as the light he trains on them. Mapplethorpe's flowers are not easy. "They have a certain archness to them, a certain edge that flowers generally do not have . . . they're not fun flowers," the artist observed. Like Baudelaire's *Fleurs du Mal,* cultivated from a "grand amour de l'Art," Mapplethorpe's threaten the aesthetic orthodoxy of their time even as they demand a new one. Given the controversy that swallowed up the conversation about Mapplethorpe's work in the United States, they remind us of a couplet from Shakespeare: "How with this rage shall beauty hold a plea, / Whose action is no stronger than a flower?"

Those razor-sharp petals cut through a tough knot in the theory-laden art of our time. Purity in late-twentieth-century art has been tightly bound in abstraction and the materials of painting and sculpture, while pictorialism has gone in the opposite direction, toward what Mapplethorpe considered an excessively "messy" spontaneity of painting. He reunited purity and pictorialism in the floral works, confronting artistic fashion with a militant aestheticism that invokes another outrageous American of an earlier era: James Abbott McNeill Whistler. Defying the avant-garde of the late nineteenth century, Whistler's etchings, black-and-white works in limited series produced by a partly chemical and partly mechanical process, are in many ways the precursors of Mapplethorpe's photographs. Both artists were consummate aesthetes, and Whistler's blue-and-white porcelain is reflected in the 1950s glass vases that were Mapplethorpe's delight as a collector. Whistler, a worshipper of Ingres, delved with his etching needle what he called the "science of art," just as the intaglio of Mapplethorpe's method chases accident from the aesthetic event of his sharply defined forms. As Whistler's etchings inspired a whole generation of the early photographers, so have Mapplethorpe's works cast their shadow across not only photographers but printmakers, too, including Vija Celmins, Doug and Mike Starn, Andres Serrano, and Donald Sultan.

Mapplethorpe's idiom is unadulterated Classicism, the formal language in which the first images of Western deities were carved and painted. In its radical simplicity it advances the aesthetic of purity, Modernism's central tenet from Mondrian through Marden, to new limits. For contemporary photography, the cleanness and delicacy of Mapplethorpe's style define a new standard, returning to the beauty *(kalos)* of the calotype, the name under which the photograph was first patented back in 1841. His photographs of Greek sculpture, such as *Hermes* (1988) and *Apollo* (1988), are the most direct manifestation of the Classical ideal in his work. Unlike many photographs of Classical statuary, such as Eugène Atget's, in which the Romantic forces of decay add an

ironic commentary to the subject, or those of later artists, like Tanya
Marcuse, who add a sociosexual level to the selection of details, Mapple-
thorpe's images take a clear-eyed yet loving look at the statue as object.
They are closest to the original spirit of the sculpture. Here are the gods,
up close and still divinely distant. Their blank eyes, particularly the soft
hollow of the Hermes, are echoed in the closed eyes of many of Mapple-
thorpe's portraits of living models. For example, he dramatizes the
tightly shut eyes of the subject in *Ken Moody* (1983) as well as the closed
eyes of Moody in the double portrait *Robert Sherman* (1984), in which
Sherman's alabaster profile seems just as eternal as the marble of the Her-
mes. Sealed lips and closed eyes are a Mapplethorpe trademark, as
though to kiss the gods required at least a temporary darkness.

"If I had been born one hundred or two hundred years ago, I might
have been a sculptor," Mapplethorpe observed in an interview in 1987.
He compared the look of his black nudes to statues in bronze and ex-
plained much of his work in plastic terms. Like the fastidious Classical
works of Benvenuto Cellini, whose Perseus is a fine example of the taste
for the delicate gesture, Mapplethorpe's nudes accentuate the balletic po-
tential of the figure. It comes as no surprise that Mapplethorpe, who as a
young boy had helped to design theater sets, collaborated on a dance
piece with choreographer Lucinda Childs, whose spare lyricism is the
perfect complement to the fragile poses of his nudes. The sculptural illu-
sion of the rigid horizontal arm in *Derrick Cross* (1982) is mesmerizing,
and the gestural purity of *Thomas* (1986) might have been a study for a
Donatello or, for that matter, for Rodin's *Gates of Hell*. The Attic atti-
tude of *Lisa Lyon* (1982) is still more sculptural, taking on the Classical
challenge of conveying kinesis through stasis as it captures the gesture at
its moment of highest tension. In the series devoted to Lyon, Mapple-
thorpe blasts past the figural art of our time (the paintings of Lucian
Freud, David Salle, and Eric Fischl or the photographically based work
of Robert Longo might briefly come to mind) and even rushes by the
Classically inspired work of Ingres and Poussin to rejoin the Greeks.

Mapplethorpe's relationship to contemporary painting is enigmatic.
Just as Edward Weston, Minor White, and Paul Strand were influenced
by the work of Hans Arp, Constantin Brancusi, Wassily Kandinsky, and
Pablo Picasso (the direction of influence is important here), so the
groundwork for Mapplethorpe's figural studies was prepared not only by
Andy Warhol (an acknowledged influence) but by the rebirth or rehabili-
tated reputations of other figural artists as well—not only in New York,
where Fischl and Alex Katz and others commanded a new following
(partly through their association with the New York Academy of Art),
but also in London, where Freud and Francis Bacon held sway.

The Classical model of composition is grounded in geometry. Mapplethorpe's practice of centering the figure and the way it crowds or touches tangentially the frame are precise homages to this heritage. Several works exploit these mathematical principles, such as the Thomas series (1986) which pays homage to Leonardo's "Vitruvian Man." The works convey the impression of Herculean strength being put to the test against the "inhuman" ideals of the square and the circle. Mapplethorpe realized that the counterpoint between the human figure and its geometric context is essential to sculpture. The forceful use of light is his chief tool in these photographs. The angled lighting directs your gaze; the focal spiral of the accented ear, for example, draws in the circular perimeter of the image. When light floods the figure, as in *Princess Gloria von Thurn und Taxis* (1987), it penetrates more than highlights, as it might pour through the translucent outer edge of a marble statue. Mapplethorpe's severe white light and black shadow, together with the interior drama of his studio world, invoke the work of Caravaggio, whose occasional use of an incised outline to dramatize the sharpness of an image is echoed in the stark contrast of figure and ground in Mapplethorpe's contrasts.

In *Rosie* (1976) and *Jessie McBride* (1976), as well as in Mapplethorpe's other unusually casual portraits of small children, the exuberance of Caravaggio's spread-eagled Cupid in *Amor Vincit Omnia* lives on. Moreover, the youthful self-portrait with flowers that Caravaggio made is an ominous starting point for a consideration of Mapplethorpe's own self-portraits. The touching difference between the deific nudes and Mapplethorpe's self-portraits involves the obvious signs of decline that suddenly obtrude into the eternally young world of the nudes. As Whistler did in his self-portraits, which in their use of chiaroscuro looked back to Rembrandt, Mapplethorpe casts a cold eye on himself as he ages prematurely. Even in an early self-portrait, Mapplethorpe only plays at being a semidivine satyr with his horns (1985), and the cosmetics of *Self-Portrait* (1980) are closer to the temporary beauty of the Princess von Thurn und Taxis than to the polished Olympian vigor of *Richard Gere* (1980). The coded message of *Self-Portrait* (1988), with its eyeless death's head staring straight out, exactly parallel to the gaze of the subject, is transparently forthright: the hard grip of the white hand on the staff and the wounded depression of the right eye betray intimations of mortality that had no place in the gallery of immortals he created. Some have called Mapplethorpe's *oeuvres completes* an exercise in narcissism, but the deep chasm between the self-portraits and the nudes, as well as the ideal and fragile beauty of the flowers, should be enough to quell that suspicion.

The black-and-white world of Mapplethorpe's art was both austere and luxurious. He lived in the Manhattan studio where he worked, and

the vacuum in which his silent subjects took their places was created by a perfect black cloth backdrop against which they posed. That Minimal atmosphere was offset by the profusion of homoerotic chic that decorated the living space of the studio. Jack Shear, a young photographer who sat for Mapplethorpe in 1986 and now works closely with Ellsworth Kelly, recalls that the familiar environment of the living area, which had been featured in a number of decorating and architecture magazines, was calming. Although few photographs were to be seen, Shear remembers a white ceramic piece on which Robert Rauschenberg had depicted the Mona Lisa, as well as Mapplethorpe's famous collection of glass. "He had the portrait down to a science," Shear observers.[39] An assistant set up Shear in his pose, lit him, and took a preliminary Polaroid. Mapplethorpe worked very quietly, and instead of the three to five rolls that Shear expected to be shot, Mapplethorpe went through seventeen rolls. "It was like the challenge of a chess game, as I tried to become what he wanted and he tried to get each of my almost imperceptible changes in hand gestures," Shear recalls. Mapplethorpe thought of the photo session as a "set of problems" that had to be solved, one after another and at a swift pace (part of the Warhol legacy, one supposes).

The greatest problem, reconciling the eternal and the temporal, was insoluble. Drawing near the gods, shining your lamp on them and exploring their faces in detail, is sheer hubris, and Mapplethorpe paid his debt of love. The image-world remains divine property, fixed in a preternatural stillness, with petals that never drop and skin stretched forever across permanently toned muscles, all joined to time. In one of his "Proverbs of Hell," William Blake declared, "Eternity is in love with the productions of time." There is an underlying harmony to Mapplethorpe's work, a unity that not only invests each balanced composition but also the work as a whole. He insisted that floral and human forms were equivalent, and it is not insignificant that his eye (the use of the singular is apt) matured almost at once with his first photographs. Mapplethorpe chose the medium for its rapidity and sped toward an ideal immediacy that compressed all stages into one perfect moment.

The Priestess of Perfection: Agnes Martin

Every two years the Whitney Museum of American Art in New York explodes in a riot of rhetoric and art world boosterism that can be frankly embarrassing when the decibel level climbs high enough to attract the attention of the bemused media outside the arts press. The event sets in motion the acrimony and machinations of dealers, investment-minded

collectors, and curators, whose livelihood depends in part on selection for and even placement within the exhibition. A thick catalog is dropped into the middle of this—usually stirring up even more of an uproar—with long theoretical essays that obliquely attempt to spell out some of the criteria by which artists have been included or excluded, mirroring the sexual and political trends of the past year, which are, given the giddy carousel of contemporary art and the rapid rise and fall of reputations in the avant-garde, hopelessly out of date by the time the Biennial opens. Buried in the middle of the 1995 catalog, after the long official apologia (appropriately enough on Babel), is a two-page spread devoted to Agnes Martin that seems entirely out of place in that cacophony. On the right side is a photograph of Martin's dimly lit New Mexico studio. Against a powdery brown adobe wall, nine square canvases are leaning. We see only the first, a classic Martin consisting of pale pastel and blue horizontal stripes separated by six bands of white. The rest are known by their edges alone—just touches of white on raw canvas. Next to the stacked paintings is a tall French window, flooded with white light, through which we see a few green stalks jutting out of the desert sand. On the facing page is the simplest, most direct artist's statement in a catalog full of hype and hypocrisy: "When I think of art I think of beauty. Beauty is the mystery of life. It's not in our eye, it's in our minds. In our minds there is awareness of perfection."

The effect of the three Martin paintings in the exhibition was no less anomalous. Tucked inconspicuously into a corner along with a recent white painting by Robert Ryman, they were by no means the centerpiece of the Biennial nor the most talked-about works of art. Yet they created a still point that importantly held its ground amid the Darwinian nastiness. So much in contemporary art since the "muscular" decades of the Abstract Expressionists is about power. How, then, does Martin's understated yet unfashionably emotional art command such a following? The firmness of her stance is evident in the exquisite lyric poems and aphorisms in which she reveals the balance between intellect and emotion that grounds her work. Much of the thinking is decidedly ascetic in nature, stressing the "unmaterialistic" nature of art, which has to ignore trends, the art scene, even social questions in favor of a single-minded devotion to being ready for that moment when inspiration comes. In a lecture titled "Beauty Is the Mystery of Life," Martin stressed the need to penetrate through the "rubbishy thoughts" in the mind to the "happy emotions" that are the origin and end of real art. She declared:

> Take advantage of the awareness of perfection in your mind. See perfection in every thing around you. . . . To progress in life you must give up the

things that you do not like. Give up doing the things that you do not like to do. You must find the things that you do like. The things that are acceptable to your mind. You can see that you will have time to yourself to find out what appeals to your mind. While you go along with others you are not really living your life. To rebel against others is just as futile. You must find your way. Happiness is being on the beam with life—to feel the pull of life.[40]

The deeply spiritual, humble aspect of this view of art and life is based on a very close identification with nature. The legendary life of Agnes Martin would be too perfect as material for a latter-day D. H. Lawrence or even Henry James to turn into fiction. She was born in 1912 and raised on a wheat farm in Saskatchewan (one of the most solid biographical clues to the geometry of her later style is the referential importance of the horizon and geometry of the Canadian farmland, recalling Miró's use of the geometric patterns of tilled fields in his early landscapes). She moved to the state of Washington, finished an undergraduate degree at Washington College of Education in Bellingham, and ended up at Columbia Teachers College in Manhattan, where she had her first exposure to the gallery and museum scene that would unsuccessfully try to claim her in the 1960s as its own. Between stints at Columbia she took fine arts courses at the University of New Mexico in Albuquerque and stayed out west from 1946 through 1952, when she moved to Taos, New Mexico, to continue painting. Then she returned to New York, working in a studio on Coenties Slip, a waterfront "artist's neighborhood" and former dock at the tip of Manhattan near where Ellsworth Kelly, Jack Youngerman, Jasper Johns, Robert Rauschenberg, and James Rosenquist all worked. She was picked up by the Betty Parsons gallery, which represented Mark Rothko, on the condition that she live in New York, and relatively quickly turned into a critically acclaimed (and very marketable) artist.

The turning point in Martin's career was her shocking decision to leave the Manhattan art scene in 1967, at a moment when her work was popular enough for the exhibitions to be sold out at the openings. She announced her "retirement" and tossed her canvases and furniture into a white pickup truck to spend eighteen months driving around the western provinces of Canada and then the United States—not painting. She built a studio and an adobe house, without phone, electricity, or plumbing, in the New Mexico desert a long way from the nearest highway. She eventually came out of retirement with a retrospective of her work at the Institute of Contemporary Art in Philadelphia in 1973, and at the age of sixty-two she began the annual exhibitions at the Pace Gallery that remain the art world's only window on her solitary, art-centered existence.

The psychological struggle in Martin's paintings, according to the artist, involves a battle with the ego. In "The Untroubled Mind" she confesses, "My painting is about impotence." Elaborating on this thought, she compares the conquering ego to a wave that "makes itself up" and crashes in frustration. The introspective phase in her creativity brings the ego to the surface, where it necessarily dissolves:

I can see my ego and see its intentions
I can see that is the same as all nature
I can see that it is myself and impotent like all nature
impotent in the process of dissolution of ego, of itself
I can see that its main intention is the conquest and destruction of ego, of self
and can only go back and forth in constant battle with itself
repeating itself. (p. 18)

Like the repeating lines, the back-and-forth of the hand across the canvas, the slight tremor in the hand that shows up in the graphite that she uses to inscribe her horizons, this rhythmic shuttle pulls itself together into the outwardly calm, "resolved" state of her paintings. In their purity of tone and geometry, they aspire to an explicit perfection. "A work of art is successful when there is a hint of perfection present—at the slightest hint . . . the work is alive," she notes (p. 22). This does not automatically mean that perfection is attainable. Step up close to a Martin painting or to the splendid watercolors that for some connoisseurs are even more important for an understanding of her work, and you will see the slight tremor in the pencil line, the wrinkle of the appear, or the fraying of a thread in the canvas. More important, you will see the pulse of the brush and paint against the pull of the canvas.

Martin is a great rhythmic painter on two levels. She divides the squares of her canvases according to an innate sense of structure that uses spacing to establish a powerful rhythm. Within those panels she lays down a brushstroke that, to paraphrase Matthew Arnold, begins, and ends, and then again begins as it travels across the canvas. Like the commas and caesurae of a line of poetry, each band of a Martin painting opens and closes many times before it reaches its end at the edge of the canvas; and the way in which the paint gathers or thins out as it moves across the canvas is part of the almost subliminal rhythm of the work. This rubato is a slightly more obvious part of a work like *Trumpet* (1967), in which the gray washes of acrylic subside and gain density separately from the seven verticals and twenty-three horizontals of the graphite grid. In the broader bands of acrylic with graphite of the untitled

paintings of 1988, for example, the pulsing of the paint is scarcely discernible from more than a few inches away.

The geometric proportions of Martin's meticulously divided canvases or drawings—that space "between the rain" as she once explained it—is directly related to Classical ideals. As the critic Barbara Haskell has pointed out, Martin's perfection comes from an Asian-influenced view of the Classicism that originated with the Greeks. In Martin's own words, "I would like my work to be recognized as being in the classic tradition (Coptic, Egyptian, Greek, Chinese), as representing the ideal in the mind" (p. 24). Elsewhere, she elaborates on this in a way that reveals how important it is for the Classical to be "detached and impersonal" (p. 15). From the geometry of Mondrian, Albers, Rothko, Newman, Reinhardt, Kelly, and others, coupled with the inclination to perfection inherited from the Greeks, Martin sought to extricate for her own style an even more meditative, spiritual vocabulary.

Her version of the grid emerged in the 1960s, when she was working in New York. She used six-foot-square canvases covered with a very light, brushed-on oil paint, (later she moved to acrylic); initially bordered by a heavily textured "frame," for the earliest pieces they had a grid of horizontal and vertical lines that were designed to "lighten the weight of the square." The Guggenheim Museum included the grids in the *Systemic Painting* exhibition of 1966, which pushed her reputation into the category of Minimalists like Robert Mangold, Sol LeWitt, Donald Judd, and Carl Andre. Yet her work is too "personal" and involved with the spirit to be genuinely Minimalist. Priority must be given to the twin virtues of light and lightness, both in terms of the sun-drenched effect she pulls off in her "landscapes" and with regard to the weightlessness of her compositions. The paintings of the 1970s and later are meant to be less involved with the landscape tradition—what she called "the nature pattern"—and more a reflection of metaphysics. As she wrote in "The Untroubled Mind," the double meaning of "lightness" is the aim:

> Just a suggestion of nature gives weight
> light and heavy
> light like a feather
> you get light enough and you levitate (p. 13)

There is an enigmatic statement on asceticism in "The Untroubled Mind" that touches directly on the distinctions that Martin draws between the effort made by some to punish themselves in order to create and the more genuine (although seemingly more passive) course of the true artist, who depends on receiving inspiration from the stimuli around

her. Martin writes: "Asceticism is a mistake / so that our suffering is a mistake / but what comes to you free is enlightening" (p. 14). As she had rejected the ardent asceticism of the medieval sort, it is interesting to go back into "The Untroubled Mind" and find a passage so purely ascetic in its nature that, as a summation of Martin's unique place not only in this look at contemporary asceticism but in the art world itself, it stands alone. The solitude in which she finds her inspiration does not intimidate but becomes part of the drama of creation and re-creation. She writes:

> Night, shelterless, wandering
> I, like the deer, looked
> finding less and less
> living is grazing
> memory is chewing cud
> wandering away from everything
> giving up everything
> not me anymore, any of it
> retired ego, wandering
> on the mountain. (p. 19)

Traveling the Ellipse: Robert Mangold

It was an overcast October afternoon, and the oaks, maples, and birches edging the newly mown fields on the hilltop surrounding Robert Mangold's upstate New York home and studio were glowing red and gold against the green of the pines. A dozen big round bales of hay stood in the pastures, and nearer the two white silos of Mangold's working farm a separated pair of rusting iron wheels from an old and long-since dismantled hayrick poked up from a patch of long grass. Mangold, in his signature worn-black-cloth cap, strolled the hundred yards from the back of the house to the door of a red barn, moved through the gloom of its interior, the dim sunlight slipping through a few gaps in its old timbers, and stepped up to the special inner cell—a perfect, brightly lit white rectangle—that is his studio. He has apologetically explained in advance that, with an exhibition due to open in two weeks at his gallery, Pace/Wildenstein in Soho, there is "nothing really on the walls."[41] Surprisingly, as the fluorescent lights come on to supplement the steady suffusion of gray sunshine from the studio-length double skylights, there is indeed a great deal to look at: the walls are lined with half a dozen large works on paper as well as a new canvas near completion. Rather than coast into those months after an annual show when little is expected of

an artist, Mangold has pitched himself right back into the fray. Over and over again, with a discipline that harks back to Mondrian and Miró, he has returned to the geometric figures (ellipse, triangle, square) against a colored ground that established his reputation as one of the leading Minimalist painters of the 1970s. His ascetic achievement is this relentless exploration of a deliberately limited pictorial vocabulary through permutations so subtle that only those who have followed his career can pinpoint them.

By the modest wooden desk tucked against the wall of the studio is an array of irregularly shaped and odd-sized swatches of paper with colors on them, mainly in pairs, a reminder that in Mangold's latest, multipanel paintings in a demilunar format the interaction of colors is based on the opposition of two tones that, in the middle panel, are pulled over one another in a palimpsest effect that creates a new and often improbable tone. The books lined up on the desk beside the heater for his tea—the Modern Library selection of Kant, Edmund Wilson's journal from the 1960s, and a collection of critical essays about the philosopher (and Ruskin of our time) Arthur Danto and his critics—are clearly more aligned with literary and philosophical interests than with Mangold's powerful grasp of art history. Classicism is invoked by the little reproduction of a Greek vase from the Metropolitan Museum of Art resting on the desk, which provided the image for the frontispiece one of his gallery exhibitions in 1992. More important in terms of understanding the shape and composition of the recent work, a photocopy of one of the demilunes from the Sistine Chapel ceiling is tacked to the wall. Aside from a table for paints and a rolling step for reaching the upper parts of large canvases, the only other furniture is a rocking chair that conjures an image of long hours of contemplation before works in progress.

"I work in batches or rehearsals for large paintings that are the culmination of every year's painting," Mangold explains. "A lot of this is about testing ideas." The latest exhibition brought together a group of very large demilunes in three parts, across which Mangold's ellipses were traced. Since then he has pulled an even more ascetic curtain of black down over the center of similarly large works. For three decades the basic components of these works have remained almost exactly the same: shaped canvas, color field, and a light, floating geometrical figure usually in black on the surface. His "background" fields—the status of the hierarchy of figure and ground is an important question raised by the work—have changed not only in color but also according to the technique by which he applies the paint, from the use of sprayed oil in the earliest work (through 1967) to his later procedure of rolling acrylic onto the canvas with more and less degrees of brushlike modulation.

The figures traced across these color fields are also more complex than they seem. The steady path of the ellipse, for example, which Mangold lays down and goes over many times by hand, invokes three-dimensionality by suggesting a circular hoop turned in space. When he twists the ellipse into an infinity sign, the three-dimensional effect arises from the perception of the line crossing over itself, recalling the "weaving" of the grids in Mondrian. Mangold will bring two ellipses into a moment of contact in some paintings, and the tangent passage—like the "knot" in a Brice Marden or Mark di Suvero—becomes a point of heightened interest. It is in the close examination of the linear repetitions that the rhythm of the studio practice can be appreciated—the eye goes over and over the ellipse, just as the hand has traveled that circuit many times.

These initial problems are succeeded by even more sophisticated technical and visual ones. Mangold, who finished undergraduate and master's degrees at Yale from 1959 through 1963 under the great Josef Albers (after attending the Cleveland Institute of Art), makes profound use of the idea of Albers's "interaction of colors." On paper he will lock together planes of color, arriving at tonal intervals and nuances of weight or density until he has the contrast he wants for the paintings. He uses the curved edges of the demilune's panels as a linear element in the painting and in the past has taken the shape of the canvas as a rule-making determinant of the forms within (for example, using a curved interior figure if all four sides are rectilinear, or vice versa). The scale and shape of the figures play odd tricks on the viewer's perception. The width of the ellipse has a tendency to change the "speed" of the figure. For the same-size canvas, a narrow ellipse is a good deal "faster"—recalling Mondrian's remark on speed—than a more rounded one. In the earlier works the angular hourglass figures made with straight lines with straight borders are slow, while the figure eights are fast or slow depending on how narrow the loops are—the more slender, the faster.

Although Mangold was more of a purist in the days of High Minimalism, when the ellipse and triangle had to be steadfastly abstract, now he expresses a casual, softened, attitude toward viewers who see a human head or egg or other form in his ellipses. "I want the viewer to relate physically to the drawn line and shapes," he notes. The former tightness of the drawn ellipse, which appears to be a single line in the earlier paintings but now is more clearly the result of many lines, has been loosened, as some lines in the most recent paintings diverge from the main figure slightly. The scale of the works and of the ellipses also contributes to the way in which they "relate physically," since even the largest of the recent demilunes is not so vast as to take away the notion that Mangold, who is over six feet tall, has encompassed the whole ellipse with the sweep of his

arm. But the main connotation of the ellipse within the demilune remains "architectural" in his eyes, defining a space that is still abstract. Inside the cozy farmhouse where Mangold lives with his wife, Sylvia (a painter of great lyricism whose use of trees is strongly reminiscent of the early tree paintings and charcoal drawings of Mondrian), the art collection finds whatever wall space it can among the thousands of books in their library. It includes compact and powerful pieces by Sol LeWitt, Josef Albers, and Brice Marden, nearly all of them in black and white and almost all unfailingly geometric.

For the critic and curator Klaus Kertess, Mangold's paintings are "Thinking Walls," taking us back to the contemplative mode, and the ellipse is a figure of "intuition" that reflects the mind at work. Kertess traces the way in which Mangold's career was built on the blankness of the 1960s, which he likens to the "pursuit of primary states of consciousness" through Zen and "the neutralized grids and monochromes of Minimalism." This is the foundation for a frescolike quality that Kertess calls Mangold's "light-suffused dryness," the technical explanation for which may be the thin wishes of paint that Mangold uses. As in the work of Milton Avery, the dry effect of these veils of color arises from their attentuated, gossamer thinness. When Mangold floats the weightless ellipse over this atmospheric color, the overall effect is doubly light. Kertess compares the geometry of Mangold's Attic series with the designs on Greek vases, such as the reproduction that Mangold keeps on his desk: "Luminous dryness, incisive clarity of both internal and external contours, regimented directness of drawing, abstract coloration—all are characteristics shared by Attic pottery and Mangold's painting."[42]

As the poet Stéphane Mallarmé called himself a "syntaxer," so too the structural development of a Mangold series has its syntactical or structural dimension. The progress of the drawings and earlier studies is not a direct, stepwise progression from simplicity to complexity, or one geometric arrangement to its obvious successor, or even fullness to emptiness. However, there are certain closely related steps in a group, such as the Attic series, that can be viewed as individual syntactic arguments, not one long and directly evolving program but groups in related movements. The suite of eighteen black-and-white studies for the series underscores the schematic clarity of Mangold's earlier approach to the figure. It is interesting that in these studies the hand-guided element is always curved, even when it becomes part of the bounding edge of the canvas, at which point the inner figure becomes a straight-line, triangulated version of the infinity sign. Like Degas or Diebenkorn, who would build outward from a constrained and usually rectangular framing device by adding strips of paper and giving the supplement a border and sometimes even a

Starting from the demilune form of Michelangelo's Sistine ceiling, Robert Mangold floats ellipses, steadily traced by hand, over curtains of overlaid color to attain a painterly Minimalism. © 1998 Robert Mangold/Artists Rights Society (ARS), New York. Courtesy of Pace/Wildenstein Gallery, New York.

color of its own, so too Mangold adds geometric supplements, usually in the form of triangles. In almost every case, as he adds a "wing" that angles to the right, he tilts the twisted ellipse against it so that it balances the outward unfolding of the new part.

The most recent work is his most complex (Susan Dunne, an expert at Pace/Wildenstein, calls it "baroque") in a number of different ways. The linear element of the ellipses is traced with a bit more license than usual, straying off into the color at times and softening the pristine geometry of the figure in a way that distances the works from their Minimalist antecedents. There is greater complexity in the interaction of the three or four colored panels, their edges acting as a linear element in firm vertical counterpoint to the thicker and more expressive curved lines of the ellipses. In this group, Mangold builds and rebuilds the demilune. The allusive tie between the demilunes of the Sistine Chapel and the form as used by Mangold serves as a link to the tradition in painting and to that in architecture as well and invokes the hierarchy of line and color. "The forms come first, then the color, and the forms are used with different color fields behind them before I decide on one," Mangold explains. That traditional privileging of line over color, the secondary quality, offers an insight into how Mangold's paintings work.

Mangold's recent paintings exuberantly exploit the intersection of colored planes as well as of ellipses. The panels of gray and bright tones, yellow and orange in particular, create regions of shadow and texture offset by sectors that are bright sources of color and light. Among the toughest philosophical problems of the twentieth century is that of the "impossible" color. As Wittgenstein and others have framed this problem, the idea of a greenish red is, by definition, an impossibility. By pulling planes of green and red into central overlays that, in a murky bronze and copper way, retain characteristics of both tones, Mangold has put that impossible tone on canvas. Beginning over again is one of the challenges of the great ascetic projects like Newman's *Stations of the Cross*, Albers's *Homage to the Square*, Brice Marden's Cold Mountain series, and similarly monumental projects in music (such as Béla Bartók's *Mikrokosmos*) or literature, (T. S. Eliot's *Four Quartets* and Seamus Heaney's *Station Island* lyric sequences). While these are discrete projects around which other series or ideas are gathered, Mangold's "spiritual exercises" are a lifelong task that seemingly never ends, in a way similar to the connected fictions of Walter Abish or the great endless "Livre" that Mallarmé envisioned that would collect all his poems. Each day depends on making that trip back into the white studio inside his barn, returning to the place where that impossible color was created, to rhythmically travel, again, the ellipse.

Sense and Sensibility: Brice Marden

Brice Marden is one of those artists to whom many people "convert" in one memorable instant. Although I had always admired the elegance of his monochrome paintings from the Minimalist phase of the 1970s, my own point of no return was reached one quiet morning in 1988 at the DIA Foundation in New York's Chelsea, where I found myself surrounded by the massive (nine by twelve feet) profoundly emotional Cold Mountain paintings, a group of six major works inspired by the classic poems of a ninth-century Chinese recluse. The lonely, ascetic voice of the ancient poems spoke clearly through this virtuoso painterly achievement, which echoed the strokes and columnar organization of Chinese calligraphy. I was amazed as well by the seeming ease with which Marden had translated the lightness and animation of his drawings, which are even more like calligraphy, to the physical scale of major Pollock drip paintings. Viewers of the drawings were privy to the changing vocabulary from 1985 on, when the first of the calligraphic pieces, based on the patterns of the seashells Marden collects as well as on Kenneth Rexroth's translations of Du Fu, began to appear in gallery shows.

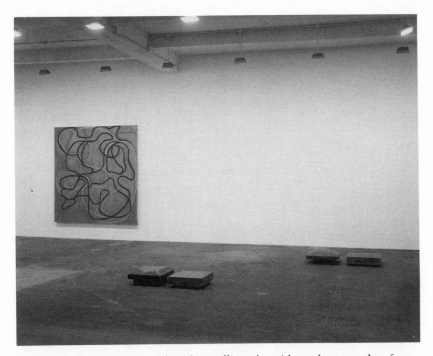

Combining paintings that are based on calligraphy with tombstones taken from a sacred mountain in China, Brice Marden interprets an ancient form of asceticism through contemporary classicism. © 1996 Brice Marden/Artists Rights Society (ARS), New York. Courtesy of the Matthew Marks Gallery, New York.

The theme of Cold Mountain invokes the intertwined disciplines of the "three perfections" of the Chinese ascetic-scholar's life: painting, calligraphy, and poetry. The series is based on the work of Han Shan, a poet who lived in exile at the sacred Chinese shrine of Tian Tai (Heavenly Terrace) in the Cinnabar Hills in present-day Zhejian province. At the time it was a real wilderness and is today one of the greatest tourist attractions for overseas Chinese returning to their homeland—particularly those who are devout Buddhists. Han Shan left his home and family in the capital city of Changan, today known as Xian, to spend the last two decades of his life 750 miles away in the monastery of Kuo Ching, one of seventy-two major temples and cloisters on the sacred mountain of Tai Shan, where the cold and constant rain (over sixty inches every year) sharpened his appreciation for the most extreme asceticism of Buddhism (as expressed in the "Bloodstream Sermon" of Shakyamuni in the Bodhidharma). There, "living alone, neither dead

nor alive," wearing pants made of paper and robes of grass, a bark cap, and wooden clog sandals, he climbed the mountain with a staff cut from an old vine and composed poetry in the traditional form of four couplets of five-character lines. One of the most famous of his lyrics, a favorite of Marden's, captures the solitude, simplicity, stasis, and sadness of Han Shan's bare existence:

> I have sat here facing the Cold Mountain
> Without budging for twenty-nine years.
> Yesterday I went to visit friends and relations;
> A good half had gone to the Springs of Death.
> Today, with only my shadow for company,
> Astonished I find two tear-drops hang.[43]

When poetry and painting interact, as with Johns's interpretation of the work of Hart Crane or Wallace Stevens's "The Snow Man," the bridge between disciplines is generally thematic or psychological. Marden captures the emotional resonance of Han Shan's poetry with an uncanny clarity, but he goes further in tightening the relationship between his art and the poetry by adopting some of the visual and formal characteristics of the calligraphic style in which the poetry would have been rendered. As Frank Lloyd Wright and Philip Glass have combined Eastern and Western sources by drawing on the forms as well as the spirit of the two traditions, Marden manages to fuse Eastern and Western thinking in three ascetically oriented groups of paintings: Cold Mountain, Grove (based on his experiences in Greece), and the Annunciation series that took as its inspiration a fifteenth-century Italian sermon.

The first painting in the Cold Mountain series is subtitled *Path*, which is one of those loaded words in Buddhism representing the route of the ascetic or exile, a method of meditation, and "the way" (in Chinese, the *tao* of Taoism) of truth. Marden began the painting in 1988 and finished it in 1989. Its eight "columns" of characters parallel the four couplets of Han Shan's poetry. Triangular and rectangular forms emerge from the tangle of dark lines, as do the femurlike, solid strokes that are part of the repertoire of calligraphers. From right to left, the traditional direction of Chinese painting, Marden begins in a relatively firm, dark tone, weaving his way back and forth and down the column, the density fading and then replenishing itself until it shoots straight off the bottom margin in the first three columns. These alternating soft and strong passages, breaking the work into phrases as in a Mozart sonata, begin to drift off as Marden reaches the paler line in the left columns. The last ends well above the edge, leaving a vacant lower-left corner, not unlike those that

Tobey kept open in his "white writing" paintings. Like the points of convergence in a Mondrian where the gray stars pulse, the passages of particular interest in these paintings are "knots" where several lines cross. The most conspicuous of them links the fifth and sixth columns, where a strong, almost straight descending vertical spine crosses a powerful transverse stroke that broadens as it enters the sixth column and is cut by a slashing diagonal. Over part of this knot, Marden has pulled some of the white that he uses to correct and efface—not just in the paintings but in the drawings as well, where it creates a range of blues and grays by mixing with the black ink.

The second painting in the series uses an atmospheric gray ground and dilute paints that run and blend together. The knots are looser; one fascinating cluster of looping closed forms in the third column near the top is not tightened down but allows the free flow of as many as nine traveling lines, including a white-blue line that is particularly active in that region. This use of a white line, again suggesting Tobey, is particularly noteworthy in the fourth painting, which negotiates an interesting balance between a relatively even black line and a ghostly white substructure that has a knot of its own just right of the painting's center. The line bounces off the bottom edge to run tightly along the right-hand side in a way that previews the edgework of Marden's most recent work, which is on a smaller scale than the Cold Mountain paintings.

Marden finished the fifth painting in the series, subtitled *Open*, in 1991. It reflects a few changes in the relationship between the larger, looser gestures in black and a more active white substructure, all drawn over a more "colorful" green haze that is reminiscent of the background tone of Miró's Constellations. A busily worked moment on the right-hand side, using longer and stronger strokes to lay down larger looping gestures in black, shows Marden turning to rounded forms rather than the more triangulated vocabulary of the earlier paintings. The sixth painting pulls off an interesting shift in the color of the understructure, starting in jade green on the right and shifting to white and blues as it moves left and the characters also incorporate more color, again in anticipation of the colored ribbons of the later works. These interact in multicolored knots that bring diagonals and their echoes, both thin and thick, across one another over the white-out shadows behind them. Because there was not enough of the smooth, preprimed Belgian linen he needed for the whole series, the last painting is on a somewhat different surface.

The paints that Marden used were mainly mineral or earth pigments, most of them actually made from cinders and ash (an oblique connection with the cinders of T. E. Hulme or Jacques Derrida), such as the ivory black that is made of burned ivory or the warmer tone of vine black from

the carbon of burned vines. The background tones of the series vary from the gray green of the second painting to terre verte mixed with vine black and the gray green that Marden based on the tone of a Japanese tea bowl's glaze that he saw in a book on ceramics. It is accomplished by using a cadmium yellow ground that he "he grays down" to match the bowl's color or the thinned vine black that provides the wash for the fourth painting. The fifth painting has the most complex range of tones, including the tea bowl's green as well as blues, gray, cadmium red, and black to darken it.

Deliberate Progress

These austere, visionary paintings, which follow in the spiritual tradition of Barnett Newman, Clyfford Still, and Agnes Martin, represent a considerable leap from the Minimalist painting for which Marden became famous. He was born in Bronxville, New York, in 1938. His father was not only a gardener by avocation but particularly enjoyed building stone walls, which demands a particular eye for fitting things together. This is worth remembering as you look at the way the early two-panel pictures tightly lock together. Marden went to Boston University's School of Fine and Applied Arts from 1957 to 1961, where he studied drawing and painting with Reed Kay, then on to Yale to work with Alex Katz, Jack Tworkow, and Esteban Vincente. His thorough training in life drawing might seem superfluous to one who felt that Marden's mainly abstract mode leaves little room for the human figure, but if you look at the torque of the columns and looping lines in the Cold Mountain series and later work you will see the benefits of a thorough grounding in the art of the figure.

At Yale, where his contemporaries included Chuck Close, Richard Serra, and Robert Mangold, his notebooks contain allusions to his belief in the "Spartan limitations" within which painting should be done. He arrived in Manhattan in 1963 to work on the Lower East Side, and he still has a magnificent studio on the Bowery. According to the official accounts of his student years, he was particularly influenced by De Kooning and Kline, specifically a painting by Kline called *Zinc Door* (1961) about which he did a series of drawings, and he now has a 1948 Kline drawing in his house. Marden spent four months in Paris in 1964, where he painted his *Homage to Giacometti*, a gray diptych in wax and oil. During his visit, many of the most famous buildings were being cleaned up by the De Gaulle regime, and Marden—like Cy Twombly in Rome—was steeped in the look of the walls of Paris, their variety of stone, tile, stucco, and plaster. In a monograph on Marden, Klauss Kertess instructively

points out that Marden was attentive to the historic preservation programs and particularly to the surface quality of the walls in Paris. "He sought to assimilate this wallness in his drawings as he built more tilelike grids and disciplined the indulgences of his hand," Kertess writes.[44]

In 1966, Marden began working as a studio assistant to Robert Rauschenberg in New York. His own early monochromes mixed beeswax and oil with turpentine to create a dense and malleable and, most important, a nonreflective surface (he started using the medium at the suggestion of Harvey Quaytman). Marden kept his mixture melted on a hot plate and mixed the colors on a refrigerator door that was his palette, applying them with a large spatula and a small painting knife. In the "frame" paintings of 1964, as well as in *Wax I* (1966), *Nebraska* (1966), and *The Dylan Painting* (1966), he explored a range of dense grays framed by or tinted with earth tones. Defying the conventional optical rules, Marden's monochrome works seem to pull light and color into themselves rather than bouncing it back. In his own words, the surfaces are "not reflecting light but looking like they are absorbing light and giving off light at the same time." After the encaustic gray and white paintings of Jasper Johns, these heavy-looking, waxy "painted" panels that have so thoroughly sealed off and buried the canvas beneath are too painterly to be considered Minimalist in the purest sense. The scars and nicks on the wax surfaces that humanize them somewhat by giving the suffering or distressed look would also disqualify him as an orthodox Minimalist.

Marden used the bottom edge of the heavily coated canvases in a novel way. He would halt the progress of the slab of waxen paint just a moment before it reached the bottom edge, lifting its hem to reveal the weave of the canvas smudged or overrun slightly with flowing paint. In musical terms, if the bass note is sounded by the monochrome, its pulsing vibrato creating its own chord with overtones, then the way it tails off is like the moment when a chord held long on the piano with the pedal is released by a master like Alfred Brendel when he is playing Beethoven sonatas. Brendel and Marden masterfully let up on the pedal so that the tone lingers on for a few beats, then drops off. The edgework is subtle; the instrument is never permitted to jangle out of control; the silence or bare canvas bear just a trace of color.

From an ascetic standpoint, the most important of these works is *Three Deliberate Greys for Jasper Johns* (1970), a triptych that was painted after Marden worked as a guard at the Jewish Museum in New York during the Johns retrospective, recalling the experience of Robert Ryman, who worked as a guard at the Museum of Modern Art in New York, where he passed his days in rooms filled with paintings by Rothko

and Newman, both of whom became an allusive presence in his work as well. The dark panel on the left of *Three Deliberate Greys* (the misspelling as well as the many senses of "deliberate" being intentional) lifts its hem and reveals a bit of the canvas and the strokes beneath. The lightest gray is kept in the center, like a source of light (as with *Range*, painted in the same year), while the right-hand panel pulls in blues as well as greens that are remarkable in their variety. Each gray reads differently—they are the characters in a pictorial drama—and none of them is really a Johns gray despite Johns's use of encaustic and other obvious technical parallels to Marden's work.

The Conversion in the Grove

After the Cold Mountain series, the most ascetic series in visual terms was the Grove group of paintings made between 1972 and 1976. Thematically, the prize for asceticism would go to the Annunciation series of 1978, with titles such as *Conturbatio* (Disquiet), *Cogitatio* (Reflection), *Interrogatio* (Inquiry), *Humilitatio* (Submission) and *Meritatio* (Merit). The Grove paintings represent Marden's meditations on the sea and on the colors of the olive groves from the vantage point of his home and studio high up on the island of Hydra, where he has spent part of every year since 1971. Like his recent immersion in Asian classicism, painting his version of Chinese calligraphy to the music of Japanese chants and Yamaguchi flute playing, Marden has bathed in the architecture of Greek Classicism (and the light of Greece) as well, with his paintings as a means of reflection on both and as "sounding boards for the spirit," as he says.

The notebook that Marden kept while painting the Grove group is full of notations on the color harmonies and close values with which he was working. Some of them are not too ascetic, such as the entry, "Grove— all panels olive grove blue, green—wide sensuous engulfment."[45] Many references are to the idea of color, including "color as character, color as weight, color as color" (p. 20). Some reflect deep spirituality in his response to the ruined temples, the sculpture of Praxiteles and the various pilgrimages he made to important Classical sites. Marden's notes show how deeply attuned he was to the Greek aesthetic: "The rectangle, the plane, the picture, the structure, is but a trampoline to bounce on spiritually" (p. 21). Some of the entries are pure arias of ecstasy: "The blue blue blue of the calm sailing sea toward Ithaca . . . seeing nothing but being *in* blue—immersion—watching the surface from beneath it" (p. 24). Marden's writings and statements about painting in the Grove notebooks are inspiring, in part because they do not bear a trace of the kind of irony or acerbic deflation of high-minded references that most Postmodernists

would display. By contrast, Marden's writing is imbued with an un-abashed spirituality. He points out the sacred role of the artist: "Painters are amongst the priests—worker priests of the cult of man—searching to understand but never to know" (p. 25). As Robert Pincus-Witten wrote in his wonderful essay accompanying the publication of the diary, the voice of the entries is unique:

> Unlike other diaries, Marden's entries do not retail the *bon mots* or brittle banter of a privileged community; nor do they ventilate an angry launder-ing of dirty linen. His journals are not the place of raw resentment or of scores settled. There are no prurient passages; revelations of domestic stress are absent. By contrast, the notebooks convey a shining-brow'd exhilara-tion, the neo-Greek zeal of the Edwardian public school. Marden's nice sense of moral balance inflects his record as do the refined drawing to be found there—pages that, in being worn and degraded, keenly manifest the painter's nostalgia for limpid beauty imperilled. If nothing else, Marden is the most poignantly aesthetic of all the artists who emerged under the Min-imalist rubric as well as its most clandestine and patrician colorist.[46]

For the Annunciation series, Marden derived his titles from a fifteenth-century Italian sermon on the five states of the Annunciation, much like Newman's *Stations of the Cross*, including the use of descending verti-cals. Works such as *Humilitatio* show what Marden meant when he said he was "taking light through" these paintings: the left-hand side is a creamy white that encounters a deep blue almost on the verge of black in a narrow vertical panel succeeded by lighter blue panels as one moves to the right. As with Newman's *Stations*, this is ostensibly a narrative series, using the rhythmic effect of two reds and two blues, recurring until they wind up in the yellow, blue, and white of *Meritatio*. Marden counters the one-way reading of the narrative with a contrapuntal use of painterly ef-fects. "The overall narrative reading, from left to right, is constantly counterpointed by the movement of paint (from right to left) and by the spatial shifts across, in and out of the flatness of the planes that comprise each painting," Kertess observes.[47]

The turning point from the weight of color to the translucency of color, setting up the "lightness" of the recent work, came in 1981, when Marden abandoned wax for oil thinned with terpineol (a distilled form of turpentine that dries flat and can be read through). Some of the most enchanting work he did at this time used fragments of marble left from a bench his wife Helen (herself an accomplished painter) had built for their home in Hydra. One of them, titled *Marble Number Twelve* (1981), uses a rough triangle of marble on which Marden has traced thin lines of

black, blue, and yellow, somewhat reminiscent of a Mondrian study or the work of Richard Diebenkorn; and the key aspect of these lines is their lightness and the way they thin to almost nothing as the brush gives up its paint. The linear vocabulary of the works and their transparent colors are reminiscent of a great series of Marden watercolors started in 1977 as studies for five large stained-glass choir windows, four sets of circular arch windows, and six rose windows, all in alchemical colors, for the Gothic chevet of the Basel cathedral. Marden worked from 1978 through 1985 on the project, creating a luminous group of geometric watercolors, reminiscent of Diebenkorn's Ocean Park series as well as Robert Delaunay's Fenêtres, that used the grid of the glass and brought a powerful diagonal into his vocabulary.

It is just this translucency that makes the recent paintings work as palimpsests. Marden, who relishes the "silvery" light of Manhattan, keeps his materials thin and taut, using unusually tight canvas that has to have foam-core padding under the edges where it meets the wooden stretchers so that it will not be marked when he presses the palette knife and scraper hard against it. He uses highly diluted oil paints and delicate palette knives like scalpels, and continually scrapes and sands away paint from the canvases, which are not layered as in the past. Like Cézanne and Milton Avery, Marden applies his paint like a watercolorist. He puts a brush mark on with one stroke and almost immediately scrapes it away with a knife or rubs it out with a towel. On top of other marks he uses gray or mixed white and color (stark white is too harsh) in what he calls his "erasures" or "cancellations" or "corrections." As he says,

> I would put on a black and then scrape it and still need to get rid of dark parts that I didn't want. At first, in Cold Mountain 2, I tried stark white to make corrections, but it was just too harsh. So I mixed a gray. But what happens is that as the gray dries, the terpineol is such a strong solvent that it dissolves some of the black underneath, so that in the process of drying, the black mixes in with that gray. So I get a different color. Then I go back in and repaint in lots of places, paint over areas of that new color, and then cancel or erase them as well.[48]

The lightness of the line comes from a drawing tool that Marden created, using ailanthus twigs of varying thickness picked from a tree near his house on Bond Street in Manhattan. Dipped in ink, then flexed as he draws, they recall the reed pens that van Gogh used to make for himself. Sometimes, in a kind of meditative style, he breathes and rises on his toes while drawing on the paper on the ground, softly tracing the characters

of the calligraphy in a way that is similar to the yoked breathing and tracing of Chinese calligraphers.

Taking a Step Backward

Marden in the studio enacts a ritual of involvement that entails continuous retreats—a movement back from the canvas, back from the black of a figure that has just been drawn, in that "recoil" that Pater celebrates. The continual corrections become part of the drama, just as the retreat is a vital part of the dance in front of the picture. Where Pollock (reproductions of whose drawings are all over Marden's studio) was known for the way he attacked the canvas, moving forward into it as it lay on the floor, Marden should be thought of as backing away from it. Trained in Zen, it has everything to do with a way of thinking about his own relationship to the art. As he says, "It's the opposite of knowing yourself through analysis. It's more like knowing yourself by forgetting about yourself, learning not to be so involved with yourself. These paintings talk about nothing, and that's what interests me. In a sense, every painting is an attempt at painting just nothing."[49]

While few of us will ever have the joy of watching Marden at work in his own studio, there is a brilliant lesson about his working methods to be gained from observing Marden in a gallery or museum, where he can often be found. His rule of thumb for looking at a painting involves precisely this establishment of distance from the work, this retreat: "A good way to approach a painting is to look at it from a distance roughly equivalent to its height, then double that distance, then go back and look at it in detail where you can begin to answer the questions you've posed at each of these various viewing distances."[50] One of the most profound lessons in understanding contemporary art I have experienced was a winter afternoon spent voyeuristically watching Marden looking at a recent exhibition of Ellsworth Kelly's paintings at the Chelsea gallery of Matthew Marks. I had in mind Marden's notable statement regarding Zurbaran: "He looked at things so hard he went off into a mystical state." It took Marden at least half an hour to settle on a couple of viewing angles that could hold him for a few minutes. He walked in an arc from side to side in front of each painting, sidled up to their edges and peered at the seams made by two shaped canvases coming together. He moved from one corner of the main room of the spacious gallery to another, looking at three pictures at a time, then he drew close enough to sniff the paint and examined the surfaces. Back and forth from one picture to another he burrowed deep into the show, returning again and again to a green and white work, *White Relief with Green*

(1994) apparently to check the intersection of the two panels, the uniformity of the tone, and the thickness of the edge.

As the afternoon continued, the light began to die, and a gallery assistant flicked on the strong, warmly toned lights. Suddenly the pictures jumped up a notch in tonality, the walls went yellow, and Marden practically leaped back from the work he was looking at. After a quiet conversation with a gallery assistant, the lights were shut off for about ten minutes and then were turned on again. It was a fascinating experience, not simply for the morbid reason that it was fun to see what one master would make of a rival of an earlier generation, but because in watching Marden look at Kelly I felt I was picking up angles not only on Kelly but probably on the movements and methods of looking that Marden uses in his studio. Marden *reads* paintings, much as one reads an Old Master drawing. It is a different kind of looking from the distant, centered gaze demanded by a big landscape or Abstract Expressionist work. When Michael Kimmelman of the *New York Times* accompanied Marden through the galleries of the Metropolitan Museum for an article in a series devoted to touring the permanent collection with noteworthy artists, Kimmelman described the fifty-five-year-old Marden's encyclopedic connoisseurship that focuses on Chinese calligraphy and painting, Indian, African, and Greek sculpture, and of course the work of Jackson Pollock and the Abstract Expressionist generation from which Marden inherited some of his compositional vocabulary.

Delving into the calligraphy, Marden commented, "I am involved in this whole thing about control and not control. And one of the things about calligraphy is that it's highly disciplined. These guys spend years repeating and repeating the same characters, and they do it so much that they obtain a kind of freedom."[51] Marden's thorough understanding of the practice of calligraphy is matched by his knowledge of the poetry, so his interest is not a purely visual or technical matter but linked to content and the entire philosophical underpinnings of the Chinese aesthetic. In the article, Marden is particularly eloquent about Chao Tso, a seventeenth-century Chinese painter and poet, whose brush-and-ink landscapes can make a painting into a walk in the woods. Looking at Southeast Asian bronze sculpture, he is attuned to the movement of another kind of asceticism, which he relates to the famous phrase of Hans Hofmann, "push and pull." This living sense of how art and asceticism work together made it important to ask him how the ascetic ideal affects his work. As Marden told me,

> I go in and out of modes having to do with asceticism, which is one thing
> that intrigues me about the Chinese painters and calligraphers of the

literati tradition. It gets rarefied when it is brought back into the studio. I like the idea of working with nature, from nature and being in nature. I look at a scroll painting and see some guy sitting in a little hut overlooking a river—that's what I want to do instead of looking out on the Bowery. It's this cruel dichotomy in our time. I don't see myself as some ascetic—I live a pretty luxurious life. There's not a lot of denial involved. I think that when you are actually doing the work and in the contemplation of the work, it's a severe discipline and one of the things you are always trying to do is come back up to that severity and not wander from the path. Asceticism is not just my way. Every artist does this.[52]

The Prison House of Abstraction: Peter Halley

Nearly anyone who becomes locked in one of Peter Halley's "take no prisoners" conversations comes away with a sense of intensity that matches the brilliant colors of his work. The forty-year-old artist, whose vast West Chelsea studio in New York is a laboratory of ideas reflecting the wide range of his interests from art through politics, science, philosophy, literature, music, film, and sociology—even a new magazine called *Index* that he personally launched, following in the footsteps of Andy Warhol's *Interview*—is not known for his relaxed dialogue even in the most casual circumstances. Superbly educated (Andover, Yale class of 1976, and the University of New Orleans, where he earned his MFA degree in 1978) and unflinchingly intellectual, albeit in a Pop sort of way, Halley will launch into a disquisition on Foucault or the Internet that will push further into serious territory than most *Artforum* essays will go—without apology or the usual flip joke with which artists will try to dismiss their theoretical digressions.

This is because theory is not a digression for Halley. No other artist of our time has so carefully articulated the readings of and in his work. His writings touch on a number of the ascetic themes of this study, including not just the religious background of asceticism but isolation, the imagery of prisons, the cold, and the glass behind which people remain isolated from one another. The "weather" of asceticism, looking back to Jasper Johns and ahead to Glenn Gould, Thomas Bernhard, and Frank Lloyd Wright, is generally chilly, and Halley's essays capture this atmosphere effectively. In a meditation on death and light called "Frozen Land" (1984), Halley describes the culture of television as an "icy landscape" as well as a "great frozen facade of pseudo-life" and "a frozen, never-ending simulacrum of itself." He traces the origins of the "icy facsimiles"

to Renaissance portraiture and specifically its ability to stop light through the use of chiaroscuro. This static quality consigns artists to a priesthood devoted to the preservation of youthful appearances and immortality. In the essay's final paragraph, he offers a remarkably prescient (for 1984) glimpse into the in vitro life of the Internet:

> But already tiny holes are being made in the wall of death. The dying are snatched from death and kept alive with simulated organs. Genetic engineering is becoming capable of cloning life from life. Meanwhile, Walt Disney, that ultimate master of time, calmly "awaits his resurrection at minus 180 degrees centigrade." If the era of modernity continues, if we continue to turn away from death in horror, perhaps through new inventions the dead will walk again; our "macabre scene" will be played another time at a new level of verisimiltude.[53]

Among the dead for whom Halley has particular reverence are the Beats, which seems odd given his studious and quiet-spoken manner. Halley discusses Jack Kerouac in particular at length in the introduction to his *Collected Essays*. Drawing the contrast between the "hot" aesthetic of the Beats and the "cold" one of the Minimalists, he puts his finger on the lasting influence of the Beat generation fully nine years before the Whitney Museum's didactic retrospective of Beat painting and artifacts—including an absolutely grievous but revealing painting by Kerouac of a seated Buddha. Kerouac called himself "a strange solitary crazed Catholic mystic" who was "waiting for God to show is face," and Beat is derived in part from "beatific." In a Genet-like twist, he used the speed and nonrepetitive nature of his writing as the exact opposite of the kind of reflection that most mystics would use to elevate their thoughts to saintliness. Both Kerouac and Halley are masters of the rhythm caught from the flashing of those phosphorescent dashes along the middle of the road during desperate holy pilgrimages through a secular society. Here is Halley's version of the sensation:

> Behind the wheel. It is to be at the altar of the linear. Hands grasping the smooth plastic of the linear made circular. Eyes on the road. Following not only the road, but the cool geometry of the lines that divide the roads into lanes. At nightfall, the landscape and even the road gradually disappear, and we are left only with this display of linear signs glowing in phosphorescent paint under the headlights. On the road. It is said for us to be the greatest feeling of freedom. But the feeling is really that of oneness. On the road, behind the wheel, hurtling down the highway, there is a feeling of unity with the formal power of the linear. It is our theater of the philosophic.[54]

The Mask of Impersonality

This fascination with the private "theater of the philosophic" also informs Halley's latest essay, titled "Images, Masks and Models." It was published in conjunction with an exhibition of three of his new paintings, curated by Richard Milazzo, in one sun-filled room of the Janis Gallery in New York. In the adjoining space, the gallery was showing early Mondrian works and the substantial connection between Halley and Mondrian was more evident than ever before. In "Images, Masks and Models," Halley puts his finger on the ironic way in which the computer, that "hyper-rationalist Cartesian" imagemaker, has become the primary weapon against the Enlightenment's contact with reality. It leads him to a theory of masks (so important to Yeats), the "construct of personality" that protects the passivity and isolation in which people live:

> In many ways, the Internet is the apotheosis of this suburban dream, a means of communicating whereby one doesn't have to leave home, come into any kind of physical proximity with anyone else, or even reveal one's identity. . . . The Internet reflects the inhibition to go outside, the fear of revealing one's self to strangers, that are the continuing legacy of the construct of personality. Yet at the same time, the Internet revives the eighteenth-century idea that public discourse is impersonal discourse, that we feel most free when masked, when our individuality is obscured or negated.[55]

The ascetic nature of this kind of avoidance of contact and the adherence to anonymity and impersonality is obvious. Even as they log on, cyber-surfers lock themselves in to monastic cells that are the main metaphors of Halley's paintings. In the essay he links this ascetic condition to a theory of models and, in turn, to the project of abstraction. The cul-de-sac to which Halley pursues abstraction is reminiscent of the position to which Frederic Jameson assigned literary studies in his tremendously influential book, *The Prison-House of Language*, which was one of the doom-and-gloom texts that ruled graduate study in literature during the 1970s and 1980s. In this part of his study, Jameson turns to the resonant effect of the linguist Ferndinand de Saussure's "archetypal" silence as it can be connected with literary silences from early Modernism (Rimbaud, Wittgenstein, Valery, Kafka, and Hofmmansthal) onward:

> All of them testify to a kind of geological shift in language itself, to the gradual deterioration in this transition period to new thought patterns, of

the inherited terminology and even the inherited grammar and syntax. "Wovon man nicht sprechen kann, darüber muss man schweigen." Yet the famous sentence, in that it can be spoken at all, carries its own paradox within itself. So it is that we learn what we know of these silences, not through the official art forms which have been emptied of their meaning, but through secondary and impermanent media, through reminiscences and snatches of conversation, through letters and fragments.[56]

The Parietal Mode

For both Halley and Jameson, as well as for Marguerite Yourcenar (in her essay on Piranesi's great Prisons series of etchings) and Simone Weil, the prison becomes the key metaphor for the ascetic condition of the artist in the 1990s. Weil's essay on *metaxu*, the Platonic intermediaries between temporal becoming and the eternal fullness of being, cites the communication between prisoners in adjoining cells: "The wall is the thing which separates them but it is also their means of communication. It is the same with us and God. Every separation is a link."[57] Halley's paintings of cells and prisons are reminders of the jail cell, the apartment house, the hospital bed, the linear patterns of computer chips, the tanks of nuclear power plants, battery cells, graves, and even the school desk— what he calls "the isolated endpoints of industrial structure."

In *The Grave* (1980), one of Halley's sparest and yet most resonant early works, a deep black bottom border yawns below a centered white stucco rectangle (vertically oriented, as his recent paintings have been) against a mottled yellow ground. It sounds the bass note for a provocative group of paintings on the prison theme that exploit the rhythmic possibilities (perhaps one should say impossibilities) of prison bars as well as the textural opportunities of walls. The gray cinder blocks of *Prison of History* (1981) surrounding a black-framed, black-barred central window represent the perfect example of Halley as an ascetic artist, as echoed in the more stripped-down, slightly more colorful (because there is a slate blue involved in the gray) version of *Prison* (1986). Halley made a group of gray fiberglass "reliefs" in 1990 (including *Cinderblock Prison* and *Cell with Smokestack and Conduit*) that have the dramatic textural effects of operatic stage sets and then returned to the gray interpretation in 1994 with fiberglass reliefs called *Prison Cell with Conduit, Asphalt Cell*, and *Prison Cell with Conduit III*. The enhanced heaviness of these thick reliefs is compounded by the literal shadows that they create behind and around their own forms.

Halley floods the prison with color in *Day-Glo Prison* (1982), which uses his signature Day-Glo orange against cadmium red and yellow, as

well as the pulsing yellow of *Prison with Underground Conduit* (1986) and the red against yellow of *Prison with Conduit* (1981) and its expanded later incarnation, *Prison with Conduit* (1986). Out of the shadow recesses of the gray and black and into the relentless, even tortuous, light of the brightly colored works, Halley somehow finds a way to avoid the usual "softening" effect of the addition of color so that the unrelenting pressure of the Day-Glo becomes, in effect, *more* rather than less ascetic than the paintings that are drained of color. This is put to the test in the highly ambiguous *Pain and Pleasure* (1981), which splits the square canvas into two sets of prison windows, one done in bright tones against orange and the other in a more subdued black, white, and pale yellow version.

Because Halley's light does glow, it can be related to the strange phosphorescence of Twombly's tracks across the blackboard, Ross Bleckner's chandeliers, and the wake of the boat in Milton Avery's famous moonlit sea scene, *Speedboat's Wake* (1959); but it is far closer (because of its strength) to the glowing colors of a Dan Flavin fluorescent sculpture. (A collector I know used to keep a big Halley next to a corner piece in bright pinks and yellows by Flavin in the dining room, and the two pieces found a meeting ground at the expense of the eyes of the guests who ate facing that way.) Halley turned to Day-Glo paints for the effect of "low budget mysticism." This penetrating effect has its echo in other arts. In music there are two ways to produce an ascetic sensation—the pianissimo in which music approaches the threshold of silence and the piercing tone at such volume that it creates a kind of discomfort, an effect that Philip Glass exploited to the full in the hallowed confines of the Metropolitan Opera House with *Einstein on the Beach*. In painting, the uses of color can be manipulated toward ascetic ends by several means. There is the path of Twombly or Johns or Reinhardt, which subdues colors to a quiet range of gray and white, or there is a device pioneered by Halley that pumps up the volume to create an almost painful sensation.

The prison series reaches its apex of severity in a group of paintings that add new meaning to the old cliché "stark contrast" through their juxtaposition of black and yellow. Like the safety stripes one sees in an industrial plant, there is a particular brutality to the sharp, straight edges where black and yellow collide in works such as the big *Rectangular Prison with Smokestack* (1986) (which has a Richard Serra–style heaviness to its central black mass) or the paler *Prison with Yellow Background* (1984) and the Judd-like *Prison* (1985), which floats four black bars in the center of a yellow field surrounded with a black border. On the simplest level—the rules of graphic design—this opposition of yellow and black, borrowed from the color codes of traditional signage, is a

straightforward and correct opposition. It satisfies the expectations of the trained viewer. In an "artistic" context it has the opposite effect, as the trained viewer accustomed to transitions in painting through modulation, harmonization, or the other conventional means of interaction among colors (to borrow Albers's wise rubric) is left high and dry by an opposition that is so direct and that leaves each element so independent. Like the abrupt tonal leaps of Webern, which so baffled the audience and even the performers of his day, this genuinely demanding *agon* of black and yellow raises the level of difficulty for the viewer. Up close, the incised or ridged handling of the edge between colors in Halley's paintings only adds to the sense of a chasm or clash between them. Halley associates these works with his reading of Beckett, particularly *Endgame*, giving us license to view the cells as characters) between whom the conduits represent communication.

That progress toward greater and greater difficulty is compounded in the more involved geometries of Halley's painting of the early 1990s by a step up in the degree of intricacy. Just as Halley's forerunner Frank Stella used more color and complexity of form to "speed up" the activity in his reliefs and paintings, so too Halley's paintings accelerate along geometric figures that travel in many directions at once. In terms of Halley's working habits, the viewer should know that he begins with the central square (more recently, an elongated or "squeezed" rectangle that gives the work a more vertical feeling) and then works outward through the conduits and framing areas that travel around the squares. The relationship to Mondrian's central white squares around which colored rectangles travel should be obvious. In utopian works like *The Other World, A Perfect World, Dreamland*, and *De Anima*, Halley take us out of the "real" world by way of denial, an ascetic distancing effect that recalls the idealism of Mondrian, except that these titles are also tongue-in-cheek.

In his comments on the prison and cell works, Halley emphasizes the autobiographical as well as sociological types of isolation that were inspired by the real architecture of New York, where he has spent most of his life and career. With reference to the work of Chris Burden and Bruce Nauman—as well as the earlier examples of Newman, Stella, Judd, and Rothko—Halley relates the early prisons to the idea of confining or immobilizing the body in a severely geometric space that had its inspiration in the white stucco wall and black window bars of his own apartment building in the East Village. The brick and cinder-block patterns of the walls made oblique reference to the architecture of Giorgio de Chirico; Edward Hopper's empty rooms and empty architecture are also points of comparison. Communication with the outside world, through electricity,

water pipes, air conditioning, fiberoptics, and other functions that are "piped in," is facilitated by the "conduits." As Halley comments, "To me, the cells are more of a prototype of isolating spaces that I'm interested in. . . . The biggest duality in my work is between isolation and connectedness. The cell or the prison is hermetic and encapsulating. That's one part of the iconography. Then all the conduits are about how things are connected."[58]

The prison and cell paintings are now fifteen years old, and the ascetic thinking from which they took shape has given way to further development's in Halley's work and writings. The broadened palette and increased experimentation with form and proportion show that Halley has moved on to a variety of other issues and strategies, although he remains fascinated with the way that Foucault, for instance, viewed modern institutions as founded in the twin ascetic systems of the military and the monastery and believes that the Protestantism and functionalism of our own time "act out those impulses in our culture." In terms of the sociology of the artistic existence, he is bemused by the disparity between the ascetic work of Newman or Judd and the hedonism of their lives, and he talks of his own indulgences, such as collecting decorative arts. As he explains,

I associate twentieth-century asceticism with alienation and the way the artist is defined as an individual, apart from society. It also reflects the way that individual perception is conducted in private or in solitude. In the late twentieth century, in a culture of overabundance—where so much is artificial, fake, simulated, cheap—the urge to get back to what is simple, direct, Zen-like (such as "truth to materials") is an understandable ascetic impulse. My work can no longer be said to be ascetic, but it was at first, and I continue to associate asceticism with the idea of a psychological isolation and deprivation. I became more interested in absurdism and exaggeration as strategies as, on a personal level, my degree of alienation as an artist decreased and I had to turn to other psychological motivations.[59]

In technical terms, the role of asceticism may play a more important role in Halley's current practice. It is present in the rigidly controlled compositional vocabulary of his paintings as well as in the meticulous manner of their execution. The artist is quick to point out that there is a difference between the asceticism of physical perfectionism and a more ideological play of perfection. As he notes, "Visual problems in which there is a reduced number of elements seem to me those in which one tries to achieve that sense of control. This was not the case for a seventeenth-century

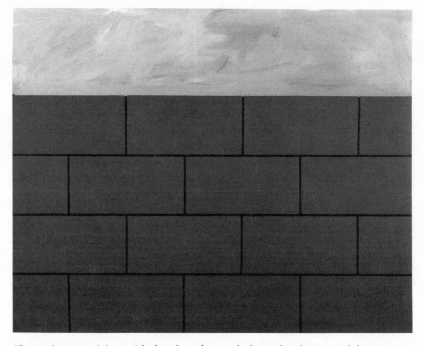

"I associate asceticism with the idea of a psychological isolation and depriva-
tion," notes Peter Halley, whose painting *The Red Wall* (1980) invokes the theme
of prisons that is central to his work. Photograph: D. James Dee. Collection of Peter Halley.

artist, for whom perfection is a giant machine. For us it is the judgment
of one proportion's relation to another. My paintings have never been
that physically perfect. They gradually transgress their own boundaries
in terms of what I think of as their proportional and compositional rela-
tionships."[60]

There is an early painting by Halley, called *The Red Wall* (1980), that
conveys some of the atmosphere not only of his own work but of Donald
Judd's walled-in compound at Marfa, Texas, or even the bleak architecture
of Walter Abish's postwar urban developments in Germany and Foucault's
beloved prisons. The steady march of broad red bricks outlined in black
ascends upward through four layers to a brushy sky, a "tent of blue" (to
borrow a phrase from Wilde's "Ballad of Reading Gaol"), that is
abruptly cut off by the top edge of the canvas. The spatial implications of
the painting are disturbing. The insurmountable wall crowds forward,
imposing itself on the viewer, and the steadily rhythmic way that the
bricks go off the canvas right and left connotes the sense that the wall

goes on forever in both directions. As a symbol of the barriers and isolation that continue to haunt his work, it is even more solid than it looks.

Effacing the Grid: Nancy Haynes

It should not be hard to make a case for the ascetic tendencies of an artist who loves to work in gray and black over deliberately fugitive paints, who uses titles like *Absent Myself* (1989) and *Object of Negation* (1995), who loves the writing of Samuel Beckett so much that she once traded one of her highly prized paintings for a rare edition of Beckett with plates by Robert Ryman, and whose greatest work to date came out of an encounter with Barnett Newman's *Stations of the Cross*. For Nancy Haynes the success of a piece can be judged by the degree to which she has managed to "break up" the grid, that legacy of Cubism and Mondrian embedded in most painting. The grid, after all, begins with the verticals and horizontals of the woven canvas or textured paper. Haynes poses an odd and seemingly impossible challenge: Working within the painterly tradition, and tending toward lyrically beautiful painting at that, how does one destroy that basic structural matrix with every painting?

One of the best analogies within this study for the way that Haynes manages to challenge the grid is offered by the composer Olivier Messiaen's rhythmic innovation in dissolving the established pulse of music. As he destroys the traditional beat in the process of building ecstatic musical crescendi, so Haynes manages to blur the grid in a movement derived in part from the motions of making art, such as brushwork or the rolling press of printmaking. One of the small but powerful monoprints that Haynes did in 1995 superimposes a netlike grid of tiny black lines against a rich velvety field of gray-blue. Its regular rhythm sputters and disappears in a band at its center and drops off completely on the right-hand side. Hovering behind the black cubes, giving them a LeWitt-like depth, is a second net of white. There is a wonderful feeling of movement in the work, which leaves the grid out of focus as it pulls across and dulls the crisp edges of the geometric outline, creating little asterisks and curves at the intersections—a constellation of luminous forms (like the pulsing gray stars at the intersections of a Mondrian) that pulses with motion. This movement is partly literal, as it derives from the way the printing press will roll across the heavy handmade paper, distorting the grid, stretching it along (in a way that is reminiscent of the curving black pencil grid on white in Robert Ryman's famous *Stretched Drawing*) until it snaps into fragments and disappears.

One of the most helpful analogies that Haynes herself spells out is that

of the flashing cels of an abstract film, streaking by while the viewer catches a glimpse of barely recognizable forms in the play of shadow and light. This works perfectly as an introduction to her large vertical painting, *Object of Negation*, and especially for two paintings that were inspired by movies: *Study for Rashomon* (1995), after the Akira Kurasawa classic that is Haynes's favorite movie and fits in beautifully with her angled, fragmented approach to image making, and also *Day for Night* (1994), which takes its title from the movies of Francois Truffaut, who used to shoot during the day with special blue filters to give the appearance of night. These works are diptychs that use a "negative" process of image making to reveal their own substructure on one side against the fuller and usually more colorful echo on the other. As Haynes explains, "One side of the diptych is a reversed diagram of the other, so the painting becomes a schematic rendering of itself. In *Study for Rashomon*, I have the color on the right, and the skeleton of the painting—as though it were undressed—over on the left."[61] In another diptych, titled *Margin and Breach* (1995), Haynes uses an allusion to three outer rectangles of color in a painting by Mondrian on the left side, rendering them in brushy grays and black against yellow, while the right side is a ghostly mélange of yellow and white tones: "The right side is collapsing and falling apart as it goes down—I used the edge of the brush to angle the rectangular forms and add to the sense of motion," she says. The effect is similar to the spectacular crashing down of the cinder-block wall at the opening of Pina Bausch's theater piece *Palermo, Palermo* (1989).

The doubling she achieves in the *Rashomon* paintings is extended in her "mirror site" works (titled after the computer term for identical but remote websites that can be independently accessed) which use multiple silkscreen images of paintings such as *Endgame* to similarly "undress" the original and reveal its hidden structures. Looking at Haynes's work, we are reminded that the Cubist grid that Haynes is trying to collapse was itself an exercise in breaking up forms, making them tumble down into abstraction involving the simultaneity of varied angles of access. When the works are doubled, as in the diptychs, the division made by the two central edges can perform like the eponymous "margin and breach." This was certainly the case in a magnificent large work, *Fort-Da* (1990–91), which is a diptych painted on two massive wooden doors that lie horizontally on top of one another. As Haynes explains, she created the work partly under the inspiration of Newman's *Stations of the Cross* and even used the fourteen parts of Newman's great project as a guide to the fourteen times she returned to it.

The title of *Object of Negation* is a direct allusion to Buddhism, an integral aspect of the artist's life and thought. The vertical format tightens

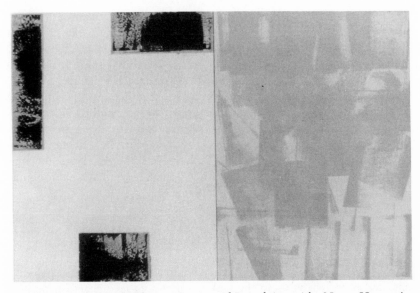

Partly an homage to Mondrian, *Margin and Breach* (1995) by Nancy Haynes is a tissue of destructions. "The right side is collapsing and falling apart as it goes down—I used the edge of the brush to angle the rectangular forms and add to the sense of motion," the artist comments. Courtesy of the artist.

the back-and-forth play of "Cubist" forms, and Haynes sets up five bands of those blurred borders that, in their counterpoint of dark and light passages, manage to have a Mondrian-like equilibrium without admitting a specific center. There is a slight unevenness to the way they are deployed, in a deliberate attempt to keep them from being too mechanical. As Haynes notes, "The human element comes from certain irregularities, like the wobble in the five rows or bands, which permits an area of light to come through the gaps between them. The grid remains irregular but present."

Haynes has returned to the core of her antihierarchical project in a recent group of paintings on a singular type of "nubby linen" custommade for her in New York. It allows her to apply a graphite surface—in a gray-blue color that pleasantly reminds her of pencils and writing, since much of her work is thematically related to language—above her trademark phosphorescent yellow ground. Because they rely for their effect on the weight or pressure of the hand on a textured surface, they are related to Seurat's webby conté crayon drawings. Minor miracles of Postimpressionism, his drawings are loose and simple in the way they turn the paper's texture into a kind of frottage that seems out of focus at close

hand yet reads like photographs of silhouetted figures from a distance. As Haynes comments, "I like the elusive nature of works like this—you can't fix them, they're not defined, they're hard to place art historically. Are they about minimalism or light? Are they slightly punk or part of the silkscreen tradition? They make you pay attention to the painting as fact." In the end, Haynes realizes how close to "nothing" a skin of graphite or paint really can be. Sometimes the responsibility of painting is so formidable that, as she says, she "freezes up" and feels we place a great philosophical burden on something as slight as a painting: "If the artist is looking for truth, there is none. We have this endless desire to hang everything on a painting, and that is why I need to present a painting undressed, revealing how little there is there."

White Light: Mark Milloff

When Mark Milloff first laid a heavy white skin of lead over a painting that had been two years in the making, in a courageous act of sacrifice that can be fully appreciated only by those who realize that the work underneath was not just complete in itself but consummately beautiful as well, in one bold act he took a stride further into the ascetic realm than his previous white cancellations in paint had led him. The surface complexities of *White Jacket* (1995), created in part by the way that Milloff presses the skin into the heavily impastoed layers of paint underneath, are only the most outward signs of the subtleties of a work that essentially summarizes all of Milloff's formidable innovations to this point. That fleshy, chalky white lead, discolored into yellow in some areas and in others cracked, covers a classic Milloff "white" painting, with its labyrinthine ridges of pure white (oil) paint in turn covering a spiral form of bold colors, the residue of which subtly peeks through the heavy layers of white burying them.

The lead jacket conveys tremendous emotional power. It sets up an ascetic barrier—a membrane, a skin, a shroud—between the skeleton and muscle of the underlying painting and the world. Sealed in, the painting takes on an introspective quality that makes us examine all the more closely the textural power of the form below. As the artist eloquently comments, there is a paradoxical fortification of the work's presence that comes with being concealed:

> This was a really beautiful painting but when it went away and was shielded, it became more real to me than it was before. It was something that I was making myself work to see, because the process is one of continually making

things more difficult for myself. The result must be beautiful. I love what happens with the white skin when it stretches, moving from one texture that it is pressed on to another. It's also the tragedy of it. Here's a painting that is now gone, and you feel the echo of it. To cover it is really to cover something that was very alive. The reality of the painting underneath is enhanced.[62]

The title of the work, *White Jacket*, comes from a novel by Herman Melville published in 1850, just a year before *Moby-Dick* appeared. Melville's own patchwork white jacket protected him and set him apart from the crew of a man-of-war and was symbolically flung into the Charles River in Boston when he returned from the voyage. Ever since his magisterial series of Whiteness of the Whale (1992–95) paintings, Milloff's affinity with Melville, somewhat like Frank Stella's interpretive approach to Melville, has been an ongoing source of inspiration. For one thing, Milloff lived in the Berkshires just a few miles from Arrowhead, the Massachusetts home where Melville spent his best years, and the undulating motion of those dramatic hills enters the hypnotic rhythms of both Milloff's paintings and Melville's prose. For another, the subtitle of Melville's *White-Jacket*, "The World in a Man-of-War," as well as a chapter title, "The Pursuit of Poetry under Difficulties," are particularly well suited to Milloff's working methods. Like Melville, who yoked together the tantalizingly cerebral and intensely physical in his fiction, Milloff's heavy, muscular paintings—and ironically, his achievements in lightness as well—arise from a continually destructive, self-doubting process, a war in which he "attacks" (his term) apparently complete paintings, plunging his trowel into their molten and still plastic colors, stirring and churning them, glopping on more paint, and then applying the skin of lead white and essentially annihilating them. They submit to him as a force driven by alternating doubt and belief in the greater beauties that must and will emerge:

There is a battle with the works that I'm willing to lose along the way, and there are paintings that I see as casualties. All of my most tragic accidents have led to my greatest breakthroughs. When I look at a painting that is mummified in a skin of white lead there is a feeling for the painting. Essentially, at every point I am willing to destroy everything that I've worked up to take it to the next level and trust and hope that something will happen. The paintings have to be really beautiful before I am ready to attack them. It doesn't interest me to destroy a bad piece—it would just be a crutch.

The lead jacket works that are taking Milloff further in the direction of accumulation, surface complexity, and heaviness have a visual and

spiritual affinity with one of the most oddly spectacular (and talked-about) paintings to hit New York in some time. Weighing close to a ton (literally) and requiring a phenomenally expensive restoration job after twenty-five years in storage just to keep its canvas from tearing off the stretchers and its chunks of decaying oil paint from falling to the ground, Jay DeFeo's *The Rose* (1958–65) is an eight-by-ten-foot monster of a painting that was the centerpiece of the Whitney Museum's retrospective, *Beat Culture and the New America*, in 1995. A radial white and gray burst of energy that looks as much like a star as a rose, DeFeo's now legendary work was made by Milloff-like trowel loads of paint out of which she sculpted a center (where the white is at its most intense) from which incised spokes, accentuated by wooden dowels and slats propping up the surface of the paint, fan outward, graying as they move from the center into the corners. Both DeFeo and Milloff use the heavy surface, geometric rhythms, and range of whites to invoke the sublime. After *The Rose* was hauled from her San Francisco home in 1965, DeFeo worked on it in a storage room of the Pasadena Museum. Her description of the experience adds to the overall ascetic effect: "It was my little cell of solid black. The only light was a little grate. If you peered up you could see the sidewalk or light coming through. It reminded me of being interred in medieval days." While DeFeo's baroque splendor has its darker side (the piece was conceived and shown in New York as the "Deathrose," and her husband, the painter Wally Hendrick, felt that the white lead in it contributed to her death by cancer at the age of sixty in 1989), its exuberance is echoed in Milloff's own expressive affirmations.

Covering and building outward to a white surface are not the only ascetic characteristics of Milloff's unique studio practice. As an abstract and materials-oriented take on the traditional analytic studio practice of *écorché* (literally "flayed," the academic use of a drawing or model of a figure with the skin stripped of to reveal the muscular construction below), Milloff uses a kind of excavation to explore successive layers of his paintings' inner structures. "Modern reality is a reality of decreation," Wallace Stevens once wrote, using Simone Weil as his starting point.[63] For Milloff, decreation means both a building up and a tearing down. After the turning of the color comes effacement by the buildup of the white paint in row after row of a sensuous woven grid. Or, as in the case of *Transparent Lake* (1995), a work that is basically the canvas with traces of a painting that has been totally chipped away, the next step can be the nearly complete removal of a painting's body.

Far from the nerve-wracking distractions of the New York art scene, Milloff cranks up the blues in his huge two-level studio, where floor-to-ceiling racks of slowly drying paintings wait to be attacked. Effacement,

removal, reversal—all become acts of creative renewal. As Pater wrote, "It is with the movement, the passage and dissolution of impressions, images, sensations, that analysis leaves off—that continual vanishing away, that strange, perpetual weaving and unweaving of ourselves."[64] When, finally, the paint begins to gel, the flamelike tips of the long horizonatal and vertical rows of thick white cream become frozen in their poses, turning up or doubling back on themselves. Looping in brittle filigrees, they snare the light and create new tones and shadows, their delicate beauty scarcely betraying the turmoil from which they emerged. Returning to Wallace Stevens, we are reminded of how art in our age is both a shield from the outside and an attack on ourselves inside: "It is a violence from within that protects us from the violence without. It is the imagination pressing back against the pressure of reality."[65] As Mark Milloff bravely dives back into the color worlds of his previous paintings and churns up the still soft paint into new and more complex structures that bare only a few traces of their original splendor, then lays down the bright white furrows of impasto or the heavy leaden "jackets" of lead, he enacts time and again the creative process that takes years to discover. If you're willing to be an archaeologist, you can discover the whole history of painting in his work.

Pursuing the Line: Theresa Chong

There is an almost intimidating scowl of concentration on Theresa Chong's face as she plays one of the Bach suites for unaccompanied cello at her East Village apartment in New York. Tearing along at a fast tempo, biting into the initial deep bass note of an ascending passage, her toes curled tightly onto the insoles of her house slippers and her eyes narrowed to piercing black hooks, Chong is attacking the Bach with passionate intensity. The prelude booms off the white walls and parquet floor of her empty, sunlit living room five stories above Houston Street. Suddenly, the piece comes to an abrupt halt, and just as quickly, before the echo of the last note ends, Chong is back into the rising figure, correcting a missed note and smoothing out the phrasing. The gruelling two-hour morning practice sessions are a daily affirmation of what she calls "the important purposefulness of purposeless play." They allow her to measure her progress, in a linear way, relieving her painting from a similar pressure:

> In many ways, cello playing can be a completely mindless activity, in which the body takes control and automatically does what it wants to do accord-

ing to what the ears dictate. It is no different in painting when the hands
mark according to what the eyes may dictate. The crucial difference is that
in music making, your mind understands what it wants the ear to hear be-
fore allowing the busy activity of the fingers. My cello playing teaches me
to be critical of choices I make, and forces me to patiently focus on what I
am doing. I admire great musicians who seem to play music so effort-
lessly—it is a reminder for me that the power of art lies in the hands of
artists who can express beauty with simplicity.[65]

But Chong, despite her professional-caliber talent for the cello, is pur-
suing an artistic calling that goes deeper. She folds away the metal chair
and music stand, grabs a couple of tapes that she wants to listen to in her
studio—the Benjamin Britten cello suite, some Hector Villa-Lobos, al-
ways Bach—puts on her coat and heads out into the gritty neighborhood
where First Avenue begins. The eight-block walk uptown takes her to
P.S. 122, the converted school building that houses the Mabou Mines
theater company as well as the third-floor artists' studios where Chong
puts in relentless six-hour days, often seven days a week, at work on the
black-and-white diptychs that fill her studio. Although they appear to
compose one long series, Chong begins on the square, thirty-by-thirty-
inch canvases individually before pairing them and working on them as a
diptych. To gain an appreciation of how one of Chong's fascinating and
superbly painted works operates, consider the statement on space she
achieves in an earlier, vertical work called *There* (1994). The most
prominent elements are a power vertical black line, echoed on the
viewer's right by two parallel vertical lines that have been partly painted
over in white. Three visible horizontals, also partly whited out, travel
from the left edge of the canvas to the right vertical, where they halt.
More faintly, three angled lines, not quite precise diagonals, appear and
disappear within the cage of the verticals and horizontals. From a dis-
tance the rest of the work is a cool white field against which these lines,
of roughly equal thickness, hold their tense fencing match.

The "diagonals" are the first clue to an intricate three-dimensionality
that, once you yield to it, becomes absolutely captivating. Her feeling
for how the lines create space is captured in the idea of cutting or carv-
ing. "I don't measure my spacing; it starts dividing evenly in a physical
way through the art of cutting and apportioning. I am trying to define a
space which points to an awareness of where and who I am." The three-
dimensional sense of space depends on the diagonals—eventually, the
curves—that are the next step in the process. Like reaching through an
open window, the gesture of the angled line suddenly reveals a network
of interior spaces receding back from the solid black vertical to the

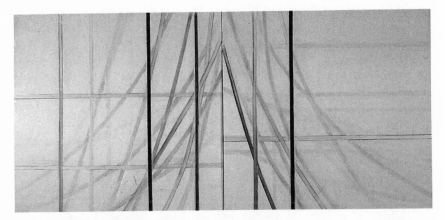

Theresa Chong's *Toward Heaven* (1996) uses a network of interior spaces to subtly suggest three-dimensionality. Her paintings are strongly influenced by the poetry of the Japanese monk Ryokan. Photo by T. Chong.

slightly less substantial strip on the right and further back in the white mists that have nearly swallowed the central vertical element. The step-wise descent through the woven black lines of a Mondrian (an easy art-historical parallel that Chong acknowledges but does not overemphasize in discussing her work) are a guide to the gradual movement of the eye into the tight interior spaces of Chong's *There*. If any artist stands behind Chong's work as a powerful influence, it is probably Richard Dieben-korn, who with Tobey was the most self-effacing survivor of the heroic generation of Abstract Expressionists. Diebenkorn's transition from fig-ure to geometry is similar to the shift Chong has made from the life drawing classes that dominated her education in art to the dance of lines that makes up her current work. Chong keeps a battered monograph on Diebenkorn in the studio, its frayed blue-cloth cover and pages finger-printed in yellow, orange, and white paint.

As you draw closer to a painting by Chong, the drama intensifies. The wealth of painterly incident, indiscernible from more than a foot away, is disclosed through a blizzard of erasures and reconfigurations. There were far more black lines above and beyond the ones that remain plainly visible. Traces of them can be seen under white paint that has been pulled over them in a manner that recalls the "canceling" process of Brice Mar-den's use of a transparent white or Mark Milloff's use of heavy white paint on top of color. Chong does not erase the lines with a blanket of white paint but with another line of white. As in Marden's work (an-other important influence), the intermingling of black and white yields a

gorgeous array of grays and blues as well as a striation within the lines that maintains the independence of black and white threads in one seemingly black stripe. Pointing to an unfinished work that sets up the same interior receding spaces, she bluntly summarizes, "This is about two lines and everything is further away than them. That's it." Stepwise, month after month for five years, with the kind of persistence that recalls Mangold or Martin, Chong pushed her linear vocabulary as far as it could go and then took the step of suing curved lines with the straight ones.

The long hours, the austerity of the black-and-white palette and liner vocabulary, and the quiet determination with which Chong goes about her life in music and art all reflect an ascetic outlook. As she reached the age of thirty in 1995, Chong deliberately slowed down her painting (you can see the change in the surface—the early ones are deeply encrusted with layer after layer of quickly applied paint, while the later ones are much smoother because she takes the time to remove paint, sand them down and reprepare the surface for additions), her music ("I used to just run through the piece; now I am working at gradually building up the quality of the sound by listening very critically"), and her life.

Chong, a Korean-American who was brought up in Fairbanks, where she and her three sisters were famous as musicians (two have gone on to professional careers in music), returns to Alaska periodically and has a strong sympathetic sense of what Gould meant by the "idea of North." In addition to Gould, John Cage is another powerful influence on her thinking. In her copy of Cage's Harvard lectures, a single passage from the chapter on discipline is marked at the back of the volume by a firmly penciled bracket in the margin. It reads: "To sober and quiet the mind, so that it is in accord with what happens, the world around it open rather than closed. Going in by sitting cross-legged, returning to daily experience with a smile, gift-giving, no why after emptiness."[67]

Chong aggressively secures and protects her isolation in an ascetic way. Except for the exhibitions she has curated at alternative spaces, she shuns the New York gallery scene. "Isolation is a necessity for the process of owning my own sense of space and time. It allows me to tune in on the ongoing development of *my* work," she notes. The closest thing to a self-portrait she has done is an exquisite drawing called *Wo-Man* (1994) on rice paper, which centers a crouching figure traced in white. It is muscular and yet feminine, its toes are pointed to the viewer, and most important, its head is down, the forehead nearly on the knees and the eyes staring intently downward. Her knobby fingers are turning a Korean dramatic mask, outlined firmly in black, to the right. The mask faces the viewer, its mouth and hollow eyes wide open in contrast to the hidden eyes and mouth of the silent figure, mirroring Chong's remote personality perfectly.

Chong's enforced isolation is not an act but a necessity. In addition to the philosophy (mainly Heidegger) that she reads analytically, she has a strong affinity for the poetry of a Japanese Buddhist monk known as Ryokan (1758–1831). Like Marden's interest in Han Shan or Tobey's attraction to Baha'i texts, Chong's devotion to Ryokan filters into her art. The world of Ryokan is defiantly, almost exuberantly simple, defined by his begging bowl, the perpetually freezing grass hut where he paints and does calligraphy, and the children in the streets—a quality that appeals to Chong as an antidote to the Machiavellian intricacies of the New York art scene.

Asceticism brings freedom: "Asceticism, as reflected in the poetry of Ryokan, is a way of being that helps me understand solitude as a positive space, which is absolutely necessary for my work—I don't know how I could work other than in solitude. It is the only freedom I have. The mundane tasks of everyday living are time consuming and demanding, and today more than ever I need to protect space and time. Asceticism is a conscious decision that takes a great deal of effort." Like so many of the composers and writers in this study, including Philip Glass with his *Koyaanisquatsi*, John Cage in his *Ryoanji*, and Simone Weil in her Plato commentaries, Chong is fighting the acceleration and brute appetites of the age. Ryokan's poetry is an effective sword. In a typical Ryokan poem, the solitary poet both suffers from privation and savors his freedom from worldly care. Chong likes the way that Ryokan consciously chose to strip himself of everything: "My greatest aspiration is to paint pictures that reflect his quiet ways," she says. Her favorite Ryokan passage reads:

> All of my life too lazy to get ahead,
> I leave everything to the truth of Heaven.
> In my sack three measures of rice,
> by the stove, one bundle of sticks—
> why ask who's got satori, who hasn't?
> What would I know about that dust, fame, and gains?
> Rainy nights here in my thatched hut
> I stick out my two legs any old way I please.[68]

Theresa Chong is not in a rush. Detached and determined, she wants to slow down her painting and her life. A superficial look at the way she returns again and again to black lines on white would give the first impression of single-mindedness, but there is an infinite range of possibilities in that problem, and she brings to it a mind that is formed and reformed continually by poetry, philosophy, music, and the challenge of painting. After four years in black and white, she is contemplating the

addition of the strong red that distinguishes the columns of Korean temple architecture, but it will take time to reach that stage of luxurious expression. She waves her hands in front of an empty wall in the studio as she maps out her next step. "I want to start leaving areas of nothingness in the corners, isolating parts of the paintings," she says. Deeper into those corners, into her quiet isolation, she will delve her way.

o II o

Asceticism and Sculpture

Most art lovers will immediately expect a consideration of asceticism in sculpture to gravitate toward the rectilinear purity of Minimalism. But there is so much more to the story than those daunting geometries. As in painting, the signals of asceticism in sculpture involve characteristics like the use of the silhouette, particularly in connection with solitude; a lightness of materials connoting an ethereal or "body-less" state; pronounced attention to repetition and rhythm; a reliance on the day-to-day keeping of a journal or ritual as in a Book of Hours or other spiritual contemplation; and a tendency to destroy the body and sever its connection from desire.

Many of the most prominent and promising sculptors who are bound to be mentioned in a survey of this kind are women. The silhouette, for instance, is one of the hallmarks of the tall, austere "tools" of Beverly Pepper as well as the more figurative works of Magdalena Abakanowicz and Ana Mendieta. The "treatment" of the body in the work of Louise Bourgeois, Rebecca Horn, Judith Shea, and Kiki Smith suggests asceticism because of the kind of violence that they bring to a medium that has its traditional or academic origins in the technique of *écorché*. Another aspect of the silhouette—involving edge and shadow—is explored in the knife edges of Dorothea Rockburne's folded paper reliefs as well as in the crisp edges of Maya Lin's admixture of architecture and monumental sculpture. By contrast with Lin's solid black Vietnam Veterans War Memorial, the great example of lightness in sculpture is the work of Judy Pfaff, an English-born artist who studied under Albers at Yale in the early 1970s. Her wire mesh installation pieces, depending from the ceiling and often swinging in graceful arcs from one corner of a gallery to another, as in the case of *Flusso e Riflusso* (1992), with various objects (including blown-glass works) caught in them, are brilliant examples of the way that sculpture can depart from mass and volume. The last time I visited Pfaff's enchanting studio in Brooklyn, the doors to the backyard were flung open, and a breeze was wafting through the works in progress, making them tremble like aeolian harps and bringing to mind

Hart Crane's description of the (nearby) Brooklyn Bridge's cables, those "transparent meshes—fleckless the gleaming staves—sybylline voices flicker, waveringly stream as though a god were issue of the strings."[1]

The idea of using a meshlike medium through which light and air, and the viewer's gaze, can easily travel was also a hallmark of the work of Nancy Graves and appears in a somewhat different context within some of the monumental works of Louise Nevelson, such as *City on the High Mountain* (1983), as well as the white lattices of Sol LeWitt or the back of the huge Frank Stella reliefs, where it reminds us of the role of the grid in painting. Like "drawings in air" (one of David Smith's catchphrases), these delicate works are reminders that the heavy, cast figure on a pedestal is not the only paradigm for contemporary sculpture. Among the other significant figures who should be mentioned in this context are Carol Hepper and Lynda Benglis. Hepper is an immensely talented sculptor whose early work used translucent stretched animal hides from her native South Dakota, marked and scarred in a way that had its own ascetic significance; her later hanging pieces and wall pieces use willow branches, wire, copper tubing, and other bent and twisted elements in fascinating, complex forms that have an oddly figurative aspect. One wall of Hepper's studio on the fringe of New York's Chinatown offers a virtuoso display of "drawing" in green rubber tubing (the kind that is used to connect gas tanks to heaters or stoves) tied into an array of loose forms. Another sculptor who uses bent and knotted forms, often casting and painting them in glitzy sparkling metallic paints or gold leaf, is Lynda Benglis. Her Lagniappe series of the late 1970s and gold-leaf *Valencia I* (1973) remind us, as do Hepper's knots, of the converging lines in a Pollock or a late Marden painting, and they offer a counterpoint to the knots at the center of the steel beams in a Mark di Suvero sculpture, or the knotted forms of the dancers in the interwoven passages of Balanchine's *Apollo* before they are disentangled to ascend the steps in one great diagonal line at its end.

Repetition and rhythm are crucial in contemporary sculpture, particularly in installations, from the seemingly endless, anonymous objects used by Haim Steinbach and the "Surrogates" of Allan McCollum to the little soap cakes of Cyrilla Mozenter, the mouthpieces for brass musical instruments of Lorna Simpson, the dolls crowding a bedroom in the installations of Portia Munson, Robert Gober's newspapers, and any number of works by other artists who use "collecting" as an art-making process. Repetition is a factor in more traditional means of making sculpture as well. In the studio of Ursula von Rydingsvard, whose work is in the permanent collection of many museums as well as Storm King Art Center, the artist is preparing to go to work on a new piece. She dons

a pair of goggles and heavy shin and knee guards, then yanks on a pair of heavy leather gloves and strides into the center of a clearing in her huge studio, which looks like the back room of a Brooklyn lumber supply store. An assistant steps up to a four-by-four plank on the floor and sticks the sole of his foot on its edge. At a signal from von Rydingsvard, they swing into action. She fires up a screeching power saw and attacks the upper edge of the four-by-four with a set of five swipes, back and forth, that hack deeply into the wood. The assistant flips the beam to its next edge, and five strokes are applied to the second edge. In less than a minute, each of the edges has been hacked in turn, and the process is repeated with the next beam. The rhythmic nature of the studio practice is observable in the final work, which is built up of many layers of these beams laminated together. She uses precisely the same thickness of wood in each layer, which is like a composer using only sixteenth notes through an allegro passage to ensure that a beat will be felt no matter how fast it is played. A "classic" von Rydingsvard is a tall, vessel-like wooden structure, hollow in its core and with the jagged, stratified outer appearance of the Palisades along the Hudson River.

Another kind of rhythm emerges from the work of sculptors whose daily thoughts, prayers and desires are set down in meditative forms that take us back to the "spiritual exercises" of the medieval mystics. One of the most remarkable gallery exhibitions of 1995 featured an art world "nobody" named Hannelore Rubin, whose fragile collages and "game boxes" are full of old scraps of cloth, string, wood, and tiny drawings, often behind glass. Art historians immediately related her emotionally intense works to the boxes of Joseph Cornell and Ray Johnson, as well as to works by Paul Klee, Hannah Hoch, Kurt Schwitters, Joseph Beuys, and Ann Ryan. The asceticism of the work derives in part from its scale and humble materials and also from the trauma of real pain that it reflects. Rubin was basically a recluse, brought up Jewish but drawn to Buddhism, Taoism, and her patron, Saint Anthony. She busied herself with collages in the attic of her home in Riverdale, a suburb of Manhattan. She also suffered three nervous breakdowns, largely as the lingering effect of the memory of how her father was beaten up and her home ransacked during Kristallnacht and the family's escape from the Nazis to New York, as well as her response to the Vietnam War and her own battle with cancer, which claimed her in 1987.

Some of the same attention to the day-by-day can be found in the work of the young sculptor Heather Hutchison, one of the rising stars on the contemporary scene. The title of her most recent show, *Thoughts for Daily Needs*, underscores her attachment to the prayerlike rituals of ordinary life. The look of Hutchison's work is ascetic, as well: she uses

beeswax and Plexiglass over rectangular wood frames, and her signature tones cluster around a range of cool blues and whites that are alive with swirling clouds of white. They are reminiscent of both Rothko's floating rectangles of color and the sculpture of a great but now largely forgotten Minimalist named Christopher Wilmarth, whose standing pieces in frosted glass, steel, and bronze are among the most beautiful and meaningful examples of the use of glass in sculpture. In 1982, Wilmarth presented a series that united glass bubbles with angled planes of blue glass and steel in an exhibition collectively titled *Breath*, which was based on his interpretations of the poetry of Stéphane Mallarmé. The serenity and ascetic restraint of these brilliant works are at odds with the wild indulgences in drugs, alcohol, and prostitution that killed Wilmarth.

These are just a few of the sculptors whose works illuminate the currency of asceticism in contemporary art. The more detailed consideration offered in the following essays reflects personal preferences as well as art historical heft. Today's sculptors are as conscious as their immediate predecessors of the problems involved in existing in the shadow of those pure white marble figures of ancient Greece or the placid seated stone Buddhas of the Far East that have been, since the Renaissance, held up as the Platonic models of what sculpture is supposed to be. If the ascetic ideal had its beginnings in those immaculate forms, it still inspires sculptors in a range of media that are every bit as inherently ascetic as marble.

The Solitude of Objects: Alberto Giacometti

In a letter Alberto Giacometti wrote to Henri Matisse in November 1950, he describes the scene at a Paris brothel called the Sphinx, one of the many such establishments in which he spent his down time. The artist sat across the room from a group of nude women, contemplating the shiny parquet floor between them, more impressed by the distance than by the women themselves and probably constrained by poverty and timidity. For Jean-Paul Sartre, who uses an excerpt from the letter as an epigraph to one of his two major essays on the sculptor, the ascetic contemplation of the gap, which Sartre relates to the invincible distance separating Hero and Leander (recalling Twombly), is the key to understanding Giacometti's haunting art. Sartre attributes to Giacometti a sense of the "vacuum," which he carries as a snail carries his shell, a metaphor for the permanent state of exile and estrangement. As Sartre wrote,

> What is this circular distance—which only words can bridge—if not negation in the form of a *vacuum*? Ironic, defiant, ceremonious and tender,

Giacometti sees space everywhere. . . . "Week after week he was captivated by the legs of a chair; they were not touching the floor." Between things, between men lie broken bridges; the vacuum infiltrates everything; each creates its own vacuum." By kneading plaster, he creates a vacuum *from a plenum*. The figure, when it leaves his fingers is "ten steps away," and no matter what we do, it remains there.[2]

This notion of distance, as captured in the shrunken and pared-away figure or the gap between the chair and the floor (looking ahead to Bruce Nauman's sculpture of the space defined by the underside of a chair), is the essential perceptual characteristic of Giacometti's sculpture. No matter how close you are to them, his figures appear distant because of the manipulation of their proportions, particularly of length, conveying the feeling of a figure on the horizon. What Sartre called the "abrupt dematerialization" of the body dissolves it into the surrounding space. In an earlier essay on Giacometti titled "The Quest for the Absolute" (1948), Sartre pulls Giacometti into a more spiritual context:

We seem at first glance to be confronted by the emaciated martyrs of Buchenwald. But almost immediately we realize our mistake. His thin, gracile creatures rise toward the heavens and we discover a host of Ascensions and Assumptions; they dance, they *are* dances, made of the same rarefied substance as the glorious bodies promised us. And while we are still contemplating the mystical upsurge, the emaciated bodies blossom and we see only terrestrial flowers. The martyred creature was only a woman but she was *all* women . . . with traces of hidden leanness showing through alluring plumpness and hideous here on earth but no longer entirely on earth, living and relating to us the astounding adventure of flesh, *our* adventure. For she chanced to be born, like us.[3]

The Studio of Perpetual Decreation

Another frequent visitor to Giacometti's studio in the 1950s was Jean Genet, who had been introduced to the sculptor by Sartre in 1954. Genet ended up posing for four drawings and three paintings between 1954 and 1957, and his essay on Giacometti is really a series of notes jotted down after returning home from sessions with the artist. The portrait of Genet completed in 1955 places the writer in the lotus position, like a Buddha—or like a pearl encased in its nacreous protection, in the midst of a vast gray space that emphasizes Genet's saintly side. Genet, for his part, captures the dusty atmosphere and ephemeral but constant activity of the artist's studio, in which Giacometti worked particularly in plaster

(the medium that Sartre preferred) as well as brown clay. Genet watched as Giacometti's thumbs flitted constantly up and down the long bodies of the standing figures, rhythmically pressing into the clay in a kind of "oscillation" that you can feel for yourself if you run your hand down the surface of one of the bronzes while the museum guards are looking the other way. "The beauty of Giacometti's sculpture seems to me to reside in this incessant, uninterrupted oscillation from the remotest distance to the closest familiarity: this oscillation never ends, and that is how it can be said that the sculptures are in motion," Genet wrote.[4]

Like that awe-inspiring sense of the *perpetuum mobile* that a listener experiences in the dead center of a Bach fugue or invention, when theme overlapped by theme appears to yield a never-ending series of pulsing possibilities, it is the "incessant, uninterrupted" quality of Giacometti's fluttering texture that not only gives the pieces the quality of motion but an ascetic kind of repetition that is captured as well in Constantin Brancusi's *Endless Column* and all the sculptural variants on it (including Tal Streeter's work of the same title). Sartre and Genet were particularly captivated by the way that Giacometti worked away at endlessly creating fibrous, fragile sculptures in plaster—the forerunners of Cy Twombly's delicate white sculpture—that were easily destroyed overnight. The plaster ended up covering everything, including himself and his old battered spectacles, in a fine layer of gray dust (Genet noted, "If he could, Giacometti would reduce himself to powder, to dust, and how happy that would make him!").[5] The rickety, decaying atmosphere suggests more than poverty to Genet—it points to "absolute reality":

> This ground-floor studio, moreover, is about to collapse from one moment to the next. All the wood is worm-eaten, there is nothing but gray dust, the statues are made of plaster with the string, oakum, pieces of wire showing though, the canvases, painted gray, have long since lost that peacefulness they had at that art-supply store, here everything is spotted and broken-down, everything is precarious and about to collapse, everything is tending to dissolve, everything drifts: now, all this is somehow apprehended in an absolute reality.[6]

For both Sartre and Genet, particularly as city dwellers, the "secret region of solitude" or "secret royalty of solitude" is transmuted into a glorious condition. In terms of the prevailing philosophical and literary winds, including Samuel Beckett's plays (Giacometti designed the tree for the original *Waiting for Godot*), the sculpture of Giacometti was perfectly attuned to that changing consciousness—or romanticization—of emptiness and being. "Figures were never for me a compact mass but like

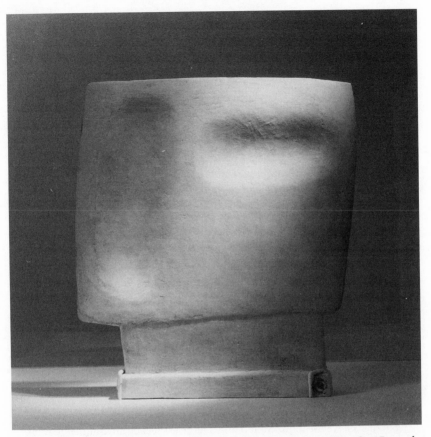

As mysterious and compelling as a Cycladic head, Giacometti's *Tête Qui Regard* (1927) is a plaster plaque that uses concave indentations to suggest the features of a face. Photo: Tomo Sukezane. Courtesy of Yoshii Gallery, New York.

transparent construction," Giacometti wrote in an important letter reviewing his career for Pierre Matisse, his dealer, in 1946 just before his first one-man show in New York opened.[7] Most accounts of Giacometti's career dwell on the split between the Surrealist period leading up to 1950 and the shocking (for his ardent followers) shift to figures after that date. While the look and texture of his sculpture did go through a dramatic change, the letter points to a continuity in Giacometti's thinking regarding the figure, its transparency, and its relationship to space that can be associated with a constant strain of asceticism linking both the early and late work. A very important exhibition in of Giacometti's early sculpture and drawing, at the Yoshii Gallery in New York in 1994, explored the

artist's fascination with austere Sumerian (especially the cannon ball–like Gudea heads), African, Mexican, Oceanic, and Egyptian sculpture in the Louvre as well as at the Musée de l'Homme and the Jardin des Plantes. Among the early Cubist sculptures in the exhibition was an astonishing, quiet "plaque" entitled *Tête Qui Regard* (1927). A thin irregular rectangle in plaster perched on a simple pedestal that slopes gently downward to the left (an anticipation of the feet of the standing figures?), the piece has the moony, blank look of Giacometti's beloved Cycladic heads. The "features" consist of a pair of oblong concave indentations, vertical on the left and horizontal on the upper-right part, the curved edges of which further soften the beveled edges of the rectangular form. These pockets, just by being indentations rather than protuberances, add to the ascetic effect of meditative inwardness that Giacometti was able to achieve throughout his career.

Paring Away Appearance

The later style (from 1950 onward), for which Giacometti is still best known, is that of the tall, very thin standing figures or busts. The process by which they are formed is an ascetic one of attenuation, of the removal of the red clay of a full body to get down to that compressed yet wind-blown wisp of a figure that unites the object with the space surrounding it. "The more I take away, the bigger it gets," Giacometti told David Sylvester.

> In the bust I'm doing at the moment, I never stop taking away, yet it's so big that I have the impression that it's twice as thick again as it really is. So I have to go on taking more and more away. And then, well, I just don't know. That's where I really get lost. It's as if the actual material were becoming illusory. You have a certain mass of clay, and at first you have the impression that you're making it more or less the right volume. And then, to make it more like, you take away. You do nothing but take away. It goes on getting bigger. But then it's as if you could stretch the actual material to infinity, isn't it? If you work on a little bit of unworked clay, it gets to look bigger. The more you work on it, the bigger it gets, doesn't it?[8]

The same perplexity regarding the space between himself and his subject strikes him as he draws. In this quite moving statement, in which Giacometti tells us how he leaves this world for another ("from one domain to another"), he reveals the experience of the artist, just after World War II, who withdraws from reality in life as well as in art. It brings us again to the inherent asceticism of abstraction as a denial of the figure as

reality, because those webby drawings of Giacometti (or Seurat) are, like Cubist renderings, a way of dissolving the figure in pattern and gesture. For Giacometti, as for Picasso and Braque, that old figure-and-ground dichotomy takes on an ascetic significance if the figure is equated with the body or the ego or subjectivity (there are many ways to allegorize this dilemma), and its "reduction" to the status of ground in an allover composition is related to its annihilation or denial. Giacometti's shrinking away of the figure has, in those terms, an ascetic significance. As he told Sylvester,

Until the war, when I was drawing I always drew things smaller than I believed I saw them; in other words, when I was drawing I was amazed that everything became so small. But when I wasn't drawing, I felt I saw heads the size they really were. And then, very gradually, and especially since the war, it has become so much a part of my nature, so ingrained, that the way I see when I'm working persists even when I'm not working. I can no longer get a figure back to life size. Sometimes, in a cafe, I watch the people going by on the opposite pavement and I see them very small, like tiny little statuettes, which I find marvelous. But it's *impossible* for me to imagine that they're life size; at that distance they simply become appearances. If they come nearer, they become a different person. But if they come too close, say two meters away, then I simply don't see them anymore. They're no longer life size, they have usurped your whole visual field and you see them as a blur. And if they get closer still, then you can't see anything at all. You've gone from one domain to another.[9]

At the end of his life, Giacometti was working on a commission for the plaza of the Chase Manhattan Bank in New York, which he eventually abandoned. It was to bring together a group of seven monumental figures—four standing women, two walking men, and a large head—that were completed as seven individual works before his death in 1966. Each of the three standing women that were auctioned off by the family of Baron Leon Lambert at Christie's in New York in 1987 was unique in attitude and character. There is a slumping, subdued quality to the *Grande Femme Debout I* (1960), with its head slightly bowed and its spindly elbows tucked in within a slightly broader pair of hips; a tiny slit of open space (those gaps between arm and body or between legs are vital to an understanding of Giacometti) pierces the legs, which are then melded together. The slightly smaller *Grande Femme Debout III* (1960) is straight and proud, its almost youthful face (for Giacometti) staring straight ahead and an elegant long gap between its straight legs. The fuller breasts and more solid hips of the largest in the group, the *Grande*

Femme Debout II (1960), has a sterner, more manly face (closer to Alberto, his brother, than to Annetta, his sister—essentially his only two regular models). One of the astonishing details of this piece is the straightness of the shoulders (so different from the slight curves of the first figure), offering a touch of rigidity, like the rigid arms and shoulders of the Jasper Johns silhouette in *Winter*.

One of the most extraordinary art monographs to be published recently is the massive biographical study of Giacometti by Yves Bonnefoy, considered by many to be France's foremost living poet. Bonnefoy begins his romantic, psychoanalytic portrait with an anecdote from Giacometti's childhood that is meant to shed light on the sphinxlike role of his mother in his development (his father, a landscape painter who also occasionally did portraits of his children, was much less of an enigma for biographers). The process of paring away appearance to reach reality becomes, for Bonnefoy, an almost Heideggerian quest for Being. He also connects the spiritual aspect of Giacometti's drawing with early Christian icons, attributing to them a "transcendent" quality that arises from the introspective rendering of the subject:

> And what is then to appear in the drawing is a figure that, more than simply depicting the receding planes of the face, reveals, dare I say, the nerve-centers of an individual's self-awareness, so that the object of one of Giacometti's drawings is not so much an appearance, as is the case with ordinary drawings, always more or less in league with geometric perspective, but this very sort of transcendency with the "inverted" or "radiating" perspectives of early Christian art implied, for instance, suggested thanks to their foreshortenings and abrupt changes of size in the representation of beings.[10]

In his touching final sentence, so loaded with emotional and symbolic weight, Bonnefoy describes the December day on which Giacometti was buried at the cemetery of Brogonovo near Stampa. The description captures the ascetic clarity and hardness, the hardness of that pencil with which Giacometti would tear the paper as he drew, that characterized the artist's work from his earliest to his latest periods. As Bonnefoy writes, "The light was icy cold, reflected from rock to rock as far down as the bright but sunless snow of Giacometti's childhood valley."[11]

This icy brilliance did not perish with Giacometti. His legacy in sculpture extends from the powerful expressionism of David Smith to the vulnerability of Eva Hesse and Judy Pfaff. Giacometti's explorations of the silhouette, like those of Jasper Johns in the seasons, push deeper into a realm of solitude than the paintings seem to reach. Two sculptors of our

time have followed in his footsteps in working with the silhouette in particular: Magdalena Abakanowicz and Ana Mendieta. Because of her use of nearly life-size standing figures, often in groups that can be arranged by curators or collectors who are often influenced by the Giacometti groupings with which they are familiar, the work of Abakanowicz is probably closer in spirit to Giacometti's own. Her headless burlap "casts" of anonymous bodies, which face front and are concave in the back, have a fragility and textural complexity that is very like the late Giacometti standing figures.

The Cuban-born Ana Mendieta's Silueta series (1973–80) used traces of her own hands or body subtly embedded in the landscape—one is a mere outline in the dirt of an embankment, showing the head and shoulders and dwindling to an indistinct point where the feet should be, all pierced by a long root or branch that bisects the full length of the body. Another traces the silhouette with a series of candles, and others, perhaps the most effective group emotionally, use silhouettes burned into the grass of an Iowa field with a cast iron hand, traced in gunpowder in the field, or carved into the clay of Old Man's Creek near Iowa City. Where both Mendieta and Abakanowicz meet Giacometti is in the way their sculpture, which in form and texture vaguely echo his standing figures, plays on the feeling of sacrifice. Taking as their cue Giacometti's odd reversal of the monumental tradition in figural sculpture, both artists attain a fluency in what is still public art by achieving the opposite of the traditional glorification. The anonymity and blankness of their staring, sometimes headless figures robs the figure of its usual Romantic appeal, perpetuating that distant tone that Giacometti first sounded.

Drawing in Air: David Smith

It would be difficult to come up with a more humorous or apt formulation of the perplexing dual image left to posterity by David Smith than Robert Motherwell's exasperated, "Oh David! You are as delicate as Vivaldi, and as strong as a Mack truck."[12] The paradoxical oppositions of qualities and intentions made Smith in his own time as well as ours an enigmatic figure for art writers (even the best, like Frank O'Hara, remained remarkably subdued in their contemporary assessments). Smith's sculpture can be by turns all about power and relinquishing power, empty space and mass, restraint and exuberance, referentiality and abstraction. His life as well shuttled unpredictably between attack and retreat, luxury and poverty, anger and sensitivity, spontaneity and sheer labor, the cerebral and the physical.

When Smith died in May 1965, turning his truck over on a mountain road as he chased Kenneth Noland's Lotus sports car to an opening in Bennington, the effect on the art world of the time was akin to that of losing one of its saints. Robert Motherwell, in an elegy for Smith that will make you cry, reminisces about the way Smith, who had a key to the apartment Motherwell shared with Helen Frankenthaler on East 94th Street, would turn up unannounced in the morning after a long night of excess. In a sentence that offers a subtle hint to those trying to grasp Smith's elusively dialectical nature, Motherwell links the art and life: "If it was late, he could be drunk, always cheerfully and perhaps abashedly—he was profoundly sensual, mad about very young women, but with a stern Midwestern puritan guilt (about working, too)."[13]

Smith was the hermit of the Abstract Expressionists, living in self-imposed exile away from New York most of the year and adhering to a strict regimen of work on the sculpture by day, on the drawings by night. "I like my solitude, black coffee, and daydreams," he wrote.[14] A classic example of the artist who cast a cold eye on the New York scene—which in his day was the now-mythic golden age of the Cedar Tavern and the Eighth Street "club" of abstract expressionists that still represents the heyday of artistic bonhomie in Manhattan—Smith removed himself at the age of thirty-four to a famously austere studio and home in Bolton Landing, a tiny town in the hills that rise above Lake George in upstate New York. As Motherwell observed in 1965, "It is not an especially comfortable place (Bolton Landing, New York), especially for women, but on its grounds, like sentinels, stands the greatest permanent one-man show of heroic contemporary sculpture in the Americas. A folk song runs: 'It takes a worried man to sing a worried song.' Well, it takes an iron will to have made all those weighty iron sculptures strewn about his mountain landscape, each silhouetted against an enormous sky."[15]

The poet and cultural impresario Frank O'Hara called Smith a "moral force in American art."[16] Like Clyfford Still, Mark Tobey, and Jackson Pollock, Smith was not an Easterner. He was born in 1906 in Decatur, Indiana. The importance of engineering to his work—as to that of so many other contemporary sculptors, including Mark di Suvero, George Rickey, and Alexander Calder—may have derived in part from the fact that his father was a telephone company engineer (his mother was a teacher). Renowned in his school days as a cartoonist, he tried a few correspondence courses in drawing and headed to Ohio University to study art, although that lasted only one year (1924–25). His main problem with the program was its stress on art history surveys in place of studio instruction. This is not to say that Smith was not steeped in the tradition, since his art (including the first paintings) from a very early stage shows

the influences of Cubism, Surrealism, German and Austrian Expressionism, De Stijl, Russian Constructivism, and even Impressionism.

Instead of university, he went to work on the assembly line, making Studebakers in South Bend. The turning point in his life was meeting Dorothy Dehner, an artist who lived in the same rooming house as Smith in New York; they were married in 1927. She dragged him to the Art Students League in New York, where he studied painting and encountered Mondrian, Hofmann, and Naum Gabo. He relished the fact that young Americans could find that these deities of abstraction were human, even if their work was utopian.

Smith gave up painting for sculpture and then gave up on Manhattan. He and Dehner moved to Bolton Landing in 1940, and it was not long before they were pressed into service as part of the war effort. During July 1942 he started work at the American Locomotive factory in Schenectady, where he welded armor plate on tanks. Smith lost fifteen pounds that summer, living in the attic of an old house in Schenectady and trying to keep up with the fierce pace of the assembly line—reminding us of the similar experience of Simone Weil. After the swing shift on Saturday morning, if Smith had Sundays off, he would drive straight up to Bolton Landing and spend the day working. At that time he used marble because all kinds of metal were in short supply, but he worked the stone with power tools rather than with a hammer and chisel.

Wired

While some escape to the countryside to relax, Smith in Bolton Landing was a twenty-four-hour bundle of nerves. He called his shop the Terminal Iron Works, an homage to the original bustling (and now dormant) hive of industry on Atlantic Avenue in Brooklyn, near where Smith and Dehner first lived and worked together. In Brooklyn he liked the all-night cacophony of the shipyards, a paradigm of the constant buzz of activity he wanted around him. So Smith turned the stars and mountains, the night sounds and fierce storms into his stimulants. At 11:30 at night he'd have a pot of strong coffee. The next morning, with the discipline that working on a mass-production line instills, he'd answer the bell early, striding into the studio at ten after an hour of reading. After particularly successful bouts of productivity, Smith would descend on Manhattan to reward himself with classical music concerts at the 92nd Street Y, gallery and museum bashing, Chinese food, jazz and drinking at places like Eddie's and Nick's as well as the Artists Club and the Cedar Tavern, where Pollock, Kline, and Motherwell fired down shots of whiskey chased by pints of Guinness. The ritual would include breakfast on

Eighth Street before returning to work upstate. In Smith's own words, he would "ride it as hard and as long as I can for a few days, then back to the hills."[17]

Smith and Dehner enjoyed greater and greater isolation at Bolton Landing as the years progressed. At first their home, without insulation and with cracks through which the wind would whistle, had only a small coal stove for heat, an outdoor hand pump for water (melted snow for the washing), and no electricity. Their cloistered existence fed the thematic development of some of his early works. One of the most important is *Interior for Exterior* (1939), which extends an earlier work in steel and bronze based on a glimpse into the artist's studio. Both of Smith's interiors are directly related to Alberto Giacometti's interior in wood, glass, wire, and string called *Palace at 4 A.M.* (1932–33). While Giacometti's is more overtly architectural, with its vertical columns, its stage tower, and peaked roofline, both Giacometti and Smith created oneiric views inside a building in which surreal little dramas are enacted. Slightly smaller and rendered in steel and bronze, Smith's sculpture is more fluid and expressive and every bit as enigmatic in terms of its referents. The story it tells seems to derive from a sinuous female contemplating a smaller female figure, her arms outstretched, lunging through an aperture to escape. The right angles of Giacometti are alluded to by Smith but softened and offset by a constellation of curved forms. More significantly, where Giacometti slips in a ceiling panel of glass or three standing panels as planar reflective surfaces, suggesting with the polished floor of the palace an echo effect, the Smith sculpture is all roughly textured and entirely open to the air, without any interior walls or surfaces against which light or sound can bounce inward.

In 1945, Smith returned to the theme to create a studio piece—in the great tradition of Matisse and Braque and so many other twentieth-century artists—that is really a self-portrait. More solidly rendered than the open form of *Interior and Exterior*, his *Home of the Welder* (1945) in steel has a heaviness and enclosed, meditative quality that is quite different in its emotional effect from the openness of the earlier work. Solidity, the relieflike pictorial elements on the walls, and the technical shift from welding to casting and brazing all combine to push the work from drawing to painting, from line to mass. The coded references in *Home of the Welder* include the millstone, which refers to Smith's unhappy marriage to Dehner; a small bronze duck that symbolizes the fantasy of "owning a game preserve in the country"; and the "double-profile reindeer" on the wall that refers to Smith's love of hunting. On the reverse side of the wall the welder's wife is in the bedroom in front of a big mirror—she is made of locomotive parts. At Bolton Landing, Smith actually maintained two

studios, one of them (in the house) clean, warm, and orderly, and the other, the one he called "the shop," a cold, cluttered, semiindustrial place where he could be a "greaseball." In the clean studio, particularly at night, Smith would draw and work on prints. That is where he kept his drawing tables, etching press, and photos. One of the most endearing stories relates the way he stacked up his drawing paper, the expensive handmade sheets mixed in with the cheaper stock, and simply reached for the next sheet without checking, then casually let the drawings fall wet to the floor as he reached for another.

Visible Wings of Silence

The shop was a large, forty-foot-long cinder-block structure that Smith designed and built himself, with a row of northern skylights set at a thirty-degree angle and a few floor areas that were in effect drawing spaces. It was equipped with as many gadgets and tools as he could afford, including a heliarc welder for stainless steel, oxyacetylene equipment, burning machines to cut large circles in steel plate, cutting machines for bar stock, a drill press, and a professional steelworkers' table to hold forms in different positions. In the shop, it all started on the floor. Taking the base as "the law," he used chalk drawings as well as spray-painted shadows of steel and cardboard to set out the initial relationships that would give rise to a piece. These forms became what he called the "think pieces" or "profiles" for new configurations of elements that in themselves were always varied, as Smith disliked using standard shapes and dimensions as his compositional building blocks. For the same reasons, the next part of the process varied from piece to piece, but for the most part it involved arranging cut steel forms and found objects on the floor, using the profile partly as matrix and partly as a pushing-off point.

In a pair of photographs taken by Dan Budnik during a 1962 shoot in the workshop, the meditative aspect of Smith is captured. The first shows Smith standing, head bowed, hands thrust into tight pockets, within a small circle of steel plates cut at diagonals, with one or two rectangles. The rubber hose of the acetylene welder snakes through the background, and his padded jacket hangs on a stand that holds the compressed gas. Buckets and tools litter the floor, but Smith is concentrating on that little ring of steel, about three feet in diameter, that he is nudging with the toe of his boot while his hands stay in the pockets of his wrinkled khakis beneath his leather vest and painter's cap. In the second photo his right foot is raised above the circle, and his left is now outside it. That posture—hands in pockets, eyes on the floor—is familiar. We see it in the film of

Glenn Gould as he listens to his first playback of the Goldbergs in the studio, as well as in the absorbed look of countless artists in between the moment of making marks—artists like Robert Mangold, Brice Marden, or even Christo.

When at some point the arrangement of loose pieces became "united" in his view, the next and possibly most important step would be the transition from the horizontal to the vertical position as the piece. As with not only Jackson Pollock, the most famous example of an artist who worked on the floor on pieces that eventually were shown vertically, but also with Brice Marden, Helen Frankenthaler, and many others, the risks and surprises inherent in this shift from horizontal to vertical are considerable. Upright, the pieces of Smith's work are welded into position, and a range of decisions and spontaneous combinatorial possibilities comes into play. Every connection, angle, and juxtaposition can be adjusted, reworked, and questioned. Because welding leaves a track—those lumps and seams and blobs of solder linking pieces that are nearly impossible to efface—the evolution of the work's syntax, the way that it accumulated, is evident to the viewer.

In its vertical phase much of Smith's work, particularly those pieces done in a thin, linear style, was achieved by a technique of addition and fusion that he called "drawing in air." A champion of line, which he opposed not only to color but to mass, Smith was a virtuoso of the open form in sculpture and the prime example we have of the way in which asceticism in sculpture is an art of lightness, empty spaces, and negative space as much as it is an art of weight and measure. When he gave up painting for sculpture in 1936 (at the urging of his friends John Graham and John Xceron), Smith consciously renounced the fullness of painted mass for its opposite, the emptiness of the spaces within sculpture of these kinds. Implicit in this is the notion that paint is somehow an obstruction, a weakening mediation that stood between him and the sculpture of the future.

These drawings in air follow the trail of Picasso's iron wire constructions of 1928–29, including the wire maquette for a monument to Apollinaire. As Smith explained, "The line contour with its variations and its comment on mass space is more acute than bulk shape. In vision the overlay of shapes seen through each other not only permits each shape to retain its individual intent but in juxtaposition highly multiplies the association of the new and more complex unity."[18] This greater "acuteness," or concentration on the enclosed space, arises from framing it. By ensuring the individuality of shapes in the palimpsest of the work—like maintaining the integrity of individual lines in a Bach fugue so that they are heard over one another in a structure of clarity and harmony—Smith

creates the sort of transparency that is in itself a realization of the ascetic ideal. The webby lightness of the open pieces also echoes Adolph Gottlieb's "pictographs" (Gottlieb was a friend of Smith's) and looks ahead to the wire mesh constructions of Judy Pfaff and Nancy Graves. Suspended in air, defying not just gravity but the usual sculptural limitations of form and mass, the drawings in air have an ethereal quality as well as a nervous energy that is extraordinary. In terms of the great painting of the time, they capture the movement and otherworldly sense of space that continue to hold viewers spellbound. After all, what was Pollock's dripping from a foot away from the floor but creating a figure in air, just like Smith's, that gravity seized and chance dropped across the canvas?

For the bounding line to perform as commentary on the enclosed space, which Smith equates with mass (taking us back to painting), the line must become subordinate. Through the complexity of linear elements that overlap, these open spaces are activated, taking on a *positive* character that is reminiscent of the colored planes in one of Mondrian's Neoplastic, sculptural paintings. In particular, many of the "drawings in air" are very close in spirit to paintings in that they are flat enough to be almost two-dimensional. By adhering closely to the Cubist grid, these works share many of the rhythmic structures that underlay other post-Cubist paintings by Mondrian and Miró. Many of the open pieces are related to landscape painting, such as *Hudson River Landscape* (1951) and *Four Soldiers* (1951) or *The Forest* (1950) and *36 Bird Heads* (1950). Some are related to both landscape and still life, such as *The Banquet* (1951), now on the porch at Kykuit, the Rockefeller estate, where it is like a window on the Hudson spreading behind it. When a friend complained about the emptiness in the centers of these pieces and the activity that crowded their borders, Smith countered: "Why don't you object to the white of canvas as a technical space?"

Among the most wonderful examples of his drawings in air are the great "alphabet" pieces such as *24 Greek Y's, 17 H's,* and *Letter* (1950), all of which bear a fascinating relationship to the alphabet and number paintings of Jasper Johns and have their link to the use of calligraphy in the work of Brice Marden and Cy Twombly. In the case of *Letter,* which is a love letter to Jean Freas (the Sarah Lawrence student that Smith left his wife for), the piece is read from top to bottom, starting with the rough script of "Dear Jeano" and running through a rhythmic array of V- and Y-forms (associated with birds on bare tree branches) as well as the more sexually suggestive O-forms, all interspersed with objects that angle in and out of the open mesh of the piece. Smith exploits the possibilities of repetition and variation more overtly in *24 Greek Y's,* a work in forged steel that sets up an openwork commentary on the Cubist grid.

Smith's description of his "locomotive method" evokes images of brute momentum and an ad hoc, trial-and-error, or impromptu mentality. In terms of the varieties of asceticism, Smith was decidedly in the camp of those who opposed the notion of the perfectibility of the sculpture as object. In terms of his studio practice, he found a way to use his failures and often incorporated the broken forms and cast-off or cut-off shards from earlier work in new pieces (much as Frank Stella created his Shards series of wall reliefs from the parts that had been cut out of earlier works). Smith preferred to start with off-sizes of steel, because warehouse stock (cut to order) was "too precise, polished and ground to .002 perfection."[19] Imperfection as license, rather than precision and finish, was one of his most potent creative forces. One of the essential tenets of Smith's aesthetic was the importance of the noble failure: "Ability may make the successful work in the eyes of the connoisseurs, but identity makes the failures, which are the most important contribution for the artist. What his critics term the failures are his best works from his own working position. These are the closest to actuality and the creative process."[20] Beyond the spare and airy style, the humility behind a statement such as this is an index to an ascetic ideal. Smith is deliberately shifting the focus from the masterpiece to the study. This valorization of the tentative and imperfect is all the more perplexing to us, as we are bound to approach sculptures by Smith as masterpieces, monuments of the canon and not interim solutions to a problem that powerfully vexes the artist. As he wrote, "The conflict for realization is what makes art, not its certainty, its technique, or material. I do not look for total success. If a part is successful, the rest clumsy or incomplete, I can still call it finished, if I've said anything new, by finding any relationship which I might call an origin. I will not change an error if it feels right, for the error is more human than perfection. I do not seek answers."[21]

By stressing the importance of the human element in his work, Smith has given a great deal of ammunition to critics who push to see an autobiographical strain in his figurelike vertical works. Knowing that Smith stood six-foot-one and comparing the range of roughly six-foot sculptures (such as *The Hero*, which is an inch taller than he) that he created seems to corroborate that notion, even where Smith adds the breasts or other female elements to the figures. But that might be narrowing the field too much. At Storm King Art Center just outside Manhattan, where a charming group of Smith sculptures is on view through most of the year, you become aware of the psychological range of Smith's "personages" (to use a good Miró title). Strolling around the top of the hill, you have probably come around to the grove of Smith sculptures, having seen a pair of reclining figures by Henry Moore, the massive Di Suvero

steel-beam structures in the fields below, and another field of Alexander Calder stabiles that are just in view when you are standing surrounded by the works of Smith. Each group offers a lesson in the referential basis for abstract sculpture through their gestural and biomorphic forms.

The cluster of Smith figures—in one historic purchase, Ralph E. Ogden, who started Storm King with H. Peter Stern, bought thirteen major works by Smith—takes on even greater resonance. They include the *Lady Painter* (1957–60), a humorous portrait that may well have had its starting point with Dorothy Dehner, who was a painter, although it was done well after they had divorced. Unlike the more vertical, "male" *Portrait of a Painter* of the same year, the horizontal character of *Portrait of a Lady Painter* holds the palette down and at the "back" while the top piece of metal is pointed resolutely to the hills bordering Storm King, guided by the brush and thumb motif. The central figure is an "eye" pierced by a circular hole that is like a gunsight.

Next to the lady painter is *Personage of May* (1957), which presents its asymmetrical, gently convex, and delicately textured face to the mountains in a gesture of embrace. Reminiscent of Miró in not only its title but its use of the figure, it also has the open, contemplative gaze of a Cycladic figure. Very near by is the tall Cubist masterwork *XI Books III Apples* (1959), which uses Smith's painterly way of working the stainless steel surfaces of a tower of rectangular panels. George Rickey, a sculptor who also uses stainless steel, would set these panels in motion with his wind-blown, pivoting standing works. The illusion of movement in sculpture is a time-honored desideratum, from the *Laocoön* through the dancelike figures of Rodin (who would not let his models remain still in the studio so that they were always in motion) and beyond. Among the many motion-filled pieces Smith made, perhaps one of the most charming is *Becca* (1964), which is based in part on his daughter Rebecca, who, when a child, was a whirlwind of activity. Like Duchamps's *Nude Descending a Staircase*, it uses a rapidly fluttering array of fanned-out, Cubist-inspired rectangles to give the sense of a little girl flying at top speed. The surfaces of these pieces keep the illusion of motion going by reflecting light from their angled, scraped, and polished planes, marked with swirling painterly strokes.

Although the "purest" work of Smith is in stainless steel or cast in bronze, there is an interesting group of mainly later pieces that brought Smith back to his work as a painter. An exquisite example of these is an untitled standing piece that is kept inside at Storm King because of its delicate condition. The focal point for the work is a large vertical, rectangular panel that is held in a long graceful curve and offset by a circular piece that is also painted. The flat surface is used for two strong paintings

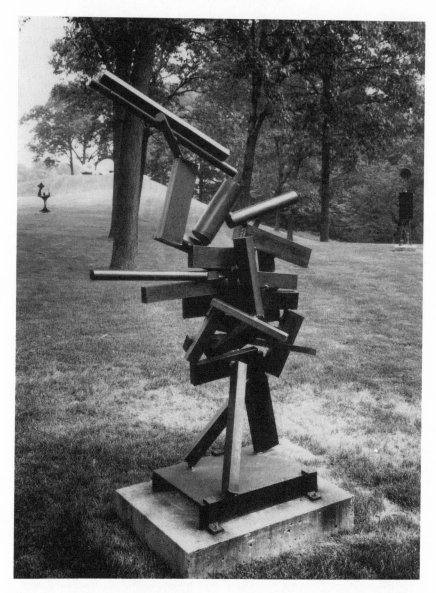

Poetry in motion: David Smith's *Becca* (1964) is a Cubist-inspired portrait of his daughter that uses an array of angled stainless steel plates to capture her rapid movement. Steel, 78 × 47½ × 23½ in. © Estate of David Smith/Licensed by VAGA, New York, N.Y. Courtesy of Storm King Art Center, Mountainville, N.Y. Gift of the Ralph E. Ogden Foundation.

by Smith. One is reminiscent of Barnett Newman because of its vertical orientation; the other, a horizontal, of Mark Rothko.

A recent exhibition of Abstract Expressionist drawings at the Metropolitan Museum of Art dramatized the strong influence of Smith's drawings on the whole generation by the close proximity of four of Robert Motherwell's energetic, quite Japanese-looking *Lyric Suite* drawings in blue, black, and a russet-colored ink on white paper, with similarly "flung" drawings by Jackson Pollock, Franz Kline, Mark Tobey, James Brooks, Philip Guston, and a powerful single stroke of black descending from a heavy top to a thinner base by Newman. Of all of these distinctly related sheets, the drawing by Smith in Chinese black ink, mixed, for thickness and opacity, with egg yolk, is the most calligraphic and compositionally complex. Like one of Marden's studies for the Cold Mountain series, the principle of organization for the free-flowing drawing is the columnar arrangement of characters. However, Smith arranges his three columns, which bear an obvious relationship to his standing figures, in the illusion of a semicircular grouping, as one would arrange the sculptures, with the two flanking pieces slightly more in the foreground and the center piece dropped back slightly.

The most vertical of the three pieces is on the left-hand side, with its tripodlike legs (reminiscent of the *Seated Typesetter* up at Storm King) supporting a sinuous upward stroke that curves over into a headlike figure, from which thicker and thinner strokes branch and cross. One of these undulates ribbonlike toward the central piece, which has a heavy, slanting, headlike character (with one extraordinarily graceful, sharp stroke balancing a heavier v-shaped appendage that uses the "black pearl" of ink in a very Chinese way). This heavier top is perched on another base that folds outward in a pyramidal form, which in turn wanders over to the right-hand figure. Set squarely on two thick pillars rooted in the ground, the right-hand torso is dramatically bisected by a long downward curving stroke, the top of which builds in a busy, cagelike fashion to a crowning section that swings not just upward but right and into the corner of the paper.

The close connection with calligraphy can be traced back to the moment when Jean Freas gave Smith *The Spirit of the Brush,* a book on Japanese and Chinese calligraphy. There are many ways in which to put a biographical tidbit like this to use. The easiest is to note the distinct influence of calligraphic gestures and even forms on the way he crisscrossed and massaged the surfaces of his stainless steel cubes with a power sander during the 1950s and 1960s. More important, perhaps, is the way in which Smith used calligraphy to help him compose, looking ahead to the work of Brice Marden based in part on the calligraphic

rendering of Chinese poetry. For one thing, there is a relationship between calligraphy and Western gestural painting—that problematic inheritance of the heroic Abstract Expressionism of the 1950s. In traditional calligraphy, gesture must flow and yet remain under precise control. The demands of Chinese and Japanese calligraphy (and there is a wonderful battle continually waged over which country is master of the brush) are in many ways paradoxical. While the work must look entirely spontaneous, the calligrapher must satisfy the connoisseur's standards of balance and remain within the inherited formal vocabulary of earlier masterpieces, often handed down through rubbings from stone tablets in which the hand of the stonecutter has miraculously captured the pressure and edgework of supple brushwork.

In another way, calligraphy and the work of Smith go together. Calligraphy proceeds according to columns, its form dictated by the vertical integration of individual and highly complex forms. The relationship of Smith's work to the column is important to appreciate. The physical and elemental basis for Smith's art is not the action of building, nor of cutting, but the principle of joining and adding. In a manner reminiscent of the composition of a collage by Kurt Schwitters, which incorporates the diverse elements of the studio environment in a progressively additive array, Smith "picks up" the fragments that lie about him and finds a way to go from one to another. Each maintains its formal and even functional identity in an open way that exceeds even the fusions of Picasso, who could disguise for a moment a toy car or a bicycle handlebar in an image. Smith's found objects include tank lids, channel beams, and even the shapes left after fabricators cut forms for his other pieces, which anticipates the "shards" from which Frank Stella created a whole series of wall reliefs.

The photographs on the dock at Bolton Landing, the little cluster of Smith figures on the lawn at Storm King, and even the placement of the piece at Kykuit at the very point on the porch that has the best view of the Hudson River and the cliffs on the other bank all point to one significant factor in the appreciation of his work: the advantage of seeing it out of doors. Sequestered in their tower room at the National Gallery, tucked away in a corner of the Fogg Museum at Harvard, or overlit and isolated at the Museum of Modern Art in New York, Smith's sculptures have a different (and arguably lesser) impact on viewers than they have "in the wild." The pure emptiness of the "white box" of a gallery keeps the inner spaces blank and empty. For his photographs of the sculpture on the dock by the lake at Bolton Landing, Smith used the big sky and gentle curves of the landscape to set up a context. The hills and lake are glimpsed through the interstices and surround the figure as a whole.

Thanks to the brilliant curatorial work of David Collens, who has been at the center since 1974 and may well be the world's top expert at siting outdoor sculpture, the arrangement of the sculpture at Storm King is directly related to the understanding of the work in the case of a number of works. The Miróesque *Personage* spreads his broad chest to the sun and gazes over a valley to the same hills that the *Lady Painter* is preparing to render. As Milo Beach, the distinguished director of the Sackler Museum in Washington, once commented to me on a memorable November day at Storm King, the best time to see these works is early in spring or late in the autumn because the raking light yields crisp, dramatic shadows across the lawns behind the pieces, and the nearly bare trees set up their own gridlike matrix against which the structural complexity of the works can be all the more readily appreciated. More than simply creating a picturesque ambiance for the work, however, or thematically giving the *Lady Painter* a prospect to paint, the siting of the sculpture out of doors invokes a vast, even overwhelming context against which the works are at their best because they stand up to it. Motherwell called them "sentinels," and from the perspective of the 1990s, we can view them, together with Giacometti's standing silhouettes, as the guardians of a particular, sacred ground in art that is often under attack but, hopefully, never will be ceded.

Caught in the Web: Eva Hesse

What Simone Weil was to contemporary philosophy, Eva Hesse has been to the recent history of sculpture. Part martyr for her tragically early death from cancer just as her work was gaining the international recognition it deserved and part hero for the independent course she steered from the brute geometries of Minimalism, Hesse holds a unique place. In subtle, fragile, partly idealistic qualities of her sculpture, which she worked so hard to distance from the tradition, from sex, from mathematics, from both the messiness of chance and the correctness of order, lies one of the great paradoxical examples of asceticism in contemporary art.

Hesse was born in 1936 in Hamburg, and as her family was Jewish, she was sent with a group of children for a three-month stay in Amsterdam. In June 1938 her family emigrated to New York, where her father became an insurance broker, eventually divorced, and took Eva to the household of her new stepmother, also named Eva, whom the artist disliked intensely. Her mother committed suicide in 1946. When she graduated from junior high school, she attended the High School of Industrial Arts in New York and moved from there to Pratt Institute to study

advertising. During her sophomore year she left to become an intern at *Seventeen* magazine and to work on life drawing at the Art Students League. In 1954 she began studying under Neil Welliver, Will Barnet, Robert Gwathmey, and others at Cooper Union, and upon her graduation she moved on to Yale School of Art to work under Josef Albers and Bernard Chaet until 1959. She took pride in being one of Albers's favorite students—his "little color studyist"—but was determined to work in a more Expressionist idiom than the tight geometries of Albers. An early still life, now in the collection of Old Master expert Margot Gordon, is a wonderfully "loose" gray-and-gold work that has Gorky and de Kooning written all over it. The formal training and even the compositional ideas she acquired under Albers were not completely sublimated, however, as anyone who has seen her drawings, especially the pen-and-wash geometric arrays of circles within grids, can attest.

After Yale she set up a studio on Ninth Avenue in New York and worked first in a jewelry store and later as a textile designer for the Boris Kroll company, where she felt like part of a machine—a little detail worth remembering with regard to her use of soft materials and also her exploration of "woven" patterns in her drawings. In 1960 she began a series of small-scale, gestural, black-and-brown ink drawings on paper—that prefigure her later works. She used silhouettes and washes against the bright white of the paper, occasionally bordered in a firm black line with an edge left in white, and sometimes burying the paper in black with just an aperture of white left. The drawings are the best route to fully appreciating her work and thinking. In many ways similar to Agnes Martin's watercolors and pencil drawings, Hesse's drawings lead the viewer directly to the spatial and rhythmic problems that are central to the sculpture. She often combined black ink wash and pencil in them, laying out a grid, sometimes crossed with lightly inscribed diagonals in which she placed circular forms washed with varying intensities of gray. They are geometric and painterly, and the ink wash is the perfect introduction to the way she softens the edges of her irregular cylinders and squares in the sculpture.

An Endless Hunger

A prolific maker who, from early in her career, suffered from bouts of anxiety and lack of confidence, Hesse was also physically frail and was in and out of New York hospitals from 1961 on. She suffered from nightmares, headaches, and severe if mysterious ailments that are mentioned many times in her diaries and, more important, set up a complex and ascetic undercurrent of pain in her art. In 1964, while she was working in

Germany, Hesse's sculpture began to incorporate plaster, cord, wire, and mesh screens. Her drawings tightened up, and strange, machinelike figures began to appear in them. As she wrote to a friend, "My drawings are very HARD. That is they are forms I have always used but enlarged and very clearly defined. Thus they look like *machines*, however they are not functional and are nonsense."[22]

Back in New York in 1966, Hesse completed two of her greatest sculptures, *Total Zero* and *Hang Up*; the latter consists of a strikingly austere wooden frame covered in cloth and punctured by two holes, one on the top near the upper left-hand corner and the other on the bottom support near the lower right-hand corner. Out of the upper hole an eerie cord snakes its way outward and downward at the viewer, bounces off the floor in front of the frame, and then awkwardly curves back into the lower hole. LeWitt and Tom Doyle, Hesse's husband, actually put the work together, using bedsheets for the bandage-like wrapping and steel tubing for the cord. Hesse painted the cloth a dull gray fading toward white to give it an "insubstantial" effect. Late in her life she called *Hang Up*, now in the Art Institute of Chicago, her most important work. The blankness of the white wall as seen through the frame, and the emptiness outlined by the cord as it protrudes into the gallery almost threateningly, are complemented by the dull gray paint and the bandagelike wrapping (which can be related to Lawrence Carroll and Salvatore Scarpitta, whose wrapped works have a similar emotional impact on viewers). With regard to *Hang Up*, the artist commented on the ascetic impulse in this ambiguous fashion: "I had an insight . . . that I deny myself pleasure, and that I'm desirous of pleasure nevertheless."[23]

As Hesse was picked up for more and more important exhibitions, such as the *Eccentric Abstraction* show at Fischbach Gallery in the fall of 1966, the scale and complexity of her work was able to grow. One of the early major works is the classically inspired *Laocoön*, which she completed in June 1966. In her version, Hesse incorporates dyed cord and wire, draped, knotted, and dangled over a ladderlike framework of plumber's pipe that she has wrapped in papier-mâché. As she worked on it, she wrote in her diary, after a brief encounter with another handsome young artist, "I unfortunately get caught in the web. The only web I know inside my dumb guts—Lock myself in a cage. I darken it besides."[24] Over ten feet tall and open at the top, with its uppermost four columns extending toward the ceiling and its lowest "snakes" trailing on the ground, Hesse's *Laocoön* is a marvelous illustration of how she softened the architecture and geometry of her friend LeWitt and the other Minimalists in her own austere yet fragile materials. The openness of the piece and its emphasis on structure are reminiscent of the white cube sculptures of

LeWitt, but the bulging "bandages" around the joints and the rippling contours of the beams and posts are closer to the knobby limbs and cage-like frames of Giacometti (not to mention the wonderfully textured legs and crossbeams of his brother Diego's tables), while the cords and wires of this work, as well as those of *Metronomic Irregularity* 1966), can be compared to the skeins of paint in a Jackson Pollock drip painting.

Assembling the Echoes

The "classic" Hesse work is a combination of repetition, slightly irregular vessel shapes, and soft materials, particularly latex and fiberglass, where one expects metal. In the spring of 1967, Hesse started on this track with *Accession I*, which used aluminum and rubber tubing, and it continues with the work (including *Schema, Repetition Nineteen III*, and *Accretion*) that made up her first one-woman sculpture show, *Chain Polymers*, at the Fischbach Gallery in November 1968. Hesse's notebooks are dotted with phrases about repetition from other artists and critics, such as the observation "endless repetition can be considered erotic" from an essay by Lucy Lippard and Carl Andre's well-known aphorism, "Anything worth doing is worth doing again and again." The fiberglass and polyester resin pieces, like *Repetition Nineteen III*, which is an array of crumpled cylindrical vessels a little less than two feet high and about a foot in diameter that are grouped on the floor, poured forth at a fiberglass and resin factory on Staten Island (where Robert Smithson and Robert Morris also had some of their work made) beginning in the spring of 1968. They are notable not only for their use of rhythm and repetition but for the strange light that they permit to flow through them. The light we experience in looking at Hesse's work is light that passes through the membrane, as through stained glass.

The translucency as well as the gummy texture of the fiberglass and latex suggested to viewers a wide array of references, from human skin to parchment or wax. They are related to some of the latex works of Louise Bourgeois and Bruce Nauman, such as his *From Hand to Mouth*, but are more abstract than their later evocations of the body. That degree of abstraction allowed Robert Morris, in the capacity of critic rather than sculptor, to include Hesse's work in his discussion of "anti-form" as an ascetic quality of Minimalist art that refused to "aestheticize" form in a positive way. Yet Hesse's work (like that of Nauman and Bourgeois) was too erotic to fit comfortably into the Minimalist agenda. The psychosexual punning of all those buckets and hoses bounces us back to the biographical element in a consideration of her work. As Anna Chave writes in her essay about the feminist element in Hesse's work, Hesse was

very conscious of her own sexuality. Chave writes, "An often coquettish woman, the sculptor was highly attentive to her figure, her attire, and her attractiveness to men."[25] Chave then quotes Hesse as often saying to herself, "My work is good, I am pretty, I am liked, I am respected." Photographs of Hesse at her openings or posing with her sculpture confirm this impression. The cover of an exhibition catalog produced in Dusseldorf shows Hesse in a tight blouse, her long dark hair flowing across half her chest, her gaze direct; she is squatting slightly to hold up her (breast-like) painting *Ringaround Arosie*. Another photograph in the catalog has her stretching her arms over her head, her shirt pulling up out of the top of her tight black jeans; and a snapshot of the opening shows her in a sleeveless and low-cut dress, her hair up and a provocative smile on her face as she chats up an admirer in the center of the room.

Just because Hesse liked to play games with the camera for her gallery catalogs and dress up for openings, her status as an ascetic artist does not have to be called into question. It is precisely the unnerving tension between this image and the austere but suggestive geometry of her sculpture that makes the work such an interesting variant on the theme. Hesse's art transcended the sensual in a way that was braver than the forbidding geometries of Minimalism. When the magnificent Hesse retrospective at Yale in 1992 brought together all five units of Hesse's magisterial *Sans II*, a wall relief using over a hundred boxlike units in fiberglass and polyester resin, it offered a dramatic display of the power that prompted Robert Smithson to admit that Hesse's work had a "vertiginous" effect on his senses. One of the most perceptive early critical assessments of Hesse's work was offered by Robert Pincus-Witten in his seminal work *Postminimalism*, which traced the importance of pain and fear in her early paintings through the "absurdist" assimilation of Oldenburg and Johns, as well as the "anti-Cubist" and anti-Minimalist "incorrectness" of the geometric work. As Pincus-Witten observed, "The voice no longer speaks to us, but beyond us. In her last year Eva Hesse discovered the sublime, another place and time at which the critic only guesses and where the historian maps only these superficial paths. She had left her Post-Minimalist colleagues and friends, and joined Newman, Still, Pollock, and Reinhardt."[26]

While Hesse often said that she deplored romanticism, it is difficult to resist the sheer emotional power of the end of her story. In September 1968, just before the triumph of *Chain Polymers*, she began to experience the the early warnings of her brain tumor. She collapsed on April 6, 1969, just after finishing *Accession II*, a ladderlike piece that combines fiberglass and resin with vinyl tubing, draped from metal screen squares and gathered in a coil on the floor. Like Miró's ladders or Cage's gamuts,

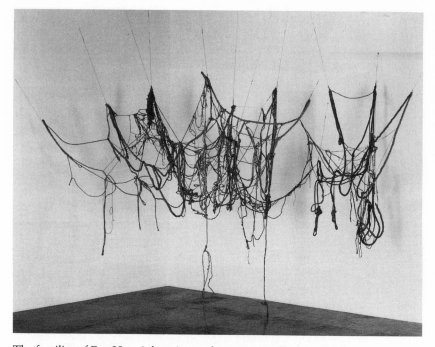

The fragility of Eva Hesse's hanging sculpture ironically foretold the tragic death of the artist at age thirty-four. In one of her last statements on art she said, "Never arbitrary, never decoration, the strength of vision and soul is there, it must. We are left ultimately with a visual presence." Whitney Museum of American Art, purchased with funds from Eli and Edith L. Broad, the Mrs. Percy Uris Purchase Fund, and the Painting and Sculpture Committee. Photo: copyright Estate of Eva Hesse. Courtesy of the Solomon R. Guggenheim Museum.

the piece has a Kantian "on and on" quality. Hesse was arguably at the peak of her powers as an artist. Twelve days later she had her first operation at New York Hospital. She arrived at the Whitney Museum in a wheelchair for the opening of *Anti-Illusion* in May, where her *Vinculum I*, *Expanded Expansion*, and *Untitled* were on view, together with work by Andre, Morris, Nauman, Serra, and others. The work in series that she was still trying so hard to do in the studio was connected to the idea of perpetuating—and surviving.

The diary of her last year, during which she made six major sculptures and an important group of ink wash drawings, is full of entries about the struggle to work through the nausea and pain. By the end of 1969 she was back in the hospital, her energy sapped by constant pain. Her third operation for the brain tumor, on March 30, 1970, was unsuccessful, just as her exhibition of drawings at Fischbach was drawing rave

reviews. During the last week of May she lapsed into a coma and died, at the age of thirty-four, on May 29. One of the most moving documents she left is an undated statement she wrote out for LeWitt, possibly for one of his exhibition catalogs, about the difference between her art and his, which follows the grids and "systems" in order, "tough stances." Hesse loves their order but has a different perspective. The incisive observation about denial and the "visual presence" is as apt a summary of what we are left with as any critical account of her work: "but I see the fragile sensitivity, the you which is and should be there. . . . never arbitrary, never decoration / the strength of vision and soul is there, it must. We are left ultimately with a visual presence. Why deny that. Can't deny that / It's what we / are left with. A visual presence. Depth: that too we must be left with."[27]

An Art of Meditation: Isamu Noguchi

In his poetic essay on the myth of Orpheus, Maurice Blanchot links inspiration with desire, perfection with failure, gift with sacrifice, and art and the impossible. Its dramatic high point is the moment when Eurydice is enveloped again by darkness:

> The sacred night encloses Eurydice, encloses within the song something which went beyond the song. But it is also enclosed itself: it is bound, it is the attendant, it is the sacred mastered by the power of ritual—that word which means order, rectitude, law, the way of Tao and the axis of Dharma. Orpheus' gaze unties it, destroys its limits, breaks the law which contains, which retains the essence. Thus Orpheus' gaze is the extreme moment of freedom, the moment in which he frees himself of himself and—what is more important—frees the work of his concern, frees the sacred contained in the work, *gives* the sacred to itself, to the freedom of its essence, to this essence which is freedom (for this reason, inspiration is the greatest gift).[28]

This complex interaction of order and freedom, of the ascetic traditions of East and West, and particularly of the sacred and profane is also what makes an understanding (particularly for Westerners) of the work and life of Isamu Noguchi so difficult and rewarding. Using the myth of Orpheus as a surprise twist for the opening of her memoir of Noguchi, Dore Ashton points out that the American-born Noguchi learned about Orpheus before he learned about Izanagi-No-Mikoto, his Japanese counterpart. Ashton points out the importance of Noguchi's collaboration in 1948 with Balanchine and Stravinsky on their masterpiece based on the Orpheus myth (the famous harp used by the New York City Ballet as its

symbol today is a sculpture by Noguchi). The artist wrote: "To me *Orpheus* is the story of the artist blinded by his vision (symbolized by a mask). In the story, animate and inanimate objects are moved by his music. In search of his bride Eurydice, he is drawn to the netherworld by the spirit of darkness. As he descends, the rocks, glowing like astral bodies, levitate."[29] The imminence of death in this myth is echoed in much of Noguchi's sculpture, despite their life-affirming titles. Just three of the pervasive hints of death in the work are his use of black, particularly basalt; his preoccupation with the design, never carried out, of a memorial to the dead of Hiroshima (his design was rejected, some say because he was an American, and Kenzo Tange did the memorial); and the fact that in Shikoku, where he had a studio, the expensive Aji granite he used is primarily used for tombstones. Probably most of the visitors to the wonderful Noguchi Museum in Queens never realize that a tiny memorial half hidden by the ivy in a corner of the courtyard marks where part of Noguchi's ashes are buried; the rest are in Japan.

The outline of Noguchi's life begins with a sad story of intercultural love that mirrors Puccini's *Madama Butterfly*. His mother, Leonie Gilmour, fell in love with Yonejiro Noguchi, a philandering Japanese poet who was in New York looking for an editor to polish up the English translations of his poetry. Even before Isamu was born in November 1904, his father had returned to Japan by way of London. When Isamu was two, his mother had the unfortunate idea of taking him to Japan, only to find that the poet had a Japanese wife and family. He provided a house for them, however, and they lived there until Isamu was thirteen. Then his mother sent him to an experimental school for creative children in Indiana, but he was ostracized (during World War I the school was virtually a military camp, and Noguchi's mixed blood made him a target), so he transferred to a public high school. Throughout his life, Noguchi treaded water between his status as a *gaijin* in Japan and an outsider in America.

After high school he moved to New York, ostensibly to attend Columbia as a premed student, but he ended up quitting school to work with the plasterers and stonecutters, mostly Italian, who helped start him as a sculptor. He gained his first appreciation for Modernism in the galleries of Alfred Stieglitz and J. B. Neumann, an admirer of both Klee and the prints of Hiroshige and Hokusai. Neumann urged him to go to Paris, and in 1927, on a Guggenheim grant, he went on a two-year trip to Europe and Japan. For several months he served as an apprentice and an assistant in the "white laboratory" of Brancusi, where the master put him to work carving limestone bases. The emphasis was on perfection. Shaping cubes and planes under the vigilant eye of Brancusi, Noguchi learned to hone,

or "true," the edge that gave his own sculpture its Ingresque linear clarity and to polish surfaces to a mirror finish.

The Pilgrim Soul

The trip to Paris was the first of many pilgrimages that took Noguchi to Europe and often onward to Asia as well as South America. In 1930 he went from Paris to Beijing, where he studied brush drawing and calligraphy with the renowned Modern Chinese master Qi Bai Shi, and then moved on to Kyoto to work with the potter Jinmatsu Uno. A fascinating large standing bronze piece, *Shodo Flowing* (1962), is based on the fluid brushwork of Chinese calligraphy (*shodo* is Japanese for calligraphy), and a great deal of Noguchi's later lyricism is attributable to the same source. His work as a potter spotlights the significance of the handling of clay for a sculptor. Most historians dwell on the importance of Noguchi's training, especially with Brancusi, in the cutting of stone, but a feeling for terra cotta and clay—Brancusi called it *bifteck*—was a vital skill for the elaborate forms of his career, as it was for Giacometti.

During the second trip to Japan, Noguchi developed a passion for the Zen poet Ryokan and rather oddly compared Ryokan's *mushin* (state of "no-mind") and *mujo* (sense of the impermanence of things) with the innocence of Duchamp, who, along with Brancusi, Mondrian, Klee, and Miró, was a powerful artistic influence on Noguchi's development. The other Japanese concept that Noguchi adopted, from the study of aesthetics was *sabi*, the principle of the beautiful ruin with its patina (*sabi-ya*, a pun on "loneliness") and sense of desolation, which Noguchi related to the purity of Mondrian and Arp. During his first trip to Kyoto, in 1931, Noguchi was entranced by the gardens of Ryoanji, also the inspiration for one of John Cage's great works. "Here is an immaculate universe swept clean," Noguchi wrote ecstatically in his diary.[30] When his reputation blossomed, Noguchi was invited to design gardens for Chase Manhattan Bank in New York, for UNESCO in Paris, and for the city of Jerusalem; and the experience of Ryoanji left its mark on those works.

During most of the 1940s, Noguchi worked in a studio at MacDougal Alley in New York's Greenwich Village, where he did delicate wall reliefs using string, wood, metal, and stone, many of them as fragile as the little plaster figures of Giacometti. He also designed his first lamp during this time—the later designs would be picked up by Knoll. Noguchi's early theater works for Martha Graham, especially the astonishing cagelike "dress" for her *Heart's Labyrinth* (1946), demonstrate the sense of lightness that was particularly important to him during this period. A Bollingen fellowship allowed him to take off again, this time

on a three-year pilgrimage from Europe through the Middle East and Bali and back to Japan, where he married the movie actress Yoshiko Yamaguchi (a disastrous move—his passion for traditional Japanese customs and dress dictated that she wear painful shoes that he insisted were beautiful enough to merit the discomfort, and she rapidly left him). He set up a studio at Kamakura, the first of his ascetic Japanese retreats, and exhibited his ceramics in Japanese galleries. Until 1956 he divided his time between Japan and New York.

The Samurai's Retreat

As Noguchi's reputation in the United States grew (the Whitney gave him a retrospective in 1968), he realized the need to establish a base in New York, so he created an extensive studio in a manufacturing neighborhood on the Queens side of the East River, where he worked in iron, marble, granite, and various other media until the end of his life. Now a garden museum—the garden, begun in 1981, just seven years before his death, is his own design—it is one of the great unknown treasures of the New York art world. Meticulously choreographed, many of Noguchi's greatest sculptures rest in a shady court under birch trees and Japanese pines, surrounded by pebbles and a modest, ivy-covered wall that keeps the noise of traffic out. Perhaps the most precious moment to visit the garden is just after a heavy rain, when the smooth black and deep brown surfaces of the outdoor pieces are glazed with the mirroring sheen of water that brings them to perfection. In the austere, cinder-block "anteroom" to the garden, *The Stone Within* (1982), a quiet standing basalt piece, encapsulates many of Noguchi's philosophical ideas about stone and virtuoso techniques for working it. Like many of Noguchi's vertical pieces, it has the feeling of a torso—a minor indentation in the center suggests a waist, and the sloping shoulder of so many of his pieces, a curved line he shares with Henry Moore, has an unmistakably figural aspect. On the top and at the bottom of the columnar mass of basalt, Noguchi has left the pale, mottled brown "skin" of the original stone in contrast to an echoing area of gray-white indentations, the "stippling" that grips the light in a matte fashion, which Noguchi would painstakingly produce with a chisel. The central passage is a smooth black belt of polished stone, gently curving around a highlighted edge. A third of the way up, the piece is sliced through (the seam is just visible) and then the top is replaced on the base. Noguchi would slice the work, turn the top and replace it, giving the figure a torque that suggests *contrapposto*. Noguchi's comment on the piece concentrates on the original stone and makes an interesting variation on the Minimalist slogan of "truth to

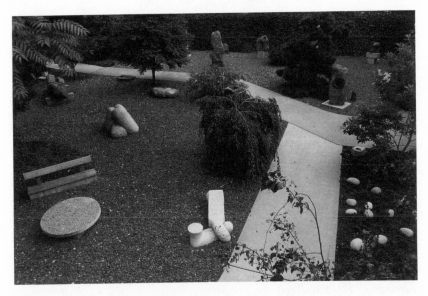

The Isamu Noguchi Garden Museum, just across the East River from Manhattan, is a meticulously choreographed (by the artist) dance of many of his greatest sculptures. Photo: Shigeo Anzai. Courtesy of the Isamu Noguchi Foundation, Inc.

materials": "To search the final reality of stone beyond the accident of time, I seek the love of matter. The materiality of stone, its essence, to reveal its identity—not what might be imposed but something closer to its being. Beneath the skin is the brilliance of matter."[31]

In a shady part of the garden court an understated white granite form made from a pile of the prized Aji stones scarcely attracts notice. It is called *The Illusion of the Fifth Stone* (1970) because only four of the stones, locked tightly together, can be seen at one point, recalling the illusion of the rocks at the temple of Ryoanji, where one group of rocks is always hidden. Noguchi left the "skin" on these gracefully rounded stones, whose edges create a shadowy, Mondrianesque grid within their nearly square facade. Another extraordinary example of the Aji granite is an almost disturbing globular form, *Childhood* (1970), that rests on a wooden pedestal in a corner room (nearly always deserted) on the second floor of the building. Like the rounded, headlike "apparition" of his *Emanation* (1971), the work refers to the body, specifically the pregnant belly; and Noguchi relates it to the "strange anatomy" of Akhnaton, the Egyptian god after whom Philip Glass also created an important work. Noguchi's enigmatic comment on the piece: "His image troubles our sense of limits."

From coast to coast, Noguchi's admirers all have their favorite pieces

or gardens. For New Yorkers, the perfectly still water on the surface of the fountain, gliding over a firm edge to drop musically on the stones below, in the Japanese wing of the Metropolitan Museum is a miracle of sculptural technique. Others prefer the massive *Momo Taro* (1977–78) at Storm King Art Center, which combines dramatic scale with a perfect site (it was made for the hill on which it rests, overlooking a long valley on one side and a grove of David Smith pieces on the other). The title comes from the Japanese legend, or *monogatari*, of the little hero Momo Taro, who emerged from a peach to answer the prayers of an old couple who could not have a child and then slew a demon that was terrorizing the countryside. The huge, thirty-ton round boulder of white granite, found on a stone-hunting trip to the foggy island of Shodoshima, had been split in two where it was found in order to be moved back to Mure. One of the workmen, spotting a hollow area in the boulder, compared the split halves of the boulder to a peach and the story of Momo Taro. Noguchi carved further into the hollow, making an ovoid cavity that visitors to Storm King love to climb into—precisely the invitation that Noguchi was extending. He also liked the synesthetic notion of the kind of echoing sound that would emerge from it. He called *Momo Taro* "a place to go . . . a metaphor for man as an end and a beginning . . . a mirror to the passage of the sun." The surface of the other half of the peach is polished to a mirror finish, and a slight concavity echoes the sun's form in its center.

The other seven pieces are deployed on the ground around these standing halves, deployed according to an experimental process of arrangement (not according to plan or drawing) by which Noguchi turned and swung the rocks in different directions until he liked the way they interacted. The group is a marvel of diverse textures, from the slick polished surface on the face of the large round forms to the craggy, unfinished crusts of the prone pieces, scored rhythmically by the drill marks that separated them when they were quarried.

The garden in Queens is not the only refuge Noguchi created. Beginning in 1971, he carefully constructed a historic haven at Mure on the island of Shikoku, which is famous in Japanese literature as the backdrop for the epic *Tale of the Heike*. The studio compound that Noguchi built there was a dramatic anachronism, with a two-hundred-year-old samurai's home and *godown*, or storage house, as its architectural highlights. Ashton describes this quiet retreat, which turned its back on the modernizations of contemporary Japan:

His two-hundred-year-old house, modified ingeniously for modern life, faced the distant mountains, hovering over the rice fields and falling toward the sea, and was framed closely by a great wall and a stand of bamboo be-

yond his veranda. Choosing each element over a period of years, Noguchi shaped his place as a sculptor, adding a void here, a volume there. Perhaps his most felicitous find was what was to become his main studio: another venerable structure of adobe and wood of extraordinary harmony in its proportions. This reconstituted godown, or storage house, with its classic simplicity—the cut of the sliding doors; the perfect horizontal molding, repeating the firm horizontal of the molding beneath the roof and the classical ridge cresting its tiles; the discreet granite stone base from which all members, including the beautiful pillars in the interior, rose—is of a breathtaking beauty.[32]

In a world of busy, loud statements that call themselves art, Noguchi's sculptures do seem anachronistic, for all their post-Brancusian modernity. "Seek the dead center of gravity," Noguchi urged himself in a note written in 1986. This dead center had a meditative, ascetic stillness to it. In his preface to the guidebook for the museum in Queens, Noguchi urged those who followed to comprehend how time is figured in his work: "The making of an art of meditation does not allow for conception or transferral. It comes from the moment, the moment which may take years. To counter the passing, I would seek the enduring. From the depth of time-consuming hardness to find the lasting and essential, by using modern tools on the oldest medium, there is an attempt to push the discovery of sculpture onward a notch."[33]

Present Perfect: Donald Judd

Under the relentless summer sun, a breeze that tosses the long dry grass and sends a tremor through the occasional stand of cottonwood is virtually the only sign of movement for miles in the West Texas panhandle. Even a gas station would seem like an oasis of culture in this deserted place. How astonishing it is, then, to find in the middle of this wasteland, on the site of a former military base near a "town" called Marfa, a veritable paradise of art—if you love Minimalism. This three-hundred-acre utopia is the work of Donald Judd, the high priest of Minimalism, whose massive rectangular sculptures march in precise formation inside and outside the glass-lined, renovated World War I–era aircraft hangars that are the core of a studio compound surrounded by labyrinthine red gravel paths and nine-foot adobe walls.

Like the Taliesin of Frank Lloyd Wright, Noguchi's studio compound in Mure, Martin's ranch in New Mexico, and Twombly's austere villa in Bolsena, Judd's retreat is eerily anachronistic. While Noguchi chose the

samurai epoch, Judd has frozen art history in the 1970s (with the help of the DIA Art Foundation, which added the rest of the army base in a major purchase completed in 1981), building the equivalent of a presidential library to give the Minimalist aesthetic he championed a permanent shrine. When a movement becomes a school, its last best hope is to be preserved as Minimalism in Marfa or to wield a lasting influence on later artists (in the case of Minimalism, the beat goes on through the work of Heather Hutchison, Peter Halley, Richard Serra, Robert Ryman, Jannis Kounellis, Cristos Gianakos, and others who pass the torch from one generation to the next).

Inside the hangars are one hundred independently configured mill aluminum boxes, each divided into sections by diagonal, horizontal, or vertical partitions of aluminum. The first of them presents itself in full scale, gleaming in the flood of sunlight, the dark recesses of its empty core just visible over its facing edge. Into the distance, in three precise columns laid out on the polished concrete floor, the rest of the "boxes" recede toward a blank wall in a stunning array of perfect right angles, polished surfaces, and mathematically correct proportions. Outside in the fields, massive, similarly configured concrete works stretch, seemingly, to the horizon (the eight-by-eight-by-sixteen-foot boxes cover a half mile). In Marfa itself, another building holds an installation of John Chamberlain's sculpture, and six of the fort's barracks are for works by Dan Flavin, Walter DeMaria, and other artists of the same school. All is geometry, order, line, and light. It is above all a *constructed* environment, measured out to the millimeter, squared, honed, and polished to perfection. Out in that desert, Minimalism reaches its apotheosis in an elementary demonstration of the Platonic ideal.

The unlikely preamble to Judd's devotion to geometry was a conventional course in life drawing at the Art Students League in New York after Judd had served in Korea as part of the Army Corps of Engineers until late 1947 (he had enlisted right after completing high school in New Jersey). He combined a rigorous program in painting—mainly figure, followed by landscapes—at the Art Students League, with an undergraduate major in philosophy at Columbia, where he came into contact with the strict adherence to verifiable experience and truth value that are the hallmarks of the empiricism of David Hume. Judd would eventually return to Columbia for graduate study in art history, and his academic training in both philosophy and art history provided the intellectual underpinnings for his extremely influential art criticism, beginning in 1959, in the form of reviews and essays (as many as fifteen a month) for *Arts* magazine and other publications. In the great tradition of the artist-writer, as exemplified by Newman, Ad Reinhardt, Robert Motherwell, and in our

time, Halley and Stella, Judd's perceptive and utterly fearless articulations of the main problems and achievements of the art of his time are primary sources for any historian of Minimalism. His rallying cry was the need for "objectivity," which he construed in terms of the "specificity" with which forms and materials are matched. As he wrote: "Three dimensions are real space. That gets rid of the problem of illusionism and of literal space, space in and around marks and colors—which is riddance of one of the salient and most objectionable relics of European art. The several limits of painting are no longer present. A work can be as powerful as it can be thought to be. Actual space is intrinsically more powerful and specific than paint on a flat surface."[34]

Judd's early paintings of the late 1950s and early 1960s were, like his critical principles, strongly formalist. He has a very strong sense that he must "get rid of the problem of illusionism and of literal space, space in and around marks and colors" as a relic of the European tradition. The heavily textured, flowing forms of the oil or Liquitex on canvas yielded a group of extremely heavy relief works in 1963, using cadmium red light oil, with wax and sand embedded in it, built up on Masonite or curved metal, sometimes with geometrically severe plastic or aluminum objects (like a yellow baking pan) embedded in them. In terms of their color and texture they offer hints of the stucco and Day-Glo of Peter Halley. The three-dimensionality of the reliefs was pulling Judd toward sculpture, and his earliest floor pieces (of 1963 and 1964) retain the cadmium red surface, this time on wood boxes with iron pipes embedded in them. Early in his compositional practice he fixed the rule that a single color would accompany a single form, becoming identical with the surface and even turning the whole "specific object" into one surface—echoing the attention to flatness and surface in the painting of the time. Closely related to the paintings of Newman, the closed wooden boxes were divided, sometimes cut to expose the hollow space inside, according to mathematical schemes.

The most distressing thing you can do in the presence of a collector of Minimalist sculpture, by Judd or DeMaria or Morris particularly, is to leave a greasy fingerprint on the polished surface of stainless steel, aluminum, or Plexiglas that carries the anxious burden of perfection. A classic Judd "stack" is a column of six, nine, ten, or twelve units, aluminum or steel, but occasionally brass, hung like a relief on the wall, starting a few inches from the floor and ascending like a ladder, usually at twelve-inch intervals. Each unit has a panel of clear, colored Plexiglas built into the top, bottom or back of the "shelf" to add a chromatic element. The most effective "stacks" often have aluminum units with dark blue or black Plexiglas deep in their recesses. The shadowy recesses and literally

empty spaces are a crucial element in the composition, as is the rhythm set up by the repetition of the unit. The "equality" of his units and the attention that the artist pays to their spacing add to the overall aesthetic of "depersonalization" that Judd espoused. As Philip Glass realized during a powerful revelation brought about by his contact with Indian raga— that "all notes are equal" and a virtually endless chain of equal units could be possible—Judd also set up a "pedal point" of equally weighted units.

The ascetic impact of cold, hard steel is one thing; the securing of the space in which those "positive" forms will function is another. Judd's work demands a particular environment. The pure "white cube" of the gallery is one context in which the tight control over color and shape can be framed. The role of empty space became more important in the open steel floor pieces that Judd began doing in the mid-1960s, using cold-rolled steel in ten or five framelike units that are crowded on the floor at intervals of five or six inches. The viewer can see from one end of the gallery to the other through their skeletal, concentric apertures. Another perspective is opened up by the glassed-in spaces and open fields at Marfa, which dramatically extend the empty spaces between, around, and within the windowlike apertures of the works.

Virtue Like Jade: Yu Yu Yang

Oddly enough, it was a Buddhist nun, complete with shaved head and gray robes, who led me to my first meeting with Yu Yu Yang. We were not in some idyllic, incense-filled courtyard of a silent mountain temple in his native mainland China, nor in Taiwan, where he lives and has his own sculpture park, but on the Upper West Side of Manhattan. Just to add to the irony, I made the acquaintance of the nun through the intermediary of the only Chinese nymphomaniac I have ever met, who was a frequent guest at the nun's apartment. None of that makes sense as an explication of Yang's subtle sculpture, of course, except as a way of pointing out one rather surprising fact that I can confirm from my own travels and experience: Wherever you are in the Chinese-speaking world, whether you are deep in the countryside of the mainland, in the streets of Hong Kong or Singapore, in the heart of Chinatown in Boston, New York, or San Francisco, or anywhere on Taiwan, if you encounter people who know even a little bit about art, they will know the name Yu Yu Yang, or Yang Ying Feng as he is sometimes called on the mainland. Like the architect I. M. Pei, a contemporary and friend with whom he has been professionally associated through a series of major commissions,

Yang's degree of recognition worldwide arguably makes him the most famous artist in the Chinese-speaking world.

Yang is considered the dean of Taiwan's artistic community, yet much of the impact of his work is yet to be felt. Like a man uttering great truths in a whisper, he demands an attentive audience, which will be rewarded as the full implications of his deceptively simple works disclose themselves. As his titles suggest and his own meditative comments on the work confirm, Yang works within the framework of a deeply felt and elaborate metaphysics, shaped by a lifelong commitment to Buddhism both as religion and as an aesthetic matrix. How many contemporary artists in this secular day and age would dare to give their work titles like *Universe and Life*, *Flight of Absolute Virtue*, or *Virtue Like Jade*? These themes are carried not just by the sincerity with which they are expressed but by the technical wizardry that Yang has attained through a long and thorough training in the sculptural language of Europe and China. As his monumental work in particular attests, Yang is a trained architect. He is currently at work on a monumental commission from the city of Paris for a site-specific outdoor work in honor of music, which will probably become a major attraction for art-loving tourists in the years to come. His understanding of architecture is a vital factor in his attraction for contemporary architects, particularly the renowned I. M. Pei, who has commissioned several of Yang's works, including *Advent of the Phoenix* for the Osaka World Expo in 1970 and *East West Gate* for the Orient Overseas Building in lower Manhattan.

Yang's relation to the tradition is enigmatic. While his materials (particularly stainless steel) and the austere forms he chooses are obviously up to the minute, the aesthetic and symbolic codes from which Yang's thinking arises are ancient. This dual character is particularly evident in the case of a work like *Modern Symbol* (1992) and *Lunar Permanence* (1991), which capture two of the most enduring symbols of Chinese art and poetry from earliest times—the moon and the phoenix—in a clean-edged, contemporary sculptural idiom. The title of *Lunar Permanence* seems ironic, given that nothing is more emblematic of change than the moon, at least to Western eyes. Yang's sculpture makes the disk of the moon the focal point, allowing it and the phoenix that curves around it to rise slowly from the earth, an effect that is brilliantly achieved by the subtle angle at which the background curve of steel lifts from the base. The convex space surrounding the moon is reminiscent of the curved canopy that surrounds Old Master portraits, but into it Yang has cut an "eye" that aligns itself in an upward progression from the moon that extends into the heavens. One of the subtle touches of the work, one that would be lost to a cursory viewer, is the way in which the disk of the

moon is slightly stretched and curved itself, giving it the sort of distortion that Salvador Dali used to make his painted disks, such as the pocket watches, more interesting. The pictorial arrangement of the moon and the aperture is also reminiscent of the desert paintings of Georgia O'Keeffe, such as *Pelvis with Shadows and the Moon* (once owned by Frank Lloyd Wright), which combine emptiness and silhouettes in quiet masterpieces that use a similar vocabulary.

The same sense of movement can be felt in *Dragon Song* (1991) and *Dragon's Shrill in the Cosmic Void* (1991), which use a serpentining and twisting curve to mimic the motion of the legendary symbol of Chinese power. The traditional fireball that the dragon chases is set between its head and tail, giving the motion a perpetual cycle. Another subtle touch adds a powerful dimension to this kinetic illusion: Yang allows the "tape," or band, of the dragon's body to become thicker and thinner, as though it were pulsing along. In *Evergreen* and *Renewal* this continuous band follows its perpetual course around a "planet" represented by a perfect mirrored steel sphere that, in musical terms, sounds the strong top note of the composition.

The apotheosis of this ribbonlike movement is found in the complex knot of *Growth* (1988), a partially abstract monumental piece that imitates the powerful forces at work in the root system of a tree as it emerges from the earth. Like the "knots" in Brice Marden's versions of ancient Chinese calligraphy or the rounded knot forms in the center of Di Suvero's major pieces, the overlapping intersection of curving forms in *Growth* attains its ascetic effect partly through the perceptual difficulties it creates. You know the hardness of the steel as a fact, yet it flows and curls around itself like satin ribbon.

Where many artists of our time derive their inspiration from other art (or money), Yang's true source is nature itself. Even if his primary material, stainless steel, seems more industrial than stone or wood or clay, he has not cut himself off from a deeply committed sense of the environment and what it means. The bridge between art and nature is form. Commenting on *Cosmic Encounter* (1992), Yang notes, "It is shape that brings all things together and sends them apart."[35] The relationship between square and round, convex and concave, or empty and solid is an erotic one in the old sense of the term, as an expression of two forces brought together. One of the most interesting families of work by Yang is represented by the relatively complex standing groups, such as *Global Village* (1991) and *The Universe and Life* (1992). In *The Universe and Life*, for example, an elegant column of stainless steel reaching to the sky is pierced by an eyelike circular hole and surrounded at its base by a swirling brood of related forms whose polished surfaces catch the passing

spectators and for an instant transform them into works of art. Note the contrast in textures between the perfection of the mirrored surfaces and the "flat" duller surfaces of the silvery planes. This seemed especially remarkable to me when I shook the sculptor's hand for the first time and felt the grainy, rather rough texture of his skin.

The "stainless" quality of Yang's material lends itself to the balanced dialogue between the separated and twisted segments of a circle in *Virtue Like Jade*, recalling the spiritual aura of the treasured Chinese jade *pi*, circular forms that since antiquity have represented harmony. As Yang explains, "The splendid heritage of Chinese culture remains the source of my inspiration, and the life aesthetics of honoring Nature's simplicity, harmony and health in the Wei and Chin periods in China stands as the spiritual nucleus of my lifescape sculptures." As we discussed the inherently ascetic nature of pieces like *Virtue Like Jade*, Yang impressed on me the importance of his many pilgrimages to the sacred sculptures of Le Shan along the Yangtze river, where he renews his attachment to ancient connections among religion, art, and the land.

After Minimalism, sculptors in particular had to face the challenge of surpassing its purity or opening a door into a different realm. Yang's answer to this problem is found on Wall Street in Manhattan, where his *East West Gate* (1973) stands. While Yang could be related to the pure idealism of Minimalist sculptors like Walter DeMaria, Robert Morris, and Donald Judd, particularly through their use of meticulously engineered steel forms, he is not a Minimalist. Yang's forms *humanize* the ascetic ideals of Minimalism, giving them movement and biomorphic qualities that the purely geometric, hard-edged art lacked. Yang does not mean to insist that we give up on rationalism. The place of nature in the equation is restored in his work. In that regard, Yang appears to have a closer relationship to other masters of twentieth-century sculpture, including Noguchi, Moore, Calder, and Di Suvero. The affinity with Noguchi is perhaps most obvious, not simply because both came from an Eastern aesthetic and never lost their respect for the concepts of *hsu* (the void) and *shi* (the real or solid) but also because both are master carvers in stone, as Yang's *Mountain Grandeur* and other works demonstrate. The subtle use of *mimesis*—Yang's allusions to the planets, the Chinese moon gate, the dragon and the phoenix, like Moore's use of the reclining nude—gives viewers who struggle with abstract art a representational toehold on the concept behind the sculpture. Finally, one can correlate the gestural, painterly aspect of Yang's work, such as the celebrated spiral of his *Dragon* or the flamelike paint strokes of *The Return of the Phoenix*, with the lyrical expressiveness of Di Suvero's massive sculptures, which have always been the three-dimensional counterpart to

the great gestural Abstract Expressionist paintings of an earlier time. In these works, Yang brings the joyful liveliness of the painter's or calligrapher's brushstrokes into his sculpture, defying gravity and the apparent limitations of metal.

Yang's education and early career had an unusual international dimension, particularly for those of his generation. Born in Taiwan, he completed his undergraduate studies in art at FuJen University in Beijing, went to the Tokyo Art Academy to learn architecture, and helped the Catholic church rebuild FuJen University after World War II. As a reward, he was offered a trip to Rome, where he remained for three years, until 1966, to study art. In Italy his paintings and sculpture were widely exhibited, and he won gold and silver medals at the Olimpiade d'Arte e Cultura in 1966. After returning to Taiwan he completed commissions for major sculptures in Japan, Lebanon, Saudi Arabia, Singapore, and Hong Kong. Americans had their first glimpse of his talent in 1973, when his profoundly symbolic *East West Gate* was unveiled in front of Pei's Orient Overseas Building. At home in Taiwan, where he is recognized a pioneer not only in sculpture but also in the use of lasers in art, he established the Yu Yu Yang Lifescape Sculpture Museum, a survey of his career from *The Philosopher*, which brought Yang one of his first awards in Paris in 1959, to the most recent work.

In a book about Yang published by the National Museum of Taiwan there is a stunning photo of the sculptor sitting cross-legged in front of a monumental statue of the Buddha on which he is putting the finishing touches. In the foreground his wife kneels, nursing his second daughter. The gold and sepia tones of the photograph and the archaic splendor of the statue Yang is carving as well as the ancient scroll behind him, all belie the date of the photograph: 1955. It is as though we have a sudden glimpse of the intimate world of the artist in China in Yang's beloved Wei dynasty more than a thousand years ago, when the formal vocabulary that is the source of so much of Yang's early sculpture was itself in its infancy. Aside from the usual curiosity that a document like this raises about the context of the artist's studio and home, the type of art and decorations around him, the natural light flooding a tall window behind him, the spare but elegant traditional living quarters, and the old wicker armchair and reed mats of the home, the photo serves a deeper purpose in the study of Yang's work and career. It underscores the sense of timelessness in Yang's thought, even to the point of presenting an apparent anachronism. Here is an artist we can meet and greet ourselves, and his hand is finishing an "ancient" Buddhist statue in a traditional Chinese home filled with the basic tools and art of an earlier epoch.

Far from being a nostalgic evocation of antiquity—a hokey attempt to

invoke the atmosphere of the past—the photo shows Yang participating in the continuing tradition of sculpture as an expression of both metaphysics and of materials. Nothing could present the impressive "rootedness" of Yang as an artist and an individual better than this photo. It shows the tranquility of traditional Chinese home life, and across a barely perceptible threshold it depicts a studio where the artist works on his individual dreams. Who would guess, looking at this peaceful and timeless scene, that his career would lead to massive stainless steel sculptures mirroring the hyperfast chaos of Wall Street, Paris, and Tokyo in the 1990s?

The Noiseless, Patient Sculptor: Mark di Suvero

On the Queens side of the East River, almost directly opposite the notorious Rikers Island prison, is a strange pocket of scruffy weeds bounded on one side by a twisted, rusting chain-link fence and on the other by a debris-strewn crescent of quiet water where the river makes an indent. It is easy to breeze right by the faded official Parks Department sign letting you know you are in the Socrates Sculpture Park and to assume, casting your eye around the rusting hulks of nondescript machinery and the hillocks of dirt and debris, that you are in a junkyard. A few steps further into the deserted and neglected yard, suddenly you spot what seems at first to be a mirage—soaring off into the sky, silhouetted against the geometry of the Manhattan skyline, is a huge, lyrical (as yet untitled) sculpture by Mark di Suvero, freshly painted a vibrant red and appearing for all the world as if it had been plucked by a massive helicopter out of a SoHo gallery and hidden here by enormously ambitious art thieves. On the hazy summer day when I saw it, with Manhattan melting into a Morandi still life on the other side of the wind-whipped river, a hurricane swept in from the west, turning the sky a metallic gray shot with deep blue, against which the red of the di Suvero glowed like a poker drawn from the fire.

No attentive student of Modernism in its many guises—sculpture, poetry, music, fiction, painting, and collage—could fail to be struck by the almost allegorical significance of the scene, which embodies that theme of art rising from the ruins of the postwar (pick your conflict) consciousness. From Wallace Stevens's "Man on the Dump" to A. R. Ammons's recent volume, simply and unappealingly called *Garbage*, from the *Merz* collages of Kurt Schwitters to the crushed cars of John Chamberlain and cobbled-together architectural detritus of Louise Nevelson or the now scruffy studio and combine works of Robert Rauschenberg, and from the

early experiments in ambient sound by John Cage to the recent monotony of Luciano Berio's speech music, the examples of art made from detritus are legion. Di Suvero himself uses the rusting hulks of old trains and abandoned dairy equipment, a steam shovel's jaws, a "dead crane," or old, twisted wrenches as his working materials. His taste in poetry, as exemplified in a delightful anthology he created that pairs photographs of his works with short poems or extracts, runs toward the aesthetic of Stevens and Marianne Moore, finding the sublime in the common and the discarded, including Shakespeare's wonderful sonnet ending, "Lilies that fester smell far worse than weeds," along with the opening of Dante's *Inferno* with its *selva selvaggia* (mired in bramble and thicket), which Di Suvero pairs with a soaring, open sculpture of his called *Vivaldi* that is bisected by a forty-foot-long horizontal beam that runs like a typical Vivaldi pedal point through the heart of the work.

The afternoon of the hurricane was not the first time I had seen the red Di Suvero. Three months earlier in 1995, in the midst of one of the worst (more charitably, most impoverished) gallery seasons in recent SoHo history, it had been the must-see attraction in the gleaming, perfectly white downtown space run by Larry Gagosian, the power broker of contemporary art dealers. With its dramatic, upswept beam nearly grazing the lights of the laboratory-like former garage that serves as the gallery, its front wall removed so that the crowd in the cobblestoned street could stop and look in awe, the shiny red sculpture looked like a fighter jet in its hangar on the day before battle or like a caged dinosaur. Its sleek lines, precisely calibrated angles and bold red surface against the white walls were the object of envy among other artists and of awe among the jaded and elsewhere-disappointed gallerygoers. Whether it sits out in a windstorm like a forgotten piece of machinery or is carefully encased like a jewel in the stillness of a gallery, the work remains a fascinating hybrid between cast-off industrial materials and artistic perfection.

Yet garbage into gold is not the whole story of Di Suvero's transmutations. In two important ways, the presence of the big red sculpture on the deserted riverbank outside of town embodies the strangely dual nature of the ascetic in contemporary art because it juxtaposes the impoverished means with the perfected end. The humility of the context and of the materials makes the leap of the art all the more dramatic. By the time the red paint, or the patina of rust that colors Di Suvero's greatest work in a signature brownish red tone, has covered the beams, they have submitted to gestural ends that are far from their original nature. A ton of metal turning in the wind balances on an invisible center of gravity as sharp as a knife's point, the laws of physics respected but pushed as well. Like David Smith nudging his bits of metal on the floor, Di Suvero at work combines

an improvisatory receptiveness to the materials around him with a sense that their ultimate combinatorial possibilities narrow as the process continues. As Di Suvero talks about that process of bringing objects together, his gesturing hands clasp and unclasp in emphasis. "You are trying to go with it, and the piece comes together. Out of the ashes of the experience you pull the piece that you give to the people," he explains.[36]

The process of hanging "a sign in the sky" (as Di Suvero likes to say) involves a great deal of movement. The angles and gestures of the finished piece, like those of Joel Shapiro, connote movement. To watch the beams and structures as they are pulled into place by a giant crane is to see them trace arcs in the air that leave, thanks to memory, the indelible impression of movement on the finished work. Like Giacometti, Di Suvero walks with a limp around the fields or yards where he assembles the pieces, and his crew continually swarms all over the massive, thirty-foot-high structures while they are in progress. He builds moving parts into many of them, pivoting on huge joints or swinging from cables and chains. Scale means everything to an understanding of Di Suvero. The view of the great dinosaurs grazing in their meadow from the hill at Storm King Art Center is entirely different from the experience of wandering among them and looking up at them from below, humanizing the works, making them more lyrical and more easily apprehended. Di Suvero himself points to a particularly Giacometti-like moment in his development when he was working on a group of works along a seven-mile stretch of beachfront in California and was able to see them diminished in size to the illusion that they were only inches tall, a trick he plays on their forms that echoes Giacometti's drawing technique.

In Di Suvero's *Open Secret*, his anthology of poetry paired with photographs of his work, asceticism is a constant theme of both the texts and the images. Opposite an image of the graceful, seventy-five-foot-tall red *Exstase* (1991), an elegant tower that supports a triangular space cradled in its tripod of beams, Di Suvero places Walt Whitman's poem "A Noiseless Patient Spider," calling our attention to the solitude of the isolated sculptural image, the thin "filaments" of its gestures and the importance of the "vacant vast surrounding." The juxtaposition sheds light on both sculpture and poem: "It launch'd forth filament, filament, filament, out of itself, / Ever unreeling down, every tirelessly speeding them."[37] The other pairings of sculpture and poetry are just as delightful and enlightening. Among the many pieces that Di Suvero has dedicated to poets are major works titled *Lao Tzu* (1991), *Rumi* (1991), and one of his masterpieces, *For Marianne Moore* (1978). The texts by these writers that Di Suvero chooses tend to emphasize the ascetic dimension of their thought. For example, the passage from Lao Tzu's *The Way of Life* that Di Suvero

includes in the anthology is a meditation on origins devoted to "the measureless untouchable source" of life, which appears to be dark and empty but which actually "brims with a quick force farthest away and yet nearest at hand from oldest time unto this day."[38] The work is a particularly complex monumental sculpture, nearly thirty feet high and more than thirty-six feet long with two bases of support. Within its tangle of circular and angled forms, Di Suvero has framed geometric patches of sky that, in their emptiness, not only echo the Lao Tzu but also draw attention to an aspect of his work that Di Suvero continually emphasizes in conversation: the spaces that it brackets or frames for a viewer looking up and through the works.

Rumi looks like a solitary figure in silhouette, rising at an angle to the ground and locked in place with an upper section of the same length by a horizontal bar that pierces the two. It picks up on the mystic poet's vision of "Unmarked Boxes" that, like the cells of prisoners or monks, hold "God's joy." The poem ends in the interplay of wealth and poverty, sublime beauty and common objects, that makes Rumi one of the enduringly popular ascetic poets even of our time and the ideal bard of Di Suvero's work:

> There's the light gold of wheat in the sun
> and the gold of bread made from that wheat.
> I have neither. I'm only talking about them,
> as a town in the desert looks up
> at stars on a clear night.[39]

The Art of Public Withdrawal: Bruce Nauman

It is Sunday afternoon, you've browsed through the last section of the *Times*, and all you want now is a nice, relaxing afternoon in the Museum of Modern Art, strolling from Seurat to Matisse by way of Kandinsky, perhaps wandering upstairs to sit surrounded by the serenely hovering clouds of color by Rothko. More than anything, you want the quiet comfort of the Modernist tradition, framed in gold, as you have studied it weekend by weekend over the years. As you meander from gallery to gallery, however, you cannot help feeling disturbed by a distant shouting—or is it something crashing? There seems to be no place in the museum the annoying noise cannot pervade.

Forget about peace and quiet—the Bruce Nauman retrospective is in town. The noise you hear could be the soundtrack for *Learned Helplessness in Rats* (1988), which features a video of a rat caught in a Plexiglas

maze, with an identical maze (no rat) on the floor in front of it, next to a video monitor playing a nonstop film of a rock-and-roll drummer tormenting a drum set. It could also be *Clown Torture* (1987), an agonizing video of a character in clown costume shouting at gallerygoers from four walls. In another room, also playing nonstop, is *Anthro/Socio (Rinde Facing Camera)* (1991), which uses four monitors in the center of the gallery and the four walls of the gallery to show the head of a bald man (his name is Rinde Eckert, and on one wall he appears upside down) bellowing a plain chant–style text with a libretto that includes, "Help me, hurt me sociology: Feed me, eat me anthropology." You will not be able to shut these completely disturbing noises out, no matter how hard you try. "All those messages have to do with making contact," the artist insists. Then he adds, with regard to *Anthro/Socio*, "My art is a more general appeal to put art outside yourself, where it becomes something you don't have any control over."[40] One of the toughest of these works is *Get Out of My Mind, Get Out of This Room* (1972), which is an audiotape of the artist ordering us out of his gallery. It would be hard to find a more ascetic approach to the relationship between the audience and his public than that.

Severe rules of distance from the viewer, repetition that strains the limits of even a machine, explicit pain and torture, mind-numbing monotony, the prison situations, the antiaesthetic impoverishment of materials, the seemingly perverse desire to make things hard or annoying—these are all the qualities that make Nauman one of the least appealing but most important examples of asceticism in contemporary art. The one idea that is central to a consideration of Nauman's asceticism, however, is summarized in his own title for a piece from 1970: "Withdrawal as an Art Form." Like Pater's "delicious recoil," like the restraint of Walter Abish's fiction or Elliott Carter's string quartets, the privileged moment of retreat is the center of a wide-ranging exploration of sculpture in various media: sound, light (through neon), performance art (the rhythms of the walking pieces, partly based on reading in Beckett, can be directly related to the ascetic use of rhythm in poetry), and texts.

As they hit each room of the retrospective, the art veterans would fire off the name and date of the museum or gallery show at which he or she first saw the piece, attesting to the extraordinary longevity of Nauman's influence on contemporary painting, sculpture, installation and conceptual art, film and video, and even music. From the historic perspective, it is just as hard to maneuver around Nauman as it is to hide from the sound of his video works when they are anywhere in the building. Now living with the artist Susan Rothenberg at a desert ranch outside Pecos, New Mexico, Nauman has been for such a long time associated with the

avant-garde of New York and Los Angeles that few realize he is origi-
nally from Fort Wayne, Indiana. His father, an engineer, worked for
General Electric. From his early years he played the piano and classical
guitar as a boy and was initially a mathematics and physics major at the
University of Wisconsin, where he also studied classical music, art, and
philosophy (particularly Wittgenstein). He switched majors, graduated
with an art degree, and moved on to the famous graduate program in
fine art at the University of California at Davis, where he was Wayne
Thiebaud's teaching assistant for life-drawing classes.

The reasoning behind Nauman's abandonment of painting opens up a
window on the ascetic core of his approach to art. As Nauman ex-
plained, he loved moving around and manipulating the traditional mate-
rials of painting (after the example of de Kooning, everybody's hero). But
he saved his greatest admiration for Johns, who was, in Nauman's view,
"the first to put some intellectual distance between himself and his phys-
ical activity of making paintings." This is the ascetic streak in him that
eventually won out. He renounced the pleasure of paint because it "got
in the way. I still don't trust any kind of lush solution, which painting
was, and so I decided—it was a conscious decision at some point—that I
was not going to be a painter."[41] That was when Nauman came to the
idea of "Withdrawal as an Art Form," the title of a text he prepared for
Artforum in 1970 in which he discussed his experiments with "sensory
manipulation and overload." He had already made some of his most ar-
resting, ascetic sculpture, such as the clever visual pun *From Hand to
Mouth* (1968), a greenish-colored wax sculpture cast from his wife's
mouth, shoulder, and arm, which hangs from the wall at about the same
height as the head and shoulder would ordinarily reach. Technically in
the tradition of George Segal and others who cast life-size figures, the
piece pulls together a number of Nauman's themes, including speech and
the simple gestures of the body, as well as a feeling of impoverishment
that is reminiscent of the thin arms and legs that Giacometti used to
make. Nauman adopted the technique of *moulage* from police work, but
he altered the cast by shortening the arm and leaving stitches on the
elbow. It carries the traditional resonance of a fragment of an ancient
Greek torso. As a silhouette, it recalls the solitude of Giacometti or Johns.

Although *From Hand to Mouth* is probably the most gripping of the
"cast" images that Nauman made, it is important to realize that there is
a large body of work by Nauman that uses this principle. In a stunning
juxtaposition, the Whitney Museum once hung a long vertical Nauman
fiberglass and polyester resin work, *Six Inches of My Knee Extended to
Six Feet* (1966)—made by casting a plaster mold over a clay form created
according to a multiplication of his body measurements—side by side

with Barnett Newman's vertical *Onement.* Not only did the form and brownish tone of the Newman zip correspond to those of Nauman's piece, but the spare economy of the two pieces, so far apart in conceptual terms, was astonishingly close. The other cast pieces, which Nauman called "traps," "containers," or "storage capsules," were abstracted from precise measurements taken of his own body and rendered in wax over cloth, plaster (sometimes painted in bronze color), and even white neon in a manner that suggested bones. The degree of abstraction varies from the precise wax model of folded arms topped by a rope tied in an echoing knot that Nauman did in 1967 (an ascetic image of closure suggesting imprisonment) to the geometric, body-annihilating galvanized iron vertical in three curved parts, standing six feet high, titled *Storage Capsule for the Right Rear Quarter of My Body* (1966).

These works also have connotations of torture and pain, which is one of the profoundly ascetic elements in Nauman's art. Other artists have mined this territory recently, with varying degrees of success. One of the most interesting of these sculptors, because he is able to make objects of great beauty from materials that offer real pain, is a young American named Tracey Henebeger, whose Brooklyn studio is filled with silhouettes of diving human figures (reminiscent of the Matisse cutouts of swimmers as well as works by Brancusi and Giacometti) that are, on close inspection, rendered in ordinary three-inch roofing nails or other sharp-edged hardware. The most striking is a five-foot-long floor piece called *Simple Pleasure* (1992–93), literally a bed of nails in the form of a human figure. The tall Henebeger, who stands on the piece in his stocking feet, explains, "It is a completely ascetic work of art because it taps that brutal aspect of life—the vast difference that exists between our expectations and their meager consequence. This can tear us apart."[42]

One of the prevailing ascetic qualities of Nauman's early pieces is their emptiness, echoed in the later work by the use of taxidermists' molds of deer, wolves, and other animals swinging from the ceiling or the colored wax heads hung upside down or in pairs by wires from the ceiling. The mask is a constant point of reference, particularly with respect to his approach to desire and solitude. The text for *Consummate Mask of Rock* (1975), an installation piece that pairs eight limestone cubes on the gallery floor surrounding a meditative inner space that is not that distant from Cage's *Ryoanji* in feeling, reads in part, "This is the mask of my painful need distressed by truth and human companionship. This is my painless mask that fails to touch my face but floats before the surface of my skin my eyes my teeth my tongue. Desire is my mask." The attention to the empty space of a form or mold is most austerely presented in pieces such as his notorious *Cast of the Space under My Chair* (1965–

68), which is a Scott Burton–like crudely unfinished lump of concrete in the form of the empty space defined by a wooden desk chair, and the *Shelf Sinking into the Wall with Copper-Painted Plaster Casts of the Spaces Underneath* (1966), which has casually dropped plaster casts of the hollows under a shelf lying on the floor below a uselessly tipped white wooden shelf. In his trenches and even in the emptiness of the steel cages that would separate a gallery into a prison and an open area, this austere yet positive focus on empty space acquires even greater emotional resonance. The piece, which looks ahead to his use of suspended chairs, is an allusion to a remark by Willem de Kooning: "If you want to paint a chair, don't paint the thing, but paint the spaces between the rungs of the chair."

Beauty is not an easy word to bring to Nauman's work, which is a deliberate part of his antiformal, antiaesthetic strategy. The lurid tones of his off-color neon "jokes" about sex and violence, the bad focus and pathetic sound quality of most of the videotapes, the shabby use of "leftover parts" from projects that make it into his installation pieces are all testimony to Nauman's refusal to let beauty play its customary role in art. One group of his works does manage, despite Nauman's best efforts, to pull beauty back into the story, even though these are arguably some of the most brutal works he has done in terms of their point of reference. In 1981, Newman suspended a cast-iron chair upside down inside a diamond-shaped frame of steel I-beams that hangs at eye level. The legs of the chair, made from a wooden model built by Nauman, are "tuned" to sound the four notes D, E, A, D when they are struck (Nauman had used this musical motif, played by him on a violin in a 1969 videotape). While the antiapartheid message of the piece is embodied in the title, *Diamond Africa with Chair Tuned DEAD*, it uses the chair as a metonymy for victims of political torture.

In *South America Circle* (1981) the chair is tipped sideways in the center of a steel circle fourteen feet in diameter, which imprisons it and shuts out the viewer. The prototype for these works used boards suspended in a triangle from the ceiling by cables that allowed them to rotate and even crash into the chair. The South American versions, which use both a circle and a square boundary, make reference to Jacopo Timmerman's memoir of torture and imprisonment in Argentina, *Prisoner without a Name, Cell without a Number*, which was published the year that Nauman made the works at his vast, hangarlike space in Pecos. A later, more and more ascetic refinement of the series strips the chair of its bounding geometry, hanging it upside down or on an angle from the ceiling by four steel cables, as though the chair was being drawn and quartered.

Like the chair that Merce Cunningham danced with in the late 1950s

or Glenn Gould's beloved folding chair, its very humility and blandness makes the association with torture all the more frightening. It seems odd to attribute beauty to a steel chair suspended upside down from the ceiling and surrounded by a huge steel circle, but I will never forget the impression *South America Circle* made on me in the most incongruous possible setting—the main gallery of Christie's in New York, where in May 1993 it eventually sold for half a million dollars. Against the plush gray-green velvet and wood paneling of the room where only a week before the paintings of Monet and Renoir had hung demurely and the week before that Louis XIV chairs and sofas had crowded the floor, the bleak, mute geometry of that circle of steel, like a strange chandelier, was able to cast its hush over the lavish preview party for the upcoming week's sales.

◦ I I I ◦

Asceticism and Architecture

The timing could not have been better. At the end of the very week in August 1995 when Calvin Klein had pulled from magazines and newspapers a series of ads using teenage models that was considered too sexy, hoping to forestall a Justice Department inquiry into its status as child pornography, he opened a retail space on Manhattan's Upper East Side that was a model of architectural purity of a monastic severity. Even the staid *New York Times*, wincing from the lost advertising revenues, had to remark on the paradox: "Where the ads are loaded with innuendo, the store is all proportion and purity," Julie Iovine wrote in her lead to a story on the new store and the way that Klein blends overt sexuality and his own type of classicism.

The serenity of architect John Pawson's design for the 22,000-square-foot store, housed in a Greek Revival building that was, when it opened in 1928, originally a branch of the Morgan Guaranty Bank, the renovation is a paean to the dying art of architectural quietude. Without display windows or escalators, the stark white, completely shadowless interior (even the greenish-blue tint that is naturally in glass has been painstakingly removed in the name of purity) provides what Iovine described as "a Zen experience" that seems more fitted to laboratory work than clothes shopping. The furniture is by Calvinist designers like A. G. Franzonie, Rudolph Schindler, and the sculptor Donald Judd. The austerity forces a certain type of attention upon visitors so that nothing distracts from the white atmosphere of the space. "Both Calvin and I thought it was a pity that any clothes had to go in at all," Pawson joked.

What about the effect of such absolute immaculateness on the great unwashed? "Such a vaporous space—blanketed in white, resolute, unyielding—may be over shoppers' heads," the *Times* critic worried. Pawson cited the most powerful influences on his design: a pathway and old factories in his native Halifax, England; Shaker workshops; Egyptian tombs; and a twelfth-century Cistercian abbey in Le Thoronet, France. His own home in the Notting Hill section of London has been described in the British press as "ostentatious emptiness." Pawson, who spent time

as a monk in a Zen monastery in Japan, explains, "I do architecture to express myself in ways I couldn't as a monk." Not all of his life has the same Zen simplicity. He shares his monastic space with his former girl-friend, his wife, his mother and his two children.

Theorists and critics seized on Pawson's pure temple to commerce as a counterweight to a preponderance of antiasceticism in current architectural practice, from the entertainment architecture of Disney to the palatial excesses of the Dutch architect Rem Koolhaas. Accenting the XL (for extra-large), in his fat and expensive book of projects titled *S,M,L,XL* (reminding us of the arrangement of sweaters by size in the Klein store if we could find them), Koolhaas has emerged as the champion of hedonism and romantic opulence, not only in building but in cybergraphics and media as well. He fancies the splashy effect of the "megastructure" as well as, judging by the lavish design of the book, even if the industrial-grade materials he is known for using are on the cheap side. "Bigness is ultimate architecture," Koolhaas insists.[1] On top of this, Koolhaas gives his profanity-laced and pornography-spiced text a naughty edge by linking "bigness" and the amoral, pulling out the rug from under the ethical stance of the purists. "Through size alone, such buildings enter an amoral domain, beyond good or bad."[2]

Somewhere between the archmonasticism of Pawson and the exuberantly self-conscious hedonism of Koolhaas is a vein of architectural asceticism that will continue to be mined throughout the twentieth century. Where Pawson and Koolhaas are too rhetorical and chic for more serious consideration in this context, they set up the parameters for a look at a small group of Modern master builders who tapped many of the ideals discussed elsewhere in this volume. It has been a century of architecture, after all, that was foreseen in the Crystal Palace in London and the White City of Chicago and reflected in the crystalline pyramid in the courtyard of the Louvre. Bracketed by those monuments to purity has been an era when asceticism held its own.

The Prophet: Frank Lloyd Wright

"A light blanket of snow fresh-fallen over sloping fields, gleaming in the morning sun. Clusters of pod-topped weeds woven of bronze here and there sprinkling the spotless expanse of white. Dark sprays of slender metallic straight lines, tipped with quivering dots. Pattern to the eye of the sun, as the sun spread delicate network of more pattern in blue shadows on the white beneath."[3] In these opening sentences of Frank Lloyd Wright's autobiography, virtually all the elements in the ascetic drama of

his life and work are embedded, from the cold purity of the snow to the interaction of form and freedom, rhythm and materials, light and shadow. Wright uses the same landscape, a hillside in Wisconsin, in different seasons, a few times in the book, but this wintry version is most apt for a study of asceticism, as is the moral of the anecdote that it spins into, in which the child runs rampant across the sloping fields while his uncle walks straight up the hill in a perfect line and then turns to chastise the child. The story creates a moral and aesthetic tension between that perfectly straight line and the child's "wavering searching, heedful line embroidering the straight one like some free, engaging vine as it ran back and forth across it. He pointed to that too—with gentle reproof." Wright's autobiography stresses the importance of work as a way of life and art, as celebrated in the exuberance of the "work-song" as well as the more grim reality of the physical pain of the labor he did as a young child. For example, he defines rhythm in terms of the simple tasks that the poet Seamus Heaney focuses on: "Any monotonous task involving repetition of movement has its rhythm. If you can find it the task can soon be made interesting in that sense. The 'job' may be syncopated by changing the accent or making an accent. Binding grain and shocking it, or pitching bundles to the wagons and the racks."[4]

Glenn Gould liked to call himself "the Last Puritan," and Wright continually invoked his descent from a line of preachers and half-seriously called himself "the First Protestant." His romantic idealism, which stemmed from the family's Unitarianism as well as the writings of Emerson, was intermingled with a powerful metaphysical inclination that expresses itself in the Euclidean way that Wright pursued the essence of an idea through geometry. It also shows up in the "magical" atmosphere that Wright cultivated at both the Wisconsin and Arizona Taliesin compounds. In his own life Wright was not what one would call a proven ascetic. He had a passion for luxury cars (particularly Lincoln Continental convertibles in a tone he called Taliesin Red), his love life occasionally became sloppy, and the discipline of form often yielded to the freedom that was its counterpart, but the Wright legacy is central to an understanding of twentieth-century asceticism in architecture.

One very simple index to Wright's asceticism is the physical discomfort his work could produce. He complained of the bruises that his early furniture designs left on his own shins, and his houses, particularly those in the Midwest, were notoriously cold (a pun here on Koolhaas is difficult to resist). Clients repeatedly complained of the cold, and even into the 1990s the problem remained serious. One young family I know in a Wright home just outside Manhattan, up the Hudson—where they hardly experience the kinds of winters one has in Wisconsin—were worried that

when their baby was born the temperature in the house would be un-healthily low. Like the harsh chill of a monastery, this minor discomfort was part of the price Wright felt one should pay for living in a work of art. The same trade-off is used by Wright's faithful to dismiss the leaking roofs, the falling glass of the Johnson Administration Building, and the ceiling collapse at the Greek Orthodox Church in Wauwatosa.

A significant factor in Wright's asceticism was the "gospel of simplifi-cation" that he learned from Japanese architecture and prints (he made his living temporarily as a dealer of woodblock prints from Japan). Wright once wrote, "The gospel of elimination preached by the print came home to me in architecture as it came home to the French painters who developed 'Cubisme' and 'Futurisme.' Intrinsically it lies at the bot-tom of all this so-called 'modernisme.'"[5] More important, however, the White City and Great Exhibition Japanese temple he studied early in his career were not "real" structures, just as his own Mile High Illinois Sky-scraper of 1956, Broadacre City, and Usonian houses remained visionary abstractions—the impossible buildings that, like the unreachable Apollo of Balanchine's choreography, remain beyond the grasp of the practical. The Mile High example is probably the most romantic and graceful of these dreams. As the long drawings of it show, the Mile High was Wright's answer to Miro's ladder to the heavens. Its cantilevered tripod supported a "sky city" that was supposed to thrust like the blade of a rapier literally a mile into the sky while the handle, its "tap-root," would be set as a foundation in the ground, the exterior suspended from the an-gled core by steel strands.

Even the original idea of the spiral of the Guggenheim Museum as the product of "one long pour" of cement—a gesture of incredible simplic-ity—is closer to this fantasy world of impossible architecture. Another of Wright's idealized moments of lyric geometry, a pure gesture like the ramps of the Guggenheim, is The Wave, also known as the Haldorn House on the coast at Carmel, California, where a gently curving con-crete, glass, and steel abstraction of the movement of water gives the structure its dominant shape. Even in our time, when materials have made gestures like this more plausible, the directness with which Wright translated geometry and metaphor into a living structure is breathtaking. The Guggenheim has all the rigor and pure concentration of Robert Mangold's ellipses. For Wright, the first principle of design was simplicity and repose, the elimination of the unnecessary, including interior walls and separate rooms. Another cardinal tenet was what he called "spiritual integrity," which was synonymous with sincerity, truth, and graciousness.

These principles are reflected in other buildings, that Wright did cre-ate, which have a variety of more rigidly ascetic characteristics. The long,

low lines of the Robie House and other Prairie examples are deliberately streamlined and simple. The terms that Wright himself used were "swift" (recalling Mondrian's notion of a "fast" painting) and, above all, clean. In his attempts to explain what he wanted with this style, Wright made frequent allusions to perfecting the "grammar" of forms. Grammar was his preferred metaphor for style, anticipating Sartre's *écriture blanche* and Barthes's tight, functional "zero degree of style." Another of Wright's ascetic gestures is what critics have called his "refusal" to abide by current fashion or tradition, particularly where they call for ornament and excess. One of the textbook examples of this is the prisonlike (or, more diplomatically, fortresslike) Larkin Administration Building, built in Buffalo between 1902 and 1906, about which Wright has written: "The Larkin Building is the first great protest against the outrageous elaboration of the period. An affirmative negation, however. It is the simple, dignified direct utterance of a plain, utilitarian type, with sheer brick walls and the indispensable protective stone-copings this climate demands."[6]

Wright was a great "negative" force in architecture, "clearing" the aesthetic of the day in the Heideggerian sense. Like Heidegger, he was not a great proponent of the Machine Age even if he did use the machine as a metaphor and a necessary tool. Le Corbusier had said that a house is a *machine à habiter* (machine for living)—a phrase that is echoed by the poet Paul Valéry in his view that a "book is a machine for reading," Corbusier's partner Emile Ozenfant's notion that a "painting is a machine for moving us," Serge Eisenstein's dictum that "theatre is a machine for acting," and Marcel Duchamp's "the idea is the machine for making art." In "The Art and Craft of the Machine," Wright called this kind of efficiency sterile and demeaning. As Anthony Alofsin has written about the later phase of his work:

> Wright's own spiritual path charted directions that were increasingly outside the mainstream of modern architecture. By the end of his career Wright's architecture conveyed a dematerialization of form; ironically, it was dematerialization that the early proponents of the modern movement had sought in their architecture of thin, floating planes. Their objective had been to create a new aesthetic that required the reduction of ornament, the primacy of function, and the disappearance of depth. Wright's dematerialization took on an entirely different character; in contrast to the work of other modernists, his architecture retained a physical depth while it became less tectonic. It breathed spiritual intention often at the cost of rationality of structure or the development of detail.[7]

The material that promised the most dramatic possibilities for change

in architecture, especially in the direction of asceticism, was glass. "Glass has now a perfect visibility, thin sheets of air crystallized to keep air currents outside or inside," Wright wrote enthusiastically.[8] The potential for an architecture that privileged light rather than mass or the cavelike shadows of earlier periods led Wright to a shadowless world of light that again reminds us of Miró and his rhythmic painting *The Farm*. As Wright declared, "Let the modern now work with light, light diffused, light reflected, light refracted—light for its own sake, shadows gratuitous."[9]

The gesture of retreat, so important to the work of Gould and Marden and Pater and others examined in this study, was also fundamental to Wright's thinking, particularly with regard to siting. The Arcadian ideal behind the siting of the first Taliesin involved the choice of a pastoral retreat—not quite in the wilderness, not quite in the suburbs. He urged clients to push outward from the cities, extending their commuting time but ensuring the kind of tranquility in which his work could be best appreciated. Wright conceived of his architecture in its essence as a revolt against "enclosure," a way to "beat the box," as he put it; the desire for freedom is an animating principle for all his work. This seems to counter the ascetic tendency toward imprisonment and the cloister, but Wright continually pushes off from that notion of enclosure, of "the architecture of the within," to dramatize freedom. The physical realization of this freedom—at Taliesin West, for example—was the new feeling of space within Wright's interiors, which flowed from living area to dining area and beyond, removing the walls that created interior boxes. Wright called this "the liberation of space to space."[10] The apotheosis of this liberation is the nearly seamless transition from interior to exterior space in the case of Fallingwater, the walls of which Wright described as "humanized screens" with all the connotations of Japanese sliding screens that can be removed at will. More subtle, perhaps, than the unobstructed sightlines that allowed Edgar Kaufmann to gaze into the Pennsylvania woods surrounding his home, the extraordinary movement of sound through the building draws attention to the spatial freedom it achieved. The constant music of the stream pervades the structure, joined by Wagnerian forest murmurs that wander through its corridors and wash over its terraces like light itself.

While Fallingwater is the most famous of these retreats, one of the most perfect examples of asceticism in the Wright canon is a gem known as La Miniatura. It is the first of Wright's "textile block" homes, built from cement blocks with metal rods tying them together in a "woven" pattern that is derived from the *oya* blocks of Wright's Imperial Hotel in Japan, together with the steel-wire-reinforced block construction of the A. M. Johnson compound in Death Valley, which Wright built in 1922.

In his autobiographical musings on the Job-like trials surrounding the building and early history of La Miniatura, which Wright built in 1923, he compares himself to the missionaries who invaded California. The overall dryness that surrounds Pasadena appealed to Wright, and he compared the building to a cactus. He and the original owner, Mrs. George Madison (Alison) Millard, deliberately chose an unconventional site, forgoing the flat parcels of land on which the neighboring houses were built and taking, at half price, a lot that was essentially a ravine flanked by two huge eucalyptus trees. The ruggedness and especially the emptiness of the ravine appealed to Wright, who did not realize that it would flood just after the house was built, coating its lower story in mud. The result is a house that has the blunt, blocklike strength of a Norman keep, poised over a moatlike chasm.

To keep the house cool, Wright used the air in a space between the inner and outer walls as a circulating system. The cruciform apertures in the blocks are filled with glass, and the light that streams through them creates an astonishing lacelike effect. Wright's workers cast the blocks with a dry compacted concrete in wooden (and later, metal) molds on the site. They were wet-cured for ten days and are marked with three patterns: symmetrical, radially symmetrical, and asymmetrical. These concrete blocks held together by steel are one of the most innovative aspects of the building because they took concrete "out of the gutter" and made it a respectable material. The building of the house was described as a process of "weaving the blocks," and Wright called himself "the Weaver" in his stories about the building of La Miniatura. This metaphor, wonderfully explored in Kenneth Frampton's recent masterpiece, *Studies in Tectonic Culture*, is the key to understanding the rhythmic density of the work, a complement to the density of mass its blocklike form conveys. Wright notes that the specially made concrete blocks were "textured like the trees," a pictorial notion that perfectly captures their complex and oddly organic effect. An anomaly among the prim, overdone suburban houses that surround it in one of California's tightest and most prosperous communities, La Miniatura presents itself as a solid, living symbol, like Yeats's Thoor Ballylee. It carries out Wright's credo of simplicity as realized in the mandate of the cube. Wright compared the grid of La Miniatura's walls to the grid of a meticulously tilled field, with exactly four feet between the rows of corn, recalling the abstract link he drew between the rhythms of work and art.

For its most recent owner it has become a kind of prison cell, unfortunately. Wearied not just by the cost but by the effort of keeping the building in the condition required by its listing as a landmark site, she has spent hundreds of thousands on an elaborate restoration project,

arranged for a photo shoot for *Architectural Digest*, and promptly placed it on the market, where it continues to languish while her inheritance drains away. The dream of gemlike perfection, along with the ambition that this "block house" would set the trend for a vernacular architecture in concrete, would not stand the test of reality. Wright admitted with chagrin that from very early on the perfection of La Miniatura was marred by a leaking roof (caused by the shrinkage of the tiles under a particularly strong sun) and floods from runoff that coursed through the ravine. In the end, he summarized the experience in glowing terms: "La Miniatura stands in Pasadena against blue sky, between the loving eucalyptus companions, and in spite of all friction, waste and slip is triumphant as Idea."[11]

It seems inevitable that Wright's ascetic pilgrimage would lead to the desert. The story of Taliesin has been told in detail many times. An anachronism that blended Welsh and Mayan mysticism, it was built after Wright had viewed similar retreats in Japan in 1922 and designed buildings in Death Valley between 1921 and 1924 as well as in Chandler, Arizona, in 1929. For Taliesin he wanted an architecture of straight lines and flat planes that would not break the tranquility of the surrounding wasteland. Only the great natural creative forces were powerful enough to shape the desert, as he wrote: "In this geologic era, catastrophic upheaval has found comparative repose; to these vast, quiet, ponderable masses made so by fire and laid by water—both are architects—now comes the sculptor, wind. Wind and water ceaselessly eroding, endlessly working to quiet and harmonize all traces of violence until a glorious unison is again bathed in the atmosphere of a light that is, it must be, eternal."[12]

The Priest: Mies van der Rohe

Where Wright's lyricism and love of metaphor could endear him even to critics, there was something about the perfection of Mies van der Rohe that brought out the worst in his detractors. Like the "hard" music of Philip Glass or the "dry" painting of Mondrian, the rigor of Mies provokes powerful rejection. The critic Lewis Mumford sharpened his pencil between every sentence of this assessment of Mies's "dry style":

> Mies van der Rohe used the facilities offered by steel and glass to create elegant monuments of nothingness. They had the dry style of machine forms without the contents. His own chaste taste gave these hollow glass shells a crystalline purity of form; but they existed alone in the Platonic world of his imagination and had no relation to site, climate, insulation, function,

or internal activity; indeed, they completely turned their backs upon these realities just as the rigidly arranged chairs of his living rooms openly disregarded the necessary intimacies and informalities of conversation. This was the apotheosis of the compulsive, bureaucratic spirit. Its emptiness and hollowness were more expressive than van der Rohe's admirers realized.[13]

What was so threatening about Mies? His own words, with their seeming indifference to human emotion, could be a starting point. The famous dictum "Less is more" is, of course, an invitation to ascetic interpretation (as well as to insult, such as Robert Venturi's funny but cruel riposte, "Less is a bore"). Mies's less famous declarations convey a sense of the impersonal that goes along with Eliot's theory of the impersonality of poetry as well as the first giddy declarations of the absolute values of abstraction in art. In 1924, Mies wrote: "The individual is losing significance; his destiny is no longer what interests us. The decisive achievements in all fields are impersonal and their authors are for the most part unknown. They are part of the trend of our time toward anonymity."[14]

In an essay by Wilhelm Worringer that we know as "Abstraction and Empathy," a work that was well ahead of its time when it was published in 1908, some of this stern but impassioned and actually surprisingly psychological thinking was foreshadowed.This quest for the absolute is pursued by Mies along an ascetic route. His indifference to the surroundings or context of his buildings was infamous. Where Wright could echo the waves off the coast of California in the curving form of a house, Mies would impose his Platonic idea of a building's ineluctable form on any site. Both Wright and Mies end up with abstractions—one maintains the vestiges of a mimetic gesture to the surroundings, and the other is straight from the mind. Both Wright and Mies, as well as Philip Johnson, made their early key statements in conjunction with the building of "retreats." Modest in scale, ascetic in function as well as style, these textbook houses (Wright's Fallingwater; Mies's Farnsworth House in Fox River, Illinois, completed in 1950; and Johnson's personal glass house) are located in the woods, where isolation is a priority. Both Mies and Wright used horizontal slabs of pure white (in Mies's case, they are painted steel) for a Mondrianesque source of strength. Mies's Farnsworth House, for which he was sued because he went over budget (it cost a whopping $73,000), uses eight steel units in two rows, twenty-eight feet apart, to demarcate a single living space for sleeping, living, and eating.

Many who have written about Mies assume that his mind was programmed for perfection from the beginning. He was born in 1886 in Aachen, Germany, and historians like to point out the possible "Thomis-

tic" influence on his architecture of the heavily religious traditions of that cathedral town, once the capital of the Holy Roman Empire. The school that Mies attended until he was thirteen was founded by Charlemagne in the ninth century, and his education was steeped in the systematic thinking of Thomas Aquinas, Augustine, Plato and Hegel. On holidays and weekends, Mies worked as a stonecutter for his family's business. He went to Berlin to became an apprentice to furniture designer Bruno Paul until 1907, then had his first independent commission—a house in the eighteenth-century style for Herr Riehl. After changing his name from Ludwig Mies to Mies van der Rohe (the addition of his mother's maiden name), he began his third and last apprenticeship with the industrial designer Peter Behrens, whose Classical style derived from Karl Friedrich Schinkel, the champion of purity of form and simplicity.

After serving in the army corps of engineers, Mies returned to Berlin in 1919, to an aesthetic climate dominated by the *Neue Sachlichkeit* and was particularly taken by the notion of a prismatic glass skyscraper, whose clarity allowed the structural beauty of the building to emerge from behind the facade. It was the principle that allowed him, in the early 1920s, to invent the office building of the 1960s, based on a floor slab cantilevered from columns laid out along a grid, its perimeter reinforced by beams set into concrete. Around this, the essential element of glass is wrapped, completing what Mies called "skin and bone construction." The great breakthrough of Mies's career came in 1929, when he designed the German pavilion for the International Exposition at Barcelona. Like Wright's earliest "visionary" experiences, the now legendary Barcelona pavilion was a temporary building without purpose. Pristine and breathtakingly sleek, it rested on a green travertine marble podium, with walls of gray glass between steel columns sheathed in chrome and encasing the famous Barcelona chairs. Outside were reflecting pools lined with black glass. The cruciform column of the Barcelona Pavilion was, in Mies's words, "an analogue for infinity." An even more noteworthy metaphorical element was the use of the stairs leading up to the podium, which, like Miró's ladders into the sky, became a signature element of ascent and the floating effect in Mies's buildings, such as the steps up to the white podium of One Charles Center in Baltimore, Chicago's Crown Hall on the IIT campus, or the "floating stairs and terraces" of the Farnsworth house.

After the Barcelona triumph, Philip Johnson arranged for Mies to come to the United States in 1937 to be the director of the School of Architecture at Chicago's Armour Institute, later the Illinois Institute of Technology, a post he held for twenty years. Mies immediately dug in

and created his own monastery, dividing the campus into a grid of twenty-four foot squares on which each building became a "module." A colleague remembered him in his later years through the monkish simplicity of the life he led in Chicago:

> On the surface, Mies lives much like any other quiet, sometimes lonely, elderly gentleman. Yet his apartment is anything but typical, for it has remained, to all intents and purposes, quite unfurnished ever since Mies moved into it. Except for the living-room, which contains several well-proportioned, black-upholstered settees and easy chairs of square silhouette, the apartment has almost no furniture at all. Its only decor is Mies's magnificent collection of Klees, carefully hung on white and otherwise empty walls, and just as carefully lit. An occasional marble shelf completes the "decorative scheme." Mies lives in this monastic setting according to a rather peculiar schedule established by himself and respected by his friends and associates.[15]

It seems ironic to dwell on the ascetic nature of what may still be the most expensive building per square foot ever to be constructed in New York City (its brutal cost was the result of substituting bronze for black-painted steel as well as the travertine casing for the elevators, granite slabs for the reception floors, and other expensive touches), but the Seagram Building is the emblem of architectural asceticism par excellence. Almost directly across from one another on Park Avenue are two great masterpieces of twentieth-century architecture that, in terms of theory, are miles apart. On the west side of the avenue is Lever House, built in 1959 by Skidmore, Owings and Merrill. It is a milestone in the development of the curtain wall (though not the first to use this technique), which uses a skin of windows that does not support the overall structure but is cantilevered from a frame. Open at street level, as though the glass and steel tower were floating on air, Lever House is lightness itself. On the east side of the avenue, set back ninety feet from the sidewalk by a border of steps that lead to a broad plaza and fountains and eventually to the building, is the thirty-nine-story Seagram Tower of Mies, completed in 1958. It also uses the curtain wall in a distinctive way, like many of the "International Style" buildings along that stretch of Park. As if to accentuate the diametrically opposed style of thinking, the Seagram building is dark brown and bronze against the brilliant blue and silver of Lever House. The main difference, however, is the sheer heaviness that the Seagram Building conveys. Like a Richard Serra among light-filled works by Calder and Di Suvero, Mies's Seagram Building makes the "neutralizing skin" of the curtain wall seem solid.

The ascetic quality of the Seagram building is not just a matter of its rhythm and symmetry—that mathematical progression of "units" from two reflecting pools to six pedestals to four interior service cores. It arises from the defiant monumentality of the work and its deliberate, hubristic assault on perfection. As the great architectural historian Charles Jencks, in an essay agonistically titled "The Problem of Mies," has written, "There is no place for a mistake in his absolute universe, because extreme simplicity makes one hypersensitive to each inch of a structure and the Platonic form, with its transcendental pretension, demands utter perfection."[16] For Peter Blake, the fascinating conjunction of spirituality, perfectionism, and humility in a thoroughly secular figure yields another ascetic characteristic: Mies's tendency toward self-effacement (something that was never said of Wright). As Blake concludes,

> Mies would probably deny any direct influence upon his work on the part of the Catholic Church. "The whole trend of our time is toward the secular," he wrote in 1924. "We shall build no cathedrals. . . . Ours is not an age of pathos; we do not respect flights of the spirit as much as we value reason and realism." And, a year earlier: "Architecture is the will of an epoch translated into space—living, changing, new." *The will of an epoch*—and Mies has never considered himself to be more than an instrument of that will, just as the great architects of the past were instruments of the will of their epoch. . . . Ludwig Mies van der Rohe, perhaps the most self-effacing architect of *his* epoch, the only architect modest enough to try to create an *anonymous* architecture to serve *all* of humanity—his name will be remembered when others are long forgotten.[17]

The Mandarin: I. M. Pei

Keeping a cool head and staying above the fray was always the secret of success for a mandarin in the imperial Chinese court. An old Chinese adage, passed down from the era when the Forbidden Palace was a hive of backstabbing, advises: *Mu hou cao zong* (The master mind remains behind the screen). Through a style of architecture as well as business that is thoroughly committed to the notion of the hidden source of power, Pei has embodied the truth of this epigram. For all the complaints that purists voice about the lack of a "body of theory" behind his work, nobody questions his ability to maneuver through the labyrinths of power after his successes at the Louvre and National Gallery of Washington. For Pei, now in active retirement at the age of eighty, the age of reflection presents the image of a man who is as ascetic

as the cool blue-green glass facades of his signature buildings. He keeps a low profile. A new, full-length biography was published without his participation. He is also critical of his own work, admitting to one interviewer, in a comment that really opens a window on Pei's asceticism, that his only regret about the infamous Louvre pyramid is that it is *not transparent enough* for his tastes.

I. M. Pei was raised in Shanghai in a wealthy household. His mother was a devout Buddhist, his father a hardworking banker. The recent biography by Michael Cannell emphasizes the formative influence of the Suzhou and Shanghai rock gardens where Pei played as a child, with their winding pathways and surprise "mountainous" vistas. These cloistered, quiet spaces are a major factor in Pei's thinking in terms of technical questions such as sight lines and also in the development of the interior as a retreat. As Pei commented, "All of it has instilled a lasting metaphysical image, if not a direct influence, on the shape of my work. The way those rock farmers did things pertains to a perception of time, and to a sense of accountability to time. And once you build in that spirit—how it *humbles* you."[18]

Pei's family sent him to MIT—he ended up at Harvard—just as Shanghai was threatened with the first of a number of military conflicts involving both the Japanese and the Communists. He studied with Walter Gropius and Marcel Breuer and then shocked his intellectual mentors by taking a job after graduation in 1948 with New York developer William Zeckendorf, who has been described as the P. T. Barnum of the building boom of the 1950s. After starting his own firm, one of his earliest triumphs was the little-known National Center for Atmospheric Research near Boulder, Colorado, a fortresslike complex that echoes the dark recesses of the nearby Pueblos. The Kennedy family made him the surprise selection in 1964 by Jacqueline Kennedy to design the presidential library in Boston, and a year later he started work on the massive Hancock Tower in Boston's Copley Square. Like Mies's Seagram Building in many ways, it thrust itself upward with seeming indifference to the historical character of the neighborhood, and critics ripped into Pei when its mirrored-glass windows started falling out. The fiasco delayed Pei's rise, but in 1968 he first started to put together his ideas on the interpenetrating trapezoids and triangles that would become the East Wing of the National Gallery in Washington, a triumph of the triangle that showed how Pei saw a geometric idea through to its complete and logical conclusion. The dramatic corners and abrupt angles both inside and outside the East Building have an ascetic sharpness to them, but the most powerful impression the East Wing seems to have, even on the layman, is the new thinking it represents with respect to glass and light.

The challenge of carrying out Pei's designs may be one of the most ascetic aspects of his work in the eyes of the architectural community. The East Wing did not contain a single right angle above the ground—the triangle shows up in its ceiling panels, bathroom tiles, columns, steps. Concerned that Pei was trying to adhere too strictly to his geometric premise, National Gallery director J. Carter Brown advised the architect not to "crucify himself on a pattern nobody would understand." Yet for Pei, no matter what the expense or how much training the builders would need to undertake his designs, there could be no compromises. The whole East Wing is on a bias of 19.5 degrees, which, together with the infinite echo of the triangle (like Wright's circles in the Guggenheim), drove the carpenters on the job crazy because most tools are suited to working on rectangles. Pei's designs, which the contractors called "funny papers" because they were so sketchy, became one of the main reasons the project was delayed for five years and ended up costing $95 million, almost three times what any of the neighboring museum buildings in Washington cost. The original design called for a coffered ceiling, which Pei replaced with the huge skylight that covers more than a third of an acre and required a sunscreen of aluminum louvers, also designed by Pei, to protect the art.

That revolutionary approach to light, which critics call Pei's "greenhouse" idea, reached its apogee in the Louvre project, one of the most controversial architectural works of the century. Whether you view it from a mystical point (in the context of the New Age mania for crystals) or from the more restrained notion of a low and transparent structure through which the Louvre can be viewed like a lens or in which the details of its upper stories in particular would be mirrored, the pyramid is an extraordinary example of asceticism in architecture. Pei seized on the idea of using the fine polished steel of the cables inside the glass to reflect light: "They work like filaments in an electric bulb—that pyramid is actually a gigantic lantern."

Pei's later civic landmarks include the curvaceous, glassy Myerson Symphony Hall in Dallas, completed in 1989; the Creative Artists Agency headquarters in Los Angeles; and most recently, the Rock and Roll Hall of Fame in Cleveland, which opened in 1995 to mixed reviews. Throughout his career, particularly after the Hancock Tower disaster, Pei has had particularly severe critics barking at his heels, and most of their objections can be tied to the forbidding nature of Pei's asceticism. In the eyes of Witold Rybczynski, "Pei's buildings are undecorated, sleek and impeccably detailed—the architectural equivalent of a Mercedes-Benz." One detractor even knocks the Madison Avenue headquarters of Pei's firm as "a frightening example of beiged-out corporate bloodlessness."

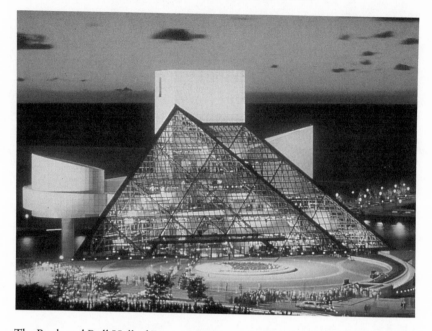

The Rock and Roll Hall of Fame and Museum in Cleveland is I. M. Pei's tribute to both rock music and Vladimir Tatlin's never-built monument to the Third International. Photo by Schuemann Architectural Photography. From the collection of the Rock and Roll Hall of Fame and Museum.

The massive steel-and-glass tent of the Rock Hall of Fame is clearly another in the line of Pei's museum projects, pulling together a number of the conflicting themes and impulses that make Pei's type of asceticism so tension-filled and interesting. The complex is on the shore of Lake Erie and is approached, after one negotiates a difficult knot of freeway ramps and bridges, from across a broad elliptical plaza. The axis of the plan is a six-story tower, which reminded some critics of Vladimir Tatlin's unbuilt monument to the Third International. The main exhibition hall, under a signature Pei skylight, is below the entrance, somewhat like the East Wing plan, while the landings and balconies soar off into space like sails—the ship is the key metaphor for most viewers. Although the dramatic forms of the sails and tent are lyrical and gestural, within the halls the grid—the aluminum panels of its exterior are scored in a grid—is dominant, and geometry reasserts its priority in a prim, rational way that bothered some of the rock faithful who wanted something a bit more "gritty." One of the great sources of tension in the project was Pei's aloof attitude about the music that the museum honors. As he told one interviewer,

The problem was that I didn't like the music. My children loved it, but I never did. And yet, since I was selected to do the project, I had to learn about the music. So I went to Graceland to see Elvis Presley's home. I went to Louisiana to listen to jazz and rhythm and blues. And then I began to understand the rich roots of rock and roll. These are the things I tried to imbue in the building's design—a sense of tremendous youthful energy, rebellion, tailing about. Part of the museum is a glass tent leaning on a column in the back. All the other forms—wings—burst out of that tent. Their thrusting out has to do with rebellion. This, for me, is an expression of the musical form of rock and roll.[19]

The idea of Pei, who loves Classical music and some jazz, going to Graceland or trailing recording executive Ahmet Ertegun around to clubs is vaguely humorous for many people. What is even more extraordinary are the manifold ironies of an eighty-year-old guardian of geometric perfection, who as a child wandered the Imperial gardens of Suzhou and yet ended up designing a rock and roll museum on the banks of Lake Erie. Ruskin called the great cathedrals of a sacred era "frozen music," and here Pei has locked the brash excesses of rock in vitro within precisely engineered forms, a triumph of the ascetic over one of its most dynamic foes.

Our Glassy Essence: A Few Contemporary Architects

The "transcendent greenhouse" of Pei was not the last word in glass, as the recent work of a new generation of architects is showing. Many of their most dramatic projects were represented in a brilliant exhibition called *Light Construction* at the Museum of Modern Art in 1995, curated by Terence Riley (no relation). Under the bywords *objectivity* and *complexity*, the projects invoked not only the architectural heritage but other media, including television and computers and the literary theories of Jean Starobinski and Italo Calvino. In terms of the architectural tradition, it measures the ground between the way many contemporary architects use glass and the more transparent, simple "skin" of Mies's Tugendhat House (1929) in Brno or Johnson's famous Glass House (1949) in New Canaan. Briefly put, the main difference is an emphasis on shadow as much as light, on translucency rather than transparency.

Among the most memorable of the projects that Riley uses to illustrate this point is Kazuyo Sejim's Saishunkan Seiyaku Women's Dormitory (1991) in Kumamoto, on the southern island of the Japanese archipelago. Its bright atrium and open-air courts, to which each room opens, combine many of Wright's notions about the free flow of space around

the tight compartments into which the living quarters are divided with the traditional *soudou* layout of the Zen monastery, all wrapped within a semitransparent curtain wall that allows outsiders to partially glimpse the structures within. Another extraordinary project by a Japanese architect is Fumihiko Maki's competition proposal for the Congress Center in Salzburg, which, like a Robert Wilson set design, uses a huge, eleven-story concrete-and-steel cube sheathed in glass, louvres, and most dramatically, a meshlike skin of perforated metal that wraps itself around an interior ellipsoidal volume, through which the silhouettes of figures on the ramps and floors of the structure can be seen. Maki designed it as part of an Ideal City, a virtuoso rhythmic illusion that exploits the potential of glass and steel.

The exhibition also featured Toyo Ito's Tower of the Winds in Yokohama (1986, dismantled in 1995) and Shimosuwa Municipal Museum (1993), a narrow, arched form that is more lyrical than many of the other projects. Its most exciting feature is a tight, thin aluminum skin that covers the odd form, created from thousands of unique aluminum panels that could only be made in our time, thanks to computer modeling. It is similar to the Waterloo Terminal in London, designed by Nicholas Grimshaw and Partners in 1993, which links up with the high-speed trains coming out of the Channel Tunnel from the Gare du Nord in Paris. Like its Victorian antecedents, the 1,312-foot-long glass canopy is actually a "soft" construction that billows as trains pass, each of the panes moving separately.

The most spectacular of these latter-day crystal palaces is the six-story Cartier Foundation for Contemporary Art by Jean Nouvel, which opened in Paris in 1994. Built on the boulevard Raspail in one of the city's most historically rich districts, on the site of a nineteenth-century villa that used to house the American Center of Paris, the building is surrounded by huge trees, including a cedar of Lebanon planted by Chateaubriand. The entire building is shielded by three palisades of glass through which passersby can see not only the structure of the offices within but the trees in the garden behind the building and the city's skyline beyond. While Nouvel emphasizes the solidity of the glass, it is this curious diaphaneity, to use a term that was dear to Pater's heart, that makes the building such an arresting sight either by day, when the clouds can be seen through its upper reaches, or by night, when it lights up like a lamp.

The exhibition featured many other notable projects, like Renzo Piano's Kansai International Airport (1994) and the "voids" of Frank Gehry's daunting Frederick R. Weisman Art Museum (1993), as well as a particularly Miesian villa by Rem Koolhaas. The most purely ascetic of

the projects seemed to be *Two Way Mirror Cylinder inside Cube* (1991) by the sculptor Dan Graham. This cell within a cell, which was installed on the roof of the DIA Foundation, where it offered a magnificent view of the Hudson and Manhattan, is a pavilion ten feet in diameter at the center of a thirty-six-foot square. Superbly engineered in steel and glass, part of the cylinder's wall glides open to allow you into the stillness at the center, even though there is no ceiling. For the city dweller, the inner sanctum of Graham's pavilion offers the pleasure of isolation, quiet, and maximum order. For the budding I. M. Pei of the future, it is an opportunity to see through and with geometry as a lens. For the student of asceticism watching all of this from the roof just outside the square pedestal on which Graham rests the glass square, it is an opportunity to reflect on how asceticism in architecture will probably never become old.

Asceticism in Music and the Dance

Contemporary music has more than its share of martyrs, but one figure in particular presided over the crossroads through which a number of the figures in this study passed. Like a mother superior governing her own order of Saint Cecilia, Nadia Boulanger tutored many of the greatest composers of our time in the salon of the apartment in the rue Ballou in Paris where she lived alone for seven decades, until her death in 1979. Having withdrawn from the concert stage and with her own compositions buried in the desk drawer, Boulanger became "Mademoiselle," the teacher who was a living link to old friends like Debussy and Ravel. She was rather dramatically devoted to the preservation of the memory of her younger (by six years), prettier, and more talented sister Lili, a piano prodigy and the first woman to win a Prix de Rome. She died at age twenty-five in 1918, and Nadia promoted her compositions throughout her life.

As unique as Boulanger was in person—a stern, deep-voiced, and perpetually pale combination of old world Russian grande dame and French schoolmarm, who dressed only in long black or gray pleated skirts that were "fifty years out of date" according to Philip Glass—she played a role in twentieth-century music comparable to that of Balanchine in dance, Hans Hofmann in painting, and Mies van der Rohe in architecture. These European master disciplinarians laid the "grammatical" foundation for the art of the next three generations, in Boulanger's case for American students like Glass, Walter Piston, John Cage, Elliott Carter, Aaron Copland, and Leonard Bernstein among many, many others. Going to Paris for Mademoiselle's weekly classes—an unbreakable ritual started in 1904 and repeated at three every Wednesday, followed by tea with her mother in the Russian manner—allowed their innovations to take root. In every way an ascetic, from the complete restraint with which she conducted with one raised finger and a minimum of gesture to her choice of teaching materials, Boulanger radiated the tranquility tempered with discipline that she most admired in her own professor at the conservatoire, Fauré. Almost all of her teaching could be classified

by the term *solfège*, or *solfeggio*, the study of pitch relationships and intervals—a dry set of exercises that bears a direct relationship to the revolutionary approaches to pitch that characterize much of contemporary composing and to the reduction to essentials like line, color, and materials in contemporary abstract art. Boulanger insisted, in a Pascalian fashion, that a composer had to be "a good grammarian" before anything.

The first afternoon of Boulanger's course in the rue Ballu always began in the same way: analysis of a plainchant work for single, unaccompanied voice, such as the anonymous *Tantum Ergo*, a melody that in her view could not bear accompaniment. She would move on to an *organum*—another chant—such as *Omnipotens verbum bonum* and then proceed to a piece by Debussy, such as "Frere, que sera-t-il le monde." The central work in her teaching canon remained Bach's *Well-Tempered Clavier*, which she knew by heart. Beyond the specific details of her life and teaching, however, there is a philosophical reason to place Boulanger at the head of a consideration of ascetic undercurrents in contemporary music. She kept her staunch Roman Catholicism to herself, but her attitude toward music, like Balanchine's toward dance, Yeats's toward poetry, and Mondrian's toward painting, could be described in no other terms than the religious. She was a believer in the divine afflatus: "Saint Teresa of Avila, afflicted despite everything with arid prayer, has visions; we say to ourselves, 'She is mad, it is hysteria.' That is very convenient! Was Menuhin hysterical while playing sublimely a sublime movement of a Brahms sonata? No, he received the power to penetrate a thought which is neither Brahms's nor his, nor mine: a thought floating in the world, above the world, bearing light."[1]

Perhaps it was her deep grounding in accompaniment or her self-effacing habit of talking more about her sister than herself, but Boulanger was an exemplar of the saintly attitude of self-restraint that characterizes the ascetic strain in contemporary music. Like a latter-day Minerva, she passed on the ethic of Classicism as well as the technical means by which it could be attained. Among the many brilliant messages of wise counsel that are left from her teaching are these words: "The company of music is a school of modesty. When you ask questions about the essence of the phenomenon of sound, you become aware that music is finally nothing but a restricted vocabulary multiplied by an incalculable number of solutions, always the same."[2]

The Spirit of the Times

It is amusing to think of what Nadia Boulanger would make of today's music industry. Wandering into a megastore and putting on the head-

phones to sample new releases, she would hear much that is familiar because of the bizarre phenomenon of the use of plainchant in electronically manipulated popular formats. Distressed by how disfigured the chants have become under New Age influences, Mademoiselle would move on to hear their traces in the more serious musical offerings; she would feel most at home with the new emphasis on pulse and pattern. The rhythmic figures that Philip Glass, Steve Reich, and others are famous for has its antecedents in some of the "Chants Espagnol" of Albeniz, Prokoffiev's *Symphonia Concertante for Cello*, and many other orchestral pieces, as well as the pedal point of Vivaldi, Handel, and her beloved French Baroque masters. The complex structures of Elliott Carter and Steve Reich, like the rhythmic virtuosity of Mondrian and other artists considered in this study, reflects a privileging of rhythm. Modernism provided an array of new approaches to the problem, including the strong-arm tactics of Igor Stravinsky in *Le Sacre du printemps* (1913, revised in 1947) and more subtly in his *Three Pieces String Quartet* (1914) as well as in later works such as the terse, Webern-like *Movements for Piano and Orchestra* (1958–59), a five-movement work lasting only ten minutes.

As for Boulanger's beloved Gregorian chant and other liturgical music, it survives in the delicate choral works of Gregor Ligeti, Arvo Part, Henryk Gorecki, Gyorgy Kurtag, Krzysztof Penderecki, Witold Lutoslawski, Sofia Gaubaidulina, and Giya Kancheli as well as in the choral parts of Reich's work. She would probably not be too surprised by the way in which this splits off into secular and mystical directions through the long line of mystics following the examples of either Darius Milhaud or Olivier Messiaen. Music's ascetic nature has its bodily aspect as well, just as ascetically based art does. As Jasper Johns and Bruce Nauman, among others, push the artistic use of the body to new limits, so too do Luciano Berio and Reich, as well as Scott Johnson, whose "John Somebody" (1986) takes speech and the voice through a panoply of manipulations, distortions, repetitions, and even destructions. In addition to the Eastern European mystics and Messiaen, an important group of Asian composers, some of them heavily influenced by the ascetic tenets of Buddhism, has become a force in the world's concert halls and in recordings. One of the leading lights was Toru Takemitsu, born in Tokyo in 1930 and a student of Kiyose in the late 1940s, who died in early 1996. Although traces of Debussy, Webern, Messaien, and others are to be found in his compositions, his most notable work uses Japanese instruments in such pieces as *November Steps* (1967), scored for the *biwa*, *shakahuchi*, and Western orchestra. His ravishingly lyrical *Requiem* (1957) is scored in the Western style for strings.

One of the most hauntingly ravishing vocal works in an ascetic vein

that I have heard is *Homa* (1988) by the Japanese composer Somei Satoh. Essentially a mantra, it is an elegy to the composer's grandmother, a professor of the *sangen*, or three-stringed Japanese lyre. Satoh, who is from Sendai in the north of Japan, worked exclusively with Japanese and Chinese instruments and music until he was fifteen. He became well known internationally after Global Vision, a multimedia arts festival in Tokyo in 1971 that featured performances that would last as long as twelve hours. The subtle movement of *Homa* is typical of the captivating and dramatic effect that a prayer can have in a concert hall. As the composer explains, "I wrote this music as a prayer for the peace of her pure spirit in the firmament." Originally scored for soprano and string quartet—specifically the Kronos Quartet, which premiered the piece in Tokyo—a revised version for string orchestra had its debut in January 1996 with the Juilliard Ensemble. The soprano line floats against quiet veils of often monotonal instrumental passages in unison and then, most effectively, emerges a cappella, punctuated by a hand chime. The text is a Buddhist prayer beginning, "Om, jewel in the lotus! Om, I believe in and worship Buddha, past, present, future."

For a group of brave avant-garde composers coming out of mainland China, all of whom lived through the dire poverty and persecution of the Cultural Revolution, the hardened asceticism of their outlook often reaches back to ancient roots. Since allusions to the great poets of the Song and Tang dynasty, Taoism, and Confucianism are construed as subtle jabs at Soviet-inspired propaganda, there is a political subtext to the reemergence of Classicism in China. A turning point was Tan Dun's *Li Sao* (1979), a symphony based on the ascetic poem of that title by the Warring States era poet Qu Yuan that propelled its young composer to international fame. Tan Dun's string quartet *Feng-Ya-Song*, also based on ancient poetry, was awarded a prize in Dresden in 1983, and *On Taoism* (1985) for voice and orchestra became well known outside China as a charming evocation of the serenity within a Taoist temple.

After Tan Dun came to the United States—to make ends meet, he played the violin in the subway and on the sidewalk—he flourished under the tutelage of Chou Wen Chung, composing such inventive works as *Soundshape* (1990), which used a chamber orchestra that played ceramic vessels by the artist Ragnar Naess, and *Orchestral Theater* (1990), which combined Western instruments, Chinese mannerisms, and the singing and shouting of the orchestra. More recently, Tan Dun triumphed with *Marco Polo*, a magnificently inventive opera that was part of the New York City Opera 1997–98 repertoire, which offers one of the great desert scenes in opera history—a haunting, lyrical example of asceticism

The brilliant young Chinese composer Tan Dun has collaborated with Paul Griffiths on the opera *Marco Polo* as well as with Yo Yo Ma on a historic symphony to celebrate the handover of Hong Kong.
Photo: © Steve Zaho. Courtesy of Sony Records.

in music. In person Tan Dun is jovial in an earthy sort of way and a bit of a sybarite. Married to a fashion model, he is blessed with a fat recording contract with Sony, lives in a huge Manhattan townhouse, is courted by producers to do film scores, and has become accustomed to jetting around the world to Cannes and Shanghai and Europe (he conducts the BBC Scottish Symphony) in the company of movie stars. A prize in his extensive art collection is a brilliant "smoke" drawing by John Cage, who was his mentor in New York. It is a sign of an underlying commitment to the ascetic ideal. As Tan Dun says, "My music will always have a profoundly ascetic background that comes from a variety of ancient poetic and spiritual sources."[3]

Another of the most formidable and ascetically minded pieces of the early Chinese avant-garde is *Sounds of Nature* (1986) by He Xuntian, who based the work on his long childhood walks along the mountain trails of his native Sichuan province during the Cultural Revolution to collect the meager salary of his father, who had been branded a rightist and sent for punishment to the countryside. Full of atmospheric effects

that depict the ghostly fears the young boy experienced, the work uses the Chinese flute, *xin* (zither), drums, and a heartbeatlike pulse over which floating tones on the Chinese *xun* (similar to an ocharina) imitate the wind and spirits. The twelve-tone method and new music from the West were introduced to China's young composers in large part through the work of Alexander Goehr, a British composer who taught in Beijing using scores by Messiaen, Stockhausen, Boulez and others. In the 1980s, a number of Japanese composers, including Takemitsu, Yasushi Akutagawa, and Isang Yun, also visited the conservatories in Shanghai and Beijing. In the eyes of composer Zhou Long, the assimilation of Viennese pantonality into a Chinese sound is comparable to the arrival of Buddhism in China more than a thousand years ago. As Yu Yu Yang and Noguchi have built Buddhism into their partly Westernized sculpture, so too Zhou has found a way to use not just the instruments and sounds of Chinese court music but its philosophy as well. He came to New York in 1985 to study at Columbia with Chou Wen Chung, Mario Davidovsky, and George Edwards, having been a leading light of the Beijing music community. In *Wu Ji*, Zhou takes as his title a pair of characters from an ancient philosophical text: *wu*, which means the lack of something, or nothingness, and *ji*, which means polarity or extremity. Together they can be taken as either "lack of polarities" or "beyond extremity" (more poetically, "beyond infinity"). The work has been presented in three versions since its premiere in 1987 as a piece for piano and tape. A more Chinese sound is created by the *xin*, or zither, with piano and percussion; and the third scoring, done in 1991, substitutes the harp for the *zheng*. Beyond those Asian composers, there is a group of Western composers who have been strongly influenced by East Asian writing, including the American Lou Harrison who, along with John Cage, worked in Los Angeles under Schoenberg in the early 1940s, having studied previously with Henry Cowell in San Francisco. Cowell, who also worked in innovative ways with the inside of the piano, was very interested in Asian cultures and encouraged Harrison to explore the chromatic and rhythmic possibilities of Asian music.

In the work of virtually all the composers considered here, clarity is a paramount virtue. The transparency among voices and the privileged structural underpinnings of the work are ascetic characteristics (as they are in the architecture of Mies). As intricate as Carter's rhythms become, it is of the utmost importance that their almost crystalline interdependence be perceived. The thinness of the ethereally high violin line (the technique involved is called *su ponte cello,* "under the bridge," where the bow is in contact with the strings) in Janáček's chamber works, particularly the "Intimate Letters" quartet, comes from an attenuation that, like

the paring down of a Giacometti sculpture or the thinning of the paint by a painter like Brice Marden, lends an ascetic character. It also brings tension—you almost feel how taut the string on the violin is—that militates against the notion that the ascetic must be meditative, calming, hypnotic, and sometimes, boring. In the works of Janáček, Webern, Stravinsky, Carter, and others, there is a penetrating use of instrumental voices that pushes an idea upward or downward through crescendos that arrive much faster and with less preparation than those we are accustomed to in the Romantic and Classical repertory.

Music of the Eye

This is an age of the visual experience of music, not simply in terms of popular media (via MTV and cyberspace) but within the historical framework within which the works were created and presented. Both Reich and Glass, for instance, were originally darlings of the SoHo art scene in the 1960s, and many prominent painters and sculptors, such as Bruce Nauman, took part in their early performances as instrumentalists, just as later in their careers they teamed up with major artists for larger theater works—notably, the pairing of Robert Wilson and Philip Glass. These performances were often held in art galleries that featured analogous styles of sculpture and painting or in museums such as the Whitney Museum of American Art and the Museum of Modern Art in New York. The visual presentation of the scores and the crossover phenomenon of Cage as printmaker with gallery shows in the tradition of his mentor Arnold Schoenberg, enhanced this interdisciplinary element, which also extends to the documentary television work of Glenn Gould.

The "need to exceed" inherent in musical Postmodernism has led to an antimusic consonant with the antiaesthetic of the visual arts, literature, and criticism. In a landmark essay published in 1976, titled "Music Discomposed," the philosopher Stanley Cavell noted the way in which incomprehensible or inaccessible serious music has lost its audience because it began to seem "fraudulent" or untrustworthy, a crisis in confidence that has also affected the art world. Cavell explains, "Whatever music can do, modern music is concerned with the making of music, with what is required to gain the movement and the stability on which its power depends. The problems of composition are no longer irrelevant to the audience of art when the solution to a compositional problem has become identical with the aesthetic result itself."[4] Driven by new inventions and technological advances, particularly in the area of digital sound production and recording, music frequently pits the human performer against the machine. The most dramatic and directly ascetic element of

this "antimusic" is the new thinking on silence. The patron saint of silence is John Cage, and his 4' 33" of silence remains a monument not only to avant-garde strategy but to a new understanding of the fabric of music that was built on the work of similarly ascetic thinkers and composers, beginning with Debussy, Satie (one of Cage's great sources), Schoenberg, and Webern and continuing through many of the other figures in this study.

The Ascetic as Dandy: Claude Debussy

The intellectual circles of fin de siècle Paris were full of characters that could be called "decadent ascetics," from Baudelaire, Mallarmé, Rimbaud, Villiers de l'Isle Adam, Laforgue, and Proust among the writers to Satie, Poulenc, Moreau, and Degas among the composers and painters. No figure stands as a more dramatic epitome of the decadent ascetic than Claude Debussy. Suspended between the rarefied air of Mallarmé's exhortations to purity and the mocking, indulgent excesses of Proust's aestheticism, Debussy deftly balanced these extremes. While in his life he enjoyed all the pleasures of Paris he could afford and was scarcely a recluse, in his work and writings he put on a rarefied, sometimes puritanical air that clearly had an ironic subtext. In an interview with *Harper's Weekly* published in 1908, Debussy pretended to be a virtual hermit:

> I confess that I live only in my surroundings and in myself. I can conceive of no greater pleasure than sitting in my chair at this desk and looking at the walls around me day by day and night after night. In these pictures I do not see what you see; in the trees outside of my window I neither see nor hear what you do. I live in a world of my imagination, which is set in motion by something suggested by my intimate surroundings rather than by outside influences which distract me and give me nothing. I find an exquisite joy when I search deeply in the recesses of myself and if anything original is to come from me, it can only come that way.[5]

The writings of Debussy are a delightful guide to the ambivalence of asceticism in the Modern era. Even the fictive character that Debussy created for his more opinionated essays, Monsieur Croche, is something of an ascetic—ageless, timeless, wrinkled, reminiscent of the "bent, hooked, closed-fisted" Kierkegaard through all the connotations of the word *croche*. His battle cry was the need to purify and streamline the music of the day. As Mallarmé in poetry and Degas in art were attempting to shake loose from the hold of the combined grip of Romanticism and academic

notions of Classicism, so Debussy wanted to clear the air. He declared, "Let us purify our music! Let us try to relieve its congestion, to find a less cluttered kind of music."[6] He was often lyrical in his descriptions of what music could do. One of his pet projects was the idea of outdoor music, allowing a communion with nature that harks back to the Romantic image of Wordsworth listening to the "solitary highland lass" in Scotland or Ruskin eavesdropping on the singing of the shepherds in the Alps.

In line with the sensibility of his friends the Impressionist painters, Debussy's *musique en plein air* was idealized as a "collaboration between the air, the movement of the leaves and the scent of the flowers." This preference for a quieter mode is characteristic of Debussy's "eloquent silences" and his opposition to the lavish, lush, and—most important—loud gestures of Wagner. In *Pelléas et Mélisande*, Debussy's lone complete opera, there are only four moments when the dynamics call for fortissimo, as opposed to the many, many pianissimo passages. "Passion need not be measured in decibels," Debussy warned. He was particularly sensitive to the deeper ranges of the voice, and acquaintances who had the good fortune to hear him at the piano play through a song cycle or *Pelléas* remarked on the "sepulchral" depths of his own baritone voice. Few recordings can convey the richness of Debussy's writing for double bass or cello or the magnificent bassoon passages in *Pelléas* and the powerful contrabassoon part in the funeral procession of *St. Sebastian*.

Debussy was relatively uninterested in many of the traditional genres, such as the concerto, sonata, or symphony (he wrote none); and even the string quartet, given the wonderful examples we have of his writing in the genre, attracted his attention only a few times. Instead, he worked with songs, cantatas, dramas, and brief lyric pieces with descriptive or textual inspirations. He celebrated music as "a world of sensations and forms in constant renewal." The phrase is reminiscent of Pater's "strange, perpetual weaving and unweaving of ourselves" that Joyce found so seductive. Among the works that confirm Debussy's ascetic orientation, it is *Pelléas* that most obviously touches on our purposes. It has been an acknowledged influence on many of the composers under consideration in this study; at the age of ten Messiaen received the score for *Pelléas* as a gift, and it became a touchstone for his lifelong method. To begin with, asceticism is an important element in the plot. The central figure in the opera, Mélisande, is arguably the most static, empty, passive, and remote heroine in opera. From scene to scene she glides in the dreamy immobility of a trance that is never broken, except when, tossed by her hair from side to side by her brutish husband Golaud, she becomes paralyzed with fear. Her first line, "Ne me touchez pas," secures the space that remains around her until her death scene, one of the most gorgeous orchestral moments of

transfiguration in the operatic tradition. Like the heroines in Mallarmé or Musil, her entire role is defined by evasion and unattainability. Of course the great irony is the way her adulterous relationship with Golaud surprisingly brings forth an infant girl, born as Mélisande dies.

It may be useful to remember that the Symbolist dramas that Debussy's friends, particularly the Comte de Montesquiou, would privately present would almost invariably consist of a slow text declaimed "mystically" behind a muslin curtain, similar to the scrims used in most productions of Debussy's opera today. The translucent, softening action of the scrim on both the voice and image of a stage work is complemented by its more important function, which is to separate the players from the audience physically, making them more remote and ethereal. In the work of Maeterlinck and Villiers de l'Isle Adam, the ritualized style of presentation underscores the role of a quasi-religious spirit not unlike that of *Parsifal*, the opera that haunted Debussy most thoroughly. Recent critics have made a great deal about Debussy's connections to the occult, particularly the work of Eliphas Levi, whose *Dogme et rituel de la haute magie* was among the books Debussy read in 1866.[7] The visual equivalent to this is not beyond Debussy's understanding. He wrote of the phenomenon of a scene or artwork being illuminated from behind, particularly with regard to the work of Poe, and was a strong opponent of overlighting the operatic stage. The dim, out-of-focus visual qualities that he favored on stage complement the wandering snatches of melody and gradually metamorphosing harmonies of the music.

After *Pelléas*, the longest theater score Debussy composed was *Le Martyre de Saint Sebastien*, which had its debut in 1911. A set of incidental pieces commissioned by Ida Rubinstein for a text by Gabriele D'Annunzio, it still titillates audiences with its sexy blend of sadomasochism and androgyny. Among those who were turned on by the hermaphroditic Rubinstein in the original were Proust, Montesquiou, and Cocteau, and a recent production starring Sylvie Guilleme had a similar effect in New York. The historic Sebastian, executed by order of the Emperor Diocletian, gave D'Annunzio the occasion to copy an octosyllabic meter based on medieval models. For Debussy, it was similarly an occasion to try out a pseudo-religious style that, like the score of *Pélleas*, is allusively and emotionally religious rather than specifically so. "I write my music as if it had been commissioned for a church," Debussy wrote to Bizet while working on *St. Sebastian*, calling it "decorative music, if you like, a noble text interpreted in sounds and rhythms. In our times we have not in our souls the faith of other days." Stylistically, one of the most distinctive features of *St. Sebastian* is Debussy's use of a descending tremolo figure on divided strings.

The score was left incomplete, and Nadia Boulanger (who had herself composed a work based on D'Annunzio, her *Città Morte* of 1911), thought she had the perfect ending for it in a dark thirteenth-century motet, *Iste Confessor*, that would take Debussy directly back to his roots in medieval chant. Although he never completed them, there are several other theater projects that are noteworthy in terms of Debussy as an ascetically minded artist. One is the incidental music he started in 1904 for *King Lear*, which, like Verdi whose score for *Lear* would have been so valuable, must be interpreted as a great loss. The other project involved Victor Segalen, for whose *Siddartha* Debussy was going to create incidental music. Written in Ceylon in 1904, Segalan's five-act drama traces the ascetic life of the young Buddha. In his letter turning down Segalen's proposal in 1907, he pleaded intimidation by the vast proportions of the drama, and mentions "the frightening immobility of the principal character."

The Echo Chamber

The role of the echo in Debussy's music, which parallels the reflection in Monet or the echoes in Mallarmé and Poe, is the technical key to understanding how Debussy built asceticism into his compositions. He was particularly taken by the line in Baudelaire's great "Correspondances" poem, "de longs echos qui de loin confondent," and the mingled effects Baudelaire captures are a guiding principle for the understanding of Debussy's music. One of the best examples of this is the use of the bass pedal point in *Rodrique et Chemin*. The principle of reflection connotes symmetry, of course, and this raises a problematic issue in the study of Debussy. As musicologist Roy Howat has passionately argued in *Debussy in Proportion*, the precompositional structure of the Golden Section, with all its attendant mathematical ratios, is the hallmark of Debussy's style. Putting together references in Debussy's letters and writings to "the divine number" and his own meticulous analyses of the hidden structures of several works, Howat tries to show that the proportions subtly built into Debussy's apparently fluid and almost formless works are based on the Golden Section. Like the artist Dorothea Rockburne, who has based many works explicitly on the principle of the Golden Section, Debussy avoided symmetry but took advantage of the mathematically based regularity of the Golden Section. Howat points to Debussy's interest in the writings of Poe and Paul Serusier on the rules of composition in art and poetry to indicate that he might have used a far more structured map for his compositions than is ordinarily believed. By pushing this to suggest a relationship between Debussy's proportions and the Fibonacci sequence (the mathematical principle behind the relations of

the Golden Section), Howat ties together the "arithmetic of sound" with Debussy's compositions in a way that might not convince all listeners.

To relate this more closely to asceticism, let's take it from the ideal of the mathematical model to the reality of musical composition. The problem of deviation invokes the tension between the ascetically pure music that conforms to the rules and the technically less orderly writing that arises when those rules are broken. As recent composers such as Pierre Boulez, Elliott Carter, Milton Babbitt, and Karlheinz Stockhausen have shown, the relationship between music as transgression and the strict regulation of time (what some call "clock time") or the constant formulas of computer-generated models creates the kind of tension that reflects the ascetic struggle to control. The composer often discussed in his writing the arabesque as an analogy for the gesture traced by a musical phrase from the time of the madrigal to his own work. In particular, Debussy thought of melodies as curves that turn through a different angle with each new note, creating the spirals in nature that were a key figure in the teaching of Charles Henry, an American expert in color who had a profound influence on Signac, Seurat, and other painters of Debussy's time.

Howat gracefully relates these spatial metaphors to Debussy's fascination with the vortex or whirlpool as observed not only in the works of Poe and the English painter J. M. W. Turner but also in his love for Hokusai's wave image, "Hollow of the Wave off Konagawa," which he insisted on having as the cover image for *La Mer* and which hung on Debussy's wall at home. Like the central importance of the whirlpool in the poetry of both Poe and Swinburne, its destructive beauty as an empty, repeating form is perfectly suited to Debussy's dramatic music.The feeling of vertigo suggested by the whirlpool is an important illusion in Debussy's descriptive passages. In *Pelléas et Mélisande*, it is most dramatic when Golaud leads Pelléas to a point overlooking the water below—in some productions, it is the sea, in others a kind of Poe-like tarn or even the castle's diabolical moat or sewage system, a darker answer to the well at which Melisande is discovered in the opening scene. In a recent production at the Metropolitan Opera House, the threatening atmosphere of this scene was wonderfully conjured by the slowly revolving set on a turntable that brought into view the cluttered back storage areas of a country house, a dark and dangerous-looking inverse of the softly lit luxury of the main rooms.

The Voice of Angels: Olivier Messiaen

The heir to Debussy, in asceticism as in so many other ways, is Olivier Messiaen. Imprisonment and poverty are two cardinal ascetic themes,

and both play a dramatic role in the composition and first performance of one of the most moving, marvelous pieces of chamber music in the twentieth-century repertory, the *Quartet for the End of Time* (1940) by Messiaen. In a freezing barracks during the dead of winter at Stalag 8A, using the only available instruments and players, Messiaen created a masterpiece. As a French soldier, he became a prisoner of war at Gorlitz in Silesia after being captured near the Maginot Line and sent with thousands of others in cattle trucks, without food or water for days, to the camp, where the soldiers fought over water—except Messiaen, who sat aside reading a pocket score. For a year he lived on a bowl of soup every day, sustained in part by his early morning view of the aurora borealis. A pacifist, he was permitted by his captors to write music in the bathroom with paper the Germans supplied and a piece of bread to eat.

The quartet begins with the *liturgie de cristal*, a brief passage that layers a repeated five-note phrase on the cello over a *tala* (an Indian rhythmic unit that reflects Messiaen's study of Asian musics) of seventeen rhythmic clusters, lightly dropped into the phrasing on the piano, accented by birdsong solos on the violin and rising clarinet figures that foreshadow the great cello and violin lines to come. This is followed by a heavy set of dissonant piano chords announcing the *vocalise* for the angel who announces the end of time, again in violin and cello in double octaves accompanied by "rainbow water drops" softly heard on the piano. The Book of Revelation is the main text for the piece, and the description of the Apocalypse is captured in the long clarinet solo, with wonderful arpeggios and a vivid repeated bottom note, that constitutes the third part, the negative and death-centered moment of the *abime des oiseaux* as well as in the "furor" of the sixth movement, which Messiaen described in architectural and clearly ascetic terms as the "irresistible movement of steel, of huge blocks of purple fury, of abandonment frozen." This is followed by an intermezzo during which Messiaen, in the original performance, scored his own absence (the piano is also missing from the third movement) so that he could rest to listen to the other three players—another of those self-effacing gestures that is typical of Messiaen. In the *fouillis d'arcs-en-ciel*, Messiaen offers an early exploration of his synesthetically based music of colors.

The most moving parts of the work are undoubtedly the long cello and violin movements, the fifth and eighth of the piece, based on earlier pieces the composer had written, called the *Louane a l'eternite de Jesus*. The mode for both versions of this music is E major—the first identifiable tonal center in the quartet—and the "infinitely slow, ecstatic" dynamics of the composer have to be achieved by an extraordinarily still, calm bow on the cello or violin. The first time around, the voice of the

cello is high, initially unaccompanied, with a serenity that is not broken by the subdued piano chords. In both statements of the theme, more sublimely in the violin because it thins and rises more dramatically, the ascending movement is as visual as the thin black thread against a blue ground that Miró painted in his last, vast canvases (the only chamber piece I know that is as close to the spirit of Miró, in this case his Constellations series, is the fifth quartet of Dutilleux). It floats upward, backs off momentarily, then becomes more and more attenuated until it reaches the threshold of audibility as the last echoes of the piano chords die away. As several commentators have noted, the tempo of these movements is so slow and halting that time itself seems to stand still; as in Mann's *Magic Mountain*, the whole temporal progress of the work seems to be arrested.

The quartet announces a new way of thinking about rhythm that baffled the performers of his day, and still stands in contradiction to most of what one brought up on Haydn and Mozart would consider to be rhythm. It also strongly contrasts the pulselike regular rhythms of Glass or Reich as explored later in this study. The "additive" aspect of Messiaen's rhythms in the *Quartet for the End of Time* is created by the way a longer unit is constructed by two or three smaller ones that have a regular value. What separates Messiaen from the additive rhythmic styles of Reich and Glass, however, is his way of making rhythm irregular by adding together these units, as opposed to their way of blocking out larger and larger regular structures. In the simplest terms, that pulse of quarter or half notes that we expect to hear in a piece of music is dissolved by Messiaen in ever longer washes of sound that have the same effect as Proust's meandering sentences have on conventional syntax. The "dissolution of time," an end of time as we knew it musically, arises from a new kind of nonrepetitive rhythm, without the customary bar lines. In the end, as with his explorations of melody through birdsong, he turned to nature for his inspiration.

With time Messiaen became the dean of French music, comfortably ensconced in his wife's Paris mansion with eight pianos scattered through its maze of rooms and the sounds of Paris deadened in a Proustian fashion by four-inch-thick custom-built wooden shutters. He worked on the rhythmic dimension of his compositions at his desk, and turned to the piano to determine harmony and pitch. As a living link to Les Six, he was almost morally obliged to uphold the tradition of Classicism in contemporary music, but his own compositions entered a late period of great complexity. Their lush colors and exoticism and their lyric power are far from ascetic, and many forget that one of his most frequently played orchestral works, the weird and loud *Turangalila-symphonie* (1946–48) for

full orchestra plus celesta, vibraphone, glockenspiel, and *ondes martinot*, is actually Messiaen's interpretation of that antiascetic Wagnerian theme of Tristan and Isolde.

The most controversial moment in Messiaen's public career was the debut of *Chronochromie* (1959), when the public simply could not disentangle the crisscrossing passages of birdsong. Like the most complex of the Jasper Johns crosshatch patterns, the layered textures of flitting and swooping intervals set up elusive rhythmic patterns, particularly in the rhythmically intricate, four-minute epode. Over eighteen independent solo string parts, the birds are set free from their rhythmic and harmonic cages in a stupendous gesture of liberation. Using Classical models to hold the structure in control—specifically the strophe, antistrophe, and epode of Greek dramatic poetry—Messiaen also relies on brief silences, as in *Reveil*, to mark off structural units. Adding to the difficulty is the virtually encyclopedic, global scope of the birdsong collected from the jungles of South America and China to the cardinal of the United States and the little finch outside his window. Messiaen imposes order through a self-designed "system of limited permutation" by which he chooses the duration. Like some of the computer-generated pitch class and durational selection methods of John Cage or the mathematically based compositional formulas of Messiaen's student Boulez, there is an underlying algorithmic foundation to these permutations, and the tabular outlines for the entrance of certain birds in *Oiseaux exotiques*, for example, bears more than a slight resemblance to Cage's columnar modes of organization.

A consideration of Messiaen's ascetic nature inevitably leads to a discussion of his religious sources of both material and inspiration. Of the approximately fifty works in the canon of his compositions, at least half have biblical or theological titles. The greatest of these is his one opera, *Saint Francis in Ecstasy*, which occupied him for eight years, including wide-ranging research trips as far afield as New Caledonia, to track down birdsongs he needed. Ironically, he never once visited Assisi. "I am a composer of the Middle Ages," he often said, and in his use of plainchant and liturgical techniques he built sacred anachronisms into many of his major works. *Saint Francis* is certainly one of the masterpieces of twentieth-century asceticism. Nonetheless, it is not a model of restraint—Messiaen's poor wife needed two years just to write out the part scores for it. For the text he uses nearly the whole of Francis's poem, the "Cantico del Sole," and drew as well upon the hagiographies of St. Bonaventure as well as the writings of a contemporary Capuchin scholar, Father Louis Antoine.

Unlike Hindemith's *Mathis der Maler*, Messiaen's opera is not a dramatization of the rites of passage and uncertainties that Francis faced

as he renounced the world. Messiaen despised what he called the "filth" of the morbid stories of the early sins of the saint and all the psychological accounts of the life of Francis. Most operatic composers would have jumped at the chance to play up the romantic pairing of Saint Clare and Saint Francis, but Messiaen deliberately excluded her, and he opened the opera with Francis in charge of the order at Assisi. Messiaen's restraint as an operatic composer borders on the saintly. Most composers would also have cast Francis as a tenor, the Parsifal-like hero, but Messaien made it a baritone role which he wanted to combine the vitality of Golaud from his beloved *Pelléas* with the gravity of Mussorgsky's Boris Godunov. Messiaen pictured many of the scenes in terms of Renaissance paintings: Francis in his brown habit and reddish beard is supposed to resemble the portrait by Cimabue at Assisi as well as the physical poses of Giotto's frescoes at the Arena chapel. The Angel, a soprano role in the third scene of the first act, is conceived after an annunciation by Fra Angelico that is in San Marco in Florence; the leper in the same scene is based on Grunewald's Isenheim altarpiece.

The role of Francis is sung and chanted in alternating unaccompanied and ensemble passages. The opera is punctuated by liturgical choral music, such as the lauds of the second scene, sung by the bass voices over a deep orchestral accompaniment by the brothers in the church. The most powerful choral passage, however, comes at the moment of the stigmatization. The fortissimo massed voices sing "C'est moi" and proceed, in a powerful tutti passage, to proclaim: "The Man-God! Who comes from beyond time, goes from future into past." Suddenly, there is silence, followed by the orchestral theme of the angel knocking (from earlier in the opera), another silence and then the chorus, as Christ, calling Francis by name, pianissimo in E major, echoing in orchestral chords in high E major. Often staged with lasers that represent the five rays of light that strike Francis's hands, feet, and side, it is a stunning operatic moment.

The finale is set in the church of Porziuncola, where Francis is saying farewell to the monks and birds. After the last verses of the "Cantico del Sole" over the chant of bass voices, the leper returns to bless Francis in a powerful aria. Francis then prays for his soul, against the forte ringing of bells. The final chorus, in C major, is a hymn to resurrection. Like the earlier lauds, this chorus is "modal" and consciously based on the tradition of medieval chants in which Messiaen felt his vocal music belonged. The fascinating contrast between the advanced orchestral effects of the opera and its liturgically based vocal writing takes Debussy's use of chant to a new level. Rarely produced in its entirety, partly because of its massive length (over six hours, requiring a chorus of 150 singers and an orchestra

of 120), the opera has a profound effect. As the superb scholar of Modern music Paul Griffiths has written with regard to Messiaen's Saint Francis,

> The great paradox of Messiaen's music—and most spectacularly of his largest work—is that there is no conflict between the icon-maker's selfless transcription of what is given and the artist's assertion of an unmistakably individual world. His music is instantly recognizable as his, and yet it says nothing about him—beyond what it says by saying nothing. The goal of his creation is a transparency to the divine creation: to the natural world, and to the natural history, too, of heaven. One can find explanations for his detachment from the personal in his detachment from the diatonic progression and metrical uniformity of post-Renaissance musical time—a double detachment shared with other composers who have addressed themselves to the sacred, including the growing throng who, around the time of Saint François, were beginning to make Messiaen's position as a twentieth-century religious composer less isolated. Yet he remained extraordinarily isolated in combining singleness of purpose with vast multiplicity of means.[8]

Musician of Silence: John Cage

Whether it was his soft speaking voice, kind eyes, the inevitable blue work shirt and jeans he wore to the concert hall or gallery opening, or simply his infinite patience with admirers and people with questions, there was something saintly about John Cage in person. In her detailed and moving introduction to a recent, generous volume of conversations with Cage, Joan Retallack notes that Cage, although famously a part of "the scene," had a reclusive streak: "But, though Cage in many ways enjoyed being a public figure, his extraordinary accessibility was the other side of a very private person who longed for invisibility, for a mode of being in the world where ego disappears, leaving no trace. In the middle of enormous responsibilities and a fame about which he certainly felt ambivalence, Cage made getting lost a way of life."[9] Cage's evanescent music, art, and poetry is so closely tied to his personal beliefs and behavior that the cautious division of art and life is less imperative in his case. Even the use of the I Ching and Zen in his work was openly spelled out in the writings and scores, rather than used in some kind of obscurantist "black box" fashion to hide the progress from idea to sound. The ascetic qualities of the work—its restrained tempi, the fine edge it treads along the threshold of silence, its tendency toward open outlines visually and aurally, its use of repetition and a meditative connection to real time, as well as many

other facets—directly reflect the conduct of the composer's life, because, moment by moment, so much of that life made it into the work.

The Cage story is marked by an intriguing dialectic between break-through and retreat. The son of an inventor, Cage went from being class valedictorian at his California high school to wandering around Europe as a college dropout during 1930 and 1931, enjoying the Gothic archi-tecture of cathedrals and even working at odd jobs as an architectural draftsman. He returned to California and in 1934 started counterpoint classes with Arnold Schoenberg as well as music theory courses at UCLA. He became involved in modern dance and moved to Seattle in 1937 to work with Bonnie Bird at the Cornish School, where he met Merce Cunningham, one of her students. Cunningham and Cage would become Modern dance's answer to Stravinsky and Balanchine. In 1942 he made the move to New York, and his first major concert in New York, in February 1943, featured work for percussion. The landmark concert of that period, however, was the January 1949 evening at Carnegie Hall when Muro Ajemian played one of Cage's early works for prepared piano. During a 1949 trip to Europe, Cage worked on his second string quartet, using an Indian view of the four seasons as creation, preserva-tion, destruction, and most important, winter as quiescence or tranquil-ity—later the centerpiece of his work. This emphasis on tranquility, itself an ascetic priority, was meant in part to counter the suffering of arthritis. Although he credited his macrobiotic diet with the conquest of the worst discomfort, saving him from taking twelve aspirins a day, Cage retained to the end of his career an undertone of concern for what he once called "a world pain," a consciousness of suffering that his more playful and ethereal side often masked.

The focus on dance and percussion, together with Cage's way of fuzzing pitch or making it more complex (think of what a bolt or screw in the piano strings does to the purity of tone!), drove him to concentrate on the one musical element—rhythm—that is left after pitch is taken from the picture. In his *First Construction* (1939) and even in the First String Quartet of 1950, the emphasis is on rhythmic innovation. Cage became interested in the Chinese book of changes, the *I Ching*, in the late 1940s and studied Zen Buddhism at Columbia University with the already leg-endary Daisetz T. Suzuki. Much of the Buddhist thought that informs the work of Brice Marden, Nancy Haynes, Philip Glass, and others in this study can be traced to Suzuki's charismatic presence in New York. For Cage, Zen translated into a cardinal principle of his compositional method, which from the 1950s on involved relinquishing rational control (the legacy of Schoenberg) and allowing chance operations, as well as the performer to a certain degree, to fill the creative space of a work.

The first major composition for which Cage used the *I Ching* was the initial stage of a massive (eventually four-volume) piano opus called the *Music of Changes*, which Cage began in 1951. Previously, he had used what he called a "magic square" to help him keep an "empty mind" in composing his second string quartet. With *Music of Changes*, Cage learned that musical structure could be determined by the charts together with the tossing of three coins. Although the use of chance operations in Cage's later work was more codified by computer programming, done by assistants, the basic notion of an aleatory art remains the same. Within limits set at the beginning by Cage (sometimes with a performer, as when the tonal range is specified based on the capabilities of the instrument), the duration and pitch of the sounds would be "selected" by the charts, rather than by Cage. The whole process is simpler than it sounds at first, because the charts tell Cage how long to hold a note and which note to choose. The indeterminate nature of this process anticipated, by about four decades, some of the most sophisticated, usually computer-based thinking on chaos and game theory, nonlinear physics, and even genetics in our time.

While Cage always insisted that the charts of the *I Ching* (particularly as generated by computers) function like a machine, the transition to a more mechanical compositional process came about when Cage moved into the electronic arena with his *Imaginary Landscape No. 5* (1952). Jean Erdman, his collaborator, helped him to use excerpts from forty-two gramophone records, that were chopped into tiny fragments of sound and reassembled. This splicing technique, which may be one of the few tangential links between the work of Glenn Gould and Cage (Gould was downright nasty about most of Cage's aleatory techniques, however), was later expanded in a work called the *Williams Mix* (1952), which brought together a mind-boggling six hundred different recordings, in fragmentary form, each carefully measured and configured according to chance operations. The metaphorical presence of the machine in Cage's work is another of his links to the Modern ascetic tradition. He called the *I Ching* "a kind of computer, a facility" to distinguish it from being a "source of wisdom."[10] Like James Merrill's use of the ouija board in a late series of poems or the rhythmic pulse generator that Steve Reich used experimentally early in his career, Cage's computer programs and chance operations introduce an automatic quality to the music, distancing it in an ascetic way from the human and emotive qualities (of the composer and the performer) that we associate with more "personal" music.

The electronic generation of sound was not the only cutting-edge technique Cage was exploring in 1952. This was also the year that he composed *Water Music*, which featured Cage pouring water from pots

into other pots or big bowls, blowing a whistle under water, and doing visual routines like card tricks. The conceptual nature of the piece, down to the pun on Handel's famous suite, might seem obvious, and through it the link to performance art, or "happenings," could be made; but that would detract from the musical intentions that Cage brought to the work, particularly in terms of the perceptual awareness that Cage was hoping to invoke. *Water Music* was echoed nearly four decades later by a brilliant work by Cage, entitled *One* (1992), that involved the melting of a sculpture in snow, ice, and pebbles by Mineko Grimmer. While her pyramidal form—a snow cone—melts and releases pebbles to tumble down through a network of wooden sticks, Cage's violin piece adds a continuo to the rattling and plopping sound of the stones dropping. In his view it put the short sounds of the stones hitting the sticks against the long, sustained sound of the violin. The inventiveness of the *Water Music* is also shown in another piece, called *Inlets and Branches*, that makes use of plant materials and a conch shell full of water that is tipped and either gurgles or has another rhythm. As Cage observed, "In the case of *Inlets*, you have no control whatsoever over the conch shell when it's filled with water. You tip it and you get a gurgle, sometimes; not always. So the rhythm belongs to the instruments and not to you."[11]

Effacing the Ego

In the 1950s, Cage was becoming more involved in "a testing of art by means of life," along the lines of Suzuki's teaching. He realized that music need not be the traditional marriage of form and content nor a vehicle for pushing ideas and emotions of one person into the head of another, even though he uses the word "didactic" in relation to his work. One of Cage's famous remarks was his expression of antipathy for Handel's beloved *Messiah*. As Cage said, "I don't mind being moved, but I don't like to be pushed" (p. 79). His music became directly attuned, in a Heideggerian sense of that term, to alterations in the mind of both listener and composer. As he wrote: "I think there is a didactic element in my work. I think that music has to do with self-alteration; it begins with the alteration of the composer, and conceivably extends to the alteration of the listeners. It by no means secures that, but it does secure the alteration in the mind of the composer; changing the mind so that it'll be changed not just in the presence of music, but in other situations too" (p. 78).

By building in a mirrorlike receptivity to the changing mind of the maker and conditions surrounding music, Cage ascetically turns the tables on the ego and the role of the composer as ultimate agent of control in the musical situation. In *Silence* he equated time and space in terms of

a "magnetic" void: "All that is necessary is an empty space of time and letting it act in its magnetic way" (p. 178). This is a crucial point for understanding Cage's view of his relationship to the listener, the performer, and the music. While Cage's restraint of subjectivity seemingly cuts out the feelings of the performer, much to the frustration of some who have attempted to play his work, it is important to note that the effacement or suppression of the ego is the all-important first movement of music for him. In this passage from *Silence*, Cage reveals the danger of what might be missed if the ego rules:

> It is in the ego, as in a home, that those feelings and ideas take place. The moment you focus on them, you focus on the ego, and you separate it from the rest of Creation. So then a very interesting sound might occur, but the ego wouldn't even hear it because it didn't fit its notion of likes and dislikes, its ideas and feelings. It becomes not only insensitive, but, if you persist in annoying it, it will then put cotton in its ears. So if it isn't sufficiently insensitive to the outside, it will cut itself off from possible experience. (p. 79)

One way that Cage found of reducing intention, knocking the ego back, was by multiplying intentions or making his music or art so complex that the single-mindedness of one idea was mediated by the intrusion of a number of other ideas. This can be done simultaneously in a work such as *Roaratorio* or *Europera* or through quicksilver changes of temperament within a piece, as though the composer were changing his mind constantly. One of the reasons that Cage and Cunningham were such a good match is that Cunningham also likes to add layer on layer of simultaneous but not necessarily consonant complexity, and both Cage and Cunningham use this device as a way of privileging intelligence over power.

For all his seeming nonchalance (this is in large part a misconception, as we will see), Cage was detail-crazy. To know that you only had to watch him leaning way in under the lid of a piano he was preparing, both hands busy with the rubber bands, screws, and bits of paper and wood that he was carefully inserting in the strings. As his theory of composition makes clear, the real act of composition proceeds "note to note." He wrote, "Method is the means of controlling the continuity from note to note. The material of music is sound and silence. Integrating these is composing" (p. 62). He was dissatisfied with the way that neo-Classicism had dodged the bullet of structural innovation. Having studied with Boulanger and Schoenberg, Cage knew that he had a responsibility to push past their formal definitions. The ascetic dimension of his experimentation was related to Zen concepts like "disinterestedness" and

calm. Like Jasper Johns in his zero-through-nine abstractions, Cage found a way to put the zero back into Schoenberg's twelve-tone system with his silences and his unclassifiable pitches. The goal of this work—and it was hard work—was a degree of perfection: "The responsibility of the artist consists in perfecting his work so that it may become attractively disinteresting" (p.64). One of Cage's many definitions of the kind of perfection toward which he was aiming combines grace and clarity, which has a coldly ascetic character and is mainly associated with rhythm: "With clarity of rhythmic structure, *grace* forms a duality. Together they have a relation like that of body and soul. Clarity is cold, mathematical, inhuman, but basic and earthy. Grace is warm, incalculable, human, opposed to clarity, and like the air. Grace is not here used to mean prettiness; it is used to mean the play with and against the clarity of the rhythmic structure. The two are always present together in the best works of the time arts, endlessly, and life-givingly, opposed to each other" (pp. 91–92).

In terms of oppositions and the quest for perfection, Cage's notorious "silent" piece, titled 4' 33" because it originally consisted of four minutes and thirty-three seconds of silence while a pianist sat before the piano with the keyboard closed, stands as the epitome of how the opposite of sound can be shaped and presented musically. It would be hard to find a better example of musical asceticism. The role of ambient sound in the experience of 4' 33" draws attention again to Cage's valorization of the sensitivity to the outside sounds that become musical material. Cage's own experience in an anechoic chamber taught him that there really is no such thing as silence in an absolute sense. Cage introduced the world to the idea of an aesthetic silence that could autonomously constitute an entire work, in a way that was lyrical, technological or even meditative. Like his idol Satie, as well as Debussy, Cage knew the dramatic and musical value of the dynamics of pianissimo. As Cage noted, there was a difference between his silence and the "real" or commonplace version: "Art silence is not real silence and the difference is continuity versus interpenetration" (p. 189). In the last year of his life, Cage reflected on how the work 4' 33" had changed for him, accumulating a technological or "electrified" edge and an added ascetic dimension as the threshold of pain is brought into play: "Now I think of it more in relation to the world as a whole. And I have another form of it which brings the silence of the room up to the level of feedback but doesn't allow the feedback to be heard, only sensed, so that you realize that you're in an electronic situation that could be painful. But isn't, hmmmm? But could be. And in that highly electrified silence I then leave the stage and go and sit in the audience and experience it for an unmeasured length of time."[12]

For some observers, a composer or performer who relinquishes the stage to listen to the silence he has created seems too relaxed. However, to fully grasp how Cage and asceticism fit together, particularly in large, multipart works such as *Ryoanji* and *Europera*, the composer's subtly hidden sense of discipline has to be considered more carefully. Often hidden behind the affable exterior and popular notion of Cage's aleatory methods as a way of avoiding the problem of control and rigor, his strict attention to proportion, intervals (including his beloved fifths), the preparation of instruments, and the presentation of scores lay a powerful sense of discipline, which his friend Norman O. Brown used to criticize as too Apollonian. One of the most fascinating examples of Cage as ascetic and as disciplinarian is the series of works known as *Ryoanji*, the scores for which are based on Cage's drawings of the outlines of a set of stones that are placed on paper through chance operations. Beyond the emptiness of the outline—with all its architectural connotations of structure, closure, edge, and plan—the immediate reference of *Ryoanji* is itself ascetic. The garden of Ryoanji in Kyoto, created around 1500 A.D., is one of Japan's most famous ascetic retreats and a superb example of the *kare sansui*, or dry garden, in which water and landscape (even seascape) elements are represented by rocks. Its wall alone is considered a national treasure, with its complex patina of several tones of brown.

Cage's outlines and his use of empty brackets in his compositional practice go together with the importance of the wall or perimeter. On the "sea" of raked gravel inside the wall, fifteen stones "float" surrounded by moss, its only living plants. The garden is a sacred site for the Rinzai sect of Zen Buddhism and is kept by the monks of the nearby monastary, Myoshin-ji. Since it is outside Kyoto, the garden was virtually unknown until the 1930s. One rock is always hidden when seen from any point along the veranda of the viewing pavilion, which controls the perspective on the rocks. When Cage visited Ryoanji, he was fascinated by this illusion of the hidden rock, as well as the Swiftian tricks of scale that allow the rocks to grow to seem as tall as real mountains. As Cage observed, "I think of the garden or the space for the fifteen stones as being four staves, or two pages—each page having two staves."[13]

The music of Cage's *Ryoanji* is based on a monotone played by the soloist on any pitch but constantly and rhythmically so that the flute, voice, double bass, cello, or oboe (Cage wrote a version of the piece for each) becomes a percussion instrument against an accompaniment of string parts that "follow" the curved lines of the outlines of the stones. They ascend or descend according to the curves, which are read from left to right on the musical staves, and they make use of the microtonal scale that allows Cage to build an element of "imprecision" into the work

(after the example of Ives). Each page of the music is meant to represent a "garden of sound." Between the half-steps we all know from the piano (from C to C-sharp for example) there is what can only be described spatially as a small step or jump, distinct from what happens in a glissando, which Cage relates to the sounds of traffic or other traditionally non-musical noise. Using the microtones, Cage reaches different shades of meaning for that space between C and C-sharp. In the score, these movements are indicated by little arrows up or down between, for example, C and C-sharp, like the small arrows one sees in the work of Paul Klee or Robert Ryman. Cage worked with Michael Bach on the cello version of *Ryoanji*, for example, the performer and composer placing their emphasis on the "unspoken" sounds of the cello, blurring the pitch or the interval. The collaboration, which is wonderfully documented as one of the transcribed interviews in *Musicage*, began with Cage asking Bach to determine what he wanted the range of his cello to be, and it ended with Bach playing the piece under a sheet of clear plastic during a mild rain in the open sculpture garden of the Museum of Modern Art during the 1992 Summergarden festival devoted to Cage's music.

The written instructions for these works make it clear that Cage was not without a sense of discipline, as his collaborators can confirm. He wanted them to tell him what their limits were as instrumentalists or vocalists, and then he would remind them of their limits in his act of composing the works. Looking at a typical Cage score, such as those for *Europeras*, one is struck by the way that instructions and information are presented as columns. Like Marden's columns of Chinese "characters," Cage's columns are often long strings of numbers typed out or printed from a computer, with annotations in Cage's hands showing pitches or gamuts. The computer printouts are done by Andrew Culver, and they are used to generate everything—mesostic routines for Cage's poetry, chair positions, flat movements for the Europeras, light cues and events, artwork, the data tables that allow him to work out the time values, even the pencil sizes and stone selections for the Ryoanji series. The annotations are in Cage's distinctive scrawl, creeping upward toward the top right-hand corner of the page.

Legend has it that Cage gives his performers virtual carte blanche with his works, but that is far from true, as these tightly organized scores attest. He resented the mess created by the New York Philharmonic under Leonard Bernstein when they sabotaged his *Atlas Elipticalis* in 1964 at Lincoln Center. Not only did the audience walk out, as they still do, right in the middle of contemporary works, but the orchestra itself ended up hissing during the work, missing their cues, and trampling the microphones at the end of the performance. Cage later called them "gangsters,"

and it was clear that his patience as well as his laissez-faire attitude toward the performance of his work was limited. He was similarly annoyed when the Juilliard School students would "emote" at the piano or add their concert tricks to performances of his music rather than listening to the sounds they were creating.

The importance of discipline to the performance of Cage's music as well as to his own habits of composition is underestimated. Those minute particulars that made up his mosaics of sound, whether they were snippets of recordings or literally bits of hardware bouncing between the strings of a piano, were not minor elements in some free-floating improvisation. He may have left it to the I Ching to determine how sharp his pencil would have to be before he traced the paper outlines that represented the rocks of *Ryoanji*, but he followed that determination with the greatest care. There is a revealing comment on "discipline" in one of Cage's interviews with Richard Kostelanetz. The two had been talking about academic disciplines and the kind of knowledge that is required of one to become an expert in a discipline, but Cage segues to a more general and philosophical comment on discipline in the broader sense:

> The way I was educated I was not given the meaning of discipline. I was told that if I were going to be a composer I should know harmony, counterpoint, and all those things. You are told that you have to study those things, although they are of no use to you ultimately, and that you learn those things in order later to give them up when finally you get around to self-expression. But this isn't the nature of discipline. True discipline is not learned in order to give it up, but rather in order to give oneself up. Now, most people never even learn what discipline is. It is precisely what the Lord meant when he said, give up your father and mother and follow me. It means give up the things closest to you. It means give yourself up, everything, and do what it is you are going to do. At that point, what have you given up? Your likes, your dislikes, etc. When it becomes clear, as it now becomes to many people, that the old disciplines need no longer be taken seriously, what is going to provide the path to the giving up of oneself?[14]

In terms of the asceticism behind Cage's outlook, this comment is crucial. It is concerned with "giving up" oneself as well as the old views of music and composition and the opinions that went along with them. The statement has an almost religiously ascetic quality in calling for the renunciation of "the things closest to you."

The issue of control now arises, as it does in the case of Balanchine's ballets, in the performance of Cage's music after his death. He was assiduous in his attendance of performances of his work and was accessible

for performers and conductors who needed guidance in interpretation. He was also very opinionated about which performances had been better than others. As the conductor Paul Zukowski wrote in his introduction to the program notes for the Summergarden series at the Museum of Modern Art dedicated to Cage's work, too many liberties have been taken in the past by performers, and now that Cage is no longer with us the scores have to safeguard his disciplined intentions:

> It is true that no re-hearing is ever *precisely* the same. Even when we listen to a recording, we perceive certain aspects differently each time, and it is only to be expected that live performances differ one from another. Nevertheless, these differences are usually within the boundary of "sufficiently similar" for us to consider the result to be more or less the "same." When Cage allowed the strictures of precise temporal replicability to slip (and let us be honest—for every finger of freedom he allowed, performers took an arm, and when Cage allowed the arm, they tried for the whole body, until, in a fairly famous, or infamous, moment in Buffalo, Cage cried FOUL, and began the long walk back to a more controlled and controllable notation system), it was not longer possible to conceive of pitch centers, as the relationship between pitches had become mutable, and that in turn meant the end of being able to think in terms of *harmony* in Cage's music of that time.[15]

The future of Cage's music is ensured in part by his scores and the philosophy they reflect. Cage had a strong sense of the interrelationship between temporal and spatial effects. His spatial view of music is reflected in the dramatic innovations he made in the use of annotation. By the time he wrote the *Concert for Piano and Orchestra* (1957), dedicated to Elaine de Kooning, he would provide no "master score" for the work and was not aiming at the kind of "harmonious fusion" that the word *concert* or the traditional expectations of the concerto would raise. The piece presented "specific directives and specific freedoms" for each player, including the conductor, and applied chance operations to the orchestra, which could present the work as a solo, ensemble, symphony, aria, or traditional concerto. The only coordinating factor was elapsed time, as indicated by the conductor, who used his arms as a clock and was free to slow or speed up the piece at will. The players spread themselves out as far as possible in the concert hall (an interesting parallel with the quartets of Elliott Carter, which use a wider than normal spacing among players), and they can play as long or as briefly as they want, while the pianist is free to select any number of "elements" from a book of eighty-four short compositions, which can be combined in any sequence.

The Mark of Silence

This element of chance begins even with the very first confrontation between the composer and the piece of paper (recalling Mallarmé's fascination with the "blank stronghold" of the paper) or any artist's feelings on looking at a stretched canvas or nice piece of handmade paper without an artificial mark yet on it. When Cage gave his Norton lectures at Harvard in 1990, he explained that the irregularities or imperfections of the paper could contribute to the process:

> Turning the paper into a space of time, imperfections in the paper upon which the music is written. The music is there before it is written. Composition is only making it clear that is the case. Finding out a simple relation between paper and music, how to read it independently of one's thoughts, what instrument or instruments, staff or staves, the possibility of a microtonal music. More space between staff lines representing major thirds than minor so that if a note has no accidental, it is between well known points in the field of frequency or just a drawing in space. Pitch vertically, time reading from left to right, absence of theory.[16]

Ask a professional musician to listen to a recording, and you instantly invite a critique of the pressing of the compact disk or the miking in the studio or any of a number of other little technical glitches that betray themselves aurally. How many musicians look at a sheet of music paper, though, and complain about irregularities of surface or discoloration? This acute visual sense enriched Cage's composing and his performance practice and led him to the print atelier. From 1978 to 1992, Cage worked annually (for two weeks each January) at Crown Point Press on suites of etchings, making 160 editions, as well as watercolors and drawings. He became a force in the contemporary art world, particularly among connoisseurs of works on paper. It began during that stay in France in the early thirties, when he was fascinated with "flamboyant gothic architecture" and spent long days drawing Greek columns as an apprentice to an architect called Erno Goldfinger. During that time and throughout his life, Cage was a great gallery hopper, a habit that started in Paris, where there were plenty of great works by Klee, Picasso, Matisse and other Modern masters to study. Cage's own earliest paintings were heavily indebted to van Gogh, and then, while in California, he found a way to scrub paint into canvas using steel wool, the forerunner of later technical innovations involving materials, especially in the use of fire and smoke on paper.

Most historians point to the tight circle of Jasper Johns, Robert Rauschenberg, and Cage as the beginning of this foray into the visual arts, but Cage was giving lectures on Mondrian and music to, as he put it, "housewives in Santa Monica," years before he arrived in Manhattan and visiting the magnificent collection of paintings and drawings by the Blue Four—Klee, Jawlensky, Feininger, and Kandinsky—that Galka Scheyer had brought to California. Cage also was interested in graphic design and created the programs for concerts as well as designing stationery. One of the significant crossings of art and music, at least from an ascetic point of view, was Cage's first encounter with the "white writing" of Mark Tobey in a Manhattan gallery soon after he arrived. Asked to name a specific piece of art or a performance that changed he way he saw things, Cage singled out Tobey, whose work he bought on installment from a New York gallery. The link between Tobey and Cage is revealing. Both had the kind of light touch that combined lyricism and abstraction, the traditional and the shockingly new, in tightly controlled, gestural pieces that could be perceived as ethereal or could be compared to the sidewalk underfoot. Where Tobey inscribed lyric poetry in white light that was about anything but himself, Cage sketched the outlines of distant rock gardens in movements that were equally self-concealing.

Cage was such an international figure—identified by his fans with East Asian philosophy and aesthetics, revered in Germany and France to the degree that festival directors were whipping him over the Atlantic by Concorde to attend the eightieth-birthday celebrations that wore him down at the end of his life—that it is almost ironic to find an ideal summary of his legacy in the works of that quintessentially American romantic, Henry David Thoreau. But Thoreau was a great favorite of Cage's, and citations from *Walden*, including the following passages, were prominent parts of the mesostics and lectures. The image of the dome of blue glass, as well as the reference to the shipwreck (which we can relate to Hopkins and Mallarmé), was taken from Thoreau by Cage as an intriguing picture of how the creative individual can encapsulate himself in what might be though of as a visually attractive and acoustically perfect, yet artificial, sphere: "We will not be shipwrecked on a vain reality. Shall we with pains erect a heaven of blue glass over ourselves, though when it is done we shall be sure to gaze still at the true ethereal heaven far above, as if the former were not?"[17] As an even broader summary of the originality coupled with ascetic detachment that characterized Cage's life and work, another of his favorite excerpts from Thoreau is even more apt. With Cage's affinity for percussion, it is not surprising that he was taken with this famous passage, which in our time has become a cliché but in association with Cage's saintly life apart from the corruptions and competition

of his time takes on new resonance and freshness: "Why should we be in such desperate haste to succeed and in such desperate enterprises? If a man does not keep pace with his companions, perhaps it is because he hears a different drummer. Let him step to the music which he hears, however measured or far away."

Complexity and Contradiction: Elliott Carter

There is silence in the hall. The Juilliard string quartet has just completed the flowing andante of Elliott Carter's second string quartet and is in the third cadenza of the piece just before the allegro begins. The silence is utterly unlike the genial, contemplative silences of Cage's music or the awkward, empty parentheses that customarily surround the movements of a chamber piece. It is tense, stony, almost unnerving. First violinist Robert Mann has just whipped through a series of fast, bravura phrases. His bow swings upward and pauses, like a fencer's challenge, *en garde*, to the opponent. But the bow hands of the cellist, violist, and second violin are resting on their laps, and they are looking down at the music. Their last notes were resonant pizzicato moments of punctuation that have long since died away. The silence seems interminable, and for a moment the audience could be excused for wondering if something has gone desperately wrong. Then the allegro begins, and the quartet flows again in a rapid fantasy that moves to and fro among the voices—romantic and lyrical for the viola, fast and virtuosic for the first violin, frenetic for the cello—to a crescendo over the clockwork pizzicato of the second violin.

That long moment of silence is, in fact, more than a rest or pregnant pause—it is an extension of an idea established in the three cadenzas of the quartet that dramatizes Carter's unique sense of the instruments of a quartet as characters in a drama. The Second Quartet of Carter is his earliest realization of the *conflict* between the individual instrument and the ensemble as a whole. By separating the instruments stylistically—the violin, for example, is given the virtuoso part while the second violin becomes more machinelike and dry; the viola, too, is far more restrained and sad while the cello takes on the Brahmsian romantic role—Carter individuates the characters in the piece dramatically. Understanding his complexity is helped immensely by watching the quartet perform the work live, rather than listening to a recording. Quite often the seating for a Carter quartet is different than for those by Haydn or Beethoven—the composer has suggested that the players space themselves further apart, making the spaces among them literal. That is one of many visual clues to the ascetic character of his music, which in large part arises from its difficulty as well as its Classicism (it is worth noting that the greatest

book on the subject of Classicism in music, Charles Rosen's *The Classical Style*, is dedicated to Carter).

The characters of the quartet interrelate, as the composer has explained, in three ways. The first is "discipleship," in which one or all imitate a lead voice. The second is "companionship," by which they reply to one another and, in the traditional sense of quartet playing, work together. Finally, Carter says that there is "confrontation," and the long silence is the ultimate example of this. Each movement of the piece features a particular instrument to which the other instruments are related as disciples. The first is given to the first violin; the second, a *presto scherzando*, is dominated by the second violin; and the *andante espressivo*, by the viola. These movements are followed by cadenzas, in which the lead instrument changes and the discipleship turns around, becoming opposition. In the second cadenza, the legato lines of the cello are met with pizzicato from the violins. The dramatic silence of the third cadenza is the way the other three instruments greet (refuse to answer) the complex phrases of the violin as they grow longer.

While the voices express their characters with power and emotion—a Carter quartet does not present a subdued, meditative ascetic effect—the drama is enacted within tight parameters, or what the composer calls "the notion of strictness and regularity as opposed to improvisation and freedom." As Carter reveals, the discipline and systematic complexity of this kind of writing is a strain even on his abilities, although he refuses to resort to a computer for technical assistance:

> My music does have a rather strong bias towards systematizing—as you can understand, for instance, in the Second Quartet. Each one of the instruments for a good part of the time plays all the various material that it has within a certain range of intervals. The cello has minor sixths, for instance, and perfect fourths. A great deal of its material is built out of that—that's very restrictive indeed. The same is true of each one of the instruments, and none of them have the same thing. This was one of the modes of keeping them apart. Now, to have decided to give a repertory of certain sounds to one instrument and another, and then to solve that with the twelve-tone system—I would've had to have had a computer. I didn't do it that way. I sat down and simply worked out little sample passages that would do this, and when they didn't work I tried other ones, and gradually I taught myself how to write a piece that would have this technical requirement enough of the time so that it would be fairly audible to a listener who knew what was happening.[18]

To understand the dynamic importance of that long passage (not moment) of silence in the Second Quartet is to grasp the ascetic genius of

one of the great string quartet composers of our time. Carter, a native New Yorker, was born in 1908 and studied under Walter Piston and Gustav Holst, who was a visiting professor while Carter was at Harvard. His love of literature (his program notes are studded with allusions to St. John Perse, Alexander Pope, Lucretius, and Jean Cocteau) led him to major in English, partly because the music department held the contemporary composers he liked (Stravinsky, Schoenberg, Bartók) in disdain. After Harvard he went to Paris to work with Nadia Boulanger, who put him through the rhythmic drills of medieval and Elizabethan music as well as the rapid rhythmic changes of the Beethoven quartets. In the 1940s, Carter's discovery of metric modulation led to a kind of rhythmic complexity that is still the hallmark of his work; its first expression was in a cello sonata completed in 1948. There are moments when Carter's music sounds like that of Schoenberg, Stravinsky, and Berg, all of whom used accents on sevens, fives, and threes, especially as a means of changing—in a way that recalls Mondrian yet again—from one "speed" to another within a piece. Carter explored this in his famous collaborations with Conlon Nancarrow, whose music for player pianos, composed in Mexico City, has an almost legendary mathematical complexity that is reminiscent, to my ear, of jazz. As Carter has explained, "One speed emerges from the other, so you can't tell in certain passages which speed the piece is in. There are superimpositions of one speed over another, and one becomes more dominant than the previous one, and that leads into the next section."[19]

Still going strong, Carter recently produced a powerful setting of five poems by John Hollander under the title *Of Challenge and of Love* (1996) as well as his *Adagio Tenebroso* (1996) for orchestra. His extraordinary body of quartet writing continues to expand with the addition of a fifth string quartet (1996), bringing comparison with the wonderful output of composers like Verdi, Schutz, and Richard Strauss in their eighties. He maintains his own rules of ascetic restraint, which are remarkably simple: "The censorship that I exercise on my own music is the censorship of difficulty of performance: two instruments playing two rhythmic patterns that nearly coincide but not quite; I tend to try to avoid that. I try to make it quite clear that they are not coinciding, and that everybody else can hear it in just that degree."[20]

The Master Craftsman: Steve Reich

One of the key images for understanding Steve Reich is a grainy black-and-white photograph of a long, rectangular Lucite box with thirty-six

RCA jacks sticking out of it and a tangle of wires inside—to our eyes in the 1990s, having seen the guts of personal computers, a primitive, if indecipherable, array. This is the Phase Shifting Pulse Gate, a custom-designed electronic contraption that Reich himself constructed, over the course of 1968 with the help of two engineers at Bell Laboratories. It was going to be Reich's Stradivarius or Steinway, but it produces no pitch or sound of its own, and it became obsolete after only its second performance. It was an instrument entirely given to rhythm. Each of its channels could divide a repeated measure into 120 equal parts. Instead of eighths and sixteenths, it gave Reich 120ths even at the slowest possible tempos—a pulse in which one note is almost imperceptibly differentiated from the next (recalling the level, in the area of pitch, on which Cage was working with his microtones). All the ins and outs of the Gate's modus operandi would be boring to any but studio technicians. In the most basic terms, Reich fed twelve constant sounds (including recorded versions of droning violins, voices, a finger circling the top of a crystal glass, and pitches generated by oscillators) into the open gate, which sends a pulse from one fifteenth to one half second in width to the next gate, into a power amp and then a loudspeaker.

Reich first used the Gate in performance in a work called "Pulse Music 1969" at concerts at the New School and the Whitney Museum in New York. In addition to oscillators, he used four log drums in a piece that featured Philip Glass as one of the performers. The performers had headphones, and the pulses from the gate were transmitted to each, who had to play in exact synchronization with the pulses from the Gate, which was run by Reich, sitting at a table at their center. It was an astonishing moment in the history of performance, particularly in the "serious music" and art circle that surrounded Reich at the time. In retrospect, anyone who has watched a "mixmaster" at work on the sound and light board during a rock concert in our day of digital enhancement would think that Reich at the Whitney was far from the most obtrusive presence on the stage, but in its time the effect was chilling to some, outrageous to others.

The composer himself had doubts, particularly when it came to the disparity between the absolute precision of the machine and the more "musical" coordination of human players. When he returned to his studio from the Whitney that evening, he did not unpack the Gate from its special fiberglass case, for a couple of reasons. Since it was a prototype, he was worried that it was fragile and might not work correctly in performance if it was handled too much. More important, he was not satisfied. He did not like the sensation of just twisting dials on a machine instead of using his hands and body to make music. As he wrote in an

essay subtitled "An End to Electronics," the most serious reason for abandoning the Gate was the conflict he felt existed between its mechanical absolutism and the "microvariations" of his ensemble: "The 'perfection' of rhythmic execution of the gate (or any electronic sequencer or rhythmic device) was stiff and un-musical. In any music which depends on a steady pulse, as my music does, it is actually tiny micro-variations of that pulse created by human beings, playing instruments or singing, that gives life to the music."[21]

So Reich gave up the Gate after a year of hard work. The experiment was not a waste, however, in that it brought him face to face with essential issues. Steady perfection ends up being opposed to what is musical and enters the realm of the antimusical that Cage and others, including the whole "antiaesthetic" group of visual artists, were exploring. It sets up a confrontation between electronic or mechanical media and acoustic or human sound production that has been explored by a number of composers since, another opposition that has its ascetic overtones in it distancing of the production of music from the haptic, aural, gestural, and even visual elements—the aesthetic realm of physical sensation—that give musicians themselves, as well as their audience, pleasure. It is important to note that, unlike Gould, who did not mind standing in isolation behind a glass partition during an orchestral concert, Reich was not content to remain outside the physical making of the music. For most of their careers, both Reich and Philip Glass, a member of Reich's ensemble during most of the formative period, played their own music.

Reich is a native New Yorker, now sixty-one years old, who studied philosophy at Cornell and then studied composition at Juilliard under William Bergsma and Vincent Persichetti and at Mills College where he got his master's degree, under Luciano Berio and Darius Milhaud. His career and education very closely paralleled Glass's in the early years. Just as Glass had branched into non-Western music in the 1970s, Reich became interested in Balinese gamelan pieces, African drumming, and Hebrew chanting. Both of them avoid using electric guitars and other sound effects, and like Glass (after Berio's example), Reich makes extensive use of speech and poetry. At its inception in 1966, Reich's ensemble was made up mainly of doctoral candidates in ethnomusicology who specialized in African, Indonesian, and Indian music and percussion, as well as medievalists and early instrument specialists. As Reich conceives the work of the ensemble, there is an ascetic dimension to the way in which they renounce "self-expression" and their personal styles or agendas to attain a degree of coordination that is in quality no different from the selflessness that traditionally makes a good ensemble click; but in an age when stars take the stage to play Brahms piano trios (Ax, Ma, and

Stern in the spotlight at Carnegie Hall) the reaffirmation of the anonymity of the chamber performer seems refreshing. As Reich explains, "A performance for us is a situation where all the musicians, including myself, attempt to set aside our individual thoughts and feelings of the moment, and try to focus our minds and bodies clearly on the realization of one continuous musical process" (p. 44). The same philosophy was espoused by the innovative guitarist Robert Fripp, whose tuning system and purist principles introduced an element of asceticism into the history of rock.

Reich's collaborators in the 1960s and 1970s included many of the brightest lights of the SoHo art scene. Richard Serra and Bruce Nauman were on stage with him at the Whitney on May 27, 1969, swinging the microphones for his *Pendulum Music* (1968), which depended on the feedback produced when, after the performers let go of the microphones in unison, a series of feedback pulses is created as the microphones swing by one another. Serra, Nauman, James Tenney, and the Canadian filmmaker Michael Snow sat down and listened with the rest of the audience until the microphones came to rest and began feeding back a continuous tone, at which point the power cords of the amplifiers were pulled out and the piece ended. Snow's role in the development and refinement of the Minimalist aesthetic, and of asceticism in contemporary art, is still underappreciated. His long, repetitive films ratified the concept of the trancelike, ascetic experience in the temporal arts, a major step forward for the musicians who had similar strategies in mind.

Setting high technology aside, Reich's other great attraction in the early part of his career was to exotic music, particularly the musics of Africa and Bali. It is important to note that he transcribed only the accompaniment to songs when he went to Ghana in 1970 to study with a master drummer of the Ewe tribe. In 1973 he made a similar study of gamelan semar pegulingan in Seattle with a famous Balinese musician, I Nyoman Sumandhi. Ecstasy in traditional music or dance, as well as in the ascetic tradition in religion, is an elusive but important state. As we have seen with Messiaen, there is one path to ecstasy, which, in Blakean terms, arises from an excess. Another is the kind of music that the critic Terry Teachout calls "Holy Minimalism," referring to the work of Gorecki, Part, the British composer John Tavener, and others involved in the more direct use of liturgical models, as well as the work of Reich and Glass. Part's "tintinnabulation" uses the bell-like repetition of chords, while Tavener and Gorecki draw more directly on chant and plainsong. The immensely popular Third Symphony of Gorecki, which sold half a million copies, is subtitled "Symphony of Sorrowful Songs for Soprano and String Orchestra." It uses a fifteenth-century Catholic prayer in Polish as well as a prayer written on the wall of a Gestapo prison cell to arouse the

kind of emotional response that ecstasy relies on, and that is where ec-
stasy and asceticism have to cross a difficult patch in psychological terri-
tory, as the music obviously cannot be too restrained.

The approach to ecstasy taken by Reich relies heavily on the structure
of the canon, as developed in the work of Terry Riley, whose *In C* (1964)
is often pointed to as the fountainhead of American Minimalism. Reich,
who worked with Riley during the time when *In C* was first played, has
said, "Obviously music should put all within listening range into a state
of ecstasy" (p. 44). The musical means to that involves the shifting rela-
tionships between identical repeating patterns that are held together by
the canon. Given the length of many of Reich's work—his famous piece
Drumming (1971) usually runs over ninety minutes—the parameters
within which the rhythmic cell (drummers call it a paradiddle) are fairly
vast. The pattern of *Drumming* is an eight-beat, left-right alternating fig-
ure slowly built up, with a beat added measure by measure and then re-
versed until only one beat remains in the measure.

In his *Piano Phase*, the melodic patterns begin with two pianists in
unison. While one stays put, the other increases tempo to move one beat
ahead. The increase is slight: by thirty seconds into the piece the lead
voice is a sixteenth note ahead. The score uses dotted lines for staves, a
visual reminder of the evanescence of the musical period. "Everything is
worked out, there is no improvisation whatsoever, but the psychology of
performance, what really happens when you play, is total involvement
with the sound; total sensuous-intellectual involvement," Reich notes (p.
52). Reich relates the intellectual side to the music of Webern, which
might not be the first influence most listeners would point to as a com-
parison (the relationship with Stravinsky, Varèse and Bartók are more
pronounced). As Reich points out vis-à-vis Webern: "Look at the num-
ber of notes on a page, think of the reduction involved in what he was
doing, and the organization that went on in serial music. Actually, there's
a great similarity between that and my early pieces, like *Piano Phase*: the
severity and clarity of the organization A very different kind of sound,
but a very pared-down, severely organized kind of music."[22]

Reich's answer to the *Saint Francis* of Messiaen is a wonderful piece
based on the poetry of William Carlos Williams. Titled *The Desert Music*
(1981), it starts with the piano, adds quickly to orchestral and vocal,
surges and then fades, each time rising to crescendi that vary in length.
The piano continuo pushes it along from episode to episode and from
crescendo to crescendo. Suddenly a horn, its last note sustained, is
echoed by two horns and then a third, never quite in unison, that lift the
top and brighten the tonality, each note lasting a bit longer. As the
crescendi subside, the dry sound of the marimbas and a light string figure

that dances above begin the process of moving the accent around in the phrasing. Reich's work privileges quickness and agility in the singers and players, as voices slip in and retreat from the crescendi on the phrase "He is my friend" as it is slowly built into a choral crescendo. Reich breaks up the entry of the voices in the chorus, delaying some and then bringing all into unison on a fading chord, succeeded again by marimbas and strings.

Like Frank Lloyd Wright's concrete blocks of La Miniatura, the process is one of weaving and building layers of sound in a highly textured effect. The percussion sharpens that texture, making it more brittle, while the smoother string and vocal parts float above it. Sound builds and departs in a wavelike Doppler effect, to which Reich adds a siren-style top note for emphasis. Reich's music picks up on the importance of music to the Williams text. In the poem, a dance vies with motionlessness as emotion and composure contend during a brief trip to Mexico, an autobiographical episode that Williams uses as a kind of pilgrimage to the muses. The little band of travelers is driven from place to place by the wind, sand, music, their need for a drink, and other weird pressures, particularly the feeling of time expiring. The ascetic qualities of the poem involve not just the poverty of the place and the dryness of the desert but the notion of a pilgrimage and the arduous aspect of repetition. They seek "relief from that changeless, endless / inescapable and insistent music."[23] The parallels with Reich's style are obvious in lines such as "when Casals struck and held a deep cello tone and I am speechless"[24] and Williams's love of "a protecting music."[25]

As with Messiaen and Glass, there is a religious dimension to Reich's writing. He began seriously studying Hebrew at age thirty-seven and incorporating his interest in Jewish chant and Sephardic styles into his own music. This research has recently brought him to an ambitious project called *The Cave* (1995) after the Cave of Machpelah on the West Bank in the town of Hebron, the burial site of Abraham and a place sacred to Arabs and Jews. The work explores the conflict between Islam and Judaism, using a projecting text designed by Reich's wife, Beryl Korot. The libretto is taken from the Koran, the Bible, and the interviews. In its complexity, as well as its desert setting, it takes Reich further into the ascetic realm explored by Carter (because of its embodiment of conflict through music) Messiaen (through the use of grandeur). In a quieter, more understated ascetic vein, Reich has created another recent piece, titled *Proverb* (1996), which uses a text by Wittgenstein and harmonies and melismata from the twelfth-century master of chant Perotinus. The Wittgenstein text is a perfect summation of Reich's genius for spinning a web of music from the most modest of fragmentary material: "How small a thought it takes to fill a whole life!"

The Lawmaker: Philip Glass

For many listeners, the soft, fleeting miniatures for cello of Webern may seem far more ascetic in nature than the lush tides of chromaticism in Messiaen's opera, and there are certainly many other directions in which this topic can lead in late-twentieth-century music. One obvious successor to Messiaen's *St. Francis* is Philip Glass's four-and-a-half-hour-long, high-volume and high-intensity opera, *Einstein on the Beach*, or perhaps the fifty-one instrumentalists (no brass, no percussion; in his words, "no tricks") in the pit for *Satyagraha*, his three-act opera on the life of Gandhi. Glass is also linked through formalism to Debussy and Elliott Carter. There are parallels between Glass's ascetic view of the rhythmic cell and Peter Halley's use of cells, and between Glass's rhythmic practices and those not only of Minimalist sculptors but of Mondrian and recent painters such as Mark Milloff, as well as a range of literary connections in the texts of the songs and operas.

Born in Baltimore, Maryland, in 1937, Glass studied at the University of Chicago and went on to a master's degree in composition at Juilliard under Vincent Persichetti and William Bergsma. His better-known mentors were Darius Milhaud and Nadia Boulanger, with whom he studied privately during a seminal three-year stint. In his writings and interviews, Glass is adamant about the importance of observing the rules of composition, a decisive sense of what is correct that he acquired under Persichetti and Boulanger. Looking over the catalog of saintly figures that Glass celebrates in his operas—Akhnaton, Einstein, Gandhi—we notice that they are not just ascetics but lawgivers. Even in rebellion there is a firm awareness of the rules, as when he broke free of three years of "no fifths" under Boulanger to write his *Music in Fifths* (1966). The rules give Glass's work an underlying technical confidence, particularly conspicuous in the architecture of counterpoint, cadence, and crescendo in works such as *Einstein*, where, to take one example, the arch formed by the progression I–VI–IVflat–V–I determines the basic interval structure of the "Knee Plays" and "Spaceship" sections. With this solid background in the tricks and traditions of Western composition behind him, Glass moved on to experiment extensively with Asian music and instruments, and his teachers included Ravi Shankar and Allah Rakha. Glass pushed this interest in Asian aesthetics into literary and philosophical endeavors as well. In addition to his long fascination with Indian culture (which began well before *Satyagraha*, his opera based on the South African years of Gandhi), Glass became deeply involved in Buddhism, which remains a profound influence on his work and life.

The route to the Metropolitan Opera House, where *The Voyage* is now part of the repertoire, led through a recapitulation of many of the formative movements in Modernism. From an early twelve-tone period, Glass progressed to Eastern source materials. Like Brice Marden, he has continued to interweave, in an explicit, dialectical way, Asian and Western classicism in his writing. During the 1960s, he worked as a copyist and arranger for a film score by Ravi Shankar, already famous for his collaboration with the Beatles. Glass was fascinated by the therapeutic potential of Sufi music to erase headaches or calm hysteria and viewed this as a cure for what ailed the cynical music scene (in terms of both rock and serious writing) of his time. The additive rhythms of Glass's music can be partly traced to the Indian raga tradition, along with the philosophically ascetic basis of a music based on the transitory states of being known as *rasa*, or "flavors," and the play of *sadhana* (discipline) and *yajina* (sacrifice) in the yoga tradition.

Most of Glass's work with Ravi Shankar involved transcribing and scoring music that Shankar would sing to him line by line, and his initial stumbling block came when he placed bar lines in the Western fashion, creating unwanted accents and divisions where there should be none. As Glass relates in a memoir, Shankar's percussion player, Allah Rakha, kept insisting "All the notes are equal." The epiphany that ensued is of importance not only to understanding the flow of Glass's music, but its self restraint as well (to remove accent is to take away the "pointing" that is a kind of intervention): "Finally, in desperation, I dropped the bar lines altogether. And there, before my eyes, I could see what Allah Rakha had been trying to tell me. Instead of distinct groupings of eighth notes, a steady stream of rhythmic pulses stood revealed. Delighted, I exclaimed to Allah Rakha: 'All the notes are equal!' He rewarded me with an ear-to-ear smile."[26]

The signature motif in Glass's music is a seductive ripple effect, like the echo a rock makes in a stream as it catches the water. It becomes both a rhythmic and a melodic element as Glass moves the top or bottom notes of the pattern. In Glass's own words, the ripple originated with "repetitive structures with very reduced pitch relationships, a steady eight-note beat, and a static dynamic level." Just the vocabulary of his description—static, repetitive, reduced—points to the ascetic aspect of his basic philosophy. In the additive process, a musical grouping of, for example, four notes can be repeated several times, retaining its melodic configuration but taking on a different rhythmic shape as it expands to five notes, then six, seven, and eight. Eventually, it can contract according to the same process. These groupings are gathered in rhythmic cycles to build the larger structures, those wheels within wheels that are

so satisfying formally because they arrive back at their starting points in such a neat, clear way.

Repeated with precision over and over, the ripple has a strangely mesmerizing effect on both the audience and the performer. As a lousy amateur pianist, intimidated by the virtuoso display of precision and speed that characterize Glass and his ensemble in performance, I always assumed that his music would be well beyond my limited technique, but I did not want to write about him without trying out a few passages from the scores. Much to my delight, when I set the metronome and sat down to sight-read the opening two pages of his "Glass Pieces," I found myself almost instantly swept into the gently undulating pattern of the basic two-note alternation that rides up and down a tight range. I spent most of a holiday weekend, much to the annoyance of the rest of my family, with my fingers locked in its steady pattern, enjoying the Bach-like sensation of gears meshing as lower and upper voices would pull together and spread apart and finding the subtle but often surprising transitions from one base pedal point to another as satisfying in their way as similar transitions in the easier keyboard works by Handel. The only problems with this immediately accessible and astonishingly melodic experience were the disorienting effect of the repetition and the (one would think) simple task of finding the exit—that is, coming to an end of what might, out of sheer pleasure as well as my own ineptitude, become a chain of infinitely repeated rhythmic and melodic cells. As Glass himself often does, I opted for the slow fade, letting the mind wander to consider the calming and meditative potential of music that virtually plays itself. That sense of not knowing where one is in a piece of music, which will be familiar to anyone who struggles with memorization, is a problem of reading the landmarks in music as one would read a map. Glass has actually added those elements to his compositions, notably the numbers and *solfège* syllables of do, re, mi in *Einstein on the Beach*, that are initially aids to memorization but become the text and basis of the composition. Musical memory is such a tricky area, and Glass's illusions and devices now represent a fascinating breakthrough in what is technically and psychologically still a labyrinth.

Most of Glass is, of course, neither easy nor simple, but this odd combination of physical and meditative pleasure remains a fundamental part of the experience of his music. Like the ecstasy of Indian music, the quickening tempi and louder and louder volume of the operas, such as *The Photographer* (1982), *Einstein*, and the later *Voyage* (1995), produce an irresistible excitement. The amplification used in *Einstein* was bothersome to some of the purists at the Metropolitan Opera House, but for those brought up on rock its decibel level is pretty tame. The accelerando

is as potent an effect as the volume when it comes to inducing the kind of physical response that Glass has in mind. It is an ascetic experience in part because of its link to that Indian spiritual tradition of ecstasy in music and dance and in part thanks to the discomfort that the Metropolitan old-timers felt when they were blasted by the loudspeakers. On the threshold of pain, amid a dizzying whirl of arpeggios that in some ways reminds us of the vortex in Debussy, the listener's capacity to hear and understand is stretched, sometimes uncomfortably. So is the performer's, and Glass has had to find novel ways to divide the winds and the chorus and to expand their physical limits through a special "circular breathing" technique in order to cover the breaks and ensure a seamless continuity of the pulse. In recordings, this can be done by double tracking, but in performance there has to be enough of an overlap to overcome the great demands on stamina.

The austerity with which Glass has treated composition—using a limited range, not allowing soloists to dominate the performance, keeping instruments from "jumping all over the place," and building his dramatic moments patiently—is a direct repudiation of the more jarring elements of Modernism as practiced by Stockhausen, Copland, Messiaen, and others. The repetition can play tricks with the listener's sense of time, but Glass insists that he uses "colloquial time" as a model. One of the most riveting moments in his operas is in *Satyagraha*, when Mrs. Alexander, the wife of the police chief, raises her umbrella to protect Gandhi from a crowd, and it was choreographed by David Pountney as a re-creation in "real time" of the historic event. Glass comments, "This moment in the performance has always given me an eerie feeling because, unlike most operatic scenes in which the true time-scale of events is distorted, what we see is literally a re-creation of events of more than eighty years ago, taking place in something like 'real time.'"[27]

Time is problematic in the experience of Glass's operas, however. As close as Glass wants to approach "real time," there is another sense in which his use of repetition seems to stop time. The same quality, sometimes considered static, is found in the symmetries and cycles of Rameau and Handel, and certainly it is the cyclical return of Glass's cadences that reinforces the odd feeling that we are going nowhere fast—because the music is so rapid, which seems the greatest contradiction of all. When Mondrian said his paintings were already "fast" and yet they clung to that solid frame of black verticals and horizontals, a similar illusion was produced. As with Reich or Pina Bausch, the principles according to which Glass writes for his own ensemble have an ascetic flavor. The collaborative aspect of the compositional process allows him to test out the kind of sound he is going to get. As the operas necessarily expand to a

larger scale of orchestration, forcing Glass to incorporate a broader palette of instruments like the double bass and clarinet, he still shuns the kind of soloistic writing that is traditional. During the first American performance of The Photographer at the Brooklyn Academy of Music in 1980, Glass aficionados were stunned when the violin broke out into a near-virtuoso, rapid phrase that recurred in the piece, because it was such a departure for a composer who keeps his instruments blended in compound textures and is probably best known for tutti passages in which individual voices are indiscernible. Gould held the tradition of the soloist in disdain (although he could be a pretty obtrusive soloistic presence), and in the same way, Glass sticks to interwoven orchestration; even his choice of instruments—the electric organ and the reed—tends toward compound textures. He has said that the orchestra in the operas is meant to imitate the range and sound of the electric organ, which sets up an intriguing reflective problem since the organ is often played to mimic an orchestra in unison. Sopranos have complained that they do not have an aria to showcase their talents. Glass's philosophy of the ensemble is inherently ascetic: "I didn't look at the orchestra as a virtuoso instrument; what I tried to do was, in a certain sense, make the orchestra disappear into the music. At a certain point, I wanted you to forget that you were hearing the orchestra. I didn't want the orchestra to do anything that drew attention to itself apart from the music—which is not at all a common idea in contemporary music."[28]

This is an effacement of all the twentieth-century "tricks" that Messiaen, Xenakis, and others deploy: the glissandi, the fluttertongues, the use of the back of the bow. It signifies a degree of restraint regarding the virtuoso or the physical characteristics of the orchestra, which sounds like Minimalism. Yet there is nothing Minimalist—recalling the Minimalist proscription against "theatricality"—about assembling an opera for a huge proscenium stage and internationally famous singers. Rather than thinking of Glass as a Minimalist, it is better just to view him as an abstract composer. During the process of composing and rehearsing Einstein, Glass noticed that the work gained strength as it became more abstract: "Each time an image reappeared, it was altered to become more abstract and, oddly enough, more powerful."[29] His work moves away from the physical or, as he says, "visceral" quality and into an even more ascetic realm of the nonordinary, metaphysical, or even religious experience. The ascent of music toward nonordinary experience becomes the goal. One of Glass's most "pure" works is the "Music in Twelve Parts" (1988). The composer wants his listener to experience this work in an exclusively musical way, not loaded with emotion or drama or visual clutter (much like the unencumbered "pure" or "abstract" dance movement to

which the choreography of both Balanchine and Cunningham has been related). The challenge, according to Glass, is "to perceive the music as a 'presence,' freed of dramatic structure, a pure medium of sound."

With the success of *The Voyage* and repeat engagements for *Einstein* and *Satyagraha* in Europe, Glass's reputation as an operatic composer has grown. It is not surprising that one of his favorite traditional operas is Rossini's *Barber of Seville*, that paradigm of crescendo building and rhythmic clockwork. Glass's work in the theater began, appropriately enough, with incidental music for Beckett's plays. The "portrait" operas move from the abstraction of *Einstein* to the structuralism of *Satyagraha*, with its seven chaconnes, dramatic use of slow parts, and strategic way of working toward a finale that would leave the audience standing. However "mainstream" the reception of the operas, they are still deeply rooted in the Modernist traditions of nonliterary theater as exemplified by the work of Meredith Monk, the Performance Group, the Open Theater, and the Living Theater, as well as the worlds of dance and painting. The libretto for *Einstein* is as spare and ascetic as Gertrude Stein's poetry, to which it is clearly indebted. In the opening scene the "Man Calculating" drones these monotonous lines: "The ones are, the ones are, the ones are like, the ones are like into where the ones are the ones, the ones . . ."[30] As with *Satyagraha*, imprisonment is a theme, and the third act moves from a trial scene to a prison.

One vitally important aspect of Glass's asceticism is his association with the artist and stage designer Robert Wilson, a master of silences and shadows. Wilson in person is almost eerily ascetic; his close-clopped hair and far-off gaze can be disarming. When he lectures, he begins by standing silently at the podium for a long period, and critics have speculated that the slowness with which he himself speaks and moves or with which his stage characters are made to move stems from a speech impediment he suffered during his youth in Waco, Texas, as well as the rigid posture and silence of his mother at the dinner table. A drama teacher saw him through the difficulties posed by the impediment, but in works such as his versions of *Parsifal* and *Hamlet*, Wilson taps the distant and even painful condition of this handicap. While Glass might be associated with the allegro of Manhattan, Wilson favors the andante.

One of the great images from the collaboration between Glass and Wilson is the tall, thin "Einstein Chair," a long silhouette of a plain wooden chair with low legs and a high back that was used as the "witness stand" in the trial scene of *Einstein*. It has the character of a Giacometti standing figure as well as the plain chairs of Nauman's work. Its strict geometry, plain form and lack of color reflect the American Shaker aesthetic as well as Greek Classicism and other aesthetic models that rely

on restraint. As Trevor Fairbrother, the curator of a recent Wilson retrospective, has noted:

> The block, the cube, the shaft, the pyramid, and the curtain of light appear either as solids, or, more frequently, as bodies of light defining the darkness. These forms recur in endless variations of scale, mood, and subject, communicating the monolithic solidity of a wall, a room, or a building; the punctuation of space by tree trunks, columns, or giant figures; or the openness of a lake, a desert, a sky or a window. The unity of form and content that underlies many of the drawings is comparable to Wilson's practice of reworking and transforming scenes from earlier theater works into new statements.[31]

Beyond their visual austerity, the librettos of the operas are themselves deeply ascetic. For example, *Akhnaten* opens with this forbidding scene: "Clouds darken the sky / The stars rain down / The Constellations stagger."[32] Its visual centerpiece is the "city of light and open spaces that represents architecturally and visually the spirit of the epoch of Akhnaten." In *Satyagraha*, Parsi Rustomji's speech in the first act, third scene, which he delivers at noon under the hot sun, taps the ascetic spirit of Gandhi's beliefs: "For nothing on earth resembles wisdom's power to purify and this a man may find in time within himself, when he is perfected in spiritual exercise Knowing this, he stands still moving not an inch from reality. Standing firmly unmoved by any suffering, however grievous it may be."[33] Perhaps the most beautiful ascetic moment in the librettos is the epilogue to *Einstein*, which offers a peaceful ending, hinting at repetition and contemplative withdrawal to an apocalyptic scene: "The day with all its cares and perplexities is ended and the night is now upon us. The night should be a time of peace and tranquility, a time to relax and be calm. We have need of a soothing story to banish disturbing thoughts of the day, to set at rest our troubled minds, and put at ease our ruffled spirits. And what sort of story shall we hear? Ah, it will be a familiar story, a story that is so very, very old, and yet it is so new. It is the old, old story of love."[34]

In the new opera, *The Voyage*, Glass and his librettist, David Henry Hwang, explore the territory of pilgrimage and ecstasy on an almost Wagnerian level. The work opens with a prologue spoken by a physicist in a wheelchair, a character based on Stephen Hawking. He poses a series of questions about time and space, black holes and boundaries, the mind of God and the purpose of the universe, enigmatically offering the epigraph: "To voyage lies where / The vision lies, / There." A spaceship escapes the Ice Age and approaches a new Earth in a story that runs parallel

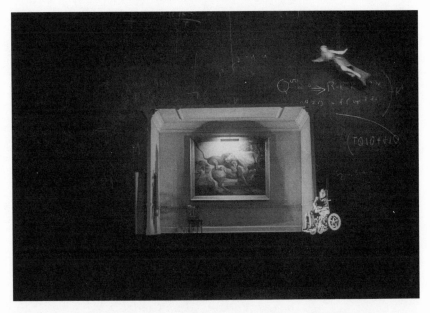

Philip Glass's *The Voyage* (1995), now part of the Metropolitan Opera's repertoire, begins with a visionary based on the real-life physicist Stephen Hawking and ends with a chorus of Dominican monks chanting a requiem.
Photo: Winnie Klotz. Courtesy of the Metropolitan Opera House, New York.

with Columbus's sighting of the New World. Columbus becomes a saintly hero of the opera. As Isabella observes,

> Empowered by God
> Your vision of such lucidity
> As if, in your hands,
> Lay already the kingdoms of Asia
> Such certainty, it is clear
> Can only have come from God
> Whose Word you disparage
> With all this weakness and weeping.

In the epilogue, with the space travelers fading away and Columbus on his deathbed, Glass has a chorus of Dominican monks chanting a requiem. In a final ascetic flourish, Columbus ignores Isabella's siren song and refuses her invitation to join her in bed: "The journey that awaits is far more seductive than all your last temptations—finally we take the voyage when the voyage takes us." Musically, the writing is somewhat

more chromatic than that of his latest operas and has a center that moves between E minor and E major in an arguably more dissonant idiom than *Einstein*. More colloquial at moments than his earlier works, it also moves into very formal prayer. Some critics have said that by working with Hwang rather than Wilson, Glass's opera is more passionate and emotional, particularly in the relationship between Columbus and Queen Isabella.

Glass is already looking ahead, and the subjects for future operas continue to have an ascetic tinge. His most recent collaboration with Robert Wilson is called *White Raven*, and his music to accompany Jean Cocteau's *Orphée* had its debut in New York in 1995. He is working on an operatic version of Franz Kafka's *The Penal Colony*, as well as another historical work based on the epic of Gilgamesh and one that uses J. M. Coetzee's *Waiting for the Barbarians* as its premise. Having worked in such broad strokes on the immense canvas of *The Voyage*, it will be fascinating to see what this pilgrim will discover next.

The Last Puritan: Glenn Gould

If ascetics are known by their gestures of withdrawal, then Glenn Gould must rank highly among the latter-day saints of music. His controversial career, defined by the internationally famous retirement from the concert stage at the age of thirty-one, left Gould a posthumous cult figure even among intellectuals for whom Bach's suites might not otherwise be a vital concern. As an oddly secular mystic who wielded his considerable influence from offstage, Gould presents one of the most difficult problems in the Modern ascetic tradition. Beyond the flamboyant modes of self-torture, both at the keyboard and away from it, and the sheer theatricality of his flight from the public arena, there is a substantial link between Gould and the ascetic tradition even as it was practiced fully a millennium ago: Gould made perfectibility the center of his creative project.

As with Mondrian, Yeats, Messaien, Eliot, Beckett, and so many others, Gould's ascetic nature arose in part from a traditional religious base. What is more difficult to establish historically, of course, are the anecdotes and notorious comments on his appearance that led even an official filmed biography to refer to Gould as "a hermit, a man of mystery." At the age of three he was afflicted with an odd sort of St. Vitus's dance, moving about all the time with his fingers fluttering, not unlike the young Swinburne. As a teenager he was a loner, forever listening to the radio and doting on a steadily accumulating menagerie of dogs, birds, even a wild skunk that made him the St. Francis of his town. But the central

enigma of this story is the later evolution of Gould as hermit. In a manner reminiscent of Yeats drawing into in his poetry the solitude of his tower, Gould dramatized his retreat to a simply furnished apartment, dominated by disorderly piles of books and papers and by two pianos, one of them a Chickering that he loved for its "dry" sound and crisp action. It is almost humorous to think of the sleek glass facades of downtown Toronto and the nondescript apartment building in which Gould would sit in solitude, picking up the phone late at night to reach out and touch distant friends with conversations that were a significant part of his legacy. Had the Internet existed in his day, Gould would have been famous for scattering his icy critiques over fiberoptic cable onto the glass screens of his friends kept at a safe distance. The *in vitro* state of Gould's isolation is dramatized by an anecdote that he used in one of his outstanding essays. He tells of standing behind the plate glass window of the recording booth and watching von Karajan conduct. It serves as an important reminder, as well, of the shift in his activity from the concert stage to a kind of music making that involved the machinery of recorded sound.

Like T. S. Eliot, who was a banker and publisher and fervent religious poet, Gould combined a kind of naiveté and monkish avoidance of the fallen world with a secular savoir faire regarding television, radio, and film projects, the commercial arguments for programming decisions, and a host of other practical problems. He had a good touch as a cultural entrepreneur. Nor was he immune to the pleasures of luxury and the senses, but he had a knack for combining them with the ascetic rigor that was his dominant mode. The happiest month in his life, he repeatedly said ("in many ways the most important precisely because it was the most solitary"), was an odd quarantine situation in which he nursed a serious kidney disorder at the posh Four Seasons Hotel in Hamburg, where he lived in splendid isolation, an episode he himself likened to something out of a novel by Thomas Mann.[35] It was not simply pleasure, however, that Gould derived from isolation and debilitation from pain or illness. These were components of his thinking and creating because they, like the experiments in the sensory deprivation tank that Cage undertook, offered a way to beat up on the body, to deny it (although, as in Mann, it dominates by drawing attention to itself) and extol the metaphysical, extratactile dimension of his "real" desires.

Gould's longing for isolation was expressed in his writings and his documentary films and particularly in "The Idea of North" (1967), his first experiment with "contrapuntal radio" (in which he overlaid speaking voices in a quasi-musical effect that would probably pass for concert quality today). All his projects for radio and television somehow hit the theme of isolation, uniting figures like Casals and Stokowski, whom

Gould admired, and "The Idea of North" was particularly devoted to "the viability of outport life" beyond the easy reach of highways, airports, trains and even television and telephones. He threatened repeatedly to spend a winter in the Arctic, for the darkness—an ambition that echoes John Cage's periodic use of the sensory deprivation tank in which he explored a deeper silence than he could find in ordinary surroundings. In a rare burst of sincerity, without the customary flourish of overstatement, Gould observed: "There is a sense of exaltation—I'm careful about using that word, but it's the only word that really applies to that particular kind of aloneness."[36]

As is the case with Walter Abish the novelist or Mondrian, Gould had a particular fondness for the notion of an overhead diagram of a landscape or work of art. Gould's rarefied notion of the landscape that he idealized in his television documentary "The Idea of North" came from aerial photographs and geological surveys. Diagrammatic and remote, they allowed him the conceptual liberty and theoretical convenience that an actual visit might have ruined. Despite all his dreams and promises to go to Frobisher Bay and other areas, he never made it past lower Ontario. But his feeling for the effect of the northern landscape on people who go there was sincere: "Something really does happen to most people who go into the north—they become at least more aware of the creative opportunity which the physical fact of the country represents and, quite often I think, come to measure their own work and life against the rather staggering creative possibility—they become, in effect, philosophers."[37] In this "separation from the world," as he called it in the interview with himself, the creative possibilities of reflection are opened up. "Monastic seclusion works for me," he told Alfred Bester in an interview.[38] In the essay on "Let's Ban Applause," Gould expanded the time frame for the application of this notion of meditation and distance: "The purpose of art is not the release of a momentary ejection of adrenalin but is, rather, the gradual, lifelong construction of a state of wonder and serenity."[39]

Gould validated the notion of "aesthetic narcissism," which he took pains to dissociate from the solipsism of Cage (whom he did not admire, satirically referring to his work under the phrase "anti alea"). For what it's worth, Gould's asceticism had genuine religious roots. From his organ playing in the suburban Ontario church that left him with a lifetime habit of singing hymns, to the prayer ("Oh Lord grant us that peace that the world can't give") that he frequently repeated, to his serious interest in reading theology, Gould's ascetic nature was in part based on conventional sacred models. One of his most striking published letters is addressed to Miss Harriet Ingham, Gould's former high school English teacher at Malvern Collegiate School in Toronto (where soprano Teresa

Stratas also studied). Replying to a letter from Ingham challenging him for not including more about religion in a television special he had written and narrated for the CBC, Gould, after politely inviting his former teacher up to tea at his apartment, proceeded to lay a great deal of emphasis on the fact that at least half of the script was dedicated to showing how Bach strove against the fin de siècle faithlessness and "theatricality" of his times. "So, although it is true that I talked very little about the sources of the German reformation in Bach's music (after all, you know, we had a French version of this translated for the Province of Quebec as well), I did put, I think, a good deal of emphasis upon the nature of Bach as a spiritual man in a world which was at that time becoming increasingly hostile to the sanctity of spirit."[40]

One minor sidelight in the letters and essays does reflect the overtly religious side of Gould's asceticism. In the late 1960s, Gould became quite obsessed with Fartein Valen, a composer he called "the Norwegian hermit." In letters to Jane Friedman of CBS Records and later to Ronald Wilford in December 1971, Gould proposes that Valen's music be added to a group of Scandinavian works. Valen had died in 1952, but Gould took pains to get recordings of a piano sonata as well as set of variations for piano and found in them a particularly refined use of twelve-tone technique in the manner of Alban Berg but without the "frenetic hyperromantic qualities of Berg," which made Valen all the more appealing. Pairing Valen's Second Sonata with the Sonata op. 7 of Edvard Grieg (who was the cousin of Gould's maternal great-grandfather) in his CBC recital, Gould included some of the incidental pieces and the variations on the flip side of one of his CBS recordings. Gould was unabashedly drawn to "the mystery of Fartein Valen," the way he lived as a recluse on a government pension at a farmhouse overlooking a fjord in Norway (much like the Austrian philosopher Ludwig Wittgenstein).

The Body Is Weak

Critics and fans were obsessed with Gould's appearance at the keyboard and his concert manner. His overcoats and gloves, hot water, and hypersensitivity to the cold in the recording studio were a topic of great speculation, as was the way he would shed his shoes for a better touch on the pedals. He would sit very low—literally debased—on a folding wooden chair given to him by his father in the early 1960s. Its paint chipped and its seat completely shot, the chair was held together at its squeaking joints (a source of great distraction on the recordings) by steel brackets with the famous screws; it looked like an instrument of torture or one of the "thrones" on which the painter Francis Bacon would seat his popes. With

his shoulders hunched over the back of his neck and his eyes frequently at keyboard level while the rest of his body crumpled upward, often with his legs crossed, Gould mostly played with a grimace and with muscles tensed to the point of contortion—like Saint Sebastian wracked with pain. Late in life, seemingly overnight, the Dorian Gray–like transformation into a ghost with hollow cheeks and thin hair only accentuated this image.

Gould, it was said by friends, had more will than strength. A central fact, which also became a legendary affliction even in his own eyes, was the "wound" he received in the Steinway showroom in New York in 1961. Accounts of the incident vary, but apparently a technician gave Gould a friendly slap on the back that either dislocated or severely bruised his shoulder—even a lawsuit failed to clear up the mystery. Any dancer, musician, or even athlete will recognize in this a convenient way to set up a chronic excuse for an off-peak performance. Like the wound of Philoctetes, Gould's odd shoulder injury, which took him off the concert circuit for the better part of 1962, has been made into a pivotal fact in the understanding of his life and work. Tucked in among a pile of letters in which Gould complains of the pain and the elaborate therapeutic regimen he must submit to, all the while begging off playing engagements, there is a fascinating one to Schuyler Chapin dated March 10, 1960. Gould confesses to Chapin, then at Columbia Records and the future director of the Masterworks series in which many of Gould's recordings were published, that the left arm is not only much better, thanks to cortisone, but that the whole experience has been good for him as a musician. "At any rate, the improvement is wondrous and I must say, retrospectively, that I have, because of the enforced abstinence, discovered a whole new enthusiasm for music and music-making."[41] Aside from the possible effects of all the drugs Gould was taking, he is obviously stimulated by the change in routine necessitated by his injury. Responding to strong stimuli—even if it is pain, hunger and sleep deprivation—Gould enters a period of genuine productivity, creativity, and even contentment.

Perhaps because of the wound or perhaps owing to more deeply rooted psychological causes, Gould had a profound aversion to touching or being touched. This manifested itself in his basically theoretical approach to the piano and his constant reference to the "tactile" problems of playing, learning, and performing. This metaphysical, clearly cerebral and in many ways imaginative manner of construing music is the ideological starting point for both his withdrawal from the stage and his well-known attitude toward practicing (he rarely did after the age of twenty), which set him apart and alienated him from so many performers whose main discipline and concern in life is spending sufficient time in the practice room.

The problem then is to have a sufficient advance and/or extra-tactile experience of the music so that anything that the piano does isn't permitted to get in the way. In my own case, my means toward this is to spend most of the time away from the piano, which can be difficult because you occasionally want to hear what it sounds like. But a certain analytical ideal (which is somehow contradictory, I can't quite think how—I'm a bit stupid today, but anyway . . .), an analytical *completeness*, at any rate, is theoretically possible as long as you stay away from the piano. The moment you go to it you're going to diminish that completeness by tactile compromise. Now at some point that compromise is inevitable, but the degree to which you can minimize its effect is the degree to which you can reach out for the ideal that we were talking about.[42]

This is an extraordinary approach to the kind of virtuoso repertoire that Gould relished, including not just the famous Bach projects (the French and English suites, the Goldberg variations—always large-scale groupings) and the Beethoven and Brahms sonatas. The brilliant technical foundation that allowed Gould to test out this idealized restraint on the level that would satisfy him is part of his accomplishment as a performer. As a thinker, his notion of "diminishment" through "tactile compromise" is the kind of insight that informs our understanding not only of his own interpretations but more broadly of all music and even poetry (where it ranks with statements of Mallarmé), painting and sculpture (the Minimalist valorization of painting and sculpture that took away "the hand"), and architecture (particularly in its relation to the many unbuilt designs that have figured so prominently in the built history of the art, from Piranesi's prison fantasies through the soaring towers of Frank Lloyd Wright's imagination).

In what might still seem like a burst of silliness or schizophrenia but is in effect one of the central documents for the understanding of Gould as a thinker, he offered an interview of himself to the magazine *High Fidelity* in 1974. Although the humor is too cute, the circling pattern of the topical organization of the interview is fascinating. Its fixed center is the superiority of the interior, private experience of music over the tactile and public experience. Early in the piece, Gould jokes around about his withdrawal from the concert stage nearly a decade earlier and makes an odd reference to a sore throat he picked up while playing the Festspielhaus in Salzburg. At first this seems completely off the mark, but as the interview continues he effectively uses the anecdote again to distance himself from the *physical* drawbacks surrounding music in order to extol the metaphysical dimension of his ideal. Much of the seemingly egomaniacal self-interview is ironically devoted to the artist's need for "anonymity" that

can allow him to "operate in secret" outside the demands of the public and the marketplace.

Gould's concern is not just with the performer, however, but with the listener as well; and he relates the anecdote about one of his own favorite moments as an audience member, observing Herbert von Karajan conducting a memorable performance of the Fifth Symphony of Sibelius. While the "interviewer" thinks he has caught Gould out, admitting that a public performance is a necessary part of the excitement of music, Gould slips the noose and explains that he was not sitting down in the audience and listening but was standing in a glassed-in recording booth watching von Karajan from the point of view of an orchestra member. Pressing himself to judge the merits of von Karajan's interpretation, Gould offers a fascinating insight into how he pictures himself in relation to the work: "My aesthetic judgements were simply placed in cold storage—which is where I should like them to remain, at least when assessing the works of others."[43] In a phrase that directly invokes the ascetic tradition, he calls the ideal state of suspended judgment, at a degree that he confesses he has not attained, "spiritual perfection" and a "state of grace." To freeze one's judgment in this way is a philosophical feat that privileges the music over the performer or performance.

After wandering through the jargon of Marshall McLuhan for a bit, the interview returns to the metaphor of purity and his experience of listening to the Berlin Philharmonic through a glass partition, with joking references to a Mennonite sect in Switzerland that feels it becomes purer and more separate from the world as it moves farther up an Alpine mountain, which echoes his fascination with Arctic outposts and the "idea of north." He also half playfully declares that he would like to spend some time incarcerated as a prisoner, in a battleship-gray cell without air conditioning, to avoid the "traumatic" problem he suffered in Salzburg, to test his "inner mobility . . . to opt creatively out of the human situation." At this point the interviewer pushes the circular return to the Salzburg affliction to a new and more dramatic height that reveals a side of Gould that is psychologically interesting. Pointing out the Kafkaesque setting of the Salzburg Festspielhaus, the interviewer suggests that Gould return there as "a man in search of martyrdom." As he interviewer continues, the combination of overstatement and insistence underscore the seriousness of the theme of how "any artist worthy of the name must be prepared to sacrifice personal comfort." The Grand Inquisitor in Gould presses the point home in the last few exchanges of the interview:

> There could be no more meaningful manner in which to scourge the flesh,
> in which to proclaim the ascendance of the spirit, and certainly no more

meaningful metaphoric mise en scene against which to offset your own hermetic life-style, through which to define your quest for martyrdom autobiographically, as I'm sure you will try to do, eventually.

GG. But you must believe me—I have no such quest in mind!

gg: Yes, I think you must go back, Mr. Gould. You must once again tread the boards of the Festspielhaus; you must willingly, even gleefully, subject yourself to the gales which rage upon that stage. For then and only then will you achieve the martyr's end you so obviously desire.[44]

This combination of the Commendatore's duet with Don Giovanni and the voice-over inquisitor in *Slaughterhouse-Five*, for which Gould had put together the music, points directly to a deeply ingrained feeling about himself as both performer and victim. Virtually every figure that Gould contemplates in his writings shares this hermitlike solitude. He observes Stokowski from a distance, walking a triangular pattern on the platform of the Frankfurt train station and looking like "like a priest at exercise in the courtyard of a seminary, scriptures in hand" while waiting for a train to arrive, and ends the long essay on Stokowski, whose "martyrdom" at the hands of the musical elite had been occasioned by his being a sellout to Hollywood, with the thought that Stokowski was like a priest with a parchment of the Gospels—the score—that he reinterpreted in his conducting. Even the dreadful Petula Clark, to whom Gould devoted an essay that he claims he worked on as hard as any of this writing, is the occasion for a reverie on solitude, ending in a memorable scene in which Gould stops his car on a drive along Lake Ontario's northern shore, wandering out onto a promontory near one of the broadcast towers of the CBC at night. His conclusion—"I walk alone and wonder, Who Am I?"—in a way is Gould's theme song.

Note Perfect

Tennyson once offered this volley of textbook-worthy oxymorons: "Faultily faultless, icily regular, splendidly null, dead perfection; no more." Like Keats's "cold pastoral," the Tennysonian equation of pure perfection and rigor mortis sets up a dilemma for the study of Gould's own perfectionism. If laymen remember Gould for one quirk, it is his fear of the cold, his insistence on soaking his hands in warm water and wearing gloves to literally warm up before a concert, and the ironic combination of this phobia with Gould's dedication to the "idea of North" and all the projects involving the Canadian wilderness that he envisioned. At least Gould was in some way identified with the idea of cold. He presented himself in this way as a thinker and performer. He liked the

quality in others, particularly Schoenberg, whom he praised as "cold, relentless, austere."[45] His favorite interpretation of the Schoenberg piano concerto was "a textbook diagram of Schoenberg,"[46] a phrase that beautifully illustrates the kind of crystalline, internal framework that is the ideal of Gould's perfectionism.

Throughout the letters and essays there is a preoccupation with structure. It is the guiding principle of his playing and his composing, and the perfection that he sought was far more a structural ideal than one of sound effects, textures, gestures, momentary flourishes or the like. One brief observation adds to the argument for the compositional rather than performative nature of Gould's perfectionism: That infernal humming, singing and whistling that even Gould admitted would mar his recordings, much as the clatter of Casals's bow on the body of his instrument would interfere with the purity of the tone, was in Gould's mind a compromise of the sound quality that he could not edit out conveniently and could not entirely repress, from childhood on, because it interfered with the overall quality of the legato line. Had Gould been just a nut for perfection as a performer, he would have found a way to eliminate this genuinely annoying problem.

Let it be noted at the outset that any professional performing musician, announced to be a prodigy at the age of six, as Gould was, and pushed to be Canada's great white hope on the concert stage in the wake of the Van Cliburn phenomenon, is going to feel the pressure to be perfect in terms of execution. Gould's perfectionism is not simply that of the acrobat, even if it is an extension of that mentality. More than a test of his accuracy and "superhuman" powers of execution, perfection is an act of creation. This spotlights the old gray area between the performer and the creator in an essentially helpful way. Most performers would insist that the interpretive steps they take to individualize a "reading" of even the most familiar pieces lend the performative act its creative validity, and the cadenza tradition has formalized this claim. When virtuosos such as Vladimir Horowitz or his great predecessors Nicolo Paganini and Franz Liszt turn to their own writing, often working from transcriptions or theme and variations, the bridge into composition is extended.

Rather than Wanda Landowska or Edwin Fischer, Gould pointed to the influence of Rosalyn Tureck on his approach to Bach. Gould put his finger on what appealed to him in Tureck's playing, which was its "sensible" aloofness and almost icy distance. "It was playing of such uprightness, to put it into the moral sphere. There was such a sense of a repose that had nothing to do with languor, but rather with moral rectitude in the liturgical sense."[47] Gould favored the nice "secco quality" of his Chickering without any pedal, especially for pieces like the fifth and

sixth suites of Bach's overture in French style. He points out the value of the harpsichord's ability "to achieve the sort of secco, pointillistic, detache line that I've always tried to produce on the piano with varying degrees of success."[48]

What is particularly fascinating about watching the documentaries that show Gould in the recording studio is the level of detail and tiny scale of the changes he was working on. While the verbal explication of why he changed and mixed two different takes for the same multivoice Bach piece could go on for pages in a book, the second or third take would in fact last a matter of six or seven seconds, and it would take a minute or more for Gould to hear again the effect of the change. In his seminal essay "The Prospects of Recording" (1966), he emphasizes the level of detail on which Schoenberg's pieces operate: "Schoenberg's theories, to simplify outrageously, have to do with attributing significance to minute musical connections, and they deal with relationships that are on the whole subsurface and can be projected with an appropriate definition only through the intercession of electronic media."[49] He worked with lightning speed on very brief snippets of each piece. Given all the fuss over his preparation in and around the piano for recitals, it is almost amazing to see how quickly he will plunge into a passage and then pull up again, like reining in a powerful horse from a canter, stopping himself at the very peak of a torrent of notes. Then the retake would be inserted in the precise location of a less satisfactory attempt at the same passage, substituted note for note, and Gould would move on to the next section. This surgical process of constant interruption, which chops the piece up more finely than the pauses between variations or sonata movements, reflects the incessantly analytical approach to music he took.

The vital gesture in this process is the cut. In his day, one would literally cut the master tape and splice in the substitute, returning to the earlier master even as soon as one note after the changed note has been dropped into place. The literary equivalent is the old "cut and paste" job that would literally require a razor or pair of scissors to overlay a word or passage of text on top of another in a manuscript or newspaper layout; and in art there is, of course, the collage, particularly as practiced by Kurt Schwitters. Both of these rudimentary editing processes have long since been supplanted by digital techniques that erase and replace data magnetically, as from a computer disk. The vitality of the debate over electronic music has not seriously abated, even if some of the early works are period pieces now (requiring obsolete, expensively maintained tape players or computers, like period violins). One of the great figures in that debate was, of course, Glenn Gould, who championed the creative potential of the electronic recording studio, and performed all kinds of professional-caliber editorial

magic on his own recordings even before the age of digital manipulation. Critics might sneer that the onstage "antics" and eccentricity were the poses of an artist who wanted to draw as much attention to himself as possible. In an era when box-office success is accorded to soloists as sex symbols, from Nadja Salerno-Sonnenberg and Ann Sophie Mutter to Igor Pogorelich and others, this suspicion is easily indulged. However, Gould, like Eliot, was on record as an advocate of the impersonal theory of creation. One of the most pointed statements he made along these lines is in the important essay "The Prospects for Recording." As Gould wrote, "In fact, this whole question of individuality in the creative situation—the process through which the creative act results from, absorbs, and re-forms individual opinion—will be subjected to a radical reconsideration."[50] By taking away the individuality factor, and replacing it with a more anonymous, and of course detached, view of how music or art is made, Gould turns from the spotlight yet again.

Asceticism in the Dance

The historical connection between religion and the dance through asceticism extends as far back as the ancient cults that used dance as a means to induce ecstasy, the death-centered danse macabre, and roving troupes of flagellants who moved in unison along pilgrimage routes in medieval Europe. Closer to us, particularly given the immense popularity of the design aesthetic it has inspired, is American Shaker worship from the eighteenth century on, with its penitential use of dancelike bowing, stamping, and whirling. The flagellants inspired Martha Graham's *El Penitente* (1940), and the Shakers prompted a major work by Doris Humphrey, which we will examine in some detail shortly. From the spectator's point of view, dance scarcely seems an ascetic medium since it is overtly a celebration of the body—sensuous, lyrical, and often as sumptuous as a pageant. But behind the scenes, where the great illusion of the classical ballet is perfected through discipline and deprivation, the body is punished and denied in ways that are entirely in keeping with the extreme austerity of the ascetic tradition.

The amount of unseen pain involved in performance, from the crippling arthritis that has afflicted so many, including Doris Humphrey and Merce Cunningham, to the physical and mental trauma of anorexia nervosa among George Balanchine's ballerinas, is a reminder of this ascetic dimension. Sometimes this touches the audience, as when Cunningham focuses part of one of his dances on his own limited mobility and evident distress or when Pina Bausch has dancers slam each other brutally to the

floor. Audiences are more likely to be aware of this aspect of dance, however, through their reading. When Nijinsky's autobiographical *Cahiers: Le Sentiment* was published in Paris in 1996, its cover image was a disturbing photo of him, at age thirty-seven, undergoing a catatonic seizure, his face twisted in pain. Gelsey Kirkland's raw, accusatory memoir of the "concentration camp" aesthetic of Balanchine's New York City Ballet was titled *Dancing on My Grave*. Even the more glowing reminiscences of Balanchine stress the extreme measures by which a dancer conformed to that sleek, fast ideal he sought ("Eat nothing," he told them) and the restraint between male and female roles that characterized his choreographic style.

Many of the most significant issues in modern dance and twentieth-century ballet involve asceticism, including the questions of personality and impersonality, abstraction and theatricality, and the freedom and degree of control conferred on the dancer by the choreographer. The rigor of the dancer's training—"drill and grill" as the dancers call it—and the choreographer's art, like the endless "correction" of the performing musician, give dance an ascetic character on at least one level. The geometry of dance, codified in the earliest texts on choreography and performance by Guglielmo Ebreo of Pesaro in the fifteenth century and by Balthasar de Beaujoyeulx in sixteenth-century Paris, emphasize the importance of *misuro*, or "measure." Even the most raucous and expressive dance answers to discipline, as William Carlos Williams reminds us in his description of the peasants' circular dance in "The Wedding Dance" from *Pictures from Breughel*: "Disciplined by the artist / to go round & round."[51]

On a more theoretical level, the asceticism of twentieth-century dance can be explored through its classicism, use of repetition, and emphasis on rhythm. As in the work of Philip Glass, the accumulated repetition of some dance induces a static sense of time. In the simplest terms, looking ahead to our consideration of Merce Cunningham's *Ocean*, that turning in a circle, movement with precision but without progress, becomes an ascetic emptying out. The classicism of Balanchine, which also performs this emptying, adds a level of anachronism. For some, it is a timeless quality that, like the silence of the dancers, offers a canvas on which their own dreams can be painted. Stéphane Mallarmé begins a famous essay on the ballet with a celebration of the word *étoiles* in the program, which leads him into raptures over the idea of watching the constellations dance, even if metaphorically:

> The modern cast of mind is well known, and even in the case of those
> whose faculties are exceptional when used, it must be replaced by some
> nameless, impersonal, glittering glance of absoluteness, like that lightning

which has in recent years enveloped the ballerinas at the Eden theater, fused its naked electricity with paints of a whiteness beyond the ken of flesh, and surely made of her that wondrous being who has drawn back beyond all conceivable living worlds. At those times when we ordinarily watch the Dance with no special object in mind, the only way to lead our imagination on is to stand patiently, calmly watching each of the dancer's steps, each strange pose—toeing, tapping, lunge, or rebound—and then ask ourselves: "What can the meaning of it be?" Or, better still, find inspiration suddenly and interpret it. Doubtless that will mean living entirely in the world of revery. World sufficient, nonetheless, nebulous or clear, spacious or limited—any of these, so long as that illiterate ballerina, flutteringly engaged in her profession, encloses it with her circlings or bears it off in flight.[52]

This quiet view of the asceticism of dance as a metaphysical lightness and transcendence is matched by a more violent one. One of the key works of the century uses the sacrifice of a virgin as its climax, to a score celebrated for its "brutally" forceful rhythms. As Adorno wrote regarding Stravinsky and Diaghilev's *Le Sacre du printemps* (1913):

The body is treated by the music as a means—an object which reacts precisely, it drives the body to its highest attainments, as manifested drastically on the stage in the robbery and in the competition of the tribes in *Sacre*. The rigidity of *Sacre* makes it insensitive to all subjective impulses, as does ritual against pain in initiations and sacrifices. At the same time, this rigidity is the commanding force which trains the body—forbidding it the expression of pain through its permanent threat—for the impossible, just as it conditions the body for ballet, the most traditional element in Stravinsky. Such rigidity—the ritual exercising of spirits—contributes to the impression that the product is nothing subjectively produced thus reflecting the human being, but rather something which exists per se.[53]

Taking that objectivity—even rigidity—as the accent, this brief consideration of dance in our time reveals that, as in the other arts, the ascetic strain in twentieth-century dance assumes many forms. From the restraint of Minimalists like Karel Armitage or Lucinda Childs, who choreographed the "Knee Plays" for Glass's *Einstein on the Beach*, to the "objectivity" of Yvonne Rainer and the Judson Dance Theater (whose work is related to Minimalist sculpture) or the "Accumulation" pieces (1971–73) and *Planes* (1971) of Trisha Brown as well as Viola Farber, there are aspects of the dance that come very close indeed to parallel developments in painting and sculpture. Having been devastated in recent

years by the impact of AIDS, some of the ascetic quality of recent dance is attributable to the fact that it falls into the genre of elegy, whether in the brilliant work of the Czech choreographer Jiri Kilian for the Netherlands Dance Theatre, including the profoundly moving ensemble piece *Heart's Labyrinth* (1989), or the more controversial and impermanent work of Bill T. Jones. There are, of course, a number of choreographers and dances that should not be called ascetic in the true sense of the word—despite her flair for the drama of asceticism, I would put Martha Graham in this category, along with José Limón, Paul Taylor, and Twyla Tharp—and the point is not to advance asceticism as some unifying force in twentieth-century dance theory or practice. As a broad conceptual rubric for the consideration of a small but diverse group of choreographers, one hopes that it will offer an interesting new perspective on work that deserves close scrutiny in any event.

The Taskmaster: George Balanchine

George Balanchine was tired that afternoon as he sat on a bench in one of the studios of the School of American Ballet, watching a rehearsal. Next to him was Ruthanna Boris, a former prima ballerina of the Metropolitan Opera Ballet who had danced with Balanchine's Ballet Caravan in the 1940s and both danced and choreographed as a guest artist for New York City Ballet. She recalls the conversation she had with the weary Balanchine:

"As they were working he said to me, 'You know, those men in Tibet up in the mountains. They sit nude in the cave and they drink only water through straw and they think very pure thoughts.' I said, 'Yes, the Tibetan monks. The lamas.' He said, 'Yes. You know, that is what I should become. I would be with them.' And then he looked around and said, 'But unfortunately, I like butterflies.'"[54]

Putting aside the decidedly unascetic philandering implied, this snippet of conversation does offer an insight into the quest for purity that characterizes Balanchine's work. When Rudolf Nureyev approached Balanchine in the 1960s in the hope of collaboration, the choreographer's now-famous refusal points directly to the asceticism that distanced him from the Romantic tradition. "My ballets are dry," Balanchine told Nureyev.[55] The style that he created—fast and crisp—as well as the look that he wanted—tall and lean—depended on a kind of perfection that some critics have related to the "machine ballets" of Nicolai Foregger and others in Russia in the 1930s when Balanchine was dancing. In the rehearsal room, the *port de bras* was straight out of Cecchetti technique,

developed at the barre with an almost endless repetition of bowing and arching forward and back, what Balanchine mundanely described as "picking up the laundry." He disdained working in the traditional three-four time because he felt the extra beat was a waste. His dancers had to be tall, painfully thin, and ethereal, with a faraway look that invites comparison with the stage presence of Robert Wilson as well as the later edgy demeanor put on by Pina Bausch's dancers.

The Balanchine body became a physical type that dominated the look of ballet companies internationally and is the subject of great debate. Even today, when you see the little ballerinas of the School of American Ballet sitting together in the early evening in the cafeteria of the Juilliard School at Lincoln Center, wolfing down pizza or hamburgers after a long afternoon in the classroom under the watchful eyes of their mothers, bobbing their heads in time as they hum a Tchaikowsky score, that carefree, cheerful movement of preadolescence is already a bit too tight and circumspect. When they put their "game faces" on, lift their jaws and narrow their eyes, the hardness creeps into their expression. When the brilliant literary critic R. P. Blackmur was in London enjoying the ballet at Sadler's Wells, he noted the difference in response of the American audience and their foreign counterparts: "The Americans did not like the softness of the Sadler's Wells girls. They missed the hardness of the American girls, hardness of flesh, of face, and the scrupulousness of motion so hard it inched on the brittle—as if every gesture were secretly fractured, but finely joined. There was also the hardness of pace or gait. What is so hard as hysteric exactness, unless it be abstract exclusiveness?"[56]

One of the most significant elements of Balanchine's style is the freezing of movement in an arrested gesture that is as demanding, in muscular as well as mental terms, as the more spectacular jetés he called for. As he told William Weslow, a New York City Ballet dancer, "Arms must be mechanical, must be perfect, must be across body, lots of movement, but movement must stop." It is the precision of that stopping as much as the movement itself that connotes asceticism. An endless debate rages among New York City Ballet patrons regarding the state of the company in the post-Balanchine era. The purists lament the way the rigor and tightness of the dancing has slipped, and some point to the continuing movement of the arms in particular, past that point of stopping that he designated, as a sign of the breakdown in Balanchine's discipline.

The effect of the Balanchine style is one of economy of movement, a kind of streamlining that, as in the development of the bullet train or race car, allows the speed and cornering to rise to hair-raising levels. One of Balanchine's stars, Barbara Walczak (who created roles in his

Scotch Symphony, Bourrée Fantasque, Roma, Pas de Dix, and other works during her sixteen-year tenure with the City Ballet) describes how this stripped-down style was fashioned. By ridding his dancers' movements and minds of extraneous stylistic memories, musical associations, even emotions, he achieved the objective vehicle he needed. Like the *solfège* and counting that Philip Glass gives to his opera singers or the "specificity" that Donald Judd called for in the sculptural handling of materials, Balanchine's purification of dance involves a range of negations, including that of the dancer's individual will. As Walczak points out, "He wanted pure movement with all the energy that your body could possibly put forth, done full out, but pure movement, with no stylistic mannerisms. He would tell us, 'Don't listen to the music, just count.' He was afraid that we would begin emoting. 'Don't listen to the music. Just count. Don't look around. Look straight forward. Not too much *epaulement.*'"[57]

Of course, this extreme rigor took its toll on fragile egos and bodies. To the disgust and fury of Balanchine fans, one of his most famous ballerinas, Gelsey Kirkland, revealed the darker side of Doctor Coppelius in a tell-all book that is, for the most part, just a long, whining chronicle of disasters with diet pills, plastic surgery, sexual exploits, and gossip. Whatever interest it has for us beyond shock value depends upon how well it opens up the door to the rehearsal room, rather than the bedroom, and shows us the emotional and physical sacrifice that Balanchine demanded from his greatest dancers. As Kirkland writes,

> I felt like a test pilot trying to break the land speed record with my body, which was riddled with breaking parts, unable to withstand the strain. His distorted emphasis and shortcuts on pointe work, including his restriction that toe shoes be worn at all times in class, delivered another blow to my Achilles tendons. I was lame, an unwitting victim of planned obsolescence. His technique targeted various parts of the body. Depending on physical type and the quality of previous training, each dancer was more or less vulnerable to premature breakdown at any time. I continued to dance through the pain as if I were set loose on a floor covered with broken glass.[58]

The rhetoric in Kirkland's book elevates her trials to the status of martyrdom. The more serious issue it raises points to the discipline and decorum, for lack of a better term, by which a dance company is governed. Having examined the relationship between Reich or Glass and their ensembles, it is interesting to compare the autocracy of Balanchine. As Kirkland notes, "In a certain sense, by strict conformity to his demands, it was

possible to dance for Balanchine without knowing how to dance."[59] On stage, some of this discipline is captured in the psychologically strange and often chilling dramas that play themselves out within the mainly abstract framework of his pieces. The remoteness of the women, the restraint and respect of the cavaliers who hold them on their pedestals, all point to an ascetic emphasis on emotions controlled, denied, and destroyed. In the middle movement of the *Concerto Barocco*, the idealization of woman and form is pushed to its limits in the symmetrical groupings of two ballerinas dancing before a chorus of eight women. Balanchine gave the men their answer with *Kammermusik No. 2*, which features eight men in a tightly choreographed *perpetuum mobile* to music by Hindemith. In the great Stravinsky–Balanchine masterpiece *Apollo*, the tiny gap between the outstretched fingers of Apollo and Terpsichore at the beginning of the pas de deux, straight out of Michelangelo's Sistine ceiling, is a metaphor for this Keatsian distance between the lovers. It also stands for the near-impossibility of the role of Apollo. It is as though Balanchine created a Classical, even anachronistic work that could never be fully mastered by the dancers of our time—even Peter Martins, the most memorable of the Apollo interpreters, could not claim to have perfected it—just as Wright designed a mile-high skyscraper he knew would never be built.

Of all the artists to whom Balanchine might be compared, perhaps Giacometti is the most directly similar. As Giacometti would make a standing woman loom larger and larger by paring more of her away physically, so Balanchine would exalt his ballerinas by winnowing them down to nothing. Both artists deliberately posed problems and challenges for themselves that involved countering the expected gesture, and both were masters of scale. That distance that Giacometti maintained even in his work is a factor in Balanchine's work as well. Consider, in closing, this lovely description of Balanchine's *Agon*, another of the great examples of his ascetic craft:

The first move the dancers make is a counteraccent to the score. Phrase by phrase, the dancers make a counterrhythm to the rhythm of the music. Each rhythm is equally decisive and surprising, equally spontaneous. The unusualness of their resources is sumptuous, like a magnificent imaginative weight. One follows the sweep of both by a fantastic lift one feels. The Balanchinian buoyancy of impetus keeps one open to the vividly changeable Stravinskian pressure of pulse and to its momentum. The emotion is that of scale. Against an enormous background, one sees detached for an instant, the hidden grace of the dancer's individual move, a chance

event that passes with a small smile and a musical sound forever into nowhere.[60]

Silent Redemption: Doris Humphrey

Doris Humphrey, one of the most important figures in the development of twentieth-century dance, was born in 1895 and brought up in Oak Park, Illinois, where her father was a newspaper reporter and her mother worked as manager and housekeeper of a hotel. As a young girl, Humphrey was trained in ballet, ballroom, and folk dancing; and when her family's fortunes plunged, her mother organized dance lessons taught by Doris, then in her mid-teens, for other children while her mother played the piano. In 1917 she went to Los Angeles to enter the Denishawn School, run by Ruth St. Denis and Ted Shawn, who took her on as a performer at the age of twenty-two. Humphrey started choreographing her own pieces, including her first work, *Valse Caprise* (1918), as well as a number of collaborations with St. Denis, such as *Sonata Pathetique* to music of Beethoven and *Soaring* to Schumann.

In 1928, Humphrey and two other disgruntled Denishawn dancers, Charles Weidman and Pauline Lawrence, started their own company. Their first concert, held on October 28 of that year, included a group of works that were among the earliest examples of abstract modern dance seen in this country, among them, *Color Harmony* and *Water Study*. The latter is a masterpiece for sixteen dancers that is danced in absolute silence; in it, silence represents the complete removal of the customary aural, rhythmic, and even emotional supporting structure that dancers are used to having. For Humphrey, this stripping away of the most important sensual aspect of the dance only served to focus attention more squarely on the movement itself. If *Water Study* is important in theory as well as beautiful in practice, it is because the work demonstrates the structural autonomy of dance. Humphrey separated choreography into raw materials that she called "design, dynamics, rhythm and motivation," and in terms of each of these, *Water Study* was a piece well ahead of its time. Of all the materials that it transforms, rhythm is the element that is handled in the least conventional manner. "Probably the thing that distinguishes musical rhythm from other rhythm is the measured time beat, so this has been eliminated from *Water Study* and the rhythm flows in natural breath phrases instead of cerebral measures," Humphrey explained.[61]

The dancers in *Water Study* are not coordinated by music or a "count." The unifying aural cue is breathing, and the dominant visual

idea is a curve. Because it is related to the image of waves rolling onto the shore, the dance is only partly abstract. The dancers work from the rhythmic idea of the crest and fall of ocean waves, as well as their own breathing. Like Frank Lloyd Wright's partially abstract residence on the California coast called "The Wave," the form is partly mimetic, created by the curvature of the dancers' backs, shoulders, necks, and heads, as well as their arm gestures and the patterns of their movement. In her wonderfully practical, straightforward book, *The Art of Making Dances*, Humphrey addressed the problem of abstraction, which in its absolute terms she seems to have held in suspicion, in terms of sickness and health:

> Painters can make nonobjective shapes and lines, dancers cannot. They only succeed in looking like human beings abdicating their right to be people and pretending to be objects in space. Is it possible that this is a legitimate expression of the disillusionment of our time? Are people so bewildered and world-weary, so afraid of life and what it offers, that abstraction is a welcome retreat, behind which they need not think, feel or suffer? That, to me, is a very sad conclusion, but logical. A sick world will produce a sick art.[62]

Abstract in the vital sense, *Water Study* is a Milton Avery seascape in motion that lasts only eleven tension-filled minutes. It opens with the dancers spaced across the stage, crouched down with their heads and arms tucked in an egg shape. From stage left to right an almost imperceptible rising motion passes from dancer to dancer in ripples, returning across the stage from right to left and then being echoed in another and more dramatic ripple across the stage that brings the dancers further up from the floor until, one by one, they rise on a knee and send the wave motion forward again. The last dancer to receive the wave sprawls forward to lie on her stomach, as the wave dies momentarily on the beach. As the advancing and retreating pulse of the wave increases, it begins to send an undertow in the other direction, and soon there are two contrapuntal sources of the momentum as the movement starts originating from both the right and left sides of the stage.

The two opposing motions meet at a central zone of tremendous energy that, like a similar medial boundary in *Shaker Dances*, acts as a force field where the forward motion of both forces is halted and turned back. Like the medial break of a Brice Marden diptych, this break in the stage keeps the dancers from making contact. It opens a tremendous space between two groups of dancers, who turn and extend toward the upper reaches of the wings of the stage. The effect is like that of a big Morris Louis painting, particularly the Alpha, Gamma, Sigma, and Omega series, in which a huge white central space, funnel-shaped, is surrounded by

nearly symmetrical bands of color poured from the top of the canvas to the bottom. As in the Louis paintings, the central hollow of Humphrey's space, that vortex, is charged with significance and energy. When the dancers do make contact inside, they have to forcefully pull each other across it. It takes strength to traverse the breach. The vertiginous energy within that space—recalling Debussy's passion for the hollow of the wave and the whirlpool—begins to surface again in *Water Study* in the form of little whirlpools of spinning dancers, spiraling down from a standing position to their knees and then into full, prone contact with the floor. As the to-and-fro shuttle and weave of the waves begins again, the dancers push and stretch from side to side. The key here is the way in which the movement is arrested momentarily as it reaches its limit on one side or the other, a stopping that calls to mind the arrested arm movement of Balanchine. The waves begin to crash again from side to side but gradually die down until the dancers are left again in the egg position on the floor, their fingers fluttering in imitation of the frothy foam flowers that sizzle down to silence at the subsiding of a long wave.

In terms of Humphrey's theory of dance, *Water Study* was the first full realization of her principle of "fall and recovery," the yielding to and defiance of gravity. Humphrey's rather ascetic-sounding explanation of fall and recovery in metaphorical terms was that it was "the arc between two deaths." As a means of designing movement in space, fall and recovery involves using the two "secure" positions of the body—lying down or standing up straight (recalling the vertical and horizontal foundations of Mondrian)—as the parameters for movement. In this schema, life—all the motion between the two deaths—is "off-balance." Like Martha Graham's "contract and release" (or even, for that matter, like the painter Hans Hofmann's "push and pull"), Humphrey's fall and recovery becomes an all-purpose mantra that has meaning in the studio as well as in the vocabulary of the audience, particularly as they watch the literal fall and recovery of dancers working off the floor, as often as they do in *Water Study*. In her discussion of rhythm in the section of *The Art of Making Dances* devoted to craft, Humphrey elaborates her view of the vertical and horizontal:

All life fluctuates between the resistance to and the yielding to gravity. Youth is "down" as little as possible; gravity holds him lightly to earth. Old age gradually takes over and the spring vanishes from the step until the final yielding, death. There are two still points in the physical life: the motionless body, in which the thousand adjustments for keeping it erect are invisible, and the horizontal, the last stillness. Life and dance exit between these two points and therefore form the arc between two deaths. This lifetime is filled

with thousands of falls and recoveries—all highly specialized and exaggerated in the dance—which result in accents of all qualities and timing.[63]

Water Study also embodies Humphrey's ideas of "moving from the inside out" and of the "successions," which Ina Hahn, a choreographer who danced with Humphrey–Weidman and is now the chief keeper of the flame through her careful teaching and restaging of Humphrey's work, defines as "movement impulses that travel through the body like the life force itself."[64] Hahn's recent revival of Water Study at the Windhover Performing Arts Center, from the labanotation score, was a triumph of dance scholarship. "Water Study is a completely ascetic work," Hahn affirms. "It's sixteen dancers and one breath."[65]

Humphrey's writings are devoted to the logic and practice of dance as an art form. Neither dreamy nor self-expressive, they value discipline and even hardness in the context of other factors within and outside the dance context but maintain the importance of viewing dance, as well as all of aesthetics, in terms of the relations between human bodies. In this regard, Humphrey is not prepared to take that final step to an ascetic valorization of the geometric (in her eyes "graceless") world of the pure formalists. Her critique of contemporary architecture, from The Art of Making Dances, is instructive:

> Endless lines of steel and stone, square, hard, the perpendiculars stabbing the horizontals like enemies with spears, and no relief from the assault. The curve has all but vanished, and grace is now a sheet of green glass encased in an oblong of chromium—almost no landscaping, no sculpture, no ornament. The right angle is possibly the prime symbol of our age, eloquent of conflict. Its parent, the straight line, is thought to be best and smartest when it is shiny and naked, pointed slightly like the end of a weapon. The "clean line" is a cult. All this suggests force, too much steel and sterility and that other prime symbol, the fact. The right angle and the fact are the voices of our time.[66]

As a choreographer of curves, Humphrey's aversion to the straight line is understandable. The "conflict" in the meeting of vertical and horizontal is a fascinating perception. As clean as Humphrey has made such dances as Water Study and The Shakers, there is a limit beyond which purity declines into sterility. This passage brings to mind a similar thought from E. M. Cioran's Tears and Saints:

> Disjunction from life develops a taste for geometry. We begin to see the world in fixed forms, frozen lines, rigid contours. Once the joy of Becoming

is gone, everything perishes through too much symmetry. What is known as the "geometrism" of so many kinds of madness may very well be an exacerbation of the disposition towards immobility characteristic of depressions. Love of forms betrays a partiality for death. The sadder we are, the more things stand still, until everything is frozen stiff.[67]

After *Water Study*, Humphrey went on to create a number of other masterpieces of modern dance, including *Air for the G String, With My Red Fires*, and *Passacaglia*. Once arthritis ended her career as a dancer, she became choreographer and artistic director for the José Limón Company, for whom she created *Night Spell, Day on Earth*, and *Ritmo Jondo*. In terms of asceticism, the most important of her works after *Water Study* is *The Shakers* (1931), a nine-minute-long work subtitled "Dance of the Chosen." It was first performed in November 1930 at Hunter College and had its first professional staging the following February at the Craig Theatre with a company that included Sylvia Manning, José Limón, Humphrey, and Weidman. Believing that they could shake off their sins, the Shakers, a Quaker sect, met in pewless meetinghouses that, to a choreographer, would immediately suggest a dance studio. There is an awkwardness to the movement in *The Shakers* that is meant to ground it in the realism of a genuine religious experience, of course, and that also brings to mind the "gauche" movements of Twombly's calligraphy in a similar attempt to prevent an ascetic work of art from becoming "too pretty."

The key visual element in Humphrey's staging is the center line of the meetinghouse, dividing the men from the women. The two groups face one another across this divide, then create two large wheeling X-formations that never touch as they mesh like gears into one another. The men and women jog and bounce up and down repetitively at the exhortation of their leaders in a crescendo of ever-quickening movement that suddenly comes to a halt when the woman leader (the Shakers were dominated by women, interestingly enough) raises her arms to heaven and the congregation drops to its knees and clasps its hands in prayer in the posture with which the dance began. When Humphrey choreographed *The Shakers*, she was pursuing the "meticulous, austere" simplicity of their artifacts, as well as the release of tension (especially sexual tension) in ecstasy. *Water Study* and *The Shakers* were put together on the same program for Humphrey's *Americana*, a Broadway musical, and the Eldress recited short prayerlike phrases, including: "Ye shall be saved when ye are shaken free of sin." Humphrey once remarked that this phrase encapsulates "the motivation behind all my dances." One funny story relating to the asceticism with which Humphrey conceived these

two dancers relates her response to the bottom-line mindset of producer Lee Shubert, who wanted to change the drab costumes to brightly colored ones. Humphrey said, "Take your predatory hands off my costumes! And I don't suppose you even know what predatory means!"

The Wizard of Solitude: Merce Cunningham

Nowhere is the isolation of the dancer more celebrated than in the work of Merce Cunningham, who explores the alienation of the members of an ensemble on a level that is comparable to what Elliott Carter has achieved in the string quartet. As with both Balanchine and Humphrey, much of what is ascetic in Cunningham's work involves a paring away of "sensual" elements, such as narrative, the fussy decor of the nineteenth-century ballet, and pretty music. The result is a depersonalized style that is visually and aurally challenging. Part of its punch comes from Cunningham's brilliant choice of collaborators, including composers John Cage, Christian Wolff, Morton Feldman, Earle Brown, Gordon Mumma, Conlon Nancarrow, and John Tudor, and an extraordinary roll call of painters and sculptors that includes Remy Charlip, Robert Rauschenberg (who created the sets for *Antic Meet* in 1958 and *Winterbranch* in 1964), Frank Stella, Jasper Johns, Andy Warhol (whose silver helium-filled balloons, lightness and asceticism at their unbeatable extreme, were the memorable feature of *Rainforest* in 1968), Robert Morris, Bruce Nauman, Mark Lancaster, and Morris Graves, as well as his current artistic advisers (since 1984), Dove Bradshaw and William Anastasi. The critic Roger Copeland has noted that Cunningham's contribution to dance is the kind of enlarged freedom that also involves a greater clarity, almost in the Classical sense in which that quality is prized. As Copeland points out,

> For Cunningham, Rauschenberg, and the extraordinary community of composers, painters and dancers with whom they collaborated, true freedom has more to do with seeing (and hearing) clearly, than with moving freely. Likewise, social mobility—regardless of whether it's horizontal or vertical—does not, in and of itself, constitute "freedom." (Oscar Wilde and Gertrude Stein both realized this when they advocated "doing nothing"—a detached contemplation of the world, rather than active involvement in it.)"[68]

Cunningham was born in Centralia, Washington, and moved from there to the Cornish School of Fine and Applied Arts in Seattle during

the mid 1930s, where he hooked up with John Cage, then on the faculty. During the summers of 1938 and 1939, Cunningham took classes at Mills College in Oakland, dancing in Lester Horton's *Conquest* in 1938; the next year he met Martha Graham, who was in residence at Mills as part of the Bennington College Summer School of the Dance. Cunningham became the second man to join the Graham company, dancing such roles as the Revivalist in *Appalachian Spring*, the Christ figure in *El Penitente*, and the Acrobat in *Every Soul Is a Circus*. In 1947 he created *The Seasons* for the Ballet Society, which later became the New York City Ballet, and was a teacher of modern dance at its School of American Ballet.

Many of Cunningham's early works have an ascetic tranquility, including "Stillness" from the *Suite for Five in Space and Time* (1956), in which the solitary man with whom the work begins wanders around the stage until he is joined by a woman for a brief duet—but they never connect emotionally (his mood is upbeat when she is pensive). She leaves, and he is left alone, in an anguished sequence that ends with him holding his hand plaintively out to the audience, with his head bowed. In *Antic Meet* (1958), Cunningham uses a bentwood chair strapped to his back and gradually incorporated into the dance as a prop. Surrounded by women dancers, he is again left alone although in this case the dance has a more humorous tone. The chair, like the simple wooden chairs of Nauman or the odd collapsing chair that accompanied Glenn Gould to all his concerts, has an impoverished, almost pathetic look.

One of the charges against Cunningham is that his dances are too impersonal. The question of personality in dance, as well as aesthetics generally, is particularly complicated, involving as it does the relationship between the composer or choreographer and his ensemble, as well as the impersonal relationship to the audience (about which T. S. Eliot has written most eloquently). According to Cunningham, "The idea of personality not being there isn't true simply because when the dancers do it, they in doing it take it on—it's like a second skin." Even for those accustomed to the "abstract" ballets of Balanchine (with whom Cunningham worked briefly, adding the dimension of historical contact to the perceptible relationship that exists between their work), Cunningham's work seems to lack the roles and moods of a more "personal" kind of dance. The faraway look of his dancers, which Balanchine's ballerinas also cultivate and which Pina Bausch takes to a further horizon, only adds to this feeling of emotion completely suppressed. The disjointed, often contrary effects of the music, especially what one critic called "the painful aural fog" of Tudor's scores, also contributes to the alienating effect; but this can be related in part to Gould's habit of turning on the vacuum cleaner

while he practiced Beethoven as a way of concentrating on the touch and movement of the playing instead of its sound.

Yet there are roles, and among them the most memorable have involved Cunningham himself. Crippled by arthritis, throughout the 1980s he hobbled up the steps or out of the wings with such difficulty that the audience cringed to see him—and then suddenly flung himself into motion as though the pain had completely dissipated. From the moment he becomes visible in the theater it is inevitable that he attract attention. It is an extraordinary and inspiring transformation. Whether as Prospero or Lear, when he is in a dance, the work becomes a meditation on his role— he is, like Beckett, his most compelling subject matter. One of the great examples of this is the solitary role he plays as the fifth dancer in *Quartet* (1982). Like the figure of death fluttering and hovering between the paired lovers, he is the epitome of loneliness, waving his arms futilely in that medial position, ignored by the youthful quartet that moves so freely around him.

The impression of impersonality has been enhanced by Cunningham's foray into computer-generated choreography. I find it almost amusing to compare that fact that Cunningham has worn out two personal computers since starting this experiment in 1991, which some might say is better than wearing out dancers with the impossible maneuvers that he is trying out on-screen in his laboratory-like studio complex at the Westbeth artists' center on Manhattan's West Side. For a long time, Cunningham and Cage worked from careful notes that included phrases created through chance procedures involving the *I Ching* or throwing dice. The computer, as with Cage's later work, is an extension of some of those image-generating processes. In addition to allowing Cunningham to visualize the impossible for the body, the effect of the computer has been to elongate the phrasing, making longer and longer movements (computers never get tired) and pushing Cunningham from being a great choreographer for the legs to involving the arms more and more (another parallel with Balanchine). As the arm movements became more complicated and prolix, changing their own rhythm sometimes on every beat, it created problems for the dancers because they could not always use them for balance or synchronization with the ensemble. For one of the first of these computer-based pieces, *Crwdspcr* (1993), the dancers felt as though they had eighteen arms each, like Buddhist sculptures. When Cunningham works them through the pieces, he teaches the movement starting with the feet and moving gradually up the legs to the torso, arms, and head.

One of the most fascinating of the computer-generated dancers is *Ocean* (1995), a dance in the round that posed particular difficulties for the dancers because it gave them, roughly, nineteen different directions

Reminiscent of Doris Humphrey's *Water Study,* Merce Cunningham's *Ocean* (1992) is the last collaboration between the choreographer and his friend, the composer John Cage. Photo © Lois Greenfield, 1994. Courtesy: Lincoln Center for the Performing Arts, New York.

that could be construed as the "front" of the stage. The fixed point in the whirling dance, which we can relate thematically to Humphrey's *Water Study*, is the immobile Cunningham. Around him the dancers whirl like a celestial clock in an extraordinary space called the Cirque Royale in Brussels, which is like a tall drum within which the steeply raked seating gives the audience a Mondrianesque overhead view of the dance. The work was commissioned for that space, and as it was started in August 1992 in collaboration with John Cage just before his death, it represents the last of the Cage–Cunningham collaborations. The title comes from Joseph Campbell's suggestion that James Joyce's next work would have been about the ocean, and it is a tribute to the daily readings from Joyce that Cunningham and Cage enjoyed. The electronic score by David Tudor is anything but ascetic in scale, using over a hundred musicians seated behind the audience, containing them in a series of concentric circles.

Ten seconds before the performance starts, Cunningham enters the circle and takes his position. The invocation begins with a circle of light,

in which the first dancer, Frederic Gafner, turns around and around. A digital clock runs from 00:00 to 90:00 during the course of the performance. Above the stage is a mesh disk by designer Marsha Skinner that slowly rises from the balcony level to the ceiling near the lights, giving the audience the impression that the cylinder of the space is growing taller. At 9:12 on the clock, the dancers begin their orbits, like the constellations in the night sky. After a series of duets that turn into solos, one by one the dancers start to exit until, just as 90:00 is reached, the blackout ends the clocklike motion. Attempting to explain the addition of so many levels of difficulty to work that is already difficult to grasp for many viewers and dancers, Cunningham merely says, regarding *Ocean*, that it is "not simply an addition of complexity, but a multiplication."

Our Lady of Pain: Pina Bausch

The British dance critic Ismene Brown recently described the German choreographer Pina Bausch in the following humorously ascetic terms: "Pina Bausch, a thin, nervous woman of 55 living in a drab, industrial town in Germany, makes dancetheatre pieces of harrowing emotional rawness. They leave her dancers bruised and exhausted, and audiences needing a stiff drink." Brown had just watched a performance of *Nelken* (1995) at the Edinburgh Festival, a relatively cheerful work by Bausch that uses a stage full of ten thousand pink carnations as its main prop. In a typical Bausch moment in the work, a man acting as though he is deaf stands on stage all alone and uses sign language to spell out the words to Gershwin's "The Man I Love." Since all the episodes are about failed love, the episode is directly related to the thematic arc of the evening, but trying to decode it further invites the kind of misinterpretation that dance critics walk into constantly when reviewing Bausch. Another scene in *Nelken* is even more interesting from the ascetic point of view, plunging right into the issue of the choreographer's control. A middle-aged man at center stage declares, "I can do anything you want." Then he desperately attempts to perform a spectacular series of grands jetés and entrechats. Who is he trying to satisfy? A tyrannical ballet teacher named Mr. Mercy yells orders at him. Is he Balanchine, a Nazi commandant, or just a bad boss at the office? Bausch leaves all possibilities open.

Pina Bausch began her work as a choreographer and dancer at the age of fourteen under the legendary Kurt Jooss at the Folkwang School, from which she graduated in 1959. The theatrical aspect of her performances is often related to the work of Harold Pinter, Robert Wilson, Peter Brook, Dennis Potter, or Angela Carter. In 1973 she was invited to create

the Tanztheater Wuppertal, the organization, now with twenty-four regular dancers, that she still heads. Postmodern theorists love the crisscross patterns of Bausch's choreography and the way that dancers maintain their "track" or path with an unflinching indifference to the "tracks" that intercept them. There is a violence that adds a sadistic element, as in *Walzer* when a pregnant woman is crucified against a wall or in *Bluebeard* (1980) when the title character slams his wife, Judith, to the floor so hard that it alarms even the other dancers. Bausch's motto for the company and for the audience's experience is: "We suffer together." Bausch's working methods make extensive use of improvisation and her dancers' own real-life experiences. As she develops each new work, she puts the dancers through a rigorous question-and-answer process that yields the scenarios, often absurd as well as frightening, that rapidly succeed one another on stage. The high-pressured interrogative aspect of her method is analogous to the fiction of Walter Abish, whose *How German Is It*, is considered later in this study.

One of the most essentially ascetic moments in recent dance history is more attributable to Bausch's artistic director, the Polish-born Peter Pabst, who has been the artistic director of the Tanztheater Wuppertal since 1980. The very first moments of *Palermo, Palermo*, a major work that was commissioned by the Sicilian city, are absolutely terrifying. A huge cinder-block wall rising to the proscenium suddenly begins to wobble and then crashes to the stage, seemingly toward the audience although it is collapsing backward with a deafening and spine-chilling crashing sound. The dust billows out into the audience, and the broken cinder blocks roll in all directions. Once the catastrophe has settled, a tall blonde woman picks her way through the debris in an almost ridiculously high pair of stiletto heels.

The wall remains a compelling image. It is like the tall adobe walls of Donald Judd's compound in Marfa, Texas, or Peter Halley's imposing prisonlike brick wall paintings of the 1980s. Pabst has said that it was inspired by the daily sight of a crumbling wall in the former movie theater in Wuppertal, where the company rehearses. Some critics related it to the code of silence surrounding the Mafia in Sicily and more universally, to the inevitable separation of individuals from one another. Bausch is German and of a certain generation for whom the great historic event of the past two decades would have to be the destruction of the Berlin Wall. Yet, probably just to confuse matters, Pabst insists, "The only definite thing I can say about the wall in *Palermo, Palermo* is that it does not symbolize the fall of the Berlin wall." Elusive if not allusive, Bausch maintains that edge by denying her audience, her dancers, and herself the indulgences of imitation, including the repetition of their own most successful moments.

• V •

Asceticism in Literature and Philosophy

The very origins of Modernism in literature and philosophy are wrapped up in the romance of an idealized ascetic writer's existence that sanctifies solitude. Among so many of the great Modernists, the psychology of writing has involved one form of self-efface-ment or another, from T. S. Eliot's "impersonal theory of poetry" to famous gestures of retreat (Marcel Proust to his cork-lined bedroom, W. B. Yeats up the winding stair of his Norman tower to the empty room at its top, the curmudgeonly disappearances of J. D. Salinger and Thomas Pynchon). Less celebrated but no less important are Gerard Manley Hopkins's anguish over whether he should publish his poetry and Walter Pater's suppression of the conclusion to his *Studies in the Renaissance*. In philosophy the almost comically improbable images of Martin Heideg-ger hiding out in a rustic cabin on a mountaintop or the bald Michel Foucault out in the desert in a white robe are balanced by the sobering thought of Simone Weil starving herself to death.

One now-forgotten episode weaves together many of the strands of asceticism in Modern literature and philosophy. In a twist of fate that fascinated both Wallace Stevens and Edmund Wilson, the philosopher George Santayana, author of the best-selling novel *The Last Puritan*, checked himself into the Convent of the Blue Nuns in Rome in 1945 to die of cancer. Living on an egg and plate of vegetables each day, Santayana shut out the tumult of world history and the petty disputes of academe to concentrate on his writing. In his memoirs, Wilson recounts his visit to this would-be Saint Francis in a strange passage that begins with a sardonic, gossipy few pages then suddenly shifts style into an al-most rhapsodic appreciation:

> I felt a sort of sacred awe at seeing him, in his little room: a shell of faded skin and frail bone, in which the power of intellect, the colors of imagina-tion, still lived and gave out, through his books and through his gentle-voiced conversation, their vibrations and rays, of which the frequency seems to increase as the generator draws closer to dissolution—as if the

spirit really worked more brightly and clearly, its communications were less interrupted, as the flesh became wasted. He wants to conserve himself, to realize himself as he never has done before. . . . He slept, in his plain single bed, in the consciousness of the whole human mind.[1]

Just as Wilson found something comforting about Santayana's peaceful condition, "alone in that little bed," so too Stevens discovered an emblem of the ascetic bridge between the physical and metaphysical, belief and reason, the spiritual and the secular, "alive yet living in two worlds" (echoing Matthew Arnold). Stevens was a student at Harvard when Santayana was teaching philosophy (he retired in 1912) but never took any of Santayana's courses. Stevens would visit the professor to discuss their poems, which led to one fascinating poetic exchange when Santayana answered Stevens's sonnet beginning "Cathedrals are not built along the sea" with his own poem "Cathedrals by the Sea."

Although Stevens never went to visit Santayana in his cell in the via Santa Sefano Rotondo, "To an Old Philosopher in Rome" offers a moving description of the scene. It focuses on liminal themes presented by Rome's sacred connotations and the philosopher's condition, drifting between consciousness and dream. It opens "On the threshold of heaven" and ends by celebrating Santayana's ascension, "a citizen of heaven though still of Rome." The beginning of the poem describes, in terms reminiscent of Giacometti and Di Suvero, "the majestic movement of men growing small in the distances of space," and Stevens notes that by a process of winnowing down sensation and resignation "we feel, in this illumined large, the veritable small." In a typical Stevensian manner the impoverishment of monastic life yields "grandeur," and in literary terms "the afflatus of ruin" and "poverty's speech" lead to poetry, so that only the "loftiest syllables among loftiest things" are left at the end. The final lines elevate Santayana to cerebral sainthood:

> It is a kind of total grandeur at the end,
> With every visible thing enlarged and yet
> No more than a bed, a chair and moving nuns,
> The immensest theatre, the pillared porch,
> The book and candle in your ambered room,
> Total grandeur of a total edifice,
> Chosen by an inquisitor of structures
> For himself. He stops upon this threshold,
> As if the design of all his words takes form
> And frame from thinking and is realized.[2]

Ironically enough, one of the ways in which "the design of all his worlds" had actually been "realized" involved the uncannily prophetic way in which Santayana's life continued to mirror the tenets of his one novel, *The Last Puritan*. Even after volumes such as *A Hermit of Carmel, Platonism and the Spiritual Life, Dominations and Powers,* and *The Realm of Spirit,* it is *The Last Puritan* that remains as one of the most influential expressions—for a certain generation of American literary figures—of the asceticism of its time. Although it is never read today, partly because it could scarcely be considered politically correct, Santayana's "memoir in the form of a novel" is the kind of philosophical fiction that Iris Murdoch and A. S. Byatt write in our era. It combines elements of Walter Pater's *Marius the Epicurean, The Education of Henry Adams* (Santayana himself noted that the hero was as "ineffectual" as Adams), and Edith Wharton's *Ethan Frome*. The philosophical ideas expressed in the work reflect Santayana's enthusiastic reading of Heidegger and Thoreau, as well as Lionel Johnson, William James, Thomas Mann, and Romain Rolland. Much to Santayana's surprise, the book, which took him forty-five years, off and on, to write, became a Book-of-the-Month Club selection in 1935, bringing him $5,000 and sudden fame through the prepublication sale of 30,000 copies that would eventually climb to well over 150,000.

The two most interesting parts of *The Last Puritan* are its prologue and epilogue, in which something of the direct relationship between Santayana's philosophy and fiction are spelled out. Its hero, Oliver Alden, is caught like a deer in the headlights of his family's wealth and traditions, as well as by deep beliefs in an age when secular, rational forces were on the ascent. In the prologue, Santayana explains the title: "It's a popular error to suppose that puritanism has anything to do with purity. The old Puritans were legally strict, they were righteous, but they were not particularly chaste. They had the virtues and vices of old age."[3] The last words of the epilogue offer an apology for the "long Arctic night" of Oliver's dark, paralytic frigidity: "But isn't the arctic night very brilliant? And after the aurora borealis isn't there an arctic day, no less prolonged? . . . After life is over and the world has gone up in smoke, what realities might the spirit in us still call its own without illusion save the form of those very illusions which have made up our story."[4] Given Wallace Stevens's own fascination with the aurora borealis, Glenn Gould's love of "the idea of North," and the young artist Theresa Chong's passion for her native Alaska, as well as the obvious parallels in Heidegger's life and work and so many other echoes in the thinkers and artists considered in this study, this resonant passage seem a particularly apt launching point for a consideration of asceticism in literature and philosophy. Not all the

writers in this group are constitutionally suited to monastic life after Santayana's fashion, but each would understand perfectly the forces that drew him to the convent.

Asceticism does not have a Modern philosophical or literary "school" to represent it, as it did in the days of the Stoics. Those chosen for this study have very little in common ideologically or even with regard to the problems they address and would probably dislike each other personally if brought together in one room. William James might find Simone Weil intriguing as a case for psychological analysis, and Søren Kierkegaard might enjoy trashing Hegel over coffee with Michel Foucault and Jean-Paul Sartre, while William Butler Yeats and Seamus Heaney could compare memories of their pilgrimages to the holy Station Island. Philosophers and poets in our time (with the possible exception of Weil, who remains far closer to the theologians) use asceticism to achieve a kind of impersonality, clarity, and most important, distance—from the object, from the problem, from their own feelings and subjectivity, or from the personal issues involved in the transmission of the tradition. As Wendy Steiner, Susan Sontag, Richard Rorty, and countless others have pointed out, this has been an agonizing time for both philosophy and literary criticism as the reputations of so many of the stars—notably Heidegger, Foucault, and Paul de Man—came crashing down to earth for their various ideological and moral sins.

The particulars of these vitriolic debates over what Steiner calls the "scoundrels" become mundane soon after they are first exposed, but the more general problem of the relationship between the life and the thought remains a challenge. This study puts together the life and the work in a way that does not demand that the two be entirely consistent with one another; in fact, the contradictions, as in the case of Mapplethorpe, Balanchine, Hopkins, Foucault, and others under consideration here, can be enlightening. These philosophers do not have to be saints in the literal sense to be considered typically ascetic. Look at Schopenhauer, who ought to be the starting point for a discussion of Modern ascetic philosophy because the concluding sections of his great *World as Will and Representation*, the culmination of his argument, is devoted to asceticism. A philanderer who lived sumptuously off the capital of his father, a wealthy merchant in Danzig, Schopenhauer was far from being a paragon of self-restraint such as those he praises in biblical tones in those final pages. His notion of asceticism was shaped by the course in Plato's thought he took in Göttingen under Fichte and Schleiermacher and refined by his interest in Indian and Chinese Buddhist philosophy.

For Schopenhauer, the goal was to escape the slavery of the Will, tied to desire, by means of aesthetics or asceticism. Schopenhauer's hero was

the saint—based more on the Buddhist than the Brahman tradition—
who did not completely annihilate himself (in suicide) but who continued
to exist in hardship under the banner of *abnegatio sui ipsius* (the denial
of self). As William James discovered in reading Schopenhauer, it makes
sense for a "Modern" thinker to study the anachronistic ecstasy of the
mystic, who reaches a state of suspension beyond thinking as a way of
avoiding the delusion of the Will. Schopenhauer's examples included the
Brahmans, the American Shakers, Meister Eckhart, Jacob Boehme, and
Pascal. As with the restrained and very Protestant James, the wary tone
of Schopenhauer admits the inescapable relationship of asceticism to
Modern thought: "No philosophy can leave undecided the theme of qui-
etism and asceticism, if the question is put to it, since this theme is in sub-
stance identical with that of all metaphysics and ethics."[5] In the closing
pages of *The World as Will and Representation*, Schopenhauer's tone be-
comes more pious. He paints a dignified picture of Christian asceticism
and hints that this attitude might, after all, be the best model for philoso-
phy. In a moving passage he stresses the prisonlike delusion of the Will:

> Thorns upon thorns are strewn on our path, and everywhere we are met by
> salutary suffering, the panacea of our misery. What gives our life its strange
> and ambiguous character is that in it two fundamental purposes, diametri-
> cally opposed, are constantly crossing each other. One purpose is that of the
> individual will, directed to chimerical happiness in an ephemeral, dream-
> like, and deceptive existence, where, as regards the past, happiness and un-
> happiness are a matter of indifference, but at every moment the present is
> becoming the past. The other purpose is that of fate, directed obviously
> enough to the destruction of our happiness, and thus to the mortification of
> our will, and to the elimination of the delusion that holds us chained to the
> bonds of this world.[6]

The Comfortable Hermit: Søren Kierkegaard

While his theology stands side by side with the recently published writ-
ings of E. M. Cioran, Søren Kierkegaard on solitude is the perfect read-
ing to set up an understanding of the novels of Samuel Beckett and
Thomas Bernhard, the music of Philip Glass, or the art of Bruce Nau-
man. Kierkegaard's tense, overexamined encounters between men and
women can be read as a philosophical prelude to the sterile restraint of
Yeats in his failed courtship of Maud Gonne, the oddly interrupted rela-
tionships of Robert Musil's *Man without Qualities*, and the empty sexual

confrontations of Walter Abish's novels. Based on his own infamous prenuptial disaster (he fled to Berlin from Copenhagen and his seventeen-year-old fiancée, Regine Olsen, in 1841), this rift between men and women is dramatically replayed through his writings, particularly his wordless encounters with Regine in the streets of his Copenhagen neighborhood. The silent torment, its absence of physical contact, is captured in the ascetic bubble in which Kierkegaard surrounds his characters—they fill it with fantasies and indulgences of an intensely erotic and decadent opulence.

The philosopher lived a life that, like that of Hopkins and Mapplethorpe and Debussy and so many others who might be considered ascetic dandies, was a mass of contradictions. With his master's degree in theology and his father's immense wealth to fall back on, he ought to have ended as a parson living in a comfortable Copenhagen townhouse. In his journal he wrote, "There is something ghostly about me, something which makes it impossible for anyone to put up with me who has to be with me day in and day out and so sustain a real relation to me . . . at home, it should be noted, fundamentally I live in a spirit world."[7] Lurking behind his writings is, in a very artistic sense, a longing for perfection. The self-wrought solitude in which Kierkegaard dwelled has been attributed to a curious spinal deformity—caricatures show him with a kind of hunchback—more psychological than physical according to biographers. He invoked it mysteriously in justifying his breakup with Regine, as well as in his sympathetic identification with the handicapped and the poor in Copenhagen, and it creeps into his writings in passages in which he addresses the notion of a dancerlike "example leap" or the "lightness" of spirituality in its idealized form. After a run-in with the popular press, there were stories of Kierkegaard's being hounded through the streets of Copenhagen by mean-spirited children who mocked his deformity. But with no evidence that he was physically impaired—he just acted as if he were—the parallel with Glenn Gould is obvious.

Ever the martyr, Kierkegaard was also a voyeur, watching passively and passionately from the windows of his well-appointed but cold apartments in Copenhagen. This odd dialectic of the hermit (among his pseudonyms, he adopted Johanne de Silentio and Victor Eremita) and the rake (the Don Giovanni streak), the abstemious and the luxuriant, is evident in the way he set up his digs in various townhouses after moving out of his family home in 1837. These palatial six-, seven-, and eight-room apartments would be the envy of any city-bound writer today. Full of rosewood and mahogany furniture in Empire style, with a writing table in every room stocked with inkwells and paper so that any wandering thought could be jotted down at once from the moment Kierkegaard walked in the door, even before taking off his coat and hat, they were

opulent dividends from his father's immensely successful hosiery business. He kept the temperature in these apartments at a constant, personally monitored fifty-seven degrees Fahrenheit. He did not like sunlight or street noise, so he kept the windows covered by white drapes. Even when he was out walking, he stayed in the shadows and would not even cross through patches of sunlight. But Kierkegaard was used to luxury. His books were bound in leather by his personal binder, N. C. Moller, and printed on vellum edged with gold. His passion for exotic coffees was famous. At home, he drank a ridiculously expensive blend brought in to him every afternoon on a silver service from a Swiss restaurant called Minni's. In what he thought would be his last word in print before becoming a country parson, the *Concluding Unscientific Postscript* (1846), which now stands as a more central, rather massive way station in Kierkegaard's writings, he brings up asceticism in the context of the danger of "pure thought" or "abstract indifference":

> The monastic movement itself was a tremendous abstraction, and the life of the cloister a continued abstraction, the time being spent wholly in prayer and psalm-singing—instead of in playing cards at the club; for if it is permissible to caricature the one without qualification, it must surely be permitted to describe the other as it has caricatured itself. Worldly wisdom has known how to make us for the monastic movement for its own advantage, just as even in this very moment it sometimes uses the cloister for the purpose of proclaiming indulgence from all concern for the religious.[8]

As a prophet of Modern asceticism, Kierkegaard's great contribution was a pair of books published in 1843: *Fear and Trembling* and *Repetition.* Intensely personal studies that use biblical referents (the stories of Abraham and Job) to illuminate his own suffering, they are devoted to a resignation of the life of the body and mundane concerns in favor of an unnatural lightness: "I can make the mighty trampoline leap whereby I cross over into infinity; my back is like a tightrope dancer's, twisted in my childhood, and therefore it is easy for me. One, two, three—I can walk upside down in existence."[9] This wonderful lightness is the signature of the saintly "knights of infinite resignation"), who achieve their unburdened state by a "movement of infinity" that is essentially an ascetic one of resignation. Kierkegaard spots them among the ordinary citizens of Copenhagen, some with a gait as "steady as the postman's" but even in their ordinary routine (an important reminder of the importance of habit) different from those who are more earthbound: "The knights of the infinite resignation are easily recognizable—their walk is light and bold. . . . He drains the deep sadness of life in infinite resignation, he

knows the blessedness of infinity, he has felt the pain of renouncing everything, the most precious thing in the world, and yet the finite tastes just as good to him as to one who never knew anything higher, because his remaining in finitude would have no trace of a timorous, anxious routine, and yet he has this security that makes him delight in it as if finitude were the surest thing of all" (p. 40).

The movement of regression is a retreat that is essentially ascetic. It links itself with the offstage role Kierkegaard assigns to his narrators as spies, observers, analysts, their eyes to the microscope, their foreheads pressed to the glass as they watch the activity in the street below. In a long, powerful essay on Kierkegaard that focuses on sin and death, Sartre uses Kierkegaard as a mirror for his own existentialism. His analysis of the use of pseudonyms and self-destructive pseudopropositions, creating a "surobjectivity" that mirrors artistic surrealism, reveals how Kierkegaard managed to backpedal in his work by destroying even the linguistic access routes to his real thoughts or feelings. If Kierkegaard was "lighting fires in the language," the residue would be the cinders of Hulme and the ashes of Derrida.

Together with this "regression," the other movement described by Kierkegaard that anticipates Modern asceticism is "repetition." It resides on the ethical, historical, aesthetic, psychological and theological planes at once. As he notes in a journal entry related to his book on the subject, "Reception is and remains a religious category" (p. 326). While he takes pains to relate this to the Classical Greek doctrine of recollection, he makes one important distinction. Whereas recollection looks to the past, Kierkegaard's view of repetition is oriented to the future. The subtle catch to this arrangement is the self-effacing, ascetic retreat from life that accompanies the disciple's assumption of the teacher's mantle. From *The Concept of Irony*, an argument for the detachment of "mastered irony" through *Repetition*, in which the young poet withdraws from life to practice the "observer's art," the sought-after "freedom" is gained by retreat. In a heartbeat, Kierkegaard makes the rapid transition from the sloppily sentimental tale of broken romance to the analytic tool of repetition, passed from teacher to disciple, that will help assuage the pain of a broken heart. As Kierkegaard found with the 1,003 lovers of Don Giovanni, or the reassuring ritual of attending a number of performances of the same play in the same theater, the role of repetition as an answer to these annoying daily crises and catastrophes becomes paramount. In a passage of extraordinary beauty that obliquely touches on Kierkegaard's frequent invocations of Prometheus, a mythic prototype of his own prophetic and tortured self, Kierkegaard rolls back time from the repetition of the wind in the mountains to a moment when it was new:

In a mountain region where day in and day out one hears the wind relent-
lessly play the same invariable theme, one may be tempted for a moment to
abstract from this imperfection and delight in this metaphor of the consis-
tency and sureness of human freedom. One perhaps does not reflect that
there was a time when the wind, which for many years has had its dwelling
among these mountains, came as a stranger to this area, plunged wildly,
absurdly through the canyons, down into the mountain caves, produced
now a shriek almost startling to itself, then a hollow roar from which it it-
self fled, then a moan, the source of which it itself did not know, then from
the abyss of anxiety a sigh so deep that the wind itself grew frightened and
momentarily doubted that it dared reside in this region, then a gay lyrical
waltz—until, having learned to know its instrument, it worked all of this
into the melody it renders unaltered day after day. (p. 155)

The "Concluding Letter" of *Repetition* pulls off some of the ironic
costumes and reveals a subtext. One of its cardinal points is the conflict
between the poetic, or philosophical, life and "all life." This points to an
ascetic movement of retreat, a willingness to destroy desire and comfort
in an absolution that is aimed at attaining the "religious resonance" of
repetition: "A poet's life begins in conflict with all life. . . . My poet now
finds legitimation precisely in being absolved by life the moment he in a
sense wants to destroy himself. His soul now gains a religious reso-
nance" (p. 228). If the first conflict, the first loss, is the love affair, then
the delayed gratification of this secondary phase is a victory through rep-
etition in the poet's writings. This conflict, like that between the poet and
"life," plagued Kierkegaard in the writing of the work and continues to
be one of the most timely aspects of his work. It is manifest in the diffi-
culty Kierkegaard had in finding a way to dispose of the poet in his story.
One possible ending has him shoot himself. In another, he simply "disap-
pears," a fate that is much more in consonance with Kierkegaard's secre-
tive, "vanishing" author and more in keeping with the kind of asceticism
we find in contemporary thought, as we shall see.

Elected Silence: Gerard Manley Hopkins

Technically, the best example of the ascetic ideal in the history of modern
literature must be Gerard Manley Hopkins, who, as a Jesuit monk, rep-
resents the only professional ascetic in this study. Where asceticism could
be viewed as an escape from reality for most artists, for Hopkins it was
reality. The life that Hopkins actually led is the model for the imitation
reclusiveness of Proust, Heidegger, Yeats, Noguchi, Nauman, and many

of the others we have examined. The martyrs he addressed in prayer and poems were historic figures, including the five Franciscan nuns in whose memory he wrote his most celebrated poem, "The Wreck of the Deutschland." The punishing God he implored gave him a sense of Thou opposed to the self-indulgent I that continues to dominate the literature and philosophy of our time. His sacrifices, poverty, self-examination, and enforced quiet were literal. When he went on a retreat, it was a formal and rigorous ordeal filled with spiritual exercises that nearly drove him mad. His regimen as a monk required him to rise at 5:30 in the morning and turn in promptly at 10 at night. Hopkins's letters and journals are replete with accounts, and even complaints, about the deprivation and hardship he faced every day, even during prep school. "I am like a straining eunuch," he wrote to Robert Bridges.[10]

Here is the great paradox of Hopkins: Against this background of piety and self-denial, his poetry, with its excess of everything, including sensuality, is in nearly complete rebellion. Hopkins converted to Catholicism, to his family's horror, in July 1866 and started out as a Benedictine monk. This was no ordinary little monk, however. As he was earning a first in Greats at Oxford, under the tutelage of both Benjamin Jowett and Walter Pater, he was advised in spiritual matters by John Henry Newman, who gave him his first teaching position at the Oratory. He gravitated toward the systems (he called it "the machine") of the Jesuits soon after and in a burst of fanaticism in May 1868 destroyed all his extant poetry. The agony of trying to decide whether or not to publish continued to afflict him throughout his life, somewhat as the problem of public performance haunted Glenn Gould.

Where we associate most ascetic literature and thought with the ability to stand still in a contemplative stasis, Hopkins (like Swinburne) is the poet of robust motion and sound. He described himself in letters as a man who could not "stand still."[11] On the page, his poems fly along with a pounding, unstoppable rhythm. His great literary debut with "The Wreck of the Deutschland" stands with Stravinsky's *Rite of Spring* and van Gogh's *Starry Night* as pillars of the virtuoso rhythmic innovations of early Modernism. Not coincidentally, Hopkins was also a great walker in the countryside or the city, a fact that is noted by his later admirer, Seamus Heaney, in an essay about Hopkins's working habits. This invokes all the appropriate metaphors of pilgrimage and the ascetic as a wanderer, of course, but it also clues the reader in to a compositional practice that has been shared by those other walking addicts who were poets, such as Wordsworth and Tennyson.

The wonderful irony of the poet who is cloistered and yet born to sing out is embodied in "The Habit of Perfection," an early lyric that captures

the preoccupation with correctness and purity of so many of the artists in this study. Its first stanza subtly disguises a pair of crucial principles:

> Elected silence, sing to me
> And beat upon my whorled ear,
> Pipe me to pastures still and be
> The music that I care to hear.[12]

Any sophomore can pick up the conventional allusions to the Romantic tradition as well as the phraseology of Blake and even Keats. The more elusive element is a subtle twist on the logical opposition of "silence" and "sing." The song of silence is necessarily an oxymoron that allows the pasture to remain still while this seductive but soundless music is piped to him. More important, there is a decision involved. As with Hopkins's conversion to Catholicism, the speaker is choosing silence, "the music that I care to hear," over sound. As a priest, Hopkins was well aware of the passive nature of the psychology of his vocation, but is in this case asserting the active, willed determination of one mode over any other. This is why the next stanzas are in the imperative:

> Shape nothing, lips; be lovely-dumb;
> It is the shut, the curfew sent
> From there where all surrenders come
> Which only makes you eloquent.

> Be shelled, eyes, with double dark
> And find the uncreated light:
> This ruck and reel which you remark
> Coils, keeps, and teases simple sight.[13]

Hopkins opts for silence and darkness in the confidence that he can attain other, superior states of awareness. In those pre-Zen days in England, in the midst of a ritualized religious environment, he strives toward blindness, deafness, muteness, and otherwise complete state of sensory deprivation (recalling John Cage's experiments with the sensory deprivation tank) that he believes will yield eloquence, light, and visionary rewards that are as yet "uncreated" and that surpass "simple sight." The intensification of a "double dark" and its rhyming pair "remark," which drives light and sound farther away or farther down depending on how you picture this rejection, is strangely sensual. By pairing them, Hopkins deepens the darkness and silence almost tonally, as Jasper Johns or Brice Marden would go over the paper back and forth in graphite drawings so hard and so often that its blackness would well up and begin to shine.

Pushed far enough, darkness and silence become radiant and musical. In other poems, such as "The Caged Skylark," Hopkins invokes Shelley and again Keats in the great Romantic tradition linking the bird and ecstasy but takes the Keatsian position ("in embalmed darkness") and darkens it further by comparing the body to the "dull cage" and "bonehouse, men house" in which spirit is locked until it rises to "his own nest, wild nest, no prison." Similarly, in a paean to Purcell he uses the "air of angels" to account for the way the music lifts him from the "fallen" state of the opening. From the outset of his career, Hopkins made his voluntary abjuration of the common realm of the senses into a strong, reasoned, and deeply felt commitment to austerity and complete control over outside stimuli. As with Mondrian, it takes aesthetic form in a strong rhythm, which in Hopkins's case derived from his proficiency as a musician. He regularly "worked out" on the chapel organ or any keyboard available and had a splendid grasp of the way in which musical rhythm and structure worked.

Yet Hopkins was genuinely a man of the senses, with a Keatsian acuteness of hearing, smell, and particularly sight. Among the great moments in his occasional prose are splendid set pieces describing sunsets, so particular regarding color and form they are detailed enough for a decent amateur watercolorist to render the scene from the verbal picture Hopkins offers. Hopkins himself was a great draftsman who was constantly sketching particularly his beloved ash trees, which he observed and described as well as drew with an artist's and a naturalist's eye. Some of them were written for the magazine *Nature*, and their synesthetic passion is compensation for the deprivation of monastic life. As he wrote, "Searching nature I taste *self* but at one tankard, that of my own being. The development, refinement, condensation of nothing shews any sign of being able to match this to me or me another taste of it, a taste even resembling it."[14]

The passion of brief lyrics like "The Habit of Perfection" or "The Leaden Echo and the Golden Echo" swells to greater proportions in Hopkins's great masterpiece, "The Wreck of the Deutschland." An elegy for a group of nuns drowned at sea and an examination of mastery and the state of being mastered ("Thou mastering me God!"), the poem also exemplifies the tension between the rules of prosody and the exuberance of passion that animates all of Hopkins's work. Beyond the conventional elegiac language of mercy and redemption, horror and the complaint against the unfairness of death, there is a subtext to "The Wreck of the Deutschland" that involves the poet's own struggle with his enforced humility. The "lovescape crucified" of a martyr in ecstasy mirrors the pressure the poet feels. Eventually, yielding to these powers, it produces a

stillness and passivity that is completely the opposite of the raging waves and winds of the ocean that swamped the ship, yielding one of the gentlest ascetic moments in Hopkins's poetry.

> I am soft sift
> In an hourglass—at the wall
> Fast, but mined with a motion, a drift,
> And it crowds and it combs to the fall;
> I steady as a water in a well, to a poise, to a pane,
> But roped with, always, all the way down from the tall
> Fells or flanks of the voel, a vein
> Of the gospel proffer, a pressure, a principle, Christ's gift.[15]

The Poet of Purity: Stéphane Mallarmé

The other great ascetic poet of early Modernism, Stéphane Mallarmé, also devoted his most important long poem to the theme of the shipwreck. Like John Cage manipulating the silences in his compositions or Mark Tobey with his white writing, Mallarmé structures a poem by deploying white as a metaphor along with an awareness of the blank spaces of the page itself. One of the most famous examples of this is a sonnet, a favorite of Wallace Stevens and most anthologists, that begins with the seductively ascetic opening line, "Le vierge, le vivace et le bel aujourd'hui." In it the virginal swan, one of Mallarmé's many phantoms, is trapped in the ice in the middle of the sterile winter. As the rest of the flock makes its way south, the exiled bird is frozen in a cold dream of contempt ("songe froid de mepris"). The bird's paralysis ends in martyrdom: "A ghost whom to this place his lights assign / He stiffens in the cold dream of contempt."[16]

The ascetic themes of cold, sterility, virginity, and pure silence are woven through Mallarmé's lyric poems. In "Le Pitre Chatie," Mallarmé compares the lyric "I" to a virginal Hamlet, revealed in the lakelike mirror of a woman's eyes: "The sun suddenly strikes the nakedness / Whose purity breathed from my pearly cool" (p. 67). He had a particular attraction to the language of sainthood, turning a stained-glass image of Saint Cecilia, the patron of music, into a "musician of silence" (p. 129). One of his most chilling poems is the "Canticle de Saint Jean," which concludes *Hérodiade*, in which the saint's resistance to being touched ends in his beheading, sending a numbness down his spine through his extremities that signals, for him, the transition from the physical to the "supernatural" of heaven, "where the timeless / Cold is in distress / When you glacier are icier" (p. 117).

In real life, while Mallarmé (in the style of his friends Debussy and Manet) enjoyed his luxuries, he did have his saintly side, particularly through a few episodes in his life that caused him great suffering. He became a new kind of poetic hero, different from the active, swashbuckling Byronic type and more endearing to later philosopher-critics like Jean-Paul Sartre, Maurice Blanchot, and Jacques Derrida. As Sartre wrote, explaining the "pathological gap" between desire and nothingness in Mallarmé's ontology: "The goal toward which he projects himself is that peculiar kind of hypostatization of the 'no' called emptiness—that calm and soluble transparence in which a whirl of sounds and colors is revealed and which dissolves under his gaze only to reappear elsewhere— that frozen and empty eternity which, during the course of his life, he can neither approach nor escape and which stretches out through universal duration."[17] The same quality of emptiness and absence appealed to Blanchot, who observed:

> Once can say that Mallarmé saw this nothing in action; he experienced the activity of absence. In absence he grasped a presence, a strength still persisting, as if in nothingness there were a strange power of affirmation. All his remarks on language tend to acknowledge the word's ability to make things absent, to evoke them in this absence, and then to remain faithful to this value of absence, realizing it completely in a supreme and silent disappearance. In fact, the problem for Mallarmé is not to escape from the real in which he feels trapped, according to a still generally accepted interpretation of the sonnet on the swan. The true search and the drama take place in the other sphere, the one in which pure absence affirms itself and where, in so doing, it eludes itself, causing itself still to be present. It subsists as the dissimulated presence of being, and in this dissimulation it persists as chance which cannot be abolished.[18]

For Derrida, who loved the rhetorician and the escape artist in Mallarmé, the extremes of polysemy that Mallarmé attained went beyond the level of abstraction that had been reached in literature prior to his time. As he points out in a paragraph about Mallarmé that is in itself ambiguous in the style of the poet, the "operation" leads to disappearance and death: "A text is made to do without references; either to the thing itself, as we shall see, or to the author who consigns to it nothing except its disappearance. This disappearance is actively inscribed, it is not an accident of the test, it is rather its nature; it marks the signature of an unceasing omission. The book is often described as a tomb."[19] Mallarmé's obscurity, typified in the way he preferred to keep a veil of smoke between himself and the world, is of obvious attraction to a philosophical

community that values the indirect, the indistinct, the opaque or dis-
jointed, and above all, the complex. Mallarmé's early years were spent in
poverty and exile from his beloved Paris. Married to a German, teaching
English (to students who found him "cold") under impatient bureaucrats
in a provincial town, he experienced a crisis of faith in the mid-1860s
that scholars and biographers call the "Tournon nights." That spurred
him to become a poet, and he embarked on two major lyric projects at
once, his *Hérodiade* and the more famous (thanks in part to Debussy)
L'aprés-midi d'un faune." As he wrote to his friend Henri Cazalis in
1867, "I have just survived a frightening year. My thought has re-
thought itself and has reached a Pure Concept. Everything which my
being has suffered during this protracted agony is unrelatable, but fortu-
nately, I am perfectly dead and the most impure region into which my
Mind can venture is Eternity. My Mind, that hermit accustomed to living
in its own Purity, which can no longer be dimmed even by the reflection
of time itself."[20]

While Mallarmé is best known in the history of French letters for his
famous weekly salon in Paris, where many of the luminaries of the art
and poetic worlds would gather, one of the most important biographical
details for an understanding of his poetry is his need to retreat to a fam-
ily country house in Valvins where, from October to May, he did his best
writing. Along the same lines, one of his happiest periods came during a
visit to Oxford and Cambridge in the winter of 1894, when, warmed by
the serious reception his poetry and criticism received, he expressed his
love for that "world of cloisters." Of all the trials that Mallarmé suf-
fered—including the death of his mother when he was five, of his sister
when he was fifteen, and of his father when he was twenty-one—it must
have been the death of his son Anatole at age eight, in October 1879,
that hit hardest. The boy suffered from a rheumatic heart condition,
streptococcal endocarditis, which in our time would be treated by a car-
diac valve replacement. That winter was the coldest in memory in Paris,
when the Seine froze and Mallarmé and his wife endured the anguish of
their loss. Mallarmé sketched out a group of over two hundred fragmen-
tary elegies for Anatole that focus on a range of ascetic themes, including
the father's silence, the entombment of mother, father, and son, and "pu-
rity, double-identity, the eyes the two points of equal sight."[21]

The crowning achievement of Mallarmé's lyric genius is a long poem,
its title rendered in English as "A Throw of the Dice," that makes novel
use of typography and the white spaces of the paper. In the preface he
highlights the way in which the white spaces, which account for at least
two thirds of the pages, are to be taken as enforcers of the necessary
fragmentary distances that free the word groups from the constraints of

narrative. Compared with the language-based paintings of Miró or Magritte or the handwritten text for Matisse's *Jazz*, Mallarmé's cascades of verse are wonderfully suggestive in a visual way. Beyond this visual dimension, there is a complex musical logic behind "A Throw of the Dice" that anticipated a number of developments in current composition. Mallarmé asserts that the text can be taken as a musical score and the typefaces for dynamic markings. Its "doublings back" and "runnings away" lend themselves to musical interpretation—Robert Wilson and Philip Glass could make it into a superb chamber opera. Mallarmé affirms that the placement on the page (whether a phrase is high, low, or in the middle) should be an indication of rising and falling intonation.

The most complex of the musical effects in "A Throw of the Dice" is Mallarmé's attempt at counterpoint, reminiscent of Hopkins, who, in his own historic preface to the 1883 edition of his collected poetry, presented an analogous way in which typography can be used to bolster prosodic ideas. Although Mallarmé is far more inclined than Hopkins to use the musical device of the rest or silence, both poets deploy unusual typographical devices, like Mallarmé's large and small fonts (a trick that in the age of computers and laserjet printers we can perhaps understand better, having made our own font and type size decisions) or Hopkins's "loops" over groups of words, like musical slurs. Among the similarities between Hopkins and Mallarmé, particularly with respect to their major poems "The Wreck of the Deutschland" and "A Throw of the Dice"—there are thematic as well as technical common elements. Both poems make extensive use of the shipwreck as drama, and both address a godlike "Master." The shipwreck, which is foretold in the last lines of Mallarmé's earlier lyric, "Brise Marine," destroys a ship that has been headed to paradise. The dice throw emerges through the depths from the shipwreck ("du fond d'un naufrage"). The obscurity of this medium is evident in lines such as "L'ombre enfouie dans la profondeur par cette voile alternative" ("the shadow buried deep by that alternative sail"), but within it are several key symbols, including the whiteness of the sail, the murkiness of the depths, and the importance of a shadow that bears the traces or echoes a solid body. These cool forces are countered by a conflagration in the next two-page spread (as convenient a way of describing the division of the poem as any, since the two pages are conceived as an integral poetic unit).

Like Hopkins's Master, the Mallarméan ancient mariner stands apart while the winds rise and the shipwreck ensues, "invading the head" ("envahit le chef"), making all action "vain" and including a calm passivity that has its own ascetic antecedents in the tradition of the Job-like saint that accepts all punishments and distress. Eventually, this master-figure undergoes a quiet sea change, his shadow becoming childlike, divorced

from the weathered, bearded figure by the action of the waves and the sanctifying hand of chance. The purifying oscillation of the waves, the back and forth of chance, polish the ghostlike shadow to a high shine, a second childhood and virginity, that reflects the glimmers of flame. As the poem literally winds down, the North star swings into view, along with "a constellation cold from neglect and disuse." Like the dancers whirling away into the wings in Merce Cunningham's *Ocean*, the turning slows and stops with the proviso that any thought can result in another throw of the dice: watching / doubting / wheeling / shining and pondering / before it stops / at some final crowning point / Any thought utters a Dice Throw."[22]

Delicious Recoil: Marcel Proust and Walter Pater

Long before he became the most famous recluse of Paris in his cork-lined chamber, firing off his little blue messages by pneumatic tube and enjoying the telephone in its infancy (anticipating the way Glenn Gould would reach out and touch the world from his own city apartment), Marcel Proust put into practice a type of asceticism learned from one of the masters, John Ruskin—an active, even tenacious habit of delaying and holding back from sensation. The philosopher William Barrett, an expert on Zen, once remarked, in a discussion of how he was giving up drinking, that "Proust's vast novel, by the way, is the greatest manual of asceticism since the sutras of the Buddha."[23]

More subtly, the ascetic habits of mind with which Proust invests his characters involve a complex analytic process that strips physical sensation of its materiality, only to bring it back to a sensual state that Proust describes in terms of the very desire that he started to sublimate. Consider, for example, how Swann turns that lovely phrase from the violin sonata around in his mind when he hears it again at one of the dinner parties of Madame Verdurin. Proust writes: "An impression of this order, vanishing in an instant, is, so to speak *sine materia*."[24] After the death of Albertine, for example, he is half enjoying, half agonizing over how long it takes for the day "to die" in the summer. Across the street, the "pale ghost" of a white house lingers in the dusk. When at last darkness descends, a lone moment of sensation—really, of illumination—becomes, in a Keatsian way that echoes his feelings of loss, painful and cruel. The play of the cool colors, from white to blue, is one symbolic index to the ascetic subtext of this extraordinary sentence: "At last it was dark in the apartment; I stumble against the furniture in the hall, but in the door that opened on to the staircase, in the midst of the darkness I

had thought to be complete, the glazed panel was translucent and blue, with the blueness of a flower, the blueness of an insect's wing, a blueness that would have seemed to me beautiful had I not felt it to be a last glint, sharp as a steel blade, a final blow that was being dealt me, in its indefatigable cruelty, by the day."[25]

That same exquisite sensitivity is the hallmark of Walter Pater's fiction and essays. When Pater withdrew the infamous "Conclusion" from the second edition of his classic *Renaissance: Studies in Art and Poetry,* he explained that he feared it would be misread as an exhortation to hedonism and that "it might possibly mislead some of those young men into whose hands it might fall."[26] This act of self-censorship, which Pater reversed by restoring the essay to the 1893 edition, came on top of what was already a heavily ascetic text. In Pater's terms, within the context of a discussion of the "physical life" as a perpetually changing phenomenon, the "delicious recoil" of the body from cold water on a hot summer day is one of the "exquisite intervals" through which we undergo continual modification. For Camille Paglia, this recoil, symbolized by the withdrawal of the "Conclusion," is a symptom of the inhibition that she relates to more contemporary types of asceticism, like Zen as well as, of course, sexual passivity. That "horror of action" would take some of the pleasure out of the "delicious recoil," but it is the image of the "thick wall" and the "superpassivity of persona" that most directly sets up the kind of ascetic tendencies that we will examine more closely in Modern literature. As Paglia writes,

Pater complained his pagan hedonism was misunderstood: he followed ascetic Epicurus, not the sensual Cyrenaics. But was immorality the real reason for his self-censoring? Pater urges refinement of consciousness, not masculine achievement in a materialistic imperialist culture. There are Buddhist parallels: The Zen master too seeks to be rather than to strive. . . . In Pater we find emotional repression and inhibited movement, a subtle torsion or Mannerist sinuosity in the sentence, and finally an obscuring of the visible just when we eagerly turn towards it. I think Pater's distress at misreadings of the "Conclusion" came from his horror of action, sexual or otherwise. He withdrew the chapter to preserve his spiritual identity, which resided in superpassivity of persona. An act connects person to person, or self to world. But for Pater neither the world nor other people can defeat "that thick wall of personality through which no real voice has ever pierced on its way to us."[27]

In the passage from the "Conclusion" that Paglia has seized on, Pater makes the transition from physical sensation to "the inward world of

thought and feeling," and his famous flame becomes "more eager and devouring." The result is a "contraction" of observation, compressed into "the narrow chamber of the individual mind" and "ringed round for each one of us by that thick wall of personality." Pater relates this to the cold of solitary imprisonment and notes that the brief moments of perfection of form (after all, most of what has attracted Pater artistically through the essays on the art of the Renaissance has involved one or another kind of perfection) are fleeting. That is the point at which he introduces the fateful passage that, understandably, was like a match flung on gasoline for the generation that included the young Wilde and Yeats:

> Not the fruit of experience, but experience itself, is the end. A counted number of pulses only is given to us of a variegated, dramatic life. How may we see in them all that is to be seen in them by the finest senses? How shall we pass most swiftly from point to point, and be present always at the focus where the greatest number of vital forces unite in their purest energy? To burn always with this hard, gem-like flame, to maintain this ecstasy, is success in life. In a sense it might even be said that our failure is to form habits: for, after all, habit is relative to a stereotyped world, and meantime it is only the roughness of the eye that makes any two persons, things, situations, seem alike. While all melts under our feet, we may well grasp at any exquisite passion, or any contribution to knowledge that seems by a lifted horizon to set the spirit free for a moment, or any stirring of the senses, strange dyes, strange colors, and curious odors, or work of the artist's hands, or the face of one's friend.[28]

To understand better why the ecstasy and purity of this *hard* flame represents an ascetic mode of thought, we turn to Pater's novel *Marius the Epicurean*, first published in 1885. Set in the Rome of 160 to 170 A.D., an era that is meant to parallel the 1880s in England as an age when the dissolution of faith adds an edge to the question of belief, the novel permitted Pater to pursue the question of how the individual experiences impressions. Marked throughout by an intricate pattern of symbols that flash by rapidly, usually marked by the color white (the white road, the white marble of Carrara, the "white nights" and "blank forgetfulness" of dreams), it presents a young man who is known for his "cold austerity of mind" and military sense of asceticism who desires, more than anything, to live in "a world altogether finer than what he saw." The Stoicism of Marius, his eventual sacrifice or martyrdom, can be related not only to that of the early Christian ascetics but to Calvinism and the Puritanism of Pater's own age as well. Marius's "outward silence" and "inward tacitness of mind" are characteristics he develops in

childhood along with his aristocratic sense. Marius leaves his white villa to head for the Rome of Marcus Aurelius and dies while receiving the Christian sacrament in a plague that is described in terms that disturbingly anticipates the fiction of AIDS in our time: "Asceticism is an explicit point of reference for Marius, as when his natural inclination toward the priesthood is under consideration: 'Had the Romans a word for *unworldly*? The beautiful word *umbratilis* perhaps comes nearest to it; and, with that precise sense, might describe the spirit in which he prepared himself for the sacerdotal function hereditary in his family—the sort of mystic enjoyment he had in the abstinence, the strenuous self-control as *ascesis*, which such preparation involved.'"[29]

Picking up where he left off in *The Renaissance*, Pater explores the difference between "insight" and *theoria* or the need for abstraction as a way to "clear the tablet of the mind" and examine life soberly under the "dry light" of what Pater calls a new "machinery of observation." As Proust meticulously sorts the physical from the metaphysical, Pater distinguishes between the good and bad in theory. The ascetic validation of that "dry light" (recalling the *secco* sound that Gould sought in playing Bach), its sobriety and hardness and gravity, look forward to the Modernist sensibility not only in literature but art, music, and philosophy as well. It took a later era for Pater's "anti-metaphysical metaphysic" to gain traction, by which time Pater was considered a soft sensualist (or coward, in the eyes of Paglia), rather than the hard-edged ascetic he really was.

Sages in the Holy Fire: W. B. Yeats and T. S. Eliot

The opening line of W. B. Yeats's poem "The Choice" presents one of those conversation-stopping moments that strikes at the very heart of the relationship between life and art: "The intellect of man is forced to choose / Perfection of the life, or of the work."[30] An ardent believer in the poet's need for perfection through that "disembodied ecstasy," Yeats pursued it through a variety of ascetic paths that are derived from Greek Classicism, medieval alchemy, Celtic mythology, the lives of the early Christian martyrs, and a range of Romantic sources including Keats and Shelley. In the important volume *Per Amica Silentia Lunae* (1917), Yeats contrasts the "thirst for luxury" of Romanticism and the impoverished "hollow image of fulfilled desire" of Modern tragedy. Rising to the level of Keats's brilliant letter on "negative capability," Yeats offers a passage that is one of the most important articulations of his spiritual views on poetry:

We must not make a false faith by hiding from our thoughts the causes of doubt, for faith is the highest achievement of the human intellect, the only gift man can make to God, and therefore it must be offered in sincerity. Neither must we create, by hiding ugliness, a false beauty as our offering to the world. He only can create the greatest imaginable beauty who has endured all imaginable pangs, for only when we have seen and foreseen what we dread shall we be rewarded by that dazzling, unforeseen, wing-footed wanderer. We could not find him if he were not in some sense of our being and yet of our being but as water with fire, a noise with silence. He is of all things not impossible the most difficult, for that only which comes easily can never be a portion of our being; "soon got, soon gone," as the proverb says. I shall find the dark grow luminous, the void fruitful when I understand I have nothing, that the ringers in the tower have appointed for the hymen of a soul a passing bell.[31]

While we customarily associate Yeats's asceticism with his fiery later poems and essays, that "Autumn of the Body" aesthetic and an incipient Platonism characterize many of the earliest poems. Some are refreshingly candid, as "All Things Can Tempt Me" from *The Green Helmet and Other Poems* (1910) suggest or as the "pale unsatisfied ones" in the gemlike short lyric "The Magi" from *Responsibilities* (1914) also presage, with their "ancient faces like rain-beaten stones." A delicate lyric in *The Wild Swans at Coole* focuses attention momentarily on a small bone found by the edge of the water, "worn thin by the lapping of water," which the poet pierces with a gimlet so that he can "stare" (a favorite Yeatsian term for observe) through the tiny aperture at "the old bitter world where they marry in churches."

The great period of Yeats's asceticism comes with the magisterial volumes *The Tower* (1928) and *The Winding Stair* (1933). The old Norman keep in which Yeats made his home is depicted by his friend T. Sturge Moore on the book's jacket and embossed in gold on the cover of *The Tower* in a mirrored image that emphasizes its distance from the viewer, the enforced isolation of the poet from the troubled outside world. As he describes it in "Meditations in Time of Civil War," it is "an ancient bridge, and a more ancient tower" surrounded by "an acre of stony ground" and "old ragged elms, old thorns innumerable." The way up to his study at the top of the tower, an empty room with a plain table and an ancient Japanese sword on it, is by a "winding, gyring, spiring treadmill of a stair" that the old poet struggles up each day, that "laborious stair" that he puns on continuously and uses as the title for the next volume, recalling the ladder of Miró and Eva Hesse and the steps of Mies. In "The Circus Animals' Desertion," this winding stair is echoed in the

ladder image leading up to the "pure mind" out of the place where all ladders start, "in the foul rag-and-bone shop of the heart." The volume opens with a departure, a means of distancing the aging poet from the world around him, in "Sailing to Byzantium," the first sentence of which reads "That is no country for old men." It disparages the "sensual music" that is opposed to "unageing intellect." In he second stanza, Yeats reverses the scarecrow image of the old man, "a tattered coat upon a stick" by extolling the song that comes from the soul within, which becomes louder "for every tatter in its mortal dress," a reference to the Yeatsian system of the vortex by which the decline of the body represents the rise of the soul's strength. In the last two stanzas, he celebrates being gathered "into the artifice of eternity," a version of the "disembodied ecstasy" in which, transformed into a gold bird "out of nature," the poet attains prophetic status. In the third stanza he asks to be purified by fire—"consume my heart away, sick with desire"—in the same way that the saints are depicted in Byzantine mosaics and paintings. The passage describes the ascetic transformation of the poet:

> O sages standing in God's holy fire
> As in the gold mosaic of a wall,
> Come from the holy fire, perne in a gyre,
> And be the singing-masters of my soul.[32]

This sounds the keynote for a volume devoted to the failings of his "troubled heart" and the need to turn to "compel" himself to study. In *The Winding Stair* the level of asceticism is turned up a notch. The second part of "Blood and the Moon" declares, "Everything that is not God consumed with intellectual fire." In "Byzantium," a night poem, "the unpurged images of day recede." Haunted by spirits and "the superhuman," it reaches its climax in a strange midnight scene that pushes ecstasy into "an agony of trance, an agony of flame that cannot singe a sleeve . . . flames begotten of flame" (p. 498).

Yeats is at his most ascetic in the lyrics collected in *Last Poems*, particularly in a poem that directly describes the pilgrimage of Lough Derg, an experience that Seamus Heaney also used as the basis for his *Station Island* sequence (to be considered later in this study). Yeats describes fasting for forty days along the stations of the pilgrimage but, in a strategy that mirrors his "Crazy Jane" lyrics, calls orthodoxy into question in the fine line after an encounter with a sage: "And that old man beside me, nothing would he say / But fol de rol de rolly O" (p. 593). A more contemplative note is struck in "Lapis Lazuli," in which he depicts two Chinese sages, trailed by a serving man, climbing a sacred mountain (yet

another winding stair) to a pavilion halfway to the top, where they "stare" out upon the tragic scene around them. it is a poem in which Yeats's tragic joy, or "gaiety," transfigures "dread." One is accustomed to using Yeats's elegy for himself, "Under Ben Bulben," as an ending to any consideration of his poetry, and certainly the order to "cast a cold eye" is ascetic enough; but as a last word the superbly carved image of the placid Chines hermits is even more alluring:

> One asks for mournful melodies;
> Accomplished fingers begin to play.
> their eyes mid many wrinkles, their eyes,
> Their ancient, glittering eyes, are gay.
>
> (p. 567)

From Yeats's Chinese sages on their mountaintop to the windswept desert of T. S. Eliot's *Waste Land* is not an insurmountable leap with the stepping-stone of asceticism between them. Open up Eliot's *Collected Poems* to those famous footnotes, and you will find his professorial pointer on the dual source of the climatic moment of "The Fire Sermon": "The collocation of these two representatives of eastern and western asceticism, as the culmination of this part of the poem is not an accident."[33] The lines to which this refers, which take us back to Yeats's Byzantium, read: "Burning burning burning burning / O Lord Thou pluckest me out / O Lord Thou / burning" (p. 46). Throughout the poem, the marks of asceticism are prominent: dryness and sterility, the Dantesque need to keep habitually moving, and imprisonment ("Thinking of the key, each confirms a prison"). Like Mallarmé as well as Simone Weil, whom he admired, Eliot lived the life of a contemporary urban ascetic in an era of disbelief. If we think of him in terms of Prufrock, or the lonely bank clerk whose aching back at the end of the day is a symptom of the dehumanizing routine of the workaday world, he becomes a martyr of Modern life, whose passions are poured into his poetry. In his "Preludes" he pours a quiet sensitivity to pain, as in the fourth "Prelude," which reads in part: "The notion of some infinitely gentle / Infinitely suffering thing" (p. 13).

As with Yeats, the most ascetic poetry of Eliot is the later work, particularly *Four Quartets* and "Ash Wednesday." The language is more specifically related to that of Christian theology, bordering on prayer, but the visual imagery is filled with the shadows and repetitions of great Jasper paintings, or the dances of Merce Cunningham. In "The Hollow Men," for example, Eliot interposes shadow between the idea and reality in a way that Pater or Proust would enjoy: "Between the idea / And the reality . . . Falls the Shadow" (p. 58). The "place of solitude" that Eliot

clears in "Ash Wednesday," reminiscent of the "clearing" of Heidegger, becomes a haven to which Eliot's heartbroken lady can withdraw, "in a white gown, to contemplation," until the imagery shifts to "the whiteness of bones" from which the life has been bleached. One line in particular recalls the white canvases of Robert Ryman, Mark Milloff, and Cy Twombly or the folded empty canvases of Lawrence Carroll: "White light folded, sheathed about her, folded" (p. 64). To cleanse this imagery even further, Eliot takes it to the shore, where "the lost sea voices" help "the lost heart" to endure," and in an image that looks ahead to the "Voyages" of Crane, "the blind eye creates / The empty forms between the ivory gates / And smell renews the salt savour of the sandy earth" (p. 67). As the work concludes, Eliot intones a prayer that offers one of the most profoundly ascetic moments in Modern poetry: "Teach us to care and not to care / Teach us to sit still" (ibid.).

A World of Cinders: T. E. Hulme

Students of literature are as likely to have heard of T. E. Hulme as are students of philosophy, thanks to Ezra Pound, who, in one of those characteristically deft gestures of his that combined humor and serious prescience, included five precious lyric poems at the end of his own volume entitled *Ripostes* and sardonically called them "The Complete Poetical Works of T. E. Hulme." Given the decline in Pound's own academic stock, it is not surprising that Hulme is largely unknown today, although the issues he addressed in his brief literary remains, including a series of entries called "Cinders" in an interesting anticipation of Derrida, are remarkably timely.

The ascetic orientation of Hulme's thought imbues his poems. "A touch of cold in the Autumn night" is the way the first opens: a solitary walker looks up into the sky, sees the moon and stars and thinks of the ruddy face of a farmer and little town children. The second, a weary lament called "Mana Aboda," is prefaced by a sentence on aesthetics that captures the Classical ideal both Pound and Hulme were promoting at the time under the banner of Imagism: "Beauty is the marking-time, the stationary vibration, the feigned ecstasy of an arrested impulse unable to reach its natural end."[34] The third poem offers another moonlit mise-en-scéne, "above the quiet dock at midnight," with the moon tangled in the masts of a ship, suggesting one of Whistler's abstract riverscapes of Chelsea. The fourth, "The Embankment," is the "fantasia of a fallen gentleman on a cold, bitter night," recalling Ernest Dowson, that drunken hero of the Yeats generation. It reads in its entirety:

Once, in finesse of fiddles found I ecstasy,
In a flash of gold heels on the hard pavement.
Now see I
That warmth's the very stuff of poesy.
Oh, God, make small
The old star-eaten blanket of the sky,
That I may fold it round me and in comfort lie.

 (p. 267)

Hulme's life was cut short at age twenty-four in World War I. His fragmentary, contemporary observations have a certain energy to them because they show a first-rate mind, in constant contact with the artists, poets, and thinkers of his generation, trying to keep pace with the tremendous political and aesthetic changes unfolding all around him. So much of these fragments are about the art that is to come, the sculpture and painting of a moment just around the next bend in the road, that it is a wonder he was right as often as he was. Hulme, whose swashbuckling life would be the perfect subject for a Merchant-Ivory film (he was kicked out of Cambridge in 1904 for brawling yet maintained an aristocratic elegance during his international tour of studies in Canada, Brussels, France, and Germany), moved with authority and ease from Bergson to Worringer and Husserl. Much of his writing on abstract art comes from Worringer's "Art and Empathy," but there is also in these short entries a hint of the asceticism of Yeats's Byzantium poems: "The disgust with the trivial and accidental characteristics of living shapes, the searching after an austerity, a perfection and rigidity which vital things can never have, lead here to the use of forms which can almost be called geometrical. Man is subordinate to certain absolute values: there is no delight in the human form, leading to its natural reproduction; it is always distorted to fit into the more abstract forms which convey an intense religious emotion" (p. 53).

Much of Hulme's genius lay in his attunement to the tone of criticism and the way audiences respond to art. He noticed that the shift in attitude toward abstraction and against Romanticism was manifest in diction: "At the present time you get this change shown in the value given to certain adjectives. Instead of epithets like graceful, beautiful, etc., you get epithets like austere, mechanical, clear cut, and bare, used to express admiration" (pp. 95–96). Hulme's aesthetic was built on the "delicious recoil" of Pater and the reluctance to touch of Ruskin. An extraordinary passage underscores his acute sense of touch: "There are moments when the tip of one's finger seems raw. In the contact of it and the world there seems a strange difference. The spirit lives on that tip and is thrown on

the rough cinders of the world. All philosophy depends on that—the state of the tip of the finger" (pp. 236–37).

Like Pound, Hulme was right in the thick of things in the crusade for Modernism in art. There is a hint of Mondrian in his view of London by day as a "cindery chaos" while in the evening it assumes the order of a constellation. For Hulme, unity and order are of paramount importance, and it is interesting to note the way he uses the grid to express this: "Unity is made in the world by drawing squares over it (p. 223). This perfect integrity breaks up into his imperfect but real "cinders" unless some principle can hold it together: "The floating heroic world (built up of moments) and the cindery reality—can they be made to correspond to some fundamental constitution of the world?" (p. 220).

Hard-edged to the end, he remained highly suspicious of the sentimental or pleasant and recognized that the tangled ends of lines of thought often led nowhere since, unlike mathematics, they could not always be tidied up into one convenient theory of the relationship between mind and matter. "That fringe of cinders which bounds any ecstasy," he wrote, half in exasperation (p. 236). The final group of "cinders" revealed an attitude of resignation. Hulme admitted, "The truth remains that the world is not any unity, but a house in the cinders (outside in the cold, primeval)" (p. 223). The very last of the cinders takes us to the heart of asceticism, emotionally and philosophically: "A melancholy spirit, the mind like a great desert lifeless, and the sound of march music in the street, passes like a wave over that desert, unifies it, but then goes" (p. 245).

The Sensible Ascetic: William James

The important place given to asceticism by William James in the typology of his *Varieties of Religious Experience* is a quiet illustration of the way that asceticism in its spiritual sense enters the back door of Modernist thought. Considering the genuinely ascetic disposition of his brother, Henry James—both personally and in his fiction—as well as so many other novelists and poets of the early Modernist era, William's translation of historic asceticism into a twentieth-century context looks, in retrospect, like a master stroke of anticipation. If we could, by some magic, have been in the audience for just one James lecture, we would have been lucky to be in Edinburgh in 1902 to squeeze into the standing-room-only crowd of more than four hundred who attended the last of the Gifford Lectures on Natural Religion (the series became the basis for the *Varieties*). They were virtuoso displays of James at his best, spreading wide the multiplicity of experiences and observations—many of them

from the "immediate flux" of ordinary life in all its perplexingly Modern fragmentation—and then unifying them in the end. In *The Varieties of Religious Experience*, James explores how religion will continue to work in the twentieth century. Many of the stories he tells, in a narrative style that had a compelling effect on his lecture audiences, involve the most extreme examples of belief, reflecting his own fascination with fixed ideas, hallucinations, and the most violent kinds of fanaticism and self-destruction. To illustrate the function of the negative principle in religion, James turns to asceticism:

> In the religious consciousness, that is just the position in which the fiend, the negative or tragic principle, is found; and for that very reason the religious consciousness is so rich from the emotional point of view. We shall see how in certain men and women it takes on a monstrously ascetic form. There are saints who have literally fed on the negative principle, on humiliation and privation, and the thought of suffering and death—their souls growing in happiness just in proportion as their outward state grew more intolerable. No other emotion than religious emotion can bring a man to this peculiar pass. And it is for that reason that when we ask our question about the value of religion for human life, I think we ought to look for the answer among these violenter examples rather than among those of a more moderate hue.[35]

Aside from the curiosity value, the wild stories of medieval Christian, Buddhist, and Hindu mystics are useful to James as a dramatic way to shape his argument in favor of pragmatism as a "healthy" alternative to the ills of metaphysics taken to the extreme. Three central chapters of *The Varieties of Religious Experience* are devoted to saintliness and mysticism. They are filled with hagiographical episodes of the most violent types of self-destruction and self-torture. James beautifully anticipates the *via negativa* of later twentieth-century philosophy but insists that it must play the role of a stepping-stone to a "higher affirmation."

Having uncovered the dangers of asceticism and the negative principle when taken to excess, James performs a fascinating flip on this idea of "stripping" the emotional and judgmental baggage in an effort to pare down psychology to the apprehension of a purer set of feelings. A world without feeling, it turns out, is untenable, but the negative movement that permits him to test this idea is a vital part of his analytic technique. The emblem of this wholly ascetic view is the gray rock of Mont Blanc before the sun hits it:

> Conceive yourself, if possible, suddenly stripped of all the emotion with which your world now inspires you, and try to imagine it *as it exists*,

purely by itself, without your favorable or unfavorable, hopeful or appre-
hensive comment. It will be almost impossible for you to realize such a
condition of negativity and deadness. No one portion of the universe
would then have importance beyond another; and the whole collection of
its things and series of its events would be without significance, character,
expression, or perspective. Whatever of value, interest, or meaning our re-
spective worlds may appear endued with are thus pure gifts of the specta-
tor's mind. The passion of love is the most familiar and extreme of this
fact. If it comes, it comes; if it does not come, no process of reasoning can
force it. Yet it transforms the value of the creature loved as utterly as the
sunrise transforms Mont Blanc from a corpse-like gray to a rosy enchant-
ment; and it sets the whole world to a new tune for the lover and gives a
new issue to his life. (pp. 158–59)

The recovery of "mystery" that attends the religious experience of the
world is important to James. The dawn must come to Mont Blanc, no
matter how "indifferent" the mountain is to its warmth. There is some-
thing moving in the way that James, like the composers Debussy and
Messiaen or like Hopkins in his poetry, breathes a pantheistic spirit into
the passive surroundings. Stylistically, he shifts into biblical gear: "How
can the moribund old man reason back to himself the romance, the mys-
tery, the imminence of great things with which our old earth tingled for
him in the days when he was young and well? Gifts, either of the flesh or
of the spirit; and the spirit bloweth where it listeth; and the world's mate-
rials lend their surface passively to all the gifts alike, as the stage-setting
receives indifferently whatever alternating colored lights may be shed
upon it from the optical apparatus in the gallery" (p. 159).

Taking his cue from Schopenhauer, whose work he studied in Ger-
many during his undergraduate days, James includes the arts, rather than
the "monstrously negative" privations of the ascetics, to attain an aware-
ness of this "imminence of great things." Art and music provided a lad-
der to the kind of religious experience that the mystics claimed to enjoy.
The "artificial mystic state of mind" in which opposites and incon-
gruities can be resolved was achieved in a variety of ways. He also exper-
imented with nitrous oxide, personally, and interviewed or observed con-
temporary mystics. By treading that edge of consciousness he remained
in contact with the possibility of knowing hat the ascetics claimed to
know. As he observed, "There is a verge of the mind which these things
haunt; and whispers therefrom mingle with the operations of our under-
standing even as the waters of the infinite ocean send their waves to
break among the pebbles that lie upon our shores" (pp. 410–11).

Prayer and meditation are another path. James describes the orison as

a methodical means of elevating consciousness toward God through an essentially ascetic process. It begins as a process of elimination: "The first thing to be aimed at in orison is the mind's detachment from outer sensations, for these interfere with its concentration upon ideal things" (p. 396). Like the paintings of Robert Mangold, the incantatory music of Steve Reich, or the poetry of Gertrude Stein (who studied under James), the orison uses the elimination of outside stimuli to enhance the concentration upon an "ideal thing." Since James in the end is hoping to show that religion is not an anachronism and not an unhealthy state of complete denial, he places great significance on the role of art and orisons as a way of moving toward the feeling of religious communion. The goal is a Modern version of the religious experience, which James sketches in these terms:

> The further limits of our being plunge, it seems to me, into an altogether other dimension of existence from the sensible and merely "understandable" world. Name it the mystical region, or the supernatural region, whichever you choose. So far as our ideal impulses originate in this region (and most of them do originate in it, for we find them possessing us in a way for which we cannot articulately account), we belong to it in a more intimate sense than that in which we belong to the visible world, for we belong in the most intimate sense wherever our ideals belong. Yet the unseen region in question is not merely ideal, for it produces effects in this world. When we commune with it, work is actually done upon our finite personality, for we are turned into new men, and consequences in the way of conduct follow in the natural world upon our regenerative change. But that which produces effects within another reality must be termed a reality itself, so I feel as if we had no philosophic excuse for calling the unseen or mystical world unreal. (pp. 495–96)

The Habit of Indifference: Samuel Beckett

Saintly in appearance, Samuel Beckett, in his own squidlike way, could release a cloud of ink that today blurs his image, making it even more indecipherable than it was in his time. One of the myths that he fostered about his own life was the story that he had been born on Good Friday, and moreover, the day happened to be Friday the thirteenth (April 13, 1906), although diligent biographers have shown that his birth certificate indicates he was born in May of that year. His family owned its own pew at the Tullow Parish of the Church of Ireland; and while he took great

pains to distance himself from formal religion, he borrowed the idiom and rituals of the church and the tension of its various crises in the same way that Jean Genet, T. S. Eliot, Robert Musil, and many other great Modernists tapped these sources. The biblical text of greatest importance to Beckett is the book of Job, and the anecdotal progress of Dante, particularly of the *Inferno* and *Purgatorio*, is a stylistic as well as emotional foundation for his theologically based musings.

Although they are not as widely known as the plays or even the novels, Beckett's poems offer some of the most startling imagery of asceticism in his work. In "The Vulture," from the volume *Echo's Bones*, he describes the deathly bird "dragging his hunger through the sky / of my skull shell of sky and earth."[36] This desert scene, like a lost passage from Eliot, takes us right to the themes of impoverishment and pain that haunt the later plays and fiction. In another lyric titled "La mouche," Beckett sounds out the "musique de l'indifference" that, in a Mallarméan gesture, silences the lovers. Beckett invokes the same imagery in the poem "Alba" with the Mallarméan line "beyond the white plane of music."

That haunted wasteland that Beckett discovers in his poems and ten roams through in the novels and plays has baffled and inspired critics and philosophers for decades. Harold Bloom calls it "the beyond": "Call it the silence, or the abyss, or the reality beyond the pleasure principle, or the metaphysical or spiritual reality of our existence at last exposed, beyond further illusion. Beckett cannot or will not name it, but he has worked through to the art of representing it more persuasively than anyone else."[37] Writing about *Endgame*, T. W. Adorno notes that Beckett creates a "zone of indifference" regarding subjectivity and objectivity: "All content of subjectivity, which necessarily hypostatitzes itself, is trace and shadow of the world, from which it withdraws in order not to serve that semblance and conformity the world demands."[38] Adorno lowers himself into the canyons of *Endgame* on the ropes of Schopenhauer, Proust, Schoenberg, and Stravinsky. "The aesthetic *principium stilisationis* does the same to humans. Thrown back completely upon themselves, subjects—anticosmism becomes flesh—consist in nothing other than the wretched realities of their world, shrivelled down to raw necessities; they are empty *personae* through which the world truly can only resound."[39]

The language of suffering is relentless in Beckett's plays. *Waiting for Godot* invokes the cross, as well as the sheer brutality of the beatings in the ditch, the little instances of physical pain such as the cramp from shoes that are too tight or a hat that does not fit, or more pathetically, the sores around the neck of Lucky created by the rope by which he is dragged from place to place. The visual austerity and poverty of the characters is reflected in the setting, including the bare tree by Giacometti

in the first Paris production, the moon which is full and fat (a spotlight in most productions), the bare stage, the ragged clothes, and that overall sense of exposure that makes an old hat all the more precious. These clowns or tramps are not by any means saints in the ethical sense. At one point they mean to rob the passing travelers. There is an abundance of sexual innuendo, including the constant running offstage to urinate, or worse. Mean-spirited, shifty, and deceitful, as entertainers they try to dupe the audience into the notion that the time of the performance is filled satisfactorily.

The novels explore this territory in what may be an even more painful way. The only way out of distress is the gradual wearing down of the senses, to the point of unconsciousness. In *Malone Dies* the absence of sensation is represented by the condition of being in a coma and by the almost active (as illogical as that sounds) reduction of sense data. "I shall be neutral and inert," the narrator declares at the outset of the novel.[40] Even when the meals arrive according to a "time-table" (the measure of time being a very important image in all of Beckett), he occasionally shuns them. He is imprisoned, and as in the prison paintings of Peter Halley, the texture of prison life becomes the substance of the work. Like Robert Musil's hero, Ulrich, Malone uses mathematics as a way to quantitatively amuse himself. "He made a practice, alone and in company, of mental arithmetic," Beckett writes.

This focus on habit is a key factor in Beckett's work. In his challenging and often revealing little book on Marcel Proust, Beckett came closer to declaring his aesthetic credo than in any other work. One of the most significant ideas in Beckett's study is the centrality of habit in the ongoing negotiations between the individual and the environment. As Beckett wrote, "Breathing is habit. Life is habit. Or rather life is a succession of habits, since the individual is a succession of individuals."[41] In terms of the ascetic way of life, its rhythms and rituals, this strikes a fundamental pitch. In the odd opening pages of *Molloy*, a writer's miserable routine ("blackening" pages) and rag-tag physical appearance are reminiscent of a cross between the tattered old martyrs of Yeats and Melville's Pierre or Bartleby ("He gives me money and takes away the pages"). He recounts the physical abuse he has suffered and the distress he habitually inflicts upon himself in his daily existence. Like the "vanishing" reader of Heidegger's ideal, he is almost perfectly disguised: "I was perched higher than the road's highest point and flattened what is more against a rock the same color as myself, that is grey."[42] More than the ashen annihilation of color, the flattening of form and the elevation of perspective serve also to position Molly among the oddly indolent saints of Beckett's canon. Only a few passages later, this character, who has the sculptural

quality of an object, observes: "To restore silence is the role of objects" (p. 13). He eats "like a thrush," and his various ailments leave him almost paralyzed. With a Baudelairean love of the night in which he can hide, he contemplates his own objecthood: "I was a solid in the midst of other solids" (p. 100). The narrator of *Molloy* uses a routine to fight his insomnia. It leads him into a desert labyrinth and complements the imagery of drowning and inundation. In the end, it brings us closer to the mind and voice of Beckett himself, lulling us to sleep in a strange pianissimo that could be set to music by Messiaen, choreographed by Cunningham, with sets, of course, by Giacometti: "I did as when I could not sleep. I wandered in my mind, slowly, nothing every detail of the labyrinth, its paths as familiar as those of my garden and yet ever new, as empty as the heart could wish or alive with strange encounters. And I heard the distant cymbals. There is still time, and still time. But there was not, for I ceased, all vanished and I tried once more to turn my thoughts to the Molloy affair. Unfathomable mind, now beacon, now sea" (p. 106).

Metaphysics in Retreat: Martin Heidegger

If Heidegger had pursued the career path that his parents had intended for him he would have become a Catholic priest. He ended up leading a monkish existence, clad in Alpine boots, on top of a hill near Todtnau in the Black Forest. A favorite anecdote among academics (particularly those who believe in the sanctity of office hours and sabbaticals) is the tale of Heidegger firing his gun over the head of a graduate student to keep him from cutting across his property and disturbing his isolation. Against the onslaught of technology, nihilism, and obscure academic theories that had clouded the original questions philosophy is meant to address (generally Greek in origin, although Heidegger was also interested in Asian thought), Heidegger posed his own wonderfully literary, human, nostalgic question: What is Being? The opening pages of the English volume of essays known as *Poetry, Language, Thought* are devoted to a series of brief lyric poems collectively titled "The Thinker as Poet" *(Aus der Erfahrung des Denkens)*. The "single pathway" of these poems is an austere, solitary road to the top of a mountain, where Heidegger, who feels we are too late for religion and too early for Being, as he conceives it, contemplates its apparition: "To think is to confine yourself to a single thought that one day stands still like a star in the word's sky."[43] The poems celebrate the "splendor of the simple" in mountain wildflowers, butterflies on the meadow breezes, the path through the trees, the rays of the sun streaming down through the clouds, the pleasures of living in a

cabin way above society. He is careful to bring in the element of priva-
tion: "Pain gives of its healing power where we least expect it."[44] The
close communion with the seasons guides the philosopher to a calm clar-
ity: "In thinking all things become solitary and slow."[45]

Heidegger's thought is pointed toward the revelatory experience of the
"transcendental" or "ecstasy," like that of Gould, and very different
from that of Olivier Messiaen, Joan Miró, or even T. S. Eliot. While they
induce the rhapsodist's flight, through a suspension of analytic rigor,
Heidegger and Gould pushed their introspective interpretations to the
level of creativity. One of the most revealing passages in Heidegger re-
lated to ecstasy and its aesthetic roots is found in the study of Nietzsche,
which began as a series of lectures at Freiburg during the winter of
1936–37. Heidegger soars past Nietzsche's aesthetic rapture into a de-
scription of "attunement":

> Rapture is feeling, an embodying attunement, an embodied being that is
> contained in attunement, attunement woven into embodiment. But attune-
> ment lays open Dasein as an enhancing, conducts it into the plenitude of its
> capacities, which mutually arouse one another and foster enhancement.
> But while clarifying rapture as a state of feeling we emphasized more than
> one that we may not take such a state as something at hand "in" the body
> and "in" the psyche. Rather, we must take it as a mode of the embodying,
> attuned stance toward beings as a whole, a stance which for its part deter-
> mines the pitch of the attunement."[46]

To gain an appreciation of how Heidegger attains this elusive "stance"
from which the apprehension of Being becomes possible, let's consider his
reading habits. He had an approach to poetry that enabled him to ad-
dress his ontological questions in the uniquely lyrical style that has van-
quished so many translators and explicators since his time. The secret
goal that Heidegger kept in mind as a reader is a kind of self-effacement
that permits the poem to radiate its own meanings without interference.
As he writes, "The final, but at the same time the most difficult step of
every exposition consists in vanishing away together with its explana-
tions in the face of the pure existence of the poem."[47] This is more than
an act of Socratic restraint or academic politesse. It sets up an ascetic
morality of reading. Despite all that has been made lately of the highly
personal (on the brink of egomaniacal) strain of literary criticism, the
strict application of Heidegger's principle takes as its premise the efface-
ment the reader's agenda. He was also an advocate of the stillness of the
wise participant in his dialogue on language, which invokes his powerful
interest in Buddhism and Japanese aesthetics, he sets up a scene in which

an "Inquirer" encounters a Japanese scholar (the occasion for the dialogue was the actual visit to Freiburg in 1953 of a certain Professor Tezuka of the Imperial University in Tokyo). Their colloquy, interrupted by long meditative pauses, touches not only on the differences between Western and Japanese perceptions of language but on aesthetics, the No theater, and the film *Rashomon*. The Japanese scholar demonstrates the way in which a No actor conjures a mountain scene, slowly raising and opening his hand. Asked what the "essence" of the gesture evokes, he explains: "In a beholding that is itself invisible, and that, so gathered, bears itself to encounter emptiness in such a way that in and through it the mountains appear." The Westerner, perfectly attuned, completes the thought without missing a beat: "That emptiness then is the same as nothingness, that essential being which we attempt to add in our thinking as the other, to all that is present and absent."[48]

At the core of Heidegger's masterpiece, *Being and Time*, there is a passage on silence that is arguably one of the great ascetic statements in the history of twentieth-century philosophy. Bearing in mind the "death-centered" nature of Heidegger's conception of Being, which relates its wholeness in death, the symbolic importance of one who keeps silent in dialogue is chilling, reminding us of the potency of the long silences in Elliott Carter's string quartets. As a writer and thinker, Heidegger validates an economy of discourse in this passage, requiring the type of self-restraint that was noted in the dialogue on language. In his eyes, the protracted excess of words make clarity impossible, while silence bears the possibility of revealing:

> Keeping silent is another essential possibility of discourse, and it has the same existential foundation. In talking with one another, the person who keeps silent can "make one understand" (that is, he can develop an understanding), and he can do so more authentically than the person who is never short of words. Speaking at length [*Viel-sprechen*] about something does not offer the slightest guarantee that thereby understanding is advanced. On the contrary, talking extensively about something, covers it up and brings what is understood to a sham clarity—the unintelligibility of the trivial.[49]

As the paragraph continues, Heidegger raises the stakes by distinguishing between merely rhetorical reticence and the deeper, meaningful, and "authentic" silence of the sort of attunement observed earlier. There is a discernible shift in this passage from the mode in which a person is speaking or keeping silent to a condition in which Dasein ("Being-there") is communicating ("Dasein must have something to say"):

But to keep silent does not mean to be dumb. On the contrary, if a man is dumb, he still has a tendency to "speak." Such a person has not proved that he can keep silence; indeed, he entirely lacks the possibility of proving anything of the sort. And the person who is accustomed by Nature to speak little is no better able to show that he is keeping silent or that he is the sort of person who can do so. He who never says anything cannot keep silent at any given moment. Keeping silent authentically is possible only in genuine discoursing. To be able to keep silent, Dasein must have something to say—that is, it must have at its disposal an authentic and rich disclosedness of itself. In that case one's reticence [*Verschwiegenheit*] makes something manifest, and does away with "idle talk" [*Gerede*]. As a mode of discoursing, reticence articulates the intelligibility of Dasein in so primordial a manner that it gives rise to a potentiality-for-hearing which is genuine, and to a Being-with-one-another which is transparent.[50]

For Heidegger, "clarity" is a supreme virtue, and nothing could be clearer than the transparency in which this "Being with-one-another" possible by silence. The problem is finding a language with which to discuss Dasein, which in a sense confirms Heidegger's hunch that "silence is most noble in the end." As Richard Rorty has ventured to suggest, there is a linguistic brink that cannot be comfortably crossed: "We do not need to ask which understandings of Being are better understandings. To ask that question would be to begin replacing love with power."[51]

The poetry coming down from the mountain begins to echo and break up in the valley below. Heidegger labored to rescue Dasein from what Nietzsche had called the "pale, cold, gray concept nets" of philosophy and went on to try nostalgically to protect Dasein from the encroachments of technology. Ironically, because Heidegger had deep-seated reservations about the spread of technology even in his age, with the growth of the Internet, Heidegger's terminology is a fashionable resource, constantly raided by cyber-philosophers like Ernesto Grassi and Geert Lovink, whose *Metaphysics of Virtual Reality* portrays Heidegger as one who projected possibilities in the giddy way that devoted Netjunkies rhapsodize about. Much of this is far from the cold, clear atmosphere of Heidegger on his mountaintop, gripping with all his strength the scythe that made a clearing in which Dasein could be at home.

Baroque of the Void: Robert Musil

Unjustifiably neglected for decades in the English-only literary world, Robert Musil reemerged recently thanks to a new translation of his classic

The Man without Qualities. The lead character in *The Man without Qualities*, Ulrich, is a scientist and amateur philosopher, just like Musil himself, who was born in a small town called Klagenfurt in Austria in 1880. After a brief stint of military service, he became a writer. He split his life between Vienna and Berlin until, afraid that the Nazis would ban his fiction, he moved to Switzerland in 1938. Desperately poor, he never finished his materwork (it was published in part nine years after his death in 1942).

Musil used Ulrich to show how he "realizes to his astonishment that reality is at least one hundred years behind what is happening in thought." In his diaries, Musil brooded on the possibility of a new order, of "mind taking charge of the world" *(geistige Bewatigung der Welt)*. His reading in Novalis, Emerson, and Husserl is evident in this anthithetical stance, as are his literary tastes, which ran to Baudelaire, Maeterlinck, D'Annunzio, Verlaine, Rilke, and the ubiquitous Poe. Ulrich lives in a "dainty little white gem of a house" that has the cloistral touch of being both book-lined on the inside and surrounded by the "fine green filter of the garden air" on the outside. The reader usually finds Ulrich watching life through a window, keeping a muffling medium being himself and the world. We first meet him in the novel playing a weird little mathematical game, daydreaming with a stopwatch in his hand while he counts the traffic going by and attempts to calculate the unquantifiable busyness of the world. His mathematical reverie is an attempt at transcendence that take the place of theology, striving toward the kind of perfection that, sadly, often means inaction. He is mysteriously described as a "man returning after years of absence," yet as the determined reader will find out through the course of the next 1,700 pages or so, Ulrich rarely emerges from what he later calls the "Baroque of the Void." He moves through the scenes like a shadow, attuned to the "inner acoustics of emptiness," replying to the "yes" of Joyce's *Ulysses* with a deep, resonating pizzicato cello note of "no."

This indifference sets up an outer shell that protects the inner emptiness, leaving Ulrich in a state of paralysis, or "pseudoreality," with a "passive fantasy of spaces yet unfilled." Ulrich extols the "masters of the inner hovering life," looking ahead to the only genuinely happy period in his existence, when, sitting quietly with his sister Agathe in the home of his deceased father (a scene that is filled with the tension of impending incest, not unlike the kind found in the work of two other Modern Austrian masters, Georg Trakl and Thomas Bernhard), he reads the lives of the saints in search of what he calls a "sensible asceticism." The "masters" are not specifically Christian or Buddhist: "Their domain lies between religion and knowledge, between example and doctrine, between

amor intellectualis and poetry. They are saints without religion, and sometimes they are also simply men on an adventure who have gone astray."[52] Out of this, Ulrich temporarily fashions a credo that takes into account the split of morality into mathematics and mysticism and that feeds the "alchemist's fire glimmering behind the moral injunctions, no domestication of evil" (1:836–37).

These saints recur subtly and yet regularly through the novel. The powerful businessman turned statesman, Arnheim, collects Baroque and Gothic sculptures of Catholic martyrs in twisted poses of torture and death that remind him of ecstasy and give him a feeling of "horrified amazement." As Ulrich contemplates the difference between the mystical experiences of antiquity or the Middle Ages and the Modern age, he realizes that metaphysics has lost credibility. In a memorable sentence, Musil observes through Ulrich:

> And while faith based on theological reasoning is today universally engaged in a bitter struggle with doubt and resistance from the prevailing brand of rationalism, it does seem that the naked fundamental experience itself, that primal seizure of mystic insight, stripped of all the traditional, terminological husks of faith, freed from ancient religious concepts, perhaps no longer to be regarded as a religious experience at all, has undergone an immense expansion and now forms the soul of that complex irrationalism that haunts our era like a night bird lost in the dawn. (1:603)

As with the practical Arnheim, who defines even his happiness against the limits of propriety, legitimacy, and reality, Ulrich is after a moment of simplicity and clarity. To Arnheim, "at peak moments of perception, one senses how the cosmos turns on an axis of vertical austerity" (1:548). That axis presents a stark contrast to the luxurious, overactive exterior of Arnheim's wealth and business. The Proustian lush life of Musil's characters is spent in posh, if comfortless, world of titled aristocrats mixing with social-climbing industrialists in Vienna's better residences. When Ulrich fires every bullet from a revolver's chamber into a piano that Agathe, his sister, is playing, Musil takes pains to indicate that it is a very good, "expensive" piano that is destroyed. The luxurious state in which they live is at odds with the selfless intentions (pretensions) they bear and the intellectual asceticism they use to force the "paling" of their drives and desires to keep them under control. Musil peers into the cells of his meditating monks—the boudoir of Bonadea, the music room of Clarisse, the bedroom of Ulrich, or the office of the General, outside of which a red light is lit over the door to indicate that he is not to be disturbed. The reader eavesdrops on their private forays into spiritual questions behind Musil,

who drills deep into these characters' soul-searching and then, reversing the drill deftly at chapter's ends, extricates his narrative line without damaging the structure.

The imagery of Heraclitean fire in the work is significant, particularly as it leaves the ascetic residue of ashes or cinders. When, at last Ulrich and his sister do allow their relationship to become more physical, it is described (vaguely) in terms of their plunging into fire. Until then, as Musil writes, "Love and asceticism stand apart in their lonely kinship. How aimless this pair appears, how devoid of a target, compared with the aims and targets of normal life" (1:610). Against fire, Musil poses the habitual cold of Ulrich. In an early diary entry, Musil observed: "Around me there is organic solution, I rest as if under a covering of ice, one hundred meters thick."[53] Arnheim, too, is locked in ice. Staring at his Black servant, Soliman, thinking of his sterile relationship with Diotima, he realizes that "at the very summit of his life, a cold shadow separated him from everything he had ever touched."[54] A moment later, realizing that Ulrich too lived in such a selfless shadow but more comfortably—which Arnheim ascribes to an aversion to acquisitiveness—Arnheim recasts the barrier as "an almost imperceptible skin of ice" (1:597). Arnheim thinks that there is "something missing" in the younger— the sort of thing one might say about a eunuch.

The stunningly powerful ending to the novel's "Pseudo-Reality Prevails" section is a late-night walk home that brings Ulrich face-to-face with the relationship between inner and outer. As he progresses from narrow to wide street and open squares, he is struck by the "foreshortening of the mind's perspective" that allows visual relationships to be presented in a coherent picture, and he relates this to his own gift for a kind of necessary "abstraction" in the creation of narrative order. Throughout the novel, Ulrich has stopped conversations cold with his "stories," and now he notes that the mathematical order or thread of narrative allows him to hold the world at bay. On the way home he is stopped by a prostitute and gives her the money she would have demanded for sex. Then he reaches home, abstemious to the last, where he is surprised to find the lights blazing, a telegram informing him of the death of his father, and his best friend's wife throwing herself at him. But she too is rejected despite momentarily arousing him. These twin denials in close order underscore the ascetic strength of Ulrich. As dawn approaches and he slips into "a painless state of exhaustion that changed his total sense of his body," he notices how his solitude has deepened. He takes in the cool air of morning and returns to "civilized European" precision with a bath and vigorous exercise session (2:725).

For Ulrich, love becomes a kind of anesthetized "antireality" on the

same plane as the other psychological exercises (like the counting games that figure so prominently not only in Musil's work but in the novels of Thomas Bernhard as well). Even when Ulrich and his sister are lying side by side, making a "constellation" (recalling Miró and Mallarmé), they are paralyzed. Lying on their stomachs outside watching one ant murder another, having one of their protracted discussions about the Annunciation, bliss, love, and death, they hover over making love or trying to commit suicide. Ulrich advises his sister:

> Try to take it metaphorically. You don't even have to rush to give it a particular significance: just take its own! Then it becomes like a breath of air, or the sulfurous smell of readiness for dissolution tremble. I can imagine that one could even get over one's own death amicably, but only because one dies just once and therefore regards it as especially important; because the understanding of saints and heroes is pretty lacking in glory in the face of nature's constant small confusions and their dissonances! (2:1396)

Corrected Out of Existence: Thomas Bernhard

Thomas Bernhard was a challenging and morose Austrian novelist who, until his death in 1989, leveled his withering glance on his hometown of Salzburg as well as Vienna in eighteen plays and fifteen novels, including many published in English (Gargoyles, The Lime Works, Correction, Concrete, Woodcutter, and Wittgenstein's Nephew), along with his memoirs, Gathering Evidence. Originally a music student—he continued to play the violin and cello throughout his life—Bernhard began his career as a playwright and novelist in 1957 and by the age of forty had won the top three literary awards for German writers: the Grillparzer Prize from the Viennese Academy of Sciences (1971), the Austrian State Prize for Literature (1967), and the Georg Buchner Prize from the Deutsche Akademie für Sprache und Dichtung (from which he resigned in 1979 when West German president Walter Scheel became an honorary member). Unlike Canetti and Célan, who launched their attacks from beyond Austria's borders, Bernhard remained steadfastly in Salzburg and Vienna. Cackling over the newspapers in the cafés, firing off one sharp, Swiftian satire after another, he took on literary lions like Canetti as well as politicians and the national character of Austria.

Like Georg Trakl, who was a generation ahead of Bernhard in Salzburg, Bernhard was a poet of darkness, incest, and self-destructive turmoil. As Stephen Dowden, one of his principal champions, has noted,

"Bernhard's fiction as a whole might profitably be regarded as a collection of suicide notes."[55] In a critical preface to a magnificent piece of his own writing about revisiting Vienna with Bernhard's *Beton* as his Baedeker, the Austrian-born novelist Walter Abish offers a concise explication of the ascetic gravitation toward death in the novels:

> As opposed to the often abrupt, always disconcerting self-annihilation, for Bernhard the *thinking of death* evokes the incongruity, the banality, the duplicity and the ridiculousness of everything. So the thinking of death is preeminently a measure of life—invariably a diminishing measure. If in Bernhard's books there is one essential element conspicuous by its absence, it is eros. For in this *thinking of death* which is a measure of life, there can be no eros, since eros might—if only temporarily—alleviate the relentless grip of death. It goes without saying that Bernhard's *thinking of death* by excluding eros, is at best an unreliable measure. But, in this respect, Bernhard remains adamant: no relief, no pleasure, no sex. Now and then he will admit to a certain pleasurable interlude—sitting in the *Cafe Sacher* in Vienna, reading *Le Monde* or *The Times*, but one can hardly elevate this pleasant pastime, this minor division to the level of "gratification" or "pleasure" that might, however, briefly, cause one's embrce of death temporarily to weaken. No, the *Sacher* is only an insignificant reward, an interlude, something to make life more palatable.[56]

A moralist whose work focused on a series of moribund male eccentrics, some of them based on his own family, some of them linked to historical personas like Wittgenstein and Glenn Gould, Bernhard strikes most of his readers as being too tough and too cold. Biographers blame some of Bernhard's irascibility on the difficult circumstances surrounding his birth, joyless childhood, and embittered later life, plagued with illnesses. He was born in a Dutch home for unwed mothers in February 1931, where his mother had gone to escape the censure of her small village near Salzburg. Bernhard never met his father, a carpenter named Alois Zuckerstatter, who died during World War II. He was a difficult child, who disobeyed his stepfather and left his boarding school at fifteen to become the apprentice to a grocer operating out of the cellar of a housing project in Salzburg. The schools he attended were dominated by the strict ideologies of the Nazis and the Roman Catholic authorities. At eighteen, his bad diet and overwork caused doctors to predict his death from pneumonia and tuberculosis—he succumbed to pulmonary problems forty years later.

Bernhard turned to music as a voice and acting student in Vienna and later in Salzburg, at the Mozarteum, from which he graduated in 1957 at

the age of twenty-six. He eventually shifted to writing for Salzburg's *Demokratische Volksblatt*, a Socialist paper where he had family connections. His fiction is not terribly journalistic, however, as it depends on extraordinarily long sentences and paragraphs and is marked by a hazy, dreamlike subjectivity. One journalistic habit is evident in his writing. Reporters attribute quotes and facts by using a simple "he said" or "according to" formulation. Bernhard plays with layers of this by attributing a thought, memory, or statement to one character and then fuzzing it with his own indistinct qualification, as in "he said, I thought." The result is a disconcerting lack of clarity about what actually was said or thought.

Bernhard tended to plunge his self-destructive characters into a deathly, inescapable chill that descends on them in their dark, decrepit mansions and never abates. One of his earliest successes was a novel called *Frost*, and the last volume of his memoirs is called *Die Kälte; Eine Isolation*. These unfortunates are also prone to being captured in prison-like structures, from the "cage"-like hospital bed in which Wittgenstein's nephew is kept in the mental ward (and the glassy pavilion itself) to the unforgettable white cone of *Correction*, in which the hero traps and eventually kills his sister. The destructive force in these works is often an obsessive yearning for perfection, as in the hero of the *Old Masters*, who sits in front of paintings all day trying to find sources of imperfection, or the architect of the cone in *Correction*, who "corrects" only to destroy.

Some of these tendencies are drawn from what Bernhard perceives as flaws in the Austrian character, but others stem from Bernhard's own proclivities as well as the quirks of famous historical figures like Wittgenstein and Gould. The drive toward perfection, for example, is a tendency that Bernhard knew from both the writer's perspective and that of the musician. His novel *The Loser* features a trio of classical pianists, each of whom has abandoned the concert stage for roughly the same reason—a fear of contempt for imperfection—and uses a fictional version of Gould as an exemplar, not only of technical virtuosity and perfection but as the brash instigator of one suicide.

The correlation between perfection and death is the grim side of another Bernhardian theme—the passionate embrace of an ideal despite the appearance of madness and the suffering of disappointment. The music in the novel is a Modernist strain of highly ironic, tense chamber music; and the use of Gould as a "touchstone" is meant to further dispel the Romanticism often associated with the life or the sweeter Classicism of Salzburg's musical life dominated as it still is by Mozart. In the case of the two Austrian pianists, the ideal is represented by Gould's interpretation of Bach's Goldberg Variations. Both musicians have played the massively challenging piece in their own way, but they are paralyzed by Gould's

famous interpretive originality. The decisive moment for Wertheimer arrives when he shows up for his first lesson and hears Gould playing from outside the practice room:

> Glenn had played only a few bars and Wertheimer was already thinking about giving up, I remember it precisely, Wertheimer had entered the first-floor room in the Mozarteum assigned to Horowitz and had heard and seen Glenn, had stood still at the door, incapable of sitting down, had to be invited by Horowitz to sit down, couldn't sit down as long as Glenn was playing, only when Glen stopped playing did Wertheimer sit down, he closed his eyes, I can still see it in every detail, I thought, couldn't utter a word. To put it sentimentally, that was the end, the end of the Wertheimerian virtuoso career. For a decade we study the instrument we have chosen for ourselves and then, after this arduous, more or less depressing decade, we hear a genius play a few bars and are washed up, I thought.[57]

The paralysis that afflicts Wertheimer is typical of the static torment Bernhard's heroes face. Many of his most memorable scenes involve prisonlike garrets or places of meditation (the Cone in *Correction* is the paradigm). In *The Loser*, the Austrians have their forest retreat, which they compare with Gould's ideal recording studio (which Bernhard situates in the countryside as well, perhaps thinking of Gould's family retreat on the banks of Lake Ontario). This remote cage is called a "desperation machine," emphasizing its mechanical and slightly mad character, as well as the isolation it imposes, "cut off from all human contact, miles away from everything." The mental and physical health of most of his heroes is questionable, with a preponderance of schizophrenia and, in a more autobiographical vein, breathing disorders. in an interesting twist, Bernhard paints a vigorous picture of the saintly Gould:

> Glenn, whom even today people assume to have had the weakest constitution, was an athletic type. Hunched over his Steinway, he looked like a cripple, that's how the entire musical world knows him, but this entire musical world is prey to a total misconception, I thought. Glenn is portrayed everywhere as a cripple and a weakling, as the *transcendent artist* his fans can accept only with his infirmity and the hypersensitivity that goes along with this infirmity, but actually he was athletic type, much stronger than Wertheimer and me put together, we realized that at once when he went to chop down an ash tree with his own hands, an ash tree in front of his window, which, as he put it, obstructed his playing.[58]

Gould, unlike the Austrian pianists, finds a way to avoid being "ground to bits between Bach and the Steinway." It is a telling moment

in the novel that reveals a great deal about Bernhard's own view of his art. Gould "becomes" the Steinway by embracing impersonality, rather than by being the artistic middleman. "My ideal would be, *I would be the Steinway, I wouldn't need Glenn Gould,* he said, I could, by being the Steinway, make Glenn Gould totally superfluous."[59] As an insight into Gould's own development, this is rich material, although arguably off-base. As a window into the ascetic effacement of the persona, whether in music or in philosophy (Simone Weil is the best example of this) or in what Barthes once called the "zero degree of style," it goes a long way toward indicating how the ascetic posture works in contemporary aesthetics.

The terrain of *Wittgenstein's Nephew* invokes Thomas Mann's *Magic Mountain.* The narrator is imprisoned in a glassy pavilion for pulmonary patients in a fancy hospital in Austria. In another, connected pavilion for lunatics is Wittgenstein's nephew, fighting off one of his regular bouts of depression. As in Man's work, the quarantine offers a tidy ascetic premise within which a very Bernhardian martyrdom may be enacted. The narrator and Paul Wittgenstein share a compulsive disorder, "the counting disease," which also afflicted the composer Anton Bruckner in his later years. It makes them count the spaces between the windows of the buildings or the windows or doors from the streetcars or obsessively watch the way they step over cracks on the sidewalk. Like Robert Musil's hero, Ulrich, this way of dealing with the outside world seals the characters off, as does the white tailcoat or white straitjacket that Paul wears depending on whether he is sane and functioning in the outside world or a patient inside the hospital. The rapid flip between a life of luxury and the impoverishment of being a patient is captured in this brief passage: "The *Herr Baron,* as my friend was styled by everyone, was no longer wearing his white tailcoat, tailored by Knize, as he often did at night, especially at the Eden Bar—behind my back, so to speak—even in his last years. He had once more exchanged it for a straitjacket, and instead of dining at the Sacher or the Imperial, where he was still occasionally invited by the many well-off or positively rich friends he still had—some of them aristocrats, though not all—he was once more eating from a tin bowl on the marble table in the Ludwig Pavilion."[60]

The poor "Baron" is kept in a bed that is little more than a cage (it even has bars over its top) and tortured regularly by electroconvulsive therapy while he starves himself. Eventually, he is packed off by car to the huge family estate (this part is historically accurate, as the Wittgenstein family was filthy rich). The estate is one of those deathly cold places that Bernard evokes so skillfully. The old house that belongs to Paul's brother, between Altmunster and Traunkirchen in the Austrian countryside, "was so cold, all the year round, that as soon as one entered one felt that before

long one would freeze to death."[61] Its damp and mildewed walls are hung with terrifying ancestral portraits by Klimt and his followers. In the pathetic final scenes of this novella, the narrator can barely face Paul, who goes around Vienna muttering the single word "grotesque" over and over. Living in a garret, reminiscent of the opening scene of the novel *Correction*, Paul Wittgenstein has renounced all his riches and aristocratic trappings. The narrator relates his condition to the fear of artistic death among performers, which recalls the two pianists of *The Loser*:

> We shun those who bear the mark of death, and this is a form of baseness to which even I succumbed. Quite deliberately, out of a base instinct for self-preservation, I shunned my friend in the last months of his life, and for this I cannot forgive myself. Seen from across the street, he was like someone to whom the world had long since given notice to quit but who as compelled to stay in it, no longer belonging to it but unable to leave it. Dangling from his emaciated arms—*grotesque, grotesque*—were the shopping nets in which he laboriously carried home his purchases of fruit and vegetables, naturally apprehensive that someone might see him in this wretched state and afraid of what they might think.[62]

An unforgettable emblem of the ascetic ideal in literature as well as in architecture is the centerpiece of Bernhard's *Correction* (published in 1957 as *Korrektur*). Set once again in Austria, involving a character who has reminded many critics of Ludwig Wittgenstein himself, it is the story of Roithamer, an oddball geneticist who has committed suicide after the death of his sister. The focus of Roithamer's life is "The Cone," a geometrically perfect building he wants to build for his sister in the forest (Wittgenstein designed, down to the keyholes, a famous residence for his sister in Vienna). The Cone is at once castle and tower, dungeon and nun's cell. Whitewashed inside and out, it is situated at the dead center of a forest, accessible only by a road that winds six times in one direction, six times in another so that no direct view of it is possible until one is upon it. This strange structure, inspired perhaps by the geometries of Frank Lloyd Wright, has seventeen rooms, nine of them without windows, and is built to house an extraordinary "meditation chamber" on the second floor directly under a red dot that is the structure's center and "totally devoid of any objects" or light.[63]

The Cone is meant to be a place where his unmarried sister can achieve "supreme happiness," and it has been built as a strange architectural of portrait of her, reflecting her character in its introspective design. It is not just virginal and white, however—it is empty. While Roithamer believed in his ideal, from the outset the project was basically an entombment. There is a hint of Poe's "Fall of the House of Usher" in the way

this story plays itself out particularly as the family estate that Roithamer liquidates to pay for the Cone, as well as the Cone itself, are left to decay in the wilderness. As the title of the novel implies, the key intellectual and dramatic concept of the work is that of "correction," leading right to the link between his suicide and the purging of his sins. The mathematical and architectural calculations that produce the Cone are a matter of continual correction, and the little slips of paper that the narrator is attempting to gather into a volume representing Roithamer are evidence of the way in which Roithamer "corrected" himself out of existence. It is interesting that Roithamer is an avid musician who thinks of music as "audible mathematics," is devoted to the work of Purcell and Handel, and is possessed of perfect pitch. He forsakes his ancestral home, called Altensam, when he realizes that his family is unable to give up "the habit of the habit of Altensam, the habit of the Austrian habit-mechanism, the habit of the familiar, of all one is born not, he gave it all up."[64]

As with Beckett's reading of Proust or our examination of Miró's Constellations, this critical look at habit is crucial for understanding what sets Roithamer, with his "intellectual incorruptibility," apart from the rest of his family. He wants to use the proceeds from selling Altensam to liberate prisoners even as he is immuring his sister, and himself, in dungeons. He believes that he has found supreme happiness in an aesthetic endeavor, and in the face of the "habit-mechanism" of the old guard he thinks he has found "a special quite idiosyncratic innate rhythm of his own in which he had schooled himself."

The kind of disillusionment that is a hallmark of Bernhard's novels descends on Roithamer, and his attempt to run "counter" to the rational codes of his family exhausts him. From hero to paranoid and oppressive murderer, Roithamer slides downward. While Bernhard's most distinguished critics point out his vast ideological differences from Heidegger, the last words of the novel offer a shockingly Heideggerian sense of "clearing." After the dense forest imagery and sealed prison of the Cone, this final gesture of opening outward and gasping for air is a huge surprise. It is also a destructive swipe at all the vertical structures that have been set up in the novel, the last words of which read: "The end is no process. Clearing."[65]

The Freedom of Nothingness: Jean-Paul Sartre

It is the winter of 1940, and the temperature inside the barracks of Stalag XIID on top of Mount Kemmel overlooking the Moselle River hovers around ten degrees Fahrenheit. Jean-Paul Sartre has been a prisoner of

war since the previous June—he will be freed, thanks to a fake medical certificate that says he is partially blind in the right eye, in March 1941. Despite the privations of hunger and discomfort, the rigid order and the constant game of wearing down the German authorizes are exhilarating to Sartre, who relishes the drama of being a prisoner on high. "It's odd to think that freedom is *down there*, below me. To be prisoner on top of a mountain, what a paradox! The world we have been torn away from looks very small from this eagle's nest, like a toy. It has rejected us and yet we feel as if we dominate it. . . . For the moment our gaze is freer than we are, freer than that of the town jailers. It soars, it is contemptuous, and yet we are here."[66] As Olivier Messiaen made his mental escape from the German prison camp in which he was held by reading musical scores and writing the timeless *Quartet for the End of Time*, so too Sartre would write and read his way to intellectual freedom. He debates with the priests in the camp, he sings in the choir, he reads Heidegger, he boxes, he tell stories to put his barracks-mates to sleep, he becomes a playwright with a brief play, called *Bariona*, about the era when the Romans were master of Judea.

While there are biographical moments and literary passages before and after Sartre's internment that touch on the theme of asceticism, nothing is as directly relate to Sartre's work on being, consciousness, freedom, anguish, and solitude as this paradoxically immensely productive period. Sartre would remain nostalgic about the experience. When he and Simone de Beauvoir were en route to a holiday in Amsterdam in the summer of 1953, he took her to Treves, near Strasbourg, to show the remains of the camp. Beyond the straitened routine of subsistence and cleanliness, prisoners have nothing to do. It is the "nothing" of Sartre's *Being and Nothingness* and the role of self-denial in his philosophy that make his work such an important addition to the philosophical literature on asceticism. One of the strengths that he would carry with him from prison was a sharpness of observation that was attuned, in the Heideggerian sense, to suffering and alienation, imprisonment, and the power of the imagination to permit strange freedoms. He drew on the little experiences of Parisian life for the material of his ostensibly abstract meditations on the opaque monolith of being-in-itself (*l'ensoi*) and its negation, "the hole in heart of being" or consciousness of "the for-itself" (*le poursoi*). The feeling of solitude that he could pluck from the sight of a group of passengers waiting for a bus or the anguish of a café waiter's private thoughts offered him a way to link the apparent comforts of contemporary urban life to the austerity of the prison camp and a concept of "scarcity" that is linked with alienation.

In the chapter "The Origin of Negation" in *Being and Nothingness*

(1943), Sartre offers a tightly constructed comparison of being, which can "nihilate itself," and nothingess, which does not have the property of "nihilating itself" but "is nihilated." The language becomes somewhat circuitous, and the Heideggerian echoes are palpable; but it heads in the direction of a "delicacy" that, like the love of monochrome painting among post-Minimalists of the attraction to the verge of audibility among composers after Cage, showcases the importance of nothingness or emptiness in Sartre's theory:

> It would be inconceivable that a Being which is full positivity should maintain and create outside itself a Nothingness or transcendent being, for there would be nothing in Being by which Being could surpass itself toward Non-Being. The Being by which Nothingness arrives in the world must nihilate Nothingness in its Being, and even so it still runs the risk of establishing Nothingness as a transcendent in the very heart of immanence unless it nihilates Nothingness in its being *in connection with its own being*. The Being by which Nothingness arrives in the world is a being such that in its Being, the Nothingness of its Being is in question. *The being by which Nothingness comes to the world must be its own Nothingness.* By this we must understand not a nihilating act, which would require in turn a foundation in Being, but an ontological characteristic of the Being required. It remains to learn in what delicate, exquisite region of Being we shall encounter that Being which is its own Nothingness.[67]

To unravel this complex knot, we must recognize that the solidity of being is balanced by the "nihilating" process of consciousness separated from being by "nothing." To fix the origin of nothingness, Sartre points to man: "Man is the being through whom nothingness comes into the world."[68] The imagination plays its role in maintaining the distance that consciousness requires to bring nothingness into play. The imagination is particularly important in his use of the actor, whether on stage or in life, as an example of how the individual can create or alter being to escape a particular situation. By controlling consciousness and invoking nothingness at will, Sartre can distance the woman from the ardent lover who touches her arm, or the waiter from the job he abhors, or the lover plagued by desires. The imaginative side of Sartre leads to pain as well as pleasure, and in advance of Foucault he wrote extensively on sadism, another of the ascetic Sartrean themes, together with suffering, shame, violence, illness (notably "nausea"), and the disorientation of a sleepwalker gripping the edge of the bed after a nightmare.

The distance he imposes between himself and the world brings with it a sanctified air of purity and freedom. He writes, "My presence, in so far

as it is a present grasped by another as *my* present, has an outside; this presence which makes-itself present *for me* is a pure alienation of my universal present; physical time flows toward a pure and free temporalization which I am not; what is outlined on the horizon of that simultaneity which I live is an absolute temporalization from which I am separated by a nothingness."[69] This passage reminds me, strangely enough, of a photograph of Sartre, pipe in mouth, his pen touching a pad of paper, a white coffee cup by his left hand, sitting inside a Montparnasse café and trying to enjoy—playing at enjoying—one of his last quiet moments before the furor he created by rejecting the Nobel Prize for Literature in October 1964. Outside the café," a small crowd of curious onlookers— he enjoyed the kind of following that attends rock stars—are looking in at him through the window. From the moment that it became known that he was going to reject the prize, reporters and fans were after Sartre like a pack of hounds. This rejection of money and official recognition, which brought Sartre more publicity in the end than any acceptance speech he might have devised, is fundamentally the same ascetic denial as Glenn Gould's dramatic retirement from the concert stage or the withdrawal of artists like Cy Twombly and Bruce Nauman from the spotlight of the Whitney Biennial and events. Endlessly allegorized in political, ethical, and existential terms by critics, these acts of rejection are meant to multiply the distance between the untouchable artists and the world from which they have already departed.

When Sartre wrote *Saint Genet* he was working through the metamorphoses it would take to liberate himself from the ethical problems posed by his doctrine of nothingness. The fiction of Genet, its exuberant beauty in the midst of squalor, offered a way out, partly by reducing the moral experience to a verbal one. As Sartre observed,

Saintliness was that which was beyond nothingness; but since it becomes a language and *speaks*, Genet makes contact with himself as something beyond Saintliness, as a freedom. The moral experience produces the same result as the artistic experience; it *is* the artistic experience of which Genet becomes conscious and which he translates into another language. He has delivered himself from the Word by the "full employment" of the terms; he has delivered himself from Beauty by making it enter language: being the pure organization of the verbal world. Beauty sinks into silence along with this world. Above all, he has succeeded in what he did not plan to undertake: *he has freed himself from Good and Evil*, both of which have crept into the work and no longer have meaning except through the work.[70]

This leads us to Sartre's plays, where we hope to see a similar means

of both coming into contact with oneself (rather than interposing that glass window so thoroughly as to isolate one's own consciousness) and freeing oneself. In *No Exit*, his greatest play, there is an almost hysterical speech in which the sheer difficulty of discovering peace, purity, or freedom is revealed. In ascetic language, including a reference to the yogi, it contradicts the possibility of escaping oneself:

> To forget about the others? How utterly absurd! I *feel* you there, in every pore. Your silence clamors in my ears. You can nail up your mouth, cut your tongue out—but you can't prevent your *being there*. Can you stop your thoughts? I hear them ticking away like a clock, tick-tock, tick-tock, and I'm certain you hear mine. . . . You'd go on sitting there, in a sort of trance, like a yogi, and even if I didn't see her I'd feel it in my bones—that she was making every sound, even the rustle of her dress, for your benefit, throwing you smiles you didn't see. . . . Well, I won't stand for that, I prefer to choose my hell; I prefer to look you in the eyes and fight it out face to face.[71]

Blood on Snow: Simone Weil

Of all the philosophers in this study, Simone Weil has the clearest claim to sainthood, and the very essence of her writings is a sincere and religiously rooted asceticism that plunges deeper into the original ideals of denial than any other figure under consideration here, including Hopkins. Her schoolmates called her the "Red Virgin," and biographers seem to think the nickname remained apt until her horrible, utterly ascetic death at age thirty-four (she starved herself). She dressed in men's clothes and looked on pleasure—even beauty—as dishonesty. Her suicide has been linked to the migraines she suffered from her time as a brilliant undergraduate philosophy student at the Ecole Normale in Paris. The rhythm of work was fundamental to her thinking, and derived directly from experience. As she wrote, "It is at once inevitable and fitting that work should involve monotony and tedium; indeed, what considerable earthly undertakings in whatever domain have ever been free of tedium and monotony? There is more monotony in a Gregorian Chant or a Bach Concerto than in an operetta. This world into which we are cast *does* exist; and we are indeed obliged to journey painfully through time, minute in and minute out."[72]

These are not the idle musings of a spoiled philosophy grad student. During France's effort to gear up for World War II, Weil worked in a Renault factory, as well as other industrial plants. Taylorisation was becoming popular in Europe—an industrial management theory that was meant to maximize productivity through the acceleration of the production line,

with particular attention to its *rhythm*. Weil's day was spent drilling, cutting, and inserting metal parts. It was too exhausting, and she had to leave the factory for a holiday in Portugal with her parents in the summer of 1935. Most biographers concur in tracing the beginnings of her fervent Christianity to this lull.

She carried a rifle in Spain in 1936–37, spilled hot water on her foot in a kitchen accident, and had to retire to Montana in Switzerland and to Florence, where she spent the spring of 1937. That was a period of artistic awakening, fed by long, rapturous afternoons at the Uffizi and intensely emotional visits to the little Romanesque chapel where Saint Francis had prayed. She spent ten days around Easter at the Benedictine Abbey of Solesmes, where, under the influence of the Gregorian chants she heard, she experienced a mystical revelation. There she met John Vernon, an Englishman, who introduced her to the metaphysical poets, particularly George Herbert, John Donne, and Richard Crawhaw (Herbert's poem "Love" is a fundamental point of reference for much of her writing). Although during World War II she spent a great deal of time reading the Bhagavad Gita, her powerful attachment to Christianity would persevere to the end of her life. Hers is a spirituality like that of the medieval ascetics—tightly wrapped in the sensation of pain and the ideal of purity: "Blood on snow. Innocence and evil. That evil itself may be pure. It can only be pure in the form of suffering, and the suffering of someone innocent. An innocent being who suffers sheds the light of salvation upon evil. He is the visible image of the innocent God. That is why a God who loves man and a man who loves God have to suffer" (412–13).

For Weil, the "extinction of desire" was an imperative, particularly in an era when belief was in a state of crisis. As she wrote, "Today it is not nearly enough merely to be a saint, but we must have the saintliness demanded by the present moment, a new saintliness, itself without precedent" (p. 114). The "warm silence" of Weil's "void" may be closest in spirit to the "artistic silence" of Cage. As Weil observed, "The infinity of the ordinary expenses of perception is replaced by an infinity to the second or sometimes the third degree. At the same time, filling every part of this infinity of infinity, there is silence, a silence which is not an absence of sound but which is the object of a positive sensation, more positive than that of sound. Noises, if there are any, only reach me after crossing this silence" (p. 115).

The distance and mental barriers she creates are a triumph of personal asceticism. Reminiscent of the work of Mallarmé and Cage, the multidimensional labyrinth of silence protects Weil, in her prized solitude, from the threats to her concentration. Part of her self-imprisonment, in a way that Halley explored, involves the use of language:

At the best, a mind enclosed in language is in prison. It is limited to the number of relations which words can make simultaneously present to it; and remains in ignorance of thoughts which involve the combination of a greater number. These thoughts are outside language, they are unformulatable, although they are perfectly rigorous and clear and although every one of the relations they involve is capable of precise expression in words. So the mind moves in a closed space of partial truth, which may be larger or smaller, without ever being able so much as to glance at what is outside. (p. 330)

The exalted title of *Lectures on Philosophy* belies the modest circumstances and relaxed atmosphere of the high school class notes, from a course that Weil taught in 1933–34, that these writings are culled from by an editor. She held her lessons in a little pavilion away from the main school building of the lycée in Roanne, a town near Paris, and on days when the weather was pleasant enough she would move her charges to the shade of a big cedar tree. Like Mallarmé, she was bounced from school to school, running home for support between crises. Her first job was in Le Puy, seventy miles southwest of Lyons, but the authorities grew alarmed at her political activism among local factory workers and unemployed demonstrators, so they promptly had her transferred to other turf. She was considered by the authorities to be an abominable teacher, and her unconventional methods led to her dismissal within a year. Using William James, Wittgenstein, and Bergson as points of reference, as well as her beloved Plato, she taught "the role of the body in thought" and the importance of studying matter to find mind. In one lesson she annihilates all the senses as reliable sources of knowledge. Sight goes by the board, in a manner reminiscent of Wittgenstein, because it is too unreliable. "Sight presents us with an aggregate which is infinitely diverse and changing, "she observes.[73] She proceeds through touch, smell, and taste in the same way, maintaining that they not only isolate themselves from each other but that they "teach us nothing at all."

This brings us to the concept that is the most directly useful aspect of Weil's thought in a consideration of the role of asceticism in contemporary aesthetics—the idea of "decreation." Weil reveals the difference between what she calls decreation and what Modernism considers destruction. The distinction is vital: "Decreation: To make something created pass into the uncreated. Destruction: To make something created pass into nothingness. A blameworthy substitute for decreation."[74] While Wallace Stevens and others—we could mention the art of Mark Milloff, Nancy Haynes, and Giacometti here—see the analogy between decreation and their own aesthetic practice, for Weil this involves the annihilation of self in order to create an intellectual order. As she wrote, "We

participate in the creation of the world by decreating ourselves."[75] In a way more reminiscent of Beckett than the Bible, Weil paradoxically joins the *via negativa* of Modernist thought and aesthetics, anticipating the trajectory of Adorno, Foucault, Derrida, and others. Shunning the earthly beauties of the body and of art, she takes asceticism to its extreme. The only way in which this can be reversed is by recourse to faith, in which philosophy and poetry are abandoned for prayer: "A few minutes pass like this in silence. The heart empties itself of all its attachments, frozen by the imminent contact of death. A new life is received. which is made purely of mercy. That is how one should pray to God."[76]

An Effaced Order: Michel Foucault

In the wake of Michel Foucault's canonization through David Halperin's Sartrian hagiography, *Saint Foucault*, the ascetic characteristics of his writings and life grow more conspicuous. His preoccupation with asceticism is shown in the privileged place he gives to the study of punishment, pain, illness, the limits and laws of desire, and most important, death and redemption. The last sentence of the preface to his masterpiece, *The Order of Things*, invokes the metaphor of a silent desert that, although it can bloom again, is a shifting and uncertain place for man: "In attempting to uncover the deepest strata of Western culture, I am restoring to our silent and apparently immobile soil its rifts, its instability, its flaws; and it is the same ground that is once more stirring under our feet."[77]

For theorist, particularly those of the deconstructive persuasion, this "instability" is fertile ground. Foucault distanced himself from the Apollonian strain of structuralism to give himself a Mondrianesque overhead view of the mechanisms of observation from which they themselves can be observed. In his attempt to prepare the reader for *The Order of Things*, Foucault expert Allen Megill enumerates its ascetic qualities: "It is to enter into a world that is strangely silent and unmoving, into a frozen world of penetrating glances and arrested gestures."[78] Reaching that height is tricky, however, and involves an ascetic process of withdrawal. Canonizing Foucault along the lines of Sartre's elevation of Genet to sainthood, David M. Halperin notes the role of asceticism in his work:

Modern versions of ascesis may be thematically or materially opposed to the ancient ones, then, but the two versions can nonetheless be thought of as structurally isomorphic. What ultimately links the modern with the ancient forms of ascesis is the technique of cultivating a self that transcends

the self—a radically impersonal self that can serve as a vehicle for self-transformation because, being nothing in itself, it occupies the place of a new self which has yet to come into being. The dimension of the self that makes it a site of irreducible alterity nowadays is no longer the divine spark that dwells within it, of course; instead, it is the subject's determination by history. It is no longer divinity but history (in which category I also include language and the Symbolic) that guarantees us an experience of the Other at the core of our own subjectivity and brings it about that any direct encounter with the self must also be a confrontation with the not-self.[79]

For Halperin and others, the importance of Foucault is not simply confined to what he wrote but encompasses his life as well, and this is where his ascetic nature becomes more problematic, along the lines of the same issue in a consideration of Mapplethorpe or Harte Crane, who also happened to be gay, or even a dandy like Debussy. Simply put, Foucault was promiscuous to the point of recklessness, particularly late in his life when he found his excitement having anonymous sex in San Francisco bathhouses. There are vignettes from the life of Foucault that point to his ascetic nature, including his habit of speaking in the third person, his constant invocation of anonymity (he said he wanted to drown his voice in "the great, anonymous murmur of discourses"), and the monk-like shiny bald head that, like a beacon, attracted so many fashionable intellectuals to his lectures at the Collége de France, to which he was elected at the age of forty-three. My favorite anecdote about Foucault concerns his trip to Tunisia in September 1966, in search of the legendary land of the Thebaid. In Tunisia he wore white robes (rather than black leather) and affected a particularly monastic mien. He was visited there by Jean Daniel, an editor of Le Nouvel Observateur, and Jean Duvignaud, a sociologist studying Tunisia. Foucault's biographer, David Macey, relates the story:

> Daniel was introduced by Duvignaud to "a sort of frail, gnarled samurai who was dry and hieratic, who had the eyebrows of an albino and a somewhat sulphurous charm, and whose air and affable curiosity intrigued everyone." His attitude of "ceremonious humility and Asiatic politeness" was, thought Daniel, an effective device for keeping unwanted strangers at a distance. The samurai lived in a converted block of stables which had reputedly once belonged to the bey, or provincial governor. The full-length windows overlooked the sea and gave directly on to the street. The main room was kept cool and dark, and at the far end up there was a raised platform where Foucault slept on a mat which could be rolled up and put away during the day. Daniel, like most people, was immediately struck by

the smile which split the samurai's face in two. His first impression was that this was a man who was torn between the temptations of pleasure and a wish to resist temptation by transforming it into an ascetic conceptual exercise.[80]

That tension between rampant sensuality and the ascetic life of the intellect is an important factor in the study of Foucault. The strain of mediating between those two forces occasionally shows in Foucault's prose, as when he is discussing the problem of "man's finitude" in *The Order of Things* and considers the importance of laws in the "naked opening of Desire." As in Plato, the "forms of finitude" are, ultimately, death-centered. He resorts to psychoanalysis to help form the "law-language" in which the relationship between Death and Desire is articulated. As with Weil, there is a longing for "another world," but in the present age the way leads to madness: "And precisely when this language emerges n all its nudity, yet at the same time eludes all signification as if it were a vast and empty despotic system, when Desire reigns in the wild, state, as if the rigor of its rule had levelled all opposition, when Death dominates every psychological function and stands above it as its unique and devastating norm—then we recognize madness in its present form, madness as it is posited in the modern experience, as its truth and its alterity."[81]

The emotions running strongly beneath this passage include both fear and desire, as well as another kind of resignation that finds such madness, that "alterity," faintly attractive. His biographers suggest that Foucault, cruising in an age of AIDS, was fascinated by the link between Eros and Thanatos, wildly freeing himself from the ascetic constraints of system. Yet if you already know the last sentences of *The Order of Things*, then you know that the return of order is necessary; and even that will not stop a greater ascetic gesture embodied in the erasure of man, the last image of that great book: "one can certainly wager that man would be erased, like a face drawn in sand at the edge of the sea."[82]

The Poet as Pilgrim: Seamus Heaney

When Seamus Heaney won the Nobel Prize in literature in 1995, admirers pointed to his deft ability to stay above the fray in Ireland and maintain an aesthetic distance that was warmer than the nasty indifference of James Joyce's creator paring his fingernails. According to Heaney, this ability to abstract himself from conflict and find a "secret nest" was natural to him even as a child. In a short autobiographical prose piece about his original poetic stirrings, Heaney describes the quiet farmyard

in County Derry that was the center of his childhood. Even as American bombers flew in and out of the base at Toomebridge during World War II, Heaney's attention is fixed on the rhythmic music of the water pump in the yard:

> I would begin with the Greek word, *omphalos*, meaning the navel, and hence the stone that marked the center of the world, and repeat it, *omphalos*, *omphalos*, *omphalos*, until its blunt and falling music becomes the music of somebody pumping water at the pump outside our back door. It is County Derry in the early 1940s. The American bombers groan towards the aerodrome at Toomebride, the American troops manoeuvre in the fields along the road, but all of that great historical action does not disturb the rhythms of the yard. There the pump stands, a slender, iron idol, snouted, helmeted, dressed down with a sweeping handle, painted a dark green and set on a concrete plinth, marking the center of another world. Five househoulds drew water from it. Women came and went, came rattling between empty enamel buckets, went evenly away, weighed down by silent water. The horses came home to it in those first lengthening evenings of spring, and in a single draught emptied one bucket and then another as the man pumped and pumped, the plunger slugging up and down, *omphalos*, *omphalos*, *omphalos*.[83]

This passage touches many of the ascetic notes that Heaney plays throughout his poetry. For one thing, it is the steady, repetitive rhythm of work that meditatively takes him away from other realities into its own reality, somewhat as Miró became lost in the familiar visual rhythms of *The Farm* or as Frank Lloyd Wright sought salvation in the steady rhythms of rural work. The passage of characters silently in and out of the scene reminds us of the importance of pilgrims and the pilgrimage to Heaney's work, particularly with respect to the great lyric sequence *Station Island*. Finally, like Mark di Suvero nosing about the fragments he can use in new works, there is a creative pattern of renewal in Heaney's discovery of music in the common sounds of the farmyard. Much of Heaney's poetry involves the act of writing as another kind of work. A frequently anthologized early lyric titled "Digging" compares the poet at his desk, clutching his pen "snug as a gun," with his father outside the window digging in the flowerbeds. Heaney tunes in briefly to the rhythmic sound of his father, who, like Heaney's grandfather and other forebears, was known for how well he "handled a spade," as he works, "Nicking and slicing neatly, heaving sods / Over his shoulder, going down and down / For the good turf."[84] In the poem's last lines he focuses again on the pen resting in his hand and vows, "I'll dig with it."

The labor of poetry is part of Heaney's strategy for countering the world about him, a notion of "redress" that he borrows from Simone Weil's *Gravity and Grace* and expands through a discussion of her favorite poet, George, whose bursts of rapture that break the proportions of measure are the qualities that endear him most to Heaney. In an essay titled "The Redress of Poetry" that Heaney used to open his series of lectures as professor at Oxford in 1989, Heaney analyzes "Weil's law":

> "Obedience to the force of gravity. The greatest sin." So Simone Weil also writes in *Gravity and Grace*. Indeed her whole book is informed by the idea of counterweighting, of balancing out the forces, of redress—tilting the scales of reality towards some transcendent equilibrium. And the activity of poetry too, there is a tendency to place a counter-reality in the scales—a reality which may be only imagined but which nevertheless has weight because it is imagined within the gravitational pull of the actual and can therefore hold its own and balance out against the historical situation. This redressing effect of poetry comes from its being a glimpsed alternative, a revelation of potential that is denied or constantly threatened by circumstances. And sometimes, of course, it happens that such a revelation, once enshrined in the poem, remains as a standard for the poet, so that he or she must then submit to the strain of bearing witness in his or her own life to the plane of consciousness established in the poem.[85]

This fascination with the hypnotic but cleansing rhythms of work is reflected in Heaney's poems about rural Ireland, whether in the "Lough Neagh Sequence" about the fishermen's dangerous routine; the peat bog cutters and potato diggers of Derry, the seed cutters, the smith inside "the door into the dark" who labors "to beat real iron out" at a forge that Heaney compares to an altar, the cairn-maker piling up stones, or the thatcher replacing a cottage roof. It is the dominant theme of a decade of Heaney's poetry, bracketed by two of his greatest volumes, *Door into the Dark* (1969) and *Field Work* (1979). As he observes in "The Seed Cutters," repetition becomes ritual and, in an ascetic identification with the cutters that is also a moment of self-effacement, Heaney invokes their common anonymity:

> O Calendar customs! Under the broom
> Yellowing over them, compose the frieze
> With all of us there, our anonymities.[86]

The pun on "frieze" points to another of Heaney's ascetic images: the cold, which in volumes like *North* and *Wintering Out* becomes a constant

reminder of death and the difficulty of love. In a way that is distinctly reminiscent of Glenn Gould's infatuation with "the idea of North," Heaney stands on the shore of Ireland, contemplating from a distance Greenland and Iceland and the Viking conquerors who preceded him, and counsels himself to compose with a Yeatsian "cold eye":

> Compose in darkness.
> Expect aurora borealis
> in the long foray
> but no cascade of light.
> Keep your eye clear
> as the bleb of an icicle,
> Trust the feel of what nubbed treasure
> your hands have known.[87]

One theme in particular brings Heaney's asceticism into focus: the pilgrimage. From his earliest volumes, the imagery of pilgrimage has served Heaney's design for transcendence by offering a transition from the workaday to the metaphysical. In the early lyric "At a Potato Digging," the ranks of farmworkers following the mechanical digger through the furrows of a cold field, kneeling and stumbling along in "a higgledy line from hedge to headland" are recast as pilgrims bowing to the "famine god" with their "processional stooping through the turf."[88] Gradually, through the course of Heaney's career, the rhythms of labor have given way to those of the pilgrimage, and the vague Celtic flavor of the religious overtones have crystallized in a more overtly Christian context.

These tendencies culminated in a richly emotional lyric sequence published in 1985 as the Station Island poems. Station Island is an actual pilgrimage site, a small, windswept island on Lough in county Donegal, where Saint Patrick began the annual tradition of a three-day penitential vigil. Today's pilgrims spend the three days in prayer and fasting, walking barefoot from station to station. Each of the stations is a small stone circle around a cross, said to be the remains of early medieval monastic cells. Heaney's cycle uses contemporary dream encounters with ghosts out of his own past, whose stories and voices are full of modern incidents from Irish history or personal experiences. The whole sequence is powerfully reminiscent of episodes in Joyce's *Portrait of the Artist as a Young Man*, the poetry of Saint John of the Cross and, more generally, Dante's *Divine Comedy*, portions of which Heaney has translated (notably, Heaney's version of the Ugolino episode in *Inferno* for the volume *Field Work*).

The opening of the first poem is filled with the church bells summoning the hurrying faithful, who whisper "Pray for us, pray for us" as they

hustle along in the silence of a Sunday morning. The ghost of a worker with a bow saw, disdaining the Sabbath, chides Heaney for following them, but he stays on the "drugged path" cleared by the other pilgrims. This sets the pattern for the twelve lyrics, which like Barnett Newman's paintings, correspond to the stations of the pilgrimage as well as the Stations of the Cross. The third lyric begins with a memory of being in church ("I knelt. Hiatus. Habit's afterlife . . . I was back among bead clicks and the murmurs from inside confessionals"). The ascetic qualities of emptiness and repetition are particularly strong: "I thought of walking round / and round a space utterly empty, / utterly a sources, like the idea of sound."[89]

As the language of renunciation becomes stronger, the poet is drawn deeper and deeper into the emotional state of the pilgrim. Memories of school days, old girlfriends, a soccer teammate murdered in the Troubles all come to disturb his prayers, but he plods on with determination. In the twelfth poem, a fascinating transition, particularly from a stylistic point of view, takes place. It opens with a memory of plunging a prism into a fountain, and learning to read poems as prayers. Then the poem turns into a prayer:

> That eternal fountain, hidden away,
> I know its haven and its secrecy
> although it is the night.
> But not its source because it does not have one,
> which is all sources' source and origin
> although it is the night.
> No other thing can be so beautiful.
> Here the earth and heaven drink their fill
> although it is the night.
>
> (pp. 89–90)

What has happened? The change from the preceding eleven lyrics has been so abrupt as to catch many readers off guard. Then you realize that you are reading a prayer and that, remarkably, the distinctive voice, the grain of Heaney's style, has been lost. The chorus of the pilgrims has mastered, or drowned out, Heaney's modern, partly doubting, and always circumspect lyric "I." It is an astonishing moment with the greater context of Heaney's career, which is always attentive to the cultivation of that post-Wordsworthian wise voice that continually relates daily observation to the craft of poetry. Here we are at a fountain, but the concern is far more religious tan literary, despite the conventional link between fountains and muses. The choral voice maintains its hold upon him:

This eternal fountain hides and splashes
within this living bread that is life to us
although it is the night.
Hear it calling out to every creature.
And they drink these waters, although it is dark here
because it is the night.
I am repining for this living fountain.
Within this bread of life I see it plain
although it is the night.

(pp. 90–91)

The effect of the ascetic ritual has been so powerful that Heaney's or-
dinarily strong voice has been transformed temporarily. His self-efface-
ment only lasts for one poem. At the beginning of the twelfth there is a
return, physically weakened, from the experience: "Like a convalescent, I
took the hand stretched down from the jetty." The old Heaney is back,
determined to relate the experience of the pilgrimage to the writing of
poetry. The ground of the real world offers "alien comfort" and the
"fish-cold bony" hand that grips his introduces a new ghost, who warns
him, "Your obligation is not discharged by any common rite." He is sent
home to write "for the joy of it" and to turn his religious experience, crit-
icized again as a "peasant pilgrimage," into motivation for new work A
Yeatsian voice urges him to "cultivate a work-lust," to write in English,
to clear his head again. Behind all this, the reader senses the inevitability
of his return to Station Island. The final words of wisdom are directed to-
ward the notion of maintaining a point of contact that is also a position
of distance—"keep at a tangent"— itself an ascetic strategy:

You lose more of yourself than you redeem
doing the decent thing. Keep at a tangent.
When they make the circle wide, it's time to swim
out on your own and fill the element
with signatures on your own frequency,
echo soundings, searches, probes, allurements,
elver-gleams in the dark of the whole sea.

(pp. 93–94)

How Perfect Is It: Walter Abish

"I am a perfectionist," Walter Abish admits with a smile as he patiently
guides me to an understanding of how the ascetic ideal works in his

The novelist Walter Abish, author of *Eclipse Fever (1995)* and *How German Is It* (1981) notes, "Art is a great passion for me, the most meaningful thing in the world, and I am afraid we are living in a society in which this is not valued. If an ascetic retreat is what it takes to hold onto this ideal, then we must be ascetics." Photo: © Cecile Abish.

award-winning, critically acclaimed fiction, including the masterful novel *How German Is It*, which many consider the most important novel by an American writer of the past decade. Without directly pointing to one moment or another as an example of what is ascetic in his most recent novel, *Eclipse Fever*, he lays the groundwork for a reading of his work that in some way matches what is important to him as he is creating it. Abish offers a string of valuable clues to grasping his method:

> Placement, accentuated by references to seeing, and by the use of art objects or of italics, is important. I deal with how we really see. A constant framing of the scene—of a building, for example—enables me to investigate, and keep a distance. having framed the event, I can come back to it and keep it integral. Irony and the constant use of questioning or secrets are also distancing effects. There's no such thing as formlessness. In my

work you have a constant attention to form, and awareness of it. You find this in the crossings and diagonals of characters, an almost diagrammatic choreography that follows a precise structural intentionality. That is why the overhead views are so important. Being alert to one detail creates a heightened sense of awareness to all.[90]

These seem like impossibly high standards to set in our time, either for readers or for the writer. Yet Abish in his unrelenting, even heroic, rigor creates fiction that one reads as one plays a Haydn sonata, knowing at every moment in the piece, from the crystalline structure and nuanced use of repetition, exactly where one is—how far from the beginning and from the cadence a phrase occurs. It would be difficult to demonstrate this uncanny effect in a critical study, but perhaps a few brief examples of Abish's virtuosity will be a sufficient lure to bring more readers to a fuller appreciation of his craft.

In the early short story "Minds meet," which uses a Mexican desert setting, as does *Eclipse Fever*, the theme of abstinence is playfully approached through the repeated question of how a mysterious message can be delivered. One part of the story, subtitled "The Ability to Read the Message," offers a glimpse into Abish's use of incremental advances in realization and comprehension through the estranged analysis of an action that is entirely familiar. As Abish writes,

> To slide open the window and let in the cold air is to initiate an action with irreversible results. As the mind relinquishes the visual implosion, the brain cells rush items of urgent information back and forth in blind haste . . . a kind of paralysis sets in. Intention is frozen in incertitude. People are confident that they control the opening and closing of their windows . . . it imbues them with a misleading certitude that is bound to have widespread repercussions. Men think nothing of it when at night their wives ask them to shut the window. Naked they jump out of bed . . . some never make it to the window . . . some never make it back. . . . Who is to measure the perils that one may encounter between bed and the opening, that rectangular opening in the wall.[91]

Buried within this short text are the marks of the ascetic that one finds throughout his fiction. They include the rush of cold air and "frozen" intention, the "blind haste" followed by "paralysis" and paranoia, and, most important, the underlying passivity that goes with acute receptivity or, in Heideggerian terms, "attunement" to sensation or fear. As in Musil or Bernhard, characters find themselves taken prisoner by imagined dangers. Even in a darkly comic context such as this (and much of Abish's fiction has its undeniably funny moments despite its terribly serious subject

matter), you can pick up that sense of foreboding that he, often using his extensive understanding of contemporary art and cinema, cultivates in all of his work.

The trace elements that Abish scrutinizes in his fiction are all taken from what Hegel eloquently analyzed as "the familiar." As in the fiction of Proust or the studio of David Smith, familiar objects, routines or habits, sensations, and even phrases are picked up and transformed by Abish. As he states,

> The presentation of the "familiar world" is not an innocent one. To me, the familiar details are also *signs* of a familiar world. In projecting these *signs* I am aware of my own preoccupation with the "familiar" and the presentation of it. Essentially, I am questioning how we see and write about something. Levi-Strauss, wherever he went in Brazil, embodied Western clutter. How could he avoid that? He reduced everything to *signs* in order to comprehend it. At the same time his own cultural as well as personal history may distort the signs he uses by attaching a particular Western significance to them. Perhaps that is why I feel that the text I write lies between me and the experience.[92]

It is the distancing effect of the text itself, the way it intervenes between Abish and the experience, that most distinctly echoes both Proust and Pater. The critical Paul Wotipka elaborates on how this functions in the context of the novels, particularly with respect to the "technical" style of the writing: "Familiarization in the novel functions as a process of converting experience into discrete, reproducible, and easily circulated images or cliches. Not content with a mere presentation of recognizable images in a verbal style that is remarkably impersonal and unoriginal—a kind of 'technical writing'—Abish persistently thematizes the familiar and thereby produces uncanny effects."[93]

The novelist's reference to Levi-Strauss and the notion of the anthropologist as visitor is interesting in light of the exotic locales that Abish picks. Abish grew up in Shanghai during the Japanese occupation and lived in Austria, Israel, and England before settling in Manhattan. His novels have been set in Africa, Germany, and Mexico, and an early play was set in China following the revolution. Amazingly, he writes about these exotic locales before visiting them or on the basis of the briefest of experiences. For example, brief stops in South Africa, Port Suez, and West Africa with his parents were the only firsthand experience of Africa before *Alphabetical Africa* was written; and he had never been in Germany when he wrote *How German Is It* or in Mexico before *Eclipse Fever*. After the books were finished, he visited both places—once he was sure that the real Germany or Mexico could not alter the imaginary one

concocted from a mix of books and films that Abish uses in his extensive research.

Right from the beginning of *How German Is It*, Abish is firing off questions left and right. Even though the question mark is left off the title, the text is dominated by an unrelenting interrogative mode, which gives way dynamically to the imperative at times. Abish uses italics as a composer might instruct a string quartet, at the end of a movement, to dig into the opening of the next movement immediately and with emphasis: *attacca*. In *How German Is It*, the phrase that effects this is the italicized order, "Answer. Answer immediately." As one example from *How German Is It* of how the interrogative has an ascetic effect, there is a testy exchange in a bookstore between its hero, Ulrich, who has returned "home" to Germany to explore a modern city built on the site of a concentration camp, and his neighbor, Daphne, a young American student of the philosopher Brumhold for whom the city is named (based on the life of Heidegger). The scrutiny with which characters regard one another in Abish's fiction is like a searchlight. The women forget nothing; the men believe nothing. Daphne is holding a monograph about Dürer. Ulrich explains that his mother's maiden name is Dürer and that his family had at one time owned six drawings and watercolors by the artist, although now they have just one. He begins to describe a drawing called the *Double Goblet*—one ornate goblet balanced head down on the other, which can be read in a sexual way. The challenge to seeing ever more acutely dispels the erotic aspect of the exchange, "cleansing" the conversation by turning it into a threat:

> You like that, don't you, she said, challenging him.
> What? The sexual content?
> No, the duality in the picture. Seeing something that others may overlook.
> She looked startled when he said: Why are you attacking me?[94]

The interrogative mode also extends to Abish's use of interviews in *How German Is It*. One of the most interesting is the cameo appearance of a Heidegger-like philosopher named Brumhold who consents to an interview on his eightieth birthday. The question-and-answer format of so much of Heidegger's writings gives way to journalistic interviewing conventions. he goes on—Abish uses the flat verb *states*—about the daily routine of a long walk in the forest, the three hours of writing at his desk, followed by a nap and a brief interval to do his correspondence. It is one of several instances of characters attempting to perfect their lives through habit. As the old philosopher says, "I live, he stated, in a log cabin I built many many years ago in the forest. The forest, at least in our vicinity,

hasn't changed. I live simply. I do not have a radio or a television set. I have little time left, and I try to spend it speculating about things that matter."[95]

The technique of "framing" that Abish explained is most beautifully demonstrated in the way in which he portrays Ulrich and the rest of the Hargenau family from "outside" perspectives, using an old family retainer named Franz, for example, or in one stunning scene a sexy photographer named Rita. In a section called "Sweet Truth" she documents her relationship with Ulrich's powerful brother, focusing on the familiar and allowing that sense of being manipulated to surface, drawing our attention to the way in which Abish maneuvers his characters:

> Rita Tropf-Ulmwehrt photographs the hotel room before they leave. She photographs the unmade bed they have slept in, the table from which the traces of their recent breakfast have not yet been removed, the bathroom, the closet, but she pointedly avoids photographing his scowling suspicious face. He, in turn, with a great deal of self-control, restrains himself from asking her what she thinks she is doing. What, after all, is the purpose of this documentation? At this stage, if he could have gracefully, the key word here is *gracefully*, changed their plan and headed back home, he would have done so. Not because he had lost interest in Rita Tropf-Ulmwehrt—he would not lose interest in her as long as she retained any sort of interest in him. But because it suddenly occurred to him that he was being maneuvered.[96]

The psychologically intense way in which Abish's characters maneuver one another is powerfully felt in his recent novel *Eclipse Fever*. The story traces the paths across the desert of a literary critic, his wife, and a young girl who runs away from her father, ostensibly to see an eclipse in Mexico although she ends up watching it on television. Her father is having an affair with the wife of the literary critic. Abish originally thought of setting it in Italy but felt that it would have tempted him to be too lyrical. "I like Italy too much, and I wanted a rougher texture," he says.[97] From the epigraph, taken from Buñuel's *That Obscure Object of Desire*, chosen to work the title of the film into the novel, to the symbolism of the desert, sacrifice, and ruin, the novel is a continually ascetic meditation on an issue of particular concern to Abish. As he explains, "A serious reading of the novel must take into consideration that it is the muse, the source of our inspiration, that is being eclipsed."[98] He translates this fear in a Mondrianesque overhead view of the desert:

> And here and there, half buried, the traces of past incursions. . . . Now and then someone on foot or on a mule will cross the emptiness. From where to

where? Does it really matter? It certainly wasn't the Mexico the tourists had
come to visit—that's for sure. The fiestas, the processions, the fireworks, the
Spanish Baroque churches and cemeteries, the passion plays, not to mention
the Aztec and Mayan ruins, the picturesque inlets and harbors on the new
tourist coast, with the broadly smiling Mexican faces and its inviting Amer-
ican-Express-and-Visa-recommended fish restaurants and four-star hotels—
these were elsewhere. On the same highly detailed photograph taken from
approximately two hundred kilometers above the Pemex station, the satel-
lite showed heading south the advancing line of cars—a Honda Accord, a
Ford Impala, a twenty-six-foot Gulfstream Conquest class CRV, and a
speedy Nissan Maxima, an old Silver Mercedes, a BMW two-door seadan,
two VWs—a Beetle and a red Sirocco—and a nondescript delivery van, in
groups of threes and fours and fives spaced less than a mile apart.[99]

Like pilgrims, the mundane string of cars passes anonymously by the
satellite camera, leaving their traces. Abish's diagrammatic mind creates
a geometry of near-misses and encounters for his characters that main-
tains a rigid distance, as ascetic as the desert setting or the ruined statu-
ary of a museum that is described in a way that shows how framing, too,
is a subtle means of alerting us to the level of significance of every sym-
bolic detail. Like Miró painting his family's farm with an even sunlight
that treats every detail in the same unsparing way, like Glass discovering
that "all the notes are equal," Abish describes the museum, which, like
the architecture of *How German Is It*, is supposed to be part of a pro-
gram to "cleanse" Mexican history, despite being a corrupt backdoor
source of artifacts for dealers. As Abish describes it,

Facing them as they stepped into the vast courtyard was a cluster of life-size
busts, their condition so lamentable and their placement so arbitrary that
Rita concluded they were being discarded. From where they stood they
could see that crisscrossing the entire courtyard were deep trenches, with
untidy heaps of funerary sculpture and gravestones next to the mounds of
freshly dug up reddish earth. On the far side, two bare-chested men were
digging energetically, but not with the caution required for an excavation.
Why all these trenches? Bonny wondered. Half a dozen sprinklers directed
an intermittent circular trail of water on the straggly uneven patches of yel-
lowed grass. In the full glare of the midday sun, everything looked parched,
worn to the bone, hopelessly neglected. Even the shady arcades did not ap-
pear inviting. What had she expected? On the wall to her right, a bewilder-
ing display of stone heads and torso fragments, hands, feet, chests. In the
first hall, a twelve-foot frieze lay on the stone floor, while the bare walls
were covered by ceiling-high metal and wood scaffolding. One wall was

partially repainted. Dented buckets of paint and brushes had been left in one corner, as if discarded by the painters. Following the trail-like drips of beige paint on the floor, they finally reached another courtyard, in a similar state of disrepair.[100]

It is remarkable to think of descriptive writing like this being possible without the direct experience of visiting a museum in Mexico on which it could be based. This is the kind of fiction of ideas, engaged with philosophy and history, that Santayana was dreaming of when he wrote *The Last Puritan* but which our era's reader is not always ready to consider with the degree of care it requires. It is part of a struggle, a crusade that Abish and others (some of them martyrs to their art) face in their work, which makes asceticism their armor. There is one final point that Abish needs to make before our interview is over, involving that notion of cultural eclipse. He leans forward, fixes me with a steady stare, and says, with no trace of irony whatsoever, "Art is a great passion for me, the most meaningful thing in the world, and I am afraid we are living in a society in which this is not valued. If an ascetic retreat is what it takes to hold onto this ideal, then we must be ascetics."[101]

Notes

Introduction

1. Brice Marden, interview by author, February 1996.

2. Wendy Steiner, *The Scandal of Pleasure: Art in an Age of Fundamentalism* (Chicago: University of Chicago Press, 1995), p. 59.

3. Walter Pater, *The Renaissance*, ed. Donald Hill (Berkeley: University of California Press, 1979), p. 23.

4. Walter Pater, "Style," in *Prose of the Victorian Period*, ed. William E. Buckler (Boston: Houghton Mifflin, 1958), p. 559.

5. Francis Steegmuller, ed., *The Letters of Gustave Flaubert*, vol. 1. (Cambridge, Mass.: Harvard University Press, 1980), p. 158.

6. Rainer Maria Rilke, *Letters on Cézanne* (New York: Fromm, 1985), pp. 20–21.

7. Charles Baudelaire, "Le Gouffre," trans. Robert Lowell, *Imitations* (New York: Farrar, Straus, 1958), p. 56.

8. Richard Ellmann, *The Modern Tradition* (New York: Oxford University Press, 1965), p. 928.

9. *New York Times*, Sunday, November 9, 1986, sect. 2, p. 1.

10. Wallace Stevens, *Collected Poems* (New York: Knopf, 1954), p. 373.

11. Jacques Derrida, *Spurs*, trans. Barbara Harlow (Chicago: University of Chicago Press, 1979), p. 93.

12. Yves Bonnefoy, *The Lure and Truth of Painting: Selected Essays on Art* (Chicago: University of Chicago Press, 1995), p. 109.

13. Ibid., pp. 108–9.

14. Harold Bloom, *The Anxiety of Influence* (New York: Oxford University Press, 1973), p. 116.

15. Ibid., pp. 116–17.

16. Geoffrey Galt Harpham, *The Ascetic Imperative in Culture and Criticism* (Chicago: University of Chicago Press, 1987), p. xi. Subsequent references to this work are cited by page number in the text.

17. Robin May Schott, *Cognition and Eros: A Critique of the Kantian Paradigm* (Boston: Beacon Press, 1988), p. 58.

18. E. M. Cioran, *Tears and Saints*, trans. Ilinca Zarifopol-Johnston (Chicago: University of Chicago Press, 1995), p. 75. Subsequent references to this work are cited by page number in the text.

19. Witold Rybczynski, *Home: A Short History of an Idea* (New York: Viking, 1986), pp. 195–216.

20. *The Simone Weil Reader* (New York: Putnam's, 1980), p. 318.

21. Cioran, *Tears and Saints*, p. 101.

22. Katherine Bergeron, "The Virtual Sacred: Finding God at Tower Records," *New Republic*, February 27, 1995, pp. 32–34.

The Ascetic Ideal in Contemporary Painting

1. Francesco Clemente, "The Conversion of St. Paolo Malfi," *Grand Street*, 55 (February 1995), p. 34.

2. Werner Haftmann, *Painting in the Twentieth Century* (New York: Praeger, 1960), p. 200.

3. John Russell, *The Meanings of Modern Art* (New York: Harper & Row, 1981), p. 233.

4. Mark Cheetham, *The Rhetoric of Purity: Essentialist Theory and the Advent of Abstract Painting* (Cambridge: Cambridge University Press, 1991), p. 55.

5. See Yve-Alain Bois, *Painting as Model* (Cambridge, Mass.: MIT Press, 1990).

6. Yves Bonnefoy, *The Lure and the Truth of Painting: Selected Essays on Art* (Chicago: University of Chicago Press, 1995), p. 101.

7. Piet Mondrian, *Natural Reality and Abstract Reality*, trans. Martin S. James (New York: Braziller, 1995), pp. 66–67.

8. Meyer Schapiro, *On the Humanity of Abstract Painting* (New York: Braziller, 1995), p. 16.

9. Piet Mondrian, *Natural Reality*, p. 130.

10. Schapiro, *On the Humanity of Abstract Painting*, p. 54.

11. *Piet Mondrian*, ed. Angelica Zander Rudenstine (New York: Leonardo Arte in association with the National Gallery of Art and the Museum of Modern Art, 1995), p. 193.

12. Bois, in *Piet Mondrian*, p. 325.

13. *Piet Mondrian*, p. 59.

14. Ibid., p. 356.

15. Yve-Alain Bois, "The Iconoclast," in *Piet Mondrian*, p. 361.

16. Bonnefoy, *Lure and the Truth*, p. 100.

17. Ibid., p. 104.

18. Ibid., p. 106.

19. Joan Miró, *Selected Writings and Interviews*, ed. Margit Rowell (Boston: G. K. Hall, 1986), p. 51. Subsequent references to this work are cited by page number in the text.

20. Piet Mondrian, *The New Art, The New Life: Collected Writings of Piet Mondrian*, ed. Martin James and Harry Holtzman (Boston: G. K. Hall, 1986), p. 40.

21. Miró, *Selected Writings*, p. 210. Subsequent references to this work are cited by page number in the text.

22. *Mark Tobey: Paintings (1920–1960)*, exhibition catalog, Yoshii Gallery, New York, 1994, p. 37.

23. Barnett Newman, *Selected Writings and Interviews*, ed. John P. O'Neill (New York: Knopf, 1990), p. 188.

24. *Newsweek*, May 9, 1966, p. 100.

25. Barnett Newman, *TheSublime Is Now*, in *Abstract Expressionism: Creators and Critics*, ed. Clifford Ross (New York: Abrams, 1990), p. 129.

26. Barnett Newman, *Selected Writings*, p. 140.

27. Ibid., pp. 249–50.

28. Bois, *Painting as Model*, p. 203.

29. John Cage, "Jasper Johns: Stories and Ideas," in *The New Art*, ed. Gregory Battcock (New York: Dutton, 1973), p. 32.

30. Quoted in Cage, "Stories and Ideas," p. 30.

31. Nan Rosenthal and Ruth E. Fine, *The Drawings of Jasper Johns* (New York: Thames and Hudson, 1990), p. 70.

32. Jasper Johns, "Sketchbook Notes," *Art and Literature* 4 (spring 1965), pp. 185–92.

33. Roberta Bernstein, "Seeing a Thing Can Sometimes Trigger the Mind to Make Another Thing," in *Jasper Johns: A Retrospective* (New York: Museum of Modern Art, 1996), p. 90.

34. Wallace Stevens, "The Snow Man," *Collected Poems* (New York: Knopf, 1954), p. 9.

35. Stevens, "Snow Man," p. 10.

36. Robert Mapplethorpe, "Robert Mapplethorpe," *Photo/Design* 2 (August 1985): 44–45.

37. Patricia Morrisroe, *Mapplethorpe: A Biography* (New York: Random House, 1995), p. 30.

38. Cathleen McGuigan, "Walk on the Wild Side," *Newsweek*, July 25, 1988, p. 57.

39. Jack Shear, interview by author, 1993.

40. Barbara Haskell, *Agnes Martin: A Retrospective* (New York: Whitney Museum of American Art, 1992), pp. 11–12. Subsequent references to this work are cited by page number in the text.

41. All quotations from the artist from a personal interview, October 1995.

42. Klaus Kertess, "Thinking Walls," exhibition catalog statement, Pace Gallery, New York, 1992, p. 10.

43. Arthur Waley, trans., in Brenda Richardson, *Brice Marden: Cold Mountain* (Houston: Houston Fine Art Press, 1992), p. 25.

44. Klaus Kertess, *Brice Marden: Paintings and Drawings* (New York: Abrams, 1992), p. 13.

45. Brice Marden, *The Grove Group*, exhibition catalog, Gagosian Gallery, New York, 1991, p. 20. Subsequent references to this work are cited by page number in the text.

46. Robert Pincus-Witten, "Introduction," *The Grove Group*, p. 9.

47. Klaus Kertess, *Brice Marden*, p. 19.

48. Brenda Richardson, *Brice Marden: Cold Mountain* (Houston: Houston Fine Art Press, 1992), p. 69.

49. Ibid., p. 74.

50. Ibid., p. 43.

51. Michael Kimmelman, "Looking at Pictures with Brice Marden," *New York Times*, June 24, 1994.

52. Brice Marden, interview by author, February 1996.

53. Peter Halley, *Collected Essays, 1981–87* (New York: Sonnabend Gallery, 1987), p. 126.

54. Ibid., p. 153.

55. Peter Halley, *Images, Masks, Reflections*, exhibition catalog, Janis Gallery, New York, 1996, pp. 11–12.

56. Frederic Jameson, *The Prison-House of Language: A Critical Account of Structuralism and Russian Formalism* (Princeton, N.J.: Princeton University Press, 1972), p. 12.

57. *The Simone Weil Reader* (New York: Putnam's, 1980), p. 363.

58. I. Michael Danoff, *Peter Halley: Paintings*, exhibition catalog, Des Moines Art Center, 1993, pp. 17–18.

59. Peter Halley, interview by author, February 1996.

60. Ibid.

61. All quotations from Nancy Haynes, interview by author, January 1996.

62. All quotations from Mark Milloff, interview by author, October 1995.

63. Wallace Stevens, *The Necessary Angel* (New York: Vintage, 1951), p. 175.

64. Walter Pater, "Conclusion," *The Renaissance: Studies in Art and Poetry*, ed. Donald L. Hill (Berkeley: University of California Press, 1980), p. 188.

65. Stevens, *Necessary Angel*, p. 36.

66. All quotations from Theresa Chong, interview by author, December 1995.

67. John Cage, *I-VI* (Cambridge, Mass.: Harvard University Press, 1990), p. 427.

68. Burton Watson, ed. and trans., *Ryokan: Zen Monk-Poet of Japan* (New York: Columbia University Press, 1977), p. 89.

Asceticism and Sculpture

1. Hart Crane, *Complete Poems* (New York: W. W. Norton, 1993), p. 114.

2. Jean-Paul Sartre, *Essays in Aesthetics*, trans. Wade Baskin (New York: Washington Square, 1966), pp. 81–82.

3. Ibid., p. 141.

4. Edmund White, ed., *The Selected Writings of Jean Genet* (Hopewell, N.J.: Ecco Press, 1993), p. 317.

5. Ibid., p. 326.

6. Ibid., pp. 327–28.

7. Casimiro Di Crescenzo, *Albert Giacometti: Early Works in Paris (1922–1930)*, exhibition catalog, Yoshii Gallery, New York, April–June 1994, p. 119.

8. David Sylvester, "Modern Masters," in *Artnews,* March 1996, p. 59.

9. Ibid., pp. 59–60.

10. Yves Bonnefoy, *Alberto Giacometti: A Bibliography of His Work*, trans. Jean Stewart (Paris: Flammarion, 1991), p. 382.

11. Ibid., p. 528.

12 Robert Motherwell, "A Major American Sculptor: David Smith," *Vogue*, February 1, 1965, p. 30.

13. Robert Motherwell, *Selected Writings* (New York: Oxford University Press, 1989), p. 202.

14. David Smith, "Notes for 'David Smith Makes a Sculpture,'" in Clifford Ross, ed., *Abstract Expressionism: Creators and Critics* (New York: Abrams, 1988), p. 179.

15. Motherwell, "Major American Sculptor," p. 30.

16. Frank O'Hara, *Art Chronicles, 1954–1966* (New York: Braziller, 1975), p. 53.

17. Smith, "Notes," p. 179.

18. Stanley E. Marcus, *David Smith: The Sculptor and His Work* (Ithaca, N.Y.: Cornell University Press, 1983), p. 39.

19. Ibid., p. 94.

20. Garnett McCoy, ed., *David Smith* (New York: Praeger, 1973), p. 109.

21. Smith, "Notes," p. 185.

22. *Eva Hesse: A Retrospective* (New Haven, Conn.: Yale University Press, 1992), p. 32.

23. Ibid., p. 131.

24. Ibid., p. 107.

25. Anna C. Chave, "A Girl Being a Sculpture," in *Eva Hesse*, p. 99.

26. Robert Pincus-Witten, *Postminimalism* (New York: Out of London Press, 1977), p. 62.

27. *Eva Hesse*, p. 69.

28. Maurice Blanchot, *The Gaze of Orpheus*, trans. Lydia Davis (Barrytown, N.Y.: Station Hill, 1981), pp. 103–4.

29. Isamu Noguchi, *The Isamu Noguchi Garden Museum* (New York: Abrams, 1987), p. 220.

30. Dore Ashton, *Noguchi East and West* (New York: Knopf, 1992), p. 111.

31. Noguchi, *Isamu Noguchi Garden Museum*, p. 26.

32. Ashton, *Noguchi East and West*, p. 243.

33. Noguchi, *Isamu Noguchi Garden Museum*, p. 12.

34. Donald Judd, *Complete Writings, 1959–1975* (New York: New York University Press, 1975), p. 184.

35. All quotations drawn from Yu Yu Yang, interview by author, October 1993.

36. Mark Di Suvro, interview by author, December 1995.

37. Walt Whitman, "A Noiseless Patient Spider," in Mark Di Suvero, ed., *Open Secret* (New York: Rizzoli, 1992), p. 19.

38. Lao Tzu, "The Way of Life," in Mark Di Suvero, ed., *Open Secret*, p. 16.

39. Rumi, "Unmarked Boxes," in Mark Di Suvero, ed., *Open Secret*, p. 22.

40. Bruce Nauman, exhibition catalog, Walker Art Center, Minneapolis, 1994, p. 61.
41. Ibid., p. 17.
42. Tracey Henebeger, interview by author, March 1966.

Asceticism and Architecture

1. Rem Koolhaas and Bruce Mau, *S, M, L, XL* (New York: Monacelli Press, 1996), p. 495.
2. Ibid., pp. 501–2.
3. Frank Lloyd Wright, *An Autobiography* (New York: Duell, Sloan and Pearce, 1943), p. 3.
4. Ibid., p. 40.
5. Ibid., p. 32.
6. Frank Lloyd Wright, *In the Realm of Ideas,* ed. Bruce Brooks Pfeiffer and Gerald Nordland (Carbondale: Southern Illinois University Press, 1988), p. 52.
7. Anthony Alofsin, "Frank Lloyd Wright and Modernism," in *Frank Lloyd Wright, Architect,* ed. Terence Riley (New York: Museum of Modern Art, 1994), p. 54.
8. Wright, *In the Realm of Ideas,* p. 59.
9. Ibid., p. 60.
10. *In the Realm of Ideas,* p. 19.
11. Wright, *Autobiography,* p. 251.
12. Wright, *In the Realm of Ideas,* p. 28.
13. Lewis Mumford, *The Highway and the City* (New York: Dial, 1963), p. 156.
14. Mies van der Rohe, "Architecture and the Times," in *Mies van der Rohe* (New York: Simon and Schuster, 1970), p. 13.
15. Blake, *Mies van der Rohe: Architecture and Structure* (Baltimore: Penguin, 1966), pp. 74–75.
16. Charles Jencks, *Modern Movements in Architecture* (New York: Anchor, 1973), pp. 95–96.
17. Blake, *Mies van der Rohe,* p. 117.
18. Quoted in Michael Cann, *I. M. Pei: Mandarin of Modernism* (New York: Carl Southern Books, 1995), p. 578.
19. Quoted in *Technology Review* (April 1995), p. 87.

Asceticism in Music and the Dance

1. Bruno Monsaingeon, *Mademoiselle: Conversations with Nadia Boulanger,* trans. Robyn Marsach (Manchester: Carcanet, 1985), p. 38.
2. Ibid., p. 113.
3. Tan Dun, interview by author, March 1997.
4. Stanley Cavell, "Music Discomposed," in Morris Philipson and Paul J. Gudel, eds., *Aesthetics Today* (New York: New American Library, 1980), pp. 561–62.

5. Richard Langham Smith, ed., *Debussy on Music* (New York: Knopf, 1977), p. 232.

6. Ibid., p. 297.

7. Arthur B. Wenk, *Claude Debussy and the Poets* (Berkeley: University of California Press, 1976), p. 10.

8. Paul Griffiths, *The Messiaen Companion* (New York: Da Capo, 1994), pp. 504–5.

9. John Cage and Joan Retallack, *Musicage: Cage Muses on Words, Art, Music* (Hanover, N.H.: University Press of New England, 1996), p. xxxvi.

10. John Cage, interview by author, July 1992.

11. John Cage, *Silence* (Hanover, N.H.: University Press of New England, 1961), p. 77. Subsequent references to this work are cited by page number in the text.

12. Cage and Retallack, *Musicage*, p. 77.

13. Ibid., p. 243.

14. Richard Kostelanetz, ed., *John Cage* (New York: Praeger, 1970), pp. 13–14.

15. Paul Zukowsky, program notes for Summergarden concert series, New York, Museum of Modern Art, 1992, p. 4.

16. John Cage, *I–VI* (Cambridge, Mass.: Harvard University Press, 1990), p. 429.

17. Henry David Thoreau, *Walden* (New York: Library of America, 1991), p. 216.

18. Cole Gagne and Tracy Caras, *Soundpieces: Interviews with American Composers* (Metuchen, N.J.: Scarecrow Press, 1982), p. 95.

19. Ibid., p. 89.

20. Ibid., p. 96.

21. Steve Reich, *Writings on Music* (Halifax: The Press of the Nova Scotia College of Art and Design, 1974), p. 25. Subsequent references to this work are cited by page number in the text.

22. Gagne and Caras, *Soundpieces*, p. 311.

23. *The Collected Poems of William Carlos Williams* (New York: New Directions, 1988), p. 283.

24. Ibid., pp. 283–84.

25. Ibid., p. 284.

26. Philip Glass, *Music by Philip Glass* (New York: Harper and Row, 1987), p. 18.

27. Ibid., p. 103.

28. Gagne and Caras, *Soundpieces*, p. 221.

29. Glass, *Music by Philip Glass*, p. 33.

30. Ibid., p. 66.

31. Trevor Fairbrother, *Robert Wilson's Vision* (New York: Abrams, 1992), p. 10.

32. Glass, *Music by Philip Glass*, p. 177.

33. Ibid., p. 125.

34. Fairbrother, *Robert Wilson's Vision*, p. 87.

35. Jonathan Cott, _Conversations with Glenn Gould_ (Boston: Little, Brown, 1984), p. 105.

36. Ibid., p. 106.

37. Geoffrey Payzant, _Glenn Gould: Music and Mind_ (Toronto: Van Nostrand Reinhold, 1988), p. 54.

38. Alfred Bester, "Zany Genius of Glenn Gould," _Holiday_, April 1964.

39. Payzant, _Glenn Gould_, p. 64.

40. John P. L. Roberts and Ghyslaine Guertin, _Glenn Gould: Selected Letters_ (Toronto: Oxford University Press, 1992), pp. 58–59.

41. Roberts and Guertin, _Gould: Selected Letters_, p. 31.

42. Cott, _Conversations_, p. 40.

43. Tim Page, ed., _The Glenn Gould Reader_ (New York: Knopf, 1984), p. 321.

44. Ibid., pp. 327–28.

45. Roberts and Guertin, _Gould: Selected Letters_, p. 50.

46. _Ibid._, p. 46.

47. Cott, _Conversations_, p. 63.

48. Ibid., p. 49.

49. Page, _Glenn Gould Reader_, p. 346.

50. Ibid, p. 352.

51. William Carlos Williams, _Pictures from Breughel_ (New York: New Directions, 1962), p. 10.

52. Stéphane Mallarmé, "The Ballet," in _What Is Dance?_, ed. Roger Copeland and Marshall Cohen (New York: Oxford University Press, 1983), pp. 114–15.

53. T. W. Adorno, _Philosophy of Modern Music_, trans. Anne G. Mitchell and Wesley V. Blomster (New York: Continuum, 1994), pp. 173–74.

54. Francis Mason, editor, _I Remember Balanchine_ (New York: Doubleday, 1991), p. 162.

55. Ibid, p. 490.

56. R. P. Blackmur, "The Swan in Zurich," in _What Is Dance_, p. 357.

57. Mason, _I Remember Balanchine_, p. 259.

58. Gelsey Kirkland, _Dancing on My Grave_ (New York: Doubleday, 1986), p. 51.

59. Ibid, p. 31.

60. Edwin Denby, "Three Sides of Agon," in _What Is Dance_, p. 453.

61. Program notes, "A Doris Humphrey Centennial Celebration," Windhover Performing Arts Center, July 1995.

62. Doris Humphrey, The Art of Making Dances (New York: Grove, 1959), p. 171.

63. Ibid., p. 106.

64. Program notes, "A Doris Humphrey Centennial Celebration."

65. Ina Hahn, interview by author, November 1996.

66. Humphrey, _Art of Making Dances_, p. 30.

67. E. M. Cioran, _Tears and Saints_ (Chicago: University of Chicago Press, 1995), p. 100.

68. Roger Copeland, "Merce Cunningham and the Politics of Perception," in _What Is Dance_, pp. 311–12.

Asceticism in Literature and Philosophy

1. Edmund Wilson, *The Forties: From Notebooks and Diaries of the Period*, ed. Leon Edel (New York: Farrar, Straus and Giroux, 1983), p. 67.

2. Wallace Stevens, "To an Old Philosopher in Rome," in *Collected Poems* (New York: Knopf, 1967), p. 510–11.

3. George Santayana, *The Last Puritan* (New York: Scribner's, 1949), p. 8.

4. Ibid., p. 602.

5. Arthur Schopenhauer, *The World as Will and Representation*, vol. 2, trans. E. F. J. Payne (New York: Dover, 1966), p. 615.

6. Ibid., pp. 638–39.

7. Josiah Thompson, *Kierkegaard* (New York: Knopf, 1973), p. 76.

8. Søren Kierkegaard, *Concluding Unscientific Postscript*, trans. David F. Swenson and Walter Lowrie (Princeton, N.J.: Princeton University Press, 1968), pp. 359–60.

9. Søren Kierkegaard, *Fear and Trembling and Repetition*, trans. Howard V. Hong and Edna H. Hong (Princeton, N.J.: Princeton University Press, 1983), p. 36. Subsequent references to this work are cited by page number in the text.

10. Gerard Manley Hopkins, *Selected Prose*, ed. Gerald Roberts (New York: Oxford University Press, 1980), p. 165.

11. Ibid., p. 30.

12. Gerard Manley Hopkins, *Selected Poems* (New York: Penguin, 1978), p. 5.

13. Ibid., p. 6.

14. Hopkins, *Selected Prose*, p. 95.

15. Hopkins, *Selected Poems*, p. 13.

16. Stéphane Mallarmé, *The Poems*, trans. Keith Bosley (New York: Penguin, 1977), p. 169. Subsequent references to this work are cited by page number in the text.

17. Jean-Paul Sartre, *Mallarmé or the Poet of Nothingness*, trans. Ernest Sturm (University Park: Pennsylvania State University Press, 1988), p. 97.

18. Maurice Blanchot, "The Igitur Experience," in *Stéphane Mallarmé: Modern Critical Views*, ed. Harold Bloom (New York: Chelsea House, 1987), p. 6.

19. Jacques Derrida, *Acts of Literature*, ed. Derek Attridge (New York: Routledge, 1992), p. 113.

20. Quoted in Gordon Millan, *A Throw of the Dice: The Life of Stéphane Mallarmé* (New York: Farrar, Straus, 1994), pp. 152–53.

21. Stéphane Mallarmé, *A Tomb for Anatole*, trans. Paul Auster (San Francisco: North Point, 1983), p. 90.

22. Mallarmé, *Poems*, p. 297.

23. William Barrett, *The Illusion of Technique* (New York: Anchor, 1978), p. 305.

24. Marcel Proust, *The Remembrance of Things Past*, vol. 1, pp. 227–28.

25. Ibid., vol. 3, p. 491.

26. Walter Pater, *The Renaissance: Studies in Art and Poetry*, ed. Donald L. Hill (Berkeley: University of California Press, 1980), p. 186.

27. Camille Paglia, *Sexual Personae* (New Haven, Conn.: Yale University Press, 1990), p. 482.

28. Pater, *Renaissance*, pp. 188–89.

29. Walter Pater, *Marius the Epicurean* (New York: Oxford University Press, 1986), p. 15.

30. Peter Allt and Russell K. Alspach, eds., *The Variorum Edition of the Poems of W. B. Yeats* (New York: Macmillan, 1973), p. 495.

31. William Butler Yeats, *Mythologies* (New York: Collier, 1969), p. 332.

32. Allt and Alspach, *Variorum Edition*, p. 408. Subsequent references to this work are cited by page number in the text.

33. T. S. Eliot, *Collected Poems* (New York: Harcourt, Brace, 1971), p. 53. Subsequent references to this work are cited by page number in the text.

34. T. E. Hulme, *Speculations: Essays on Humanism and the Philosophy of Art* (New York: Routledge, 1987), p. 266. Subsequent references to this work are cited by page number in the text.

35. William James, *The Varieties of Religious Experience* (New York: Anchor, 1978), p. 66. Subsequent references to this work are cited by page number in the text.

36. Samuel Beckett, *Collected Poem in English and French* (New York: Grove, 1976), p. 9.

37. Harold Bloom, *Samuel Beckett: Modern Critical Views* (New York: Chelsea House, 1985), p. 5.

38. T. W. Adorno, in *Samuel Beckett: Modern Critical Views*, ed. Harold Bloom, p. 59.

39. Adorno, p. 60.

40. Samuel Beckett, *Molloy, Malone Dies, The Unnamable*, trans. Patrick Bowles (New York: Grove, 1976), p. 179.

41. Samuel Beckett, *Proust* (New York: Grove Press, 1957), p. 8.

42. Beckett, *Molloy*, p. 10. Subsequent references to this work are cited by page number in the text.

43. Martin Heidegger, *Poetry, Language, Thought*, trans. Albert Hofstadter (New York: Harper, 1971), p. 4.

44. Ibid., p. 7.

45. Ibid., p. 9.

46. Martin Heidegger, *Nietzsche: The Will to Power as Art*, vol. 1, trans. David Farrell Krell (New York: Harper & Row, 1979), p. 105.

47. Martin Heidegger, *Existence and Being*, ed. Werner Brock (Chicago: Henry Regnery, 1949), pp. 234–35.

48. Martin Heidegger, *On the Way to Language*, trans. Peter D. Hertz (New York: Harper & Row, 1971), p. 19.

49. Martin Heidegger, *Being and Time*, trans. John Macquarrie and Edward Robinson (New York: Harper & Row, 1962), p. 208.

50. Ibid.

51. Richard Rorty, "Heidegger, Contingency, and Pragmatism," in *Essays on Heidegger and Others* (Cambridge: Cambridge University Press, 1991), pp. 37–38.

52. Robert Musil, *The Man without Qualities*, trans. Sophie Wilkins and Burton Pike (New York: Knopf, 1995), vol. 1, p. 273. Subsequent references to this work are cited by page number in the text.

53. Quoted in Philip Payne, *Robert Musil's "The Man without Qualities"* (Cambridge: Cambridge University Press, 1988), p. 27.

54. Musil, *Man without Qualities* 1:596. Subsequent references to this work are cited by page number in the text.

55. Stephen D. Dowden, *Understanding Thomas Bernhard* (Columbia: University of South Carolina Press, 1991), p. 6.

56. Walter Abish, "The Fall of Summer," *Conjunctions* 7 (1985): 114.

57. Thomas Bernhard, *The Loser*, trans. Jack Dawson (New York: Knopf, 1991), pp. 84–85.

58. Ibid., p. 78.

59. Ibid., p. 82.

60. Thomas Bernhard, *Wittgenstein's Nephew*, trans. David McLintock (New York: Knopf, 1989), p. 30.

61. Ibid., p. 51

62. Ibid., p. 91.

63. Thomas Bernhard, *Correction*, trans. Sophie Wilkins (Chicago: University of Chicago Press, 1990), p. 163.

64. Ibid., p. 28.

65. Ibid., p. 271.

66. Annie Cohen-Solal, *Sartre: A Life*, trans. Anna Cancogni (New York: Pantheon, 1987), p. 150.

67. Jean-Paul Sartre, *Being and Nothingness*, trans. Hazel Barnes (New York: Philosophical Library, 1980), pp. 22–23.

68. Ibid., p. 24.

69. Ibid., p. 267.

70. Jean-Paul Sartre, *Saint Genet*, trans. Bernard Frechtman (New York: Braziller, 1963), p. 566.

71. Jean Paul Sartre, *No Exit and Three Other Plays*, trans. Stuart Gilbert (New York: Vintage, 1955), p. 23.

72. *The Simone Weil Reader* (New York: Putnam's, 1980), p. 69. Subsequent references to this work are cited by page number in the text.

73. Simone Weil, *Lectures on Philosophy*, trans. Hugh Price (Cambridge: Cambridge University Press, 1978), p. 42.

74. *Simone Weil Reader*, p. 78.

75. Ibid., p. 351.

76. Ibid., p. 438.

77. Michel Foucault, *The Order of Things: An Archaeology of the Human Sciences* (New York: Vintage, 1973), p. xxiv.

78. Allen Megill, *Prophets of Extremity: Nietzsche, Heidegger, Foucault, Derrida* (Berkeley: University of California Press, 1985), p. 217.

79. David Halperin, *Saint Foucault: Towards a Gay Hagiography* (New York: Oxford University Press, 1995), p. 104.

80. David Macey, *The Lives of Michel Foucault* (New York: Pantheon, 1993), pp. 187–88.

81. Foucault, *Order of Things*, p. 375.

82. Ibid., p. 387.

83. Seamus Heaney, "Mossbawn," in *Preoccupations: Selected Prose, 1968–1978* (New York: Farrar, Straus, 1980), p. 17.

84. Seamus Heaney, "Digging" in *Poems, 1965–1975* (New York: Farrar, Straus, 1980), p. 4.

85. Seamus Heaney, *The Redress of Poetry* (New York: Farrar, Straus, 1995), pp. 4–5.

86. Seamus Heaney, *North* (New York: Oxford University Press, 1975), p. 10.

87. Seamus Heaney, "North," in *North*, p. 20.

88. Seamus Heaney, "At a Potato Digging," in *Poems, 1965–1975*, p. 21.

89. Seamus Heaney, *Station Island* (New York: Farrar, Straus, 1985), p. 68. Subsequent references to this work are cited by page number in the text.

90. Walter Abish, interview by author, January 1996.

91. Walter Abish, *Minds Meet* (New York: New Directions, 1975), p. 14.

92. Sylvere Lotringer, "Walter Abish: Wie Deutsch Ist Es," *Semiotext(e)* 4, no. 2 (1982): 2.

93. Paul Wotipka, "Walter Abish's *How German Is It*: Representing the Postmodern," *Contemporary Literature* 30 (1989): 507.

94. Walter Abish, *How German Is It* (New York: New Directions, 1980), p. 24.

95. Ibid., p. 166.

96. Ibid., pp. 134–35.

97. Abish, interview by author, January 1996.

98. *Annals of Scholarship*, p. 388.

99. Walter Abish, *Eclipse Fever* (New York: Knopf, 1993), p. 237.

100. Ibid., p. 162.

101. Abish, interview by author, January 1996.

Bibliography

Abish, Walter. *Alphabetical Africa*. New York: New Directions, 1974.
———. *Eclipse Fever*. New York: Knopf, 1993.
———. *How German Is It*. New York: New Directions, 1980.
———. *In the Future Perfect*. New York: New Directions, 1977.
———. *Minds Meet*. New York: New Directions, 1975.
Adorno, Theodore. *Philosophy of Modern Music*. Translated by Anne G. Mitchell and Wesley V. Blomster. New York: Continuum, 1994.
Agnes Martin: A Retrospective. New York: Whitney Museum of American Art, 1992.
Allt, Peter, and Russell K. Alspach, eds. *The Variorum Edition of the Poems of W. B. Yeats*. New York: Macmillan, 1973.
Arias-Misson, Alain. "The Puzzle of Walter Abish: In the Future Perfect." *Sub-Stance* 27 (fall 1983).
Ashton, Dore. *Noguchi East and West*. New York: Knopf, 1992.
Barrett, William. *The Illusion of Technique*. New York: Anchor, 1978.
Barrette, Bill. *Eva Hesse: Sculpture Catalogue Raisonné*. New York: Timken, 1989.
Barthes, Roland. *Image, Music, Text*. Translated by Richard Howard. New York: Hill and Wang, 1977.
———. *A Lover's Discourse*. Translated by Richard Howard. New York: Hill and Wang, 1978.
———. *The Responsibility of Forms*. Translated by Richard Howard. New York: Hill and Wang, 1985.
———. *The Rustle of Language*. Translated by Richard Howard. New York: Hill and Wang, 1986.
———. *Sade, Fourier, Loyola*. New York: Hill and Wang, 1976.
———. *Writing Degree Zero*. New York: Hill and Wang, 1970.
Bataille, Georges. *The Literature of Evil*. New York: Urizen, 1973.
Beckett, Samuel. *Collected Poems in English and French*. New York: Grove, 1976.
———. *Molloy, Malone Dies, The Unnamable*. Translated by Patrick Bowles. New York: Grove, 1965.
———. *Proust*. New York: Grove Press, 1957.
Benevolo, Leonardo. *History of Modern Architecture*. 2 vols. Cambridge, Mass.: MIT Press, 1977.

Bernhard, Thomas. *Correction*. Translated by Sophie Wilkins. Chicago: University of Chicago Press, 1990.

———. *The Loser*. Translated by Jack Dawson. New York: Knopf, 1991.

———. *Old Masters*. Translated by Ewald Osers. London: Quartet, 1989.

———. *Wittgenstein's Nephew*. Translated by David McLintock. New York: Knopf, 1989.

Blake, Peter. *Mies van der Rohe: Architecture and Structure*. Baltimore: Penguin, 1966.

Blanchot, Maurice. *The Gaze of Orpheus*. Translated by Lydia Davis. Barrytown, N.Y.: Station Hill, 1981.

———. *The Space of Literature*. Translated by Ann Smock. Lincoln: University of Nebraska Press, 1982.

———. *Thomas the Obscure*. Translated by Robert Lamberton. Barrytown, N.Y.: Station Hill, 1988.

Bloom, Harold. *Agon: Towards a Theory of Revisionism*. New York: Oxford University Press, 1982.

———. *The Anxiety of Influence*. New York: Oxford University Press, 1973.

———. ed. *Søren Kierkegaard: Modern Critical Views*. New York: Chelsea House, 1989.

———. ed. *Stéphane Mallarmé: Modern Critical Views*. New York: Chelsea House, 1987.

Bois, Yve-Alain. *Painting as Model*. Cambridge, Mass.: MIT Press, 1990.

Bonnefoy, Yves. *Alberto Giacometti: A Biography of His Work*. Translated by Jean Stewart. Paris: Flammarion, 1991.

———. *The Lure and Truth of Painting: Selected Essays on Art*. Chicago: University of Chicago Press, 1995.

Bruce Nauman (exhibition catalog). Minneapolis: Walker Art Center, 1994.

Cage, John. *I-VI*. Hanover, N.H.: University Press of New England, 1992.

———. *Silence*. Hanover, N.H.: University Press of New England, 1961.

Cage, John, and Joan Retallack. *Musicage: Cage Muses on Words, Art, Music*. Hanover, N.H.: University Press of New England, 1996.

Cann, Michael. *I. M. Pei: Mandarin of Modernism*. New York: Carl Southern Books, 1995.

Celant, Germano. *Ars Povera*. New York: Praeger, 1969.

Champa, Kermit Swiler. *Mondrian Studies*. Chicago: University of Chicago Press, 1985.

Cheetham, Mark. *The Rhetoric of Purity: Essentialist Theory and the Advent of Abstract Painting*. Cambridge: Cambridge University Press, 1991.

Cioran, E. M. *Tears and Saints*. Chicago: University of Chicago Press, 1995.

Cohen-Solal, Annie. *Sartre: A Life*. Translated by Anna Cancogni. New York: Pantheon, 1987.

Cott, Jonathan, ed. *Conversations with Glenn Gould*. Boston: Little, Brown, 1984.

Cumming, Robert D., ed. *The Philosophy of Jean-Paul Sartre*. New York: Vintage, 1965.

Cy Twombly: Paintings, Works on Paper, Sculpture. Munich: Prestel-Verlag, 1987.

Derrida, Jacques. *Acts of Literature.* Edited by Derek Attridge. New York: Routledge, 1992.

———. *The Gift of Death.* Chicago: University of Chicago Press, 1996.

———. *Spurs.* Translated by Barbara Harlow. Chicago: University of Chicago Press, 1979.

Di Crescenzo, Casimiro. *Alberto Giacometi: Early Works in Paris (1922–1930)* (exhibition catalog). Yoshii Gallery, New York, April 1994.

Di Suvero, Mark. *Open Secret.* New York: Rizzoli, 1992.

Dowden, Stephen. *Understanding Thomas Bernhard.* Columbia: University of South Carolina Press, 1991.

Eisinger, Joel. *Trace and Transformation: American Criticism of Photography in the Modernist Period.* Alburquerque: University of New Mexico Press, 1996.

Eliot, T. S. *Collected Poems.* New York: Harcourt, Brace, 1932.

Eliot, Valerie, ed. *The Letters of T. S. Eliot.* New York: Harcourt, Brace, 1988.

Ellman, Richard, ed. *The Modern Tradition.* New York: Oxford University Press, 1965.

Eva Hesse: A Retrospective. New Haven, Conn.: Essays by Linda Norden, Maria Kreutzer, Robert Storr, Anna C. Chave. Yale University Press, 1992.

Fairbrother, Trevor. *Robert Wilson's Vision.* New York: Abrams, 1992.

Foucault, Michel. *The Archaeology of Knowledge.* Translated by A. M. Sheridan Smith. New York: Pantheon, 1972.

———. *Language, Counter-Memory, Practice.* Edited by Donald F. Bouchard. Ithaca, N.Y.: Cornell University Press, 1977.

———. *The Order of Things.* New York: Vintage, 1973.

Framptom, Kenneth. *Studies in Tectonic Culture: The Poetics of Construction in Nineteenth and Twentieth Century Architecture.* Cambridge, Mass.: MIT Press, 1996.

Frascina, Francis, and Charles Harrison, eds. *Modern Art and Modernism: A Critical Anthology.* New York: Harper and Row, 1982.

Gagne, Cole, and Tracy Caras. *Soundpieces: Interviews with American Composers.* Metuchen, N.J.: Scarecrow Press, 1982.

Glass, Philip. *Music by Philip Glass.* New York: Harper and Row, 1987.

Griffiths, Paul. *The Messiaen Companion.* New York: Da Capo, 1994.

———. *Modern Music: A Concise History.* New York: Thames and Hudson, 1994.

Halley, Peter. *Collected Essays 1981–87.* New York: Sonnabend Gallery, 1987.

———. *"Images, Masks, Reflections"* (exhibition catalog essay). Janis Gallery, New York, January 1996.

Halperin, David. *Saint Foucault: Towards a Gay Hagiography.* New York: Oxford University Press, 1995.

Harpham, Geoffrey Galt. *The Ascetic Imperative in Culture and Criticism.* Chicago: University of Chicago Press, 1987.

Haskell, Barbara. *Donald Judd.* New York: Whitney Museum of American Art, 1988.

Heaney, Seamus. *Door into the Dark*. London: Faber, 1969.

———. *Field Work*. New York: Farrar, Straus, 1979.

———. *North*. New York: Oxford University Press, 1975.

———. *Poems, 1965–1975*. New York: Farrar, Straus, 1980.

———. *Preoccupations: Selected Prose, 1968–1978*. New York: Farrar, Straus, 1980.

———. *The Redress of Poetry*. New York: Farrar, Straus, 1995.

———. *Station Island*. New York: Farrar, Straus, 1985.

Heidegger, Martin. *Being and Time*. Translated by John Macquarrie and Edward Robinson. New York: Harper & Row, 1962.

———. *Existence and Being*. Edited by Werner Brock. Chicago: Henry Regnery, 1949.

———. *Nietzsche: The Will to Power as Art*. Translated by David Farrell Krell. New York: Harper & Row, 1979.

———. *On the Way to Language*. Translated by Peter D. Hertz. New York: Harper & Row, 1962.

———. *Poetry, Language, Thought*. Translated by Albert Hofstadter. New York: Harper & Row, 1971.

Heywood, Leslie. *Dedication to Hunger: The Anorexic Aesthetic in Modern Culture*. Berkeley: University of California Press, 1996.

Hopkins, Gerard Manley. *Selected Poems*. New York: Penguin, 1978.

———. *Selected Prose*. Edited by Gerard Roberts. New York: Oxford University Press, 1980.

Howells, Christina. *The Cambridge Companion to Sartre*. Cambridge: Cambridge University Press, 1992.

Hulme, T. E. *Speculations: Essays on Humanism and the Philosophy of Art*. New York: Routledge, 1987.

Humphrey, Doris. *The Art of Making Dances*. New York: Grove, 1959.

James, William. *Writings: 1902–1910*. New York: Library of America, 1987.

Jameson, Frederic. *The Prison-House of Language: A Critical Account of Structuralism and Russian Formalism*. Princeton, N.J.: Princeton University Press, 1972.

Jencks, Charles. *Modern Movements in Architecture*. New York: Anchor, 1973.

Judd, Donald. *Complete writings 1959–1975*. New York: New York University Press, 1975.

Kenner, Hugh. *A Colder Eye: The Modern Irish Writers*. New York: Penguin, 1983.

Kertess, Klauss. *Brice Marden: Paintings and Drawings*. New York: Abrams, 1992.

Kierkegaard, Søren. *Concluding Unscientific Postscript*. Translated by David F. Swenson and Walter Lowrie. Princeton, N.J.: Princeton University Press, 1968.

———. *Fear and Trembling and Repetition*. Translated by Howard V. Hong and Edna H. Hong. Princeton, N.J.: Princeton University Press, 1983.

Kirkland, Gelsey. *Dancing on My Grave*. New York: Doubleday, 1986.

Koolhaas, Rem, and Bruce Mau. *S,M,L,XL*. New York: Monacelli Press, 1996.
Kostelanetz, Richard, ed. *John Cage*. New York: Praeger, 1970.
Kristeva, Julia. *Time and Sense: Proust and the Experience of Literature*. New York: Columbia University Press, 1996.
Krauss, Rosalind. *Passages in Modern Sculpture*. Cambridge, Mass.: MIT Press, 1977.
Lippard, Lucy. *Six Years: The Dematerialization of the Art Object*. New York: Praeger, 1973.
Loesburg, Jonathan. *Aestheticism and Deconstruction: Pater, Derrida, and De Man*. Princeton, N.J.: Princeton University Press, 1991.
Macey, David. *The Lives of Michel Foucault*. New York: Pantheon, 1993.
Mallarmé, Stéphane. *Oeuvres Completes*. Paris: Pleiade, 1970.
———. *A Tomb for Anatole*. Translated by Paul Aster. San Francisco: North Point, 1983.
Marcus, Stanley E. *David Smith: The Sculptor and His Work*. Ithaca, N.Y.: Cornell University Press, 1983.
Marden, Brice. *The Grove Group* (exhibition catalog). Gagosian Gallery, New York, 1991.
Mason, Francis. *I Remember Balanchine*. New York: Doubleday, 191.
McCormick, John. *George Santayana: A Biography*. New York: Knopf, 1987.
McDonagh, Don. *The Complete Guide to Modern Dance*. New York: Doubleday, 1976.
Megill, Allen. *Prophets of Extremity: Nietzsche, Heidegger, Foucault, Derrida*. Berkeley: University of California Press, 1985.
Messinger, Lisa Mintz. *Abstract Expressionism: Works on Paper*. New York: Abrams, 1992.
Meyer, Ursula. *Conceptual Art*. New York: Dutton, 1972.
Millan, Gordon. *A Throw of the Dice: The Life of Stéphane Mallarmé*. New York: Farrar, Straus, 1994.
Miró, Joan. *Selected Writings and Interviews*. Edited by Margit Rowell. Boston: G. K. Hall, 1986.
Mondrian, Piet. *Natural Reality and Abstract Reality*. Translated by Martin S. James. New York: Braziller, 1995.
———. *The New Art, The New Life: Collected Writings*. Edited by Martin James and Harry Holtzman. Boston: G. K. Hall, 1986.
Monsaingeon, Bruno. *Mademoiselle: Conservations with Nadia Boulanger*. Translated by Robyn Marsach. Manchester, England: Carcanet, 1985.
Morrisroe, Patricia. *Mapplethorpe: A Biography*. New York: Random House, 1995.
Motherwell, Robert. *Selected Writings*. New York: Oxford University Press, 1992.
Mumford, Lewis. *The Highway and the City*. New York: Dial, 1963.
Musil, Robert. *The Man without Qualities*. Translated by Sophie Wilkins and Burton Pike. New York: Knopf, 1995.
Newman, Barnett. *Selected Writings and Interviews*. Edited by John P. O'Neill. New York: Knopf, 1990.

Noguchi, Isamu. *The Isamu Noguchi Garden Museum.* New York: Abrams, 1987.

Norris, Christopher. *The Deconstructive Turn: Essays in the Rhetoric of Philosophy.* London: Methuen, 1983.

O'Hara, Frank. *Art Chronicles 1954–1966.* New York: Braziller, 1975.

Page, Tim, ed. *The Glenn Gould Reader.* New York: Knopf, 1984.

Paglia, Camille. *Sexual Personae.* New Haven, Conn.: Yale University Press, 1990.

Pater, Water. *Marius the Epicurean.* New York: Oxford University Press, 1986.

———. *The Renaissance: Studies in Art and Poetry.* Edited by Donald Hill. Berkeley: University of California Press, 1979.

Payne, Philip. *Robert Musil's "The Man without Qualities."* Cambridge: Cambridge University Press, 1988.

Payzant, Geoffrey. *Glenn Gould: Music and Mind.* Toronto: Van Nostrand Reinhold, 1988.

Philipson, Morris, ed. *Aesthetics Today.* New York: New American Library, 1980.

Pincus-Witten, Robert. *Postminimalism.* New York: Out of London Press, 1977.

Proust, Marcel. *On Reading Ruskin: Prefaces to La Bible d'Amiens and Sesame et les Lys with Selections from the Notes to the Translated Texts.* Translated by Jean Autret, William Burford, and Phillip J. Wolfe. New Haven, Conn.: Yale University Press, 1987.

———. *The Remembrance of Things Past.* Translated by C. K. Scott Moncrieff and Terence Kilmartin. New York: Random House, 1981.

Reich, Steve. *Writings on Music.* New York: New York University Press, 1974.

Richardson, Brenda. *Brice Marden: Cold Mountain.* Houston: Houston Fine Art Press, 1992.

Riley, Terence, ed. *Frank Lloyd Wright, Architect.* New York: Museum of Modern Art, 1994.

———. *Light Construction.* New York: Museum of Modern Art, 1995.

Rilke, Rainer Maria. *Letters on Cezanne.* Translated by Joel Agee. New York: Fromm, 1985.

Roberts, John P. L., and Ghyslaine Guertin. *Glenn Gould: Selected Letters.* Toronto: Oxford University Press, 1992.

Rorty, Richard. *Essays on Heidegger and Others.* Cambridge: Cambridge University Press, 1991.

———. *Philosophy and the Mirror of Nature.* Princeton, N.J.: Princeton University Press, 1979.

Rosenberg, Harold. *Barnett Newman: Broken Obelisk and Other Sculptures.* Seattle: University of Washington Press, 1971.

———. *The De-Definition of Art.* Chicago: University of Chicago Press, 1972.

Rosenthal, Nan, and Ruth E. Fine. *The Drawings of Jasper Johns.* New York: Thames and Hudson, 1990.

Ross, Clifford, ed. *Abstract Expressionism: Creators and Critics.* New York: Abrams, 1990.

Rowell, Margit, ed. *Joan Miró: Selected Writings and Interviews*. Boston: G. K. Hall, 1986.

Rudenstine, Angelica Zander, ed. *Piet Mondrian*. New York: Leonardo Arte in association with the National Gallery of Art and the Museum of Modern Art, 1995.

Russell, John. *The Meanings of Modern Art*. New York: Harper and Row, 1981.

Rykwert, Joseph. *The Dancing Column: On Order in Architecture*. Cambridge, Mass.: MIT Press, 1996.

Santayana, George. *The Last Puritan*. New York: Scribner's, 1949.

Sartre, Jean-Paul. *Being and Nothingness*. Translated by Hazel Barnes. New York: Philosophical Library, 1980.

———. *Essays in Aesthetics*. Translated by Wade Baskin. New York: Washington Square, 1966.

———. *Mallarmé, or the Poet of Nothingness*. Translated by Ernest Sturm. University Park: Pennsylvania State University Press, 1988.

———. *No Exit and Three Other Plays*. Translated by Stuart Gilbert. New York: Vintage, 1955.

———. *Saint Genet*. Translated by Bernard Frechtman. New York: Braziller, 1963.

Schapiro, Meyer. *On the Humanity of Abstract Painting*. New York: Braziller, 1995.

Schopenhauer, Arthur. *The World as Will and Representation*. Translated by E. F. J. Payne. New York: Dover, 1966.

Schott, Robin May. *Cognition and Eros: A Critique of the Kantian Paradigm*. Boston: Beacon Press, 1988.

Serra, Richard. *Weight and Measure 1992* (exhibition catalog) London: Tate Gallery, 1992.

Smith, Richard Langham, ed. *Debussy on Music*. New York: Knopf, 1977.

Sorell, Walter. *Dance in Its Time*. New York: Doubleday, 1981.

Steegmuller, Francis, ed. *The Letters of Gustave Flaubert*. Cambridge, Mass.: Harvard University Press, 1980.

Steiner, George. *On Difficulty and Other Essays*. New York: Oxford University Press, 1978.

Steiner, Wendy. *The Scandal of Pleasure: Art in an Age of Fundamentalism*. Chicago: University of Chicago Press, 1995.

Stevens, Wallace. *Collected Poems*. New York: Knopf, 1954.

Suzuki, D. T., *Zen Buddhism*. New York: Anchor, 1956.

Thompson, Josiah. *Kierkegaard*. New York: Knopf, 1973.

Varnedoe, Kirk. *Cy Twombly: A Retrospective*. New York: Museum of Modern Art, 1994.

Vendler, Helen. *Soul Says: On Recent Poetry*. Cambridge, Mass.: Harvard University Press, 1995.

von Bruggen, Coosje. *Bruce Nauman*. New York: Rizzoli, 1988.

Ward, Graham. *Barth, Derrida and the Language of Theology*. Cambridge: Cambridge University Press, 1996.

Weber, Brom, ed. *The Complete Poems and Selected Letters and Prose of Hart Crane*. New York: Liveright, 1966.

———. *Hart Crane: A Biographical and Critical Study*. New York: Bodley, 1948.

Weil, Simone. *Lectures on Philosophy*. Translated by Hugh Price. Cambridge: Cambridge University Press, 1978.

Wenk, Arthur B. *Claude Debussy and the Poets*. Berkeley: University of California Press, 1976.

White, David. *Heidegger and the Language of Modern Poetry*. Lincoln: University of Nebraska Press, 1978.

White, Edmund, ed. *The Selected Writings of Jean Genet*. Hopewell, N.J.: Ecco Press, 1993.

Williams, William Carlos. *Pictures from Breughel*. New York: New Directions, 1962.

Wilson, Edmund. *The Forties: From Notebooks and Diaries of the Period*. New York: Farrar, Straus and Giroux, 1983.

Wright, Frank Lloyd. *An Autobiography*. New York: Duell, Sloan and Pearce, 1943.

———. *In the Realm of Ideas*. Carbondale: Southern Illinois University Press, 1988.

Yeats, W. B. *Essays and Introductions*. New York: Collier Books, 1968.

———. *Mythologies*. New York: Collier, 1969.

Index

UNIVERSITY PRESS OF NEW ENGLAND publishes books under its own imprint and is the publisher for Brandeis University Press, Dartmouth College, Middlebury College Press, University of New Hampshire, Tufts University, and Wesleyan University Press.

LIBRARY OF CONGRESS CATALOGING-IN-PUBLICATION DATA
Riley, Charles A.
 The saints of modern art: the ascetic ideal in contemporary painting, sculpture, architecture, music, dance, literature, and philosophy / Charles A. Riley.
 p. cm.
 Includes bibliographical references.
 ISBN 0–87451–765–6 (cl : alk. paper)
 1. Asceticism in art. 2. Arts, Modern—20th century. I. Title.
NX650.A73R55 1998
700'.1'030904—dc21 97-43017